MODERN ART
PRACTICES AND DEBATES

Primitivism, Cubism, Abstraction

MODERN ART
PRACTICES AND DEBATES

Primitivism, Cubism, Abstraction
The Early Twentieth Century

Charles Harrison Francis Frascina Gill Perry

YALE UNIVERSITY PRESS, NEW HAVEN & LONDON
IN ASSOCIATION WITH THE OPEN UNIVERSITY

First published 1993 by Yale University Press in association with The Open University
Reprinted with corrections 1994

2 4 6 8 10 9 7 5 3

Library of Congress Cataloging-in-Publication Data
Harrison, Charles. 1942–
Primitivism, Cubism, Abstraction: The Early Twentieth Century /
Charles Harrison, Francis Frascina, Gill Perry.
p. cm. – (Modern Art – Practices and Debates)
Includes bibliographical references and index.
ISBN 0–300–05515–3
ISBN 0–300–05516–1 paperback edition

1. Primitivism in art. 2. Cubism. 3. Art, abstract. 4. Art, Modern – 20th century.
I. Frascina, Francis. II. Perry, Gillian. III. Title. IV. Series.
N6494.P7H37 1993 709'.04'1 – dc20

Edited, designed and typeset by The Open University.
Printed in Hong Kong by Kwong Fat Offset Printing Co. Ltd.

CONTENTS

PREFACE

This is the second in a series of four books about art and its interpretation from the mid-nineteenth century to the end of the twenties. Each book is self-sufficient and accessible to the general reader. As a series, they form the main texts of an Open University course *Modern Art: Practices and Debates*. They represent a range of approaches and methods characteristic of contemporary art-historical debate.

The chapters in this book consider aspects of art and visual culture in Europe from *c*.1900 to the 1920s. Although organized chronologically, each chapter investigates a period or movement of early twentieth-century art in relation to broader theoretical issues and problems of interpretation. In the process questions are raised about historical enquiry and methodology, as well as about the status of 'art'.

In the first chapter, Gill Perry explores the relationship between concepts of the 'primitive' and the interests of 'modern' and avant-garde artists working around the turn of the century. The first part of this chapter focuses on the primitivist interests involved in the formation of so many rural artists' colonies in France and Germany at the end of the nineteenth century. The second part considers the different ways in which cultural and aesthetic interests in the 'primitive' in the work of Matisse and the Fauves and the German Expressionists were inflected with value-laden concepts of the 'decorative' and the 'expressive'.

In the second chapter, Francis Frascina explores and develops a form of analysis of Cubist works derived from semiological theory. In assessing the potential of semiotics for decoding Cubist works, he assesses the social and cultural values encoded in such signifying systems, and explores Cubism as an artistic practice which raises questions about the status of the art object and the relationship between representation and ideology. In the process he makes a crucial distinction between 'mainstream semiotics' and 'social semiotics' arguing that the latter has more historical explanatory potential.

In Chapter three, Charles Harrison considers some problems of interpretation and evaluation posed by specific examples of abstract art, exploring some of the relations and differences between figurative and abstract forms of painting. He discusses the need for attention to historical context using the career of the Russian artist Kazimir Malevich as a basis, while the work of the Dutch painter Piet Mondrian is considered in relation to evaluative analysis.

Open University texts undergo several stages of drafting and review. The authors would like to thank all those who commented on the drafts, notably Lynn Baldwin and Professor Thomas Crow. Gill Perry was the academic co-ordinator. The editors were Abigail Croydon and Clive Baldwin. Picture research was carried out by Tony Coulson. Alison Clarke keyed in the texts. The graphic design is by Richard Hoyle. Roberta Glave was the course administrator.

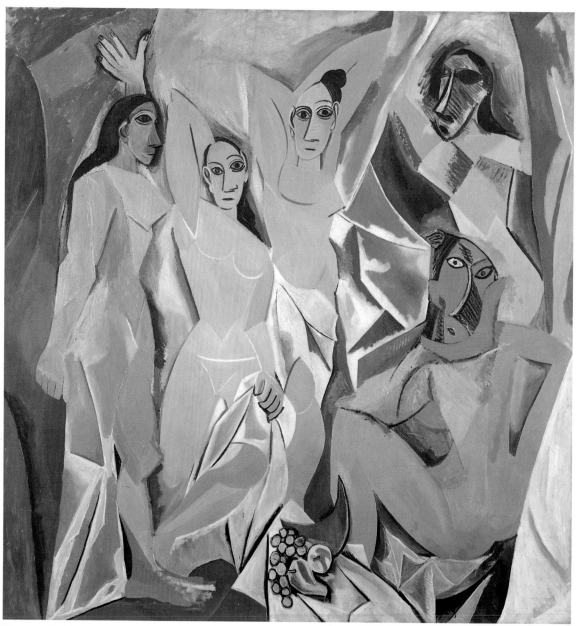

Plate 1 Pablo Picasso, *Les Demoiselles d'Avignon*, 1907, oil on canvas, 244 x 234 cm. Collection of the Museum of Modern Art, New York. Acquired through the Lillie P. Bliss Bequest, 1939. © DACS, Paris 1993.

PRIMITIVISM AND THE 'MODERN'

by Gill Perry

Introduction: Primitivism in art-historical debate

In this chapter, I want to focus on the shifts that took place around the turn of the century in the aesthetic and cultural associations of art works designated 'modern'. Increasingly, forms of representation that were explicit or implicitly *opposed* to urban Western culture co-existed with and displaced those nineteenth-century notions of modernity that were concerned with the aesthetic potential of urban themes. Many artists whom we now label 'modern' were in fact opposed to the processes of modernization (by which I mean the forces of industrialization and urbanization in Western capitalist society).

This opposition often took the form of a positive discrimination in favour of so-called 'primitive' subjects and techniques. In his seminal book *Primitivism in Modern Art*, first published in 1938, the art historian Robert Goldwater wrote:

> The artistic interest of the twentieth century in the productions of primitive peoples was neither as unexpected nor as sudden as is generally supposed. Its preparation goes well back into the nineteenth century …
>
> (*Primitivism in Modern Art*, p.3)

Goldwater argues that long before artists like Picasso began to incorporate 'primitive' elements in their canvases around 1906–7 (Plate 1), many nineteenth-century artists, among them Gauguin, had already sought out 'primitive' sources and societies, identifying in them an artistic culture that paralleled the interests of modern Western artists. Goldwater's notion of 'preparation' helps to establish an artistic root for the interests of many twentieth-century avant-gardists. According to this view, Picasso, for example, was building on an innovative tradition anticipated in the work of Gauguin's generation. Such an account focuses on the technical aspects of the artists' works, and it implies a kind of continuum of formal affinities with a wide range of supposedly 'primitive' or non-Western sources.

This argument in its various forms is now well established in the art-historical writings on the period. But there is a crucial assumption which often underlies it: the idea that the 'primitive' artefacts were invested with value at the same time as – or even *after* – similar technical innovations appeared within Western art practices. The characteristics of 'primitive' sources were thus seen to *conform to*, rather than simply to *inspire* the changing interests of modern artists. In other words, a 'primitive' tendency was already being produced from *within* modern art, and in fact was to become a distinguishing feature of the 'modern'. As we shall see, this idea also had important implications for the artist's self-image, in that it contributed to the myth that avant-garde artists such as Gauguin and Picasso were somehow in touch with a pure, direct mode of artistic expression.

Much ink has been spilled on this subject. It raises some difficult questions about the definitions of innovation and assimilation in modern art works, and the relationship between them when the artist borrows from, or is influenced by, 'primitive' works. How, for

example, can we understand Picasso's *Demoiselles d'Avignon* (Plate 1), long seen as a canonical work of modernist primitivism, in relation to these questions?

Through its distorted faces and bodies (which recall some of the conventions of African and Iberian masks) and its broken space, does this work represent a radical breakthrough, an assault on the conventions of bourgeois art? If, on the other hand, these conventions are borrowed from or inspired by other sources, does this reduce the work's innovatory status? Does Picasso's use of African and Iberian artefacts represent a Western misappropriation of alien objects? And how does the subject-matter of female nudes, based on the theme of a Barcelona brothel, function in relation to these issues? Picasso claimed to have painted *Les Demoiselles before* he made his mythologized first visit to the Trocadero Ethnographical Museum in 1907.[1] If Picasso was relatively unaware of *specific* African sources, is this a work of some kind of intuitive primitivism? If, on the other hand, Picasso consciously assimilated 'tribal' objects into this work, did he do this because he perceived some disruptive or socially transgressive potential in the associations of African objects (traditionally used for the exorcism of spirits and other ritualistic functions)? Given Picasso's left-wing views at the time, could his use of African motifs be seen as a deliberate challenge to Western colonialist views of Africa? What do these motifs from African objects contribute to the meanings of *Les Demoiselles?*

These issues have all been hotly debated in the writings of modern art history. The glossy two-volume catalogue of an ambitious and influential exhibition of 1984, *'Primitivism' in Twentieth-Century Art: Affinity of the Tribal and the Modern*, edited by William Rubin, placed considerable importance on *Les Demoiselles* as a work of modernist primitivism. The emphasis, as the title suggests, is on formal affinities between modern Western and 'primitive' art and artefacts. Following the debate on the sources Picasso might have seen when he painted *Les Demoiselles*, it is argued that he did not copy directly from individual African masks, and was therefore producing a more *intuitive* form of primitivism. Underlying this argument is the assumption, set out in a preface by Kirk Varnedoe, that 'modernist primitivism depends on the autonomous force of objects – and especially on the capacity of tribal art to transcend the intentions and conditions that first shaped it' (p.x).

In recent years this approach has been debated and qualified by art historians and critics from many different positions. One theoretical approach that has greatly influenced the study of primitivism is 'discourse theory', an approach indebted to the work of the philosopher-historian Michel Foucault.[2] This has meant exploring the political and cultural ramifications of primitivism through a theory of discourse, rather than focusing on formal affinities and the 'autonomous' meanings of objects. Foucault uses the term 'discourse' to mean a set of statements and interests inscribed in (that is, 'written into') a whole range of texts. By 'texts', he means all kinds of cultural products, including documents and publications, from books and newspapers to advertisements and letters; some art historians have extended this notion of 'text' to incorporate images.

According to this approach, 'primitivism' is seen as a complex network of sociological, ideological, aesthetic, scientific, anthropological, political and legal interests (that is, 'discourses'), which feed into and determine a culture. As a discourse, it involves, according to Foucault, a relationship of power; he means, for example, that those within Western society who analyse, teach, paint or reproduce a view of the 'primitive' would, by this activity, be dominating, restructuring and having authority over that which they define as 'primitive'. Around the turn of the century, that which was described as primitive

[1] The issue of Picasso's first 'experience' of African art has obsessed his contemporaries and his biographers. As Goldwater (among others) has shown (*Primitivism in Modern Art*, p.144 and following), contemporary reports suggest different dates for Picasso's first viewing of African works. See also T.A. Burgard, 'Picasso and appropriation', and P. Leighten, 'The white peril and *l'art nègre*: Picasso, primitivism and anti-colonialism'.

[2] See, for example, Edward Said's *Orientalism*. Said employs Foucault's notion of 'discourse' as expounded in *The Archeology of Knowledge* and *Discipline and Punish*.

often included the products of a recently colonized country. Put very simply, a reading of *Les Demoiselles* indebted to discourse theory would play down the meanings associated with the style and intentions of the individual artist and with the surface of the painting, because it would see them largely as effects of the broader political discourses of colonialism, including contemporary Western discourses on Africa, which are inscribed within the painting. My own approach will be to acknowledge some of the analytical tools provided by this notion of discourse, but I will be looking closely at how the meanings of paintings are also affected by the concerns and processes of painting. I want to focus on the problem of how ideas, beliefs and values are actually 'inscribed' in paintings: how do causes become effects, and how are they mediated through the painting?

This short discussion of *Les Demoiselles* already suggests that the labels 'primitive' and 'primitivism' are deeply problematic. Broadly speaking the label 'primitive' has been used since at least the nineteenth century to distinguish contemporary European societies and their cultures from other societies and cultures that were then considered less civilized. Up to the mid-nineteenth century, the term was also used to describe Italian and Flemish works of the fourteenth and fifteenth centuries. But by the turn of the century its scope was extended to refer to ancient Egyptian, Persian, Indian, Javanese, Peruvian and Japanese cultures, to the products of societies thought to be 'closer to nature', and to what many art historians have called the 'tribal' art of Africa and Oceania (the islands of the Pacific Ocean). The label 'primitivism', on the other hand, has generally been used to describe a Western interest in, and/or reconstruction of, societies designated 'primitive', and their artefacts. Primitivism, then, is generally used to refer to the discourses on the 'primitive'.

In the late twentieth century, the term 'primitive' has been described as Eurocentric, as revealing a Western-centred view of an alien culture (hence my use of inverted commas). It has been argued that merely by using the word 'primitive', rather than one which gives a geographical designation of the culture in question (such as 'African', 'Egyptian', 'Polynesian'), we are defining that culture as different from our own, as 'primitive' according to our Western notion of what is civilized. To use the term is to make an implicit value judgement, even though that judgement can assume different disguises. Similar criticisms can be made of the terms 'l'art nègre' ('negro art') and 'tribal' art.[3] While the term 'l'art nègre' presupposes a broad racial category, and is indifferent to different cultures within the category, 'tribal' involves the Eurocentric construct of the uncivilized tribe, the opposite, or 'other' to Western society.

The category of the 'other' has also dominated recent writings on 'the primitive'. It is a critical category (derived from postmodern theory) which describes a tendency to *mis*represent another culture, society, object or social group as different or alien, as somehow 'other' to the writer or speaker's own culture and experiences. The category implies a self-image, a vantage point, from which relations of difference are incorrectly perceived or represented. As a category, then, the 'other' is often used to refer to those Western myths and fantasies through which the 'primitive' or non-Western has been represented in art and literature.

Within this European frame of reference, concepts of the 'primitive' have been used *both* pejoratively *and* as a measure of positive value. During the late nineteenth century, a range of cultural assumptions and prejudices contributed to the discourses on the 'primitive'. For the majority of the bourgeois public at this time the word signified backward, uncivilized peoples and their cultures. At a time when the French, like the British and Germans, were extending their colonial conquests in Africa and the South Seas, and establishing ethnographic museums and various forms of institutionalized anthropological study, the artefacts of colonized peoples were widely seen as evidence of their

[3] The term 'l'art nègre' was given prominence by Jean Laude in his *La Peinture française et l'art negre*, published in 1968.

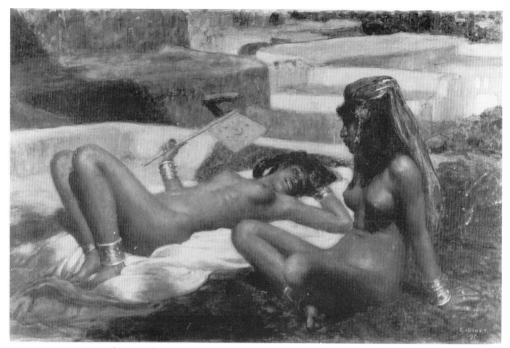

Plate 2 Alphonse-Étienne Dinet, *Sur les terraces, Clair de lune à Laghouat* (*On the Terraces, Moonlight at Laghouat*), 1898, distemper on canvas, 46 x 73 cm. Musée des Beaux Arts, Reims. © DACS 1993.

'barbaric' uncivilized nature, of their lack of cultural 'progress'. This view was reinforced by the increasing popularity of pseudo-Darwinian theories of cultural evolution.

At the same time, more positive views of the essential purity and goodness of 'primitive' life, by contrast with the decadence of over-civilized Western societies, were gaining ground within European culture. Such views were influenced both by notions of the 'noble savage' (derived, often in distorted form, from the writings of the eighteenth-century philosopher Jean-Jacques Rousseau) and by well-established traditions of pastoralism in art and literature. A so-called 'primitivist' tradition evolved, which associated what were perceived as simple lives and societies with purer thoughts and expressions. Following certain Romantic notions developed by the nineteenth-century German philosopher Herder (among others), this tradition assumed that there was a relationship between 'simple' people and more direct or purified expression; it exalted peasant and folk culture as evidence of some kind of innate creativity. In Modernist revaluations of 'primitive' art and artefacts, these ideas were reworked and modified. Gauguin (as we have seen) is often identified as the first modern artist for whom this myth of the 'savage' became the touchstone of his philosophy of art and life.

Despite his avant-garde status, Gauguin was one of a host of contemporary artists, many of them working in more traditional contexts, for whom a 'primitive' or oriental subject-matter was a fashionable and marketable option.[4] Academically successful artists such as Jean-Léon Gérôme, Alphonse-Étienne Dinet and Jules-Jean-Antoine Lecomte du Noüy were producing works on oriental themes (Plates 2, 3) that were attracting wide-

[4] Broadly speaking, the terms 'the Orient' and 'the oriental' are more geographically specific than 'the primitive'. Despite some historical shifts, they have been used since the nineteenth century to refer to the countries of Asia and North Africa. But as Said has argued in *Orientalism*, Western doctrines and theses about the Orient have helped to define Europe (or the West) as its cultural opposite: 'Orientalism is a style of thought based upon an ontological and epistemological distinction made between "the Orient" and (most of the time) "the Occident"' (p.2).

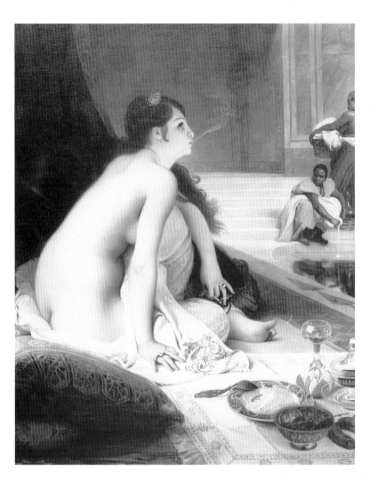

Plate 3 Jules-Jean-Antoine Lecomte du Noüy, *L'Esclave blanche* (*The White Slave*), 1888, oil on canvas, 146 x 118 cm. Musée des Beaux Arts Nantes. Photo: Patrick Jean.

spread interest at the annual Salon des Artistes Français and the slightly more liberal Salon de la Societé Nationale des Beaux Arts, at approximately the same time that Gauguin was painting his Tahitian works (although he was having little success selling them). The themes of Lecomte du Noüy's *White Slave* in the Salon of 1888, and Dinet's *Clair de lune à Laghouat* (probably) in the Nationale of 1898, are both bound up with French Imperial conquests in the Near East and North Africa. Gauguin's Tahitian works are also related to a French expansionist culture which had led to the colonization of areas of Polynesia. There are other parallels between Tahitian works like *Ia Orana Maria* (Plate 4) and the Dinet or the Lecomte du Noüy. In all three paintings a 'primitive' culture is represented through the image of naked or semi-naked women, although it is (presumably) Arab consumption of a white woman which is the theme of the Lecomte du Noüy. In the Dinet and the Gauguin, sensual, dark-skinned women are themselves represented as symbols of a 'primitive' life.

The main differences between these works lie in the techniques and the conventions employed. But these can also affect the kinds of meanings which we read out of the paintings. Gauguin's simplified and distorted style and his complex combination of pagan and Christian imagery and sources help to produce an image which is less 'transparent', that is, less easily read as an illusion of life itself, and was certainly less easily read by his contemporaries. (We will return to this point in a later section.) On the other hand, the apparent naturalism of *Clair de lune à Laghouat* allowed, even encouraged, contemporary critics to construct around it a Western myth, in this case of a 'primitive' Algerian woman with an animal-like sensuality and a 'wild musky scent', an object of male desire. In 1903,

L. Léonce Bénédicte described the painting as follows:

> This artist's brush has a quite exceptional ability to create the illusion of life itself. These
> little feminine bodies the colour of fine golden bronze, firm and rounded, moist like
> porous amphora – he knows them all. These little quivering bodies, elegant, supple,
> catlike and agile, making you think of all sorts of graceful animals, tame and wild – he
> knows their every languid, seductive and impatient gesture, every evocative and
> characteristic pose. He sees into their passionate and childlike hearts, with the jealousies of
> little pampered beasts, greedy like young monkeys. Their candid and primitive souls are
> revealed in abrupt and expressive physiognomic variations and in a vocal range which
> can encompass the most fluid inflections of birdsong and the furious and raucous barking
> of young jackals. It seems that he can even make us pick up the wild (*fauve*) and musky
> scent of these young and savage bodies.
> (quoted in *Équivoques: Peintures françaises du XIXe siècle*, translated by the author)

Bénédicte's reading of this image is replete with voyeuristic symbolic associations. He
implicitly represents Algerian woman as the 'other' of repressed Western society: she is
animal-like, child-like, savage, primitive and lascivious; she even gives off wild odours!

I am not suggesting that Gauguin's work actively resists such readings; in fact many
of his works can be seen to reinforce similar ideas. But I do want to suggest that this type
of reading becomes less clear cut in relation to Gauguin's work, because the technique it-
self came to be read as a sign for the 'primitive'. Some of the oppositions implicit in the
term 'primitivism' are opened to question when we look closely not just at the subject-
matter, but at the complex pictorial language which Gauguin employed.

Part 1 *'The going away' – a preparation for the 'modern'?*

Gauguin's primitivism – that is, his tendency to seek to represent, and to idealize, a sup-
posedly uncivilized culture – was already clearly in evidence during the years he spent
living and working in Brittany in the mid-1880s. By the late 1880s the village of Pont-Aven
in Brittany, where he stayed, was well established as an artistic centre, a community of
artists (many of them English and North American) who had come in search of cheaper
rents and a remote peasant culture which was seen as a source of artistic inspiration. In
this Breton community Gauguin believed he had found a context for artistic production
which was at odds with the civilized urban culture of metropolitan Paris. Or at least this is
what we are encouraged to believe, by his much-quoted statement, made in a letter to the
painter Émile Schuffenecker in February 1888:

> I love Brittany. I find something savage, primitive here. When my clogs echo on this
> granite earth, I hear the dull, muffled, powerful note that I am seeking in painting.
> (M. Malingue, *Lettres de Gauguin à sa femme et à ses amis*, pp.321–2)

As we shall see, Gauguin's image of Brittany as an ideal source of 'savage' imagery, which
both inspired *and* paralleled the expressive powers he sought in his painting, was rooted
in contemporary assumptions about the avant-garde artist's role as a rediscoverer or
prophet of some more direct, 'primitive' mode of expression. Given these assumptions,
'the going away' to the remote rural provinces – or to the supposed margins of civilization
– came to be seen as a crucial feature of late nineteenth-century avant-gardism. But the ac-
tual act of 'going away', of seeking out a 'primitive' culture, was often conflated with the
production of work in a 'primitive' style, though the latter did not necessarily follow from
the former. Both aspects of artistic production were often identified as evidence of
'originality', a point which I will take up later in this essay.

The cult of 'the going away' was by no means exclusive to French avant-gardism and
the circle around Gauguin. Throughout Europe as a whole, including Russia, Scandinavia
and Britain, and in Germany in particular, the vogue for forming artists' communities and

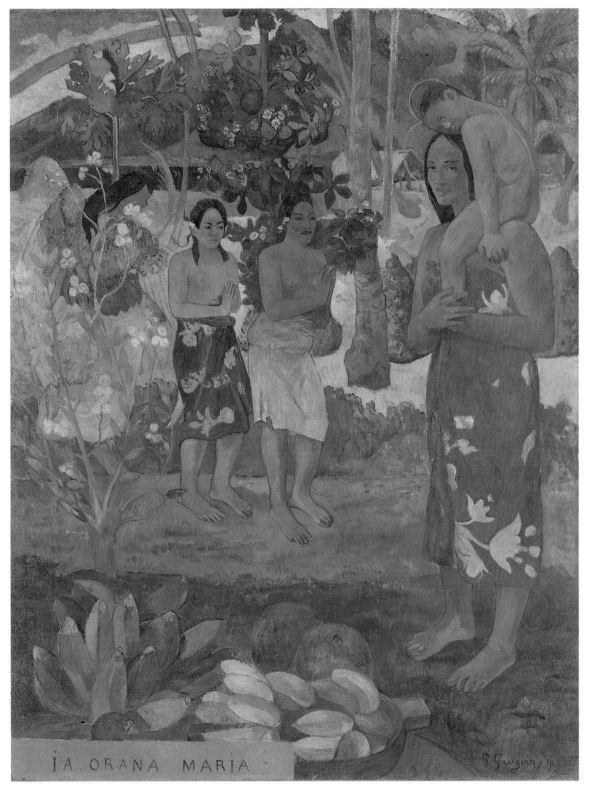

Plate 4 Paul Gauguin, *Ia Orana Maria* (*Hail Mary*), 1891–92, oil on canvas, 113 x 87 cm. Metropolitan Museum of Art, New York, Bequest of Sam A. Lewisohn, 1951.

colonies away from urban centres had been established in the mid-nineteenth century.[5] Despite national differences, there were some common causal factors which underlay the formation of so many rural artists' communities in different parts of Europe at around the same time. The contemporary European obsession with the myth of the rural peasant as a figure of great moral worth, uncorrupted by the sophistication and materialism of the modern world, was a crucial shared interest, although (as we shall see) the idea took on different associations in different national contexts. We could also single out a widespread dissatisfaction among young artists and art students with the conventional Academic training still offered in many major European art academies, and the fact that by the 1890s many young artists in different European countries had taken to painting 'en plein air', following the example of the mid-nineteenth-century French Barbizon community. And there were usually crucial material factors involved. Rents were generally much lower in the country and these rural communities formed cheap working bases for artists during the summer and early autumn. Many artists left Paris or other urban centres in the early summer with the closure of the art schools and, in France, the official government sponsored Salons, returning for the winter and the opening of the Salons in the spring.

In the following section, I want to consider these and other possible causes for the formation and artistic practices of two of the better-known European communities: Pont-Aven in the 1880s, and the German colony of Worpswede in the 1890s. I also want to focus on a related set of issues which underpinned the formation of such groups, which will involve closer examination of the art practices involved: that is the shifts and reformulations in contemporary ideas of what constituted the 'modern' in art.

These issues will also be considered in relation to Gauguin's Tahitian works. Gauguin's move to Polynesia and the cult of 'the going away' of which it was a part, reveals the construction of other myths of the 'primitive', particularly in association with the contemporary discourses of colonialism, and related notions of the exotic and the pagan.

'Clogs and granite': Brittany and Pont-Aven

From the mid-nineteenth century, Brittany became a popular place of pilgrimage in the summer months, for artists and tourists alike. With the building of new roads and the spread of the railways the area had become more accessible. By 1886 when Gauguin first visited the Breton village of Pont-Aven, the place had already attracted large numbers of artists, including a substantial group of North American and English painters. The local landscape, its people and their customs had already been the subject of a range of painted representations which appeared on the walls of the French, British and North American salons and annual exhibitions (Plates 5, 6, 7), many of which had helped to consolidate the urban bourgeois view of Brittany as a remote picturesque part of France, rich in local superstition and unusual religious customs. As Griselda Pollock and Fred Orton have argued in their essay 'Les Données bretonnantes', the discourses and practices of tourism informed a range of artistic representations of 'Bretonness', many of which misrepresented aspects of the economic and social developments which had taken place in Brittany in the second half of the nineteenth century. By the 1880s, changing farming methods, increased cultivation of land, farming of the sea, and the growth in tourist revenues had rapidly transformed Brittany from the backward rural community of earlier decades into a prosperous region of the modern agricultural industry. Although many of the old religious rituals and local customs had remained, they had lost some of their original meanings and had increasingly become part of a tourist spectacle.

[5] Michael Jacobs has documented, in *The Good and Simple Life*, some of the better known communities formed in France, Germany, Scandinavia, Britain, Russia and Hungary. This cult was not exclusive to Europe. Colonies were also formed in the USA, Canada and Australia. See also Norma Broude, *World Impressionism*.

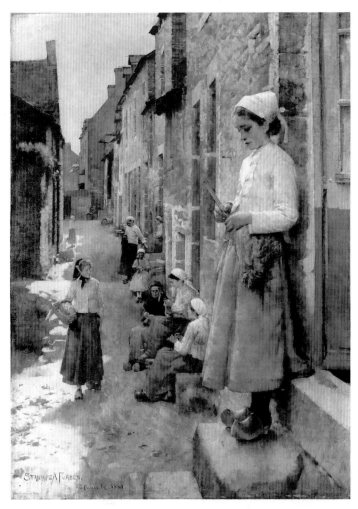

Plate 5 Stanhope Forbes, *A Street in Brittany* (painted at Cancale), 1881, oil on canvas, 104 x 76 cm. Walker Art Gallery, Liverpool. Reproduced by permission of the Board of Trustees of the National Museums and Galleries in Merseyside.

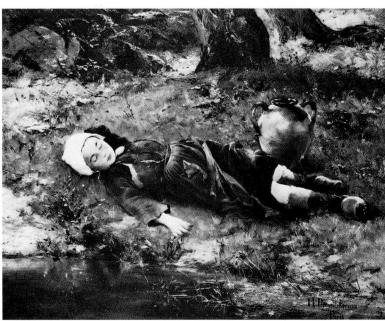

Plate 6 Marianne Preindlsberger (Stokes), *Tired Out*, c.1881–82, oil on canvas, 32 x 40 cm. Private collection, illustrated by permission of Whitford and Hughes Gallery London.

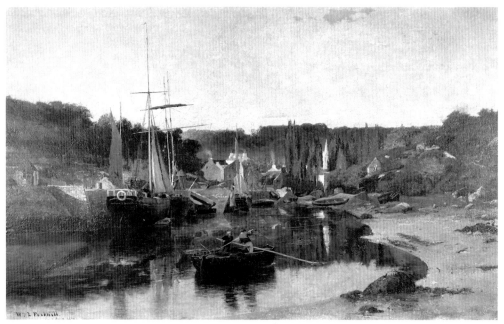

Plate 7 William Lamb Picknell, *Pont-Aven*, 1879, oil on canvas, 78 x 115 cm, Phoenix Art Museum, Arizona; purchase with funds provided by COMPAS and a friend of the museum.

Through their representations of local rituals and customs, the visiting artists, like the urban bourgeois class to which they generally belonged, helped to develop or reconstruct various prevailing notions of the primitiveness and piety of the local community – notions that were already evident in contemporary tourist literature. Dagnan-Bouveret's *Pardon in Brittany* and *Breton Women at a Pardon* (Plates 8, 9) both depict a local Catholic custom, a religious ceremony held on particular saints' days, when pilgrims and locals dressed in Breton costume, formed processions to receive religious indulgences (*les pardons*). In the earlier picture, the artist depicts the procession, while in *Breton Women at a Pardon*, he has painted a group of Breton women in costume, seated on the grass praying and passing the time between mass and vespers.

These two paintings appeared in the Paris Salon, in 1887 and 1889 respectively, and the naturalistic style and anecdotal detail of both encouraged a contemporary audience to read in various narratives – narratives which went beyond simple description of the aspect of the Pardon depicted in each. The paintings were well received by critics of varying political persuasions. But critics with different interests to promote represented differently their religious meanings, and the implications of these meanings for a supposedly 'primitive' culture. Many conservative critics read both images in terms of the pious and simple, yet profound, Catholic faith purportedly revealed. The more liberal critics, however, identified *various* types of Breton religion in these paintings, including a more sceptical curiosity among the young (as suggested by the less pious expressions of more youthful faces in *The Pardon*). Michael Orwicz has shown, in his article 'Criticism and representations of Brittany in the early Third Republic' that some liberal critics actually played down the issue of the specific nature of the peasants' religious faith, seeing their piety as one element of the region's picturesque customs, rather than as an affirmation of Catholic practice. According to this sort of reading, these two paintings are primarily representations of the quaint and picturesque culture of rural Brittany, rather than of Catholic religious fervour. In fact several of these critics identified the essence of a race, its

'Bretonness', in the faces of Dagnan-Bouveret's peasant subjects. Paul Desjardins wrote in *La République française*, in 1889, that the Breton subjects revealed signs of 'the soul of a race, which is read on the faces' ('Criticism and representations of Brittany', p.294).

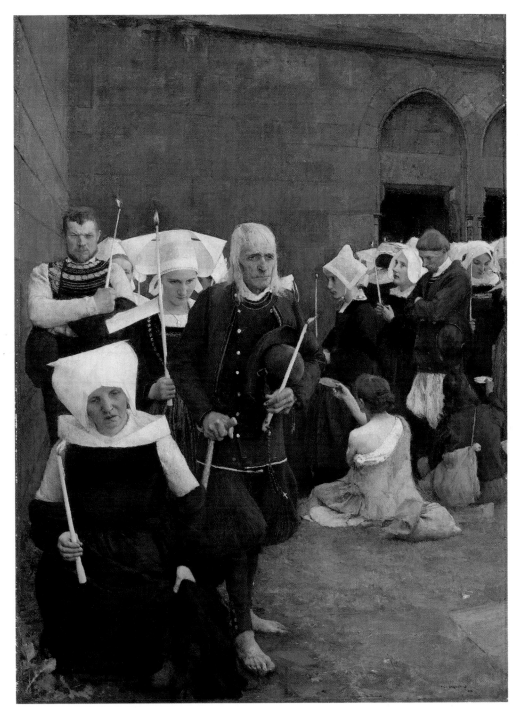

Plate 8 Pascal Dagnan-Bouveret, *Le Pardon en Bretagne* (*The Pardon in Brittany*), 1886, oil on canvas, 114 x 84 cm. Metropolitan Museum of Art, Gift of George F. Baker, 1931, New York.

Plate 9 Pascal Dagnan-
Bouveret, *Les Bretonnes au
Pardon* (*Breton Women at a
Pardon*), 1887, oil on canvas,
125 x 141 cm. Calouste
Gulbenkian Foundation
Museum, Lisbon.

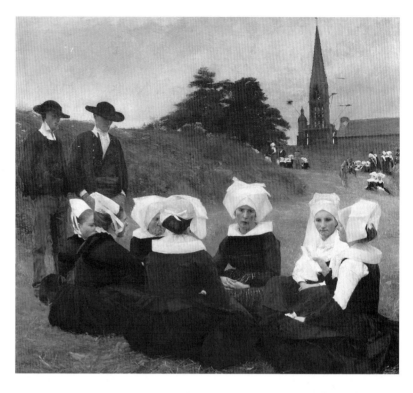

[handwritten marginal note: primitivism challenged by Breton religion]

Religion, then, is seen as one of many features of a localized Breton race with its own
'soul' or essential character, which had still survived despite the invasion of civilized cul-
ture. Despite the apparent distinctions between conservative and liberal views on religion,
notions of the 'soul' of a race – of some kind of 'primitive' essence – appear in the writings
of critics of both the right and the left, and can be found to underpin Gauguin's idea of a
'savage, primitive' Brittany, symbolized for him in the echo of 'clogs on this granite earth'.
And in the German context, as we shall see, notions of the rural peasant as the 'soul' of a
race, which influenced the formation of many German artists' colonies around 1900, con-
tribute to various mystical and nationalist discourses.

So far in this discussion of the Dagnan-Bouveret paintings, I have focused on some of
the interpretations of these two images of Breton customs, and the qualities of 'Bretonness'
which they were seen to represent. But there are some other levels of meaning which can
be read out of closer study of the paintings themselves, of the technical aspects, their re-
lationship to the subject-matter and the contemporary standards of Academic competence
to which these could be seen to conform – or otherwise.

What's interesting about Dagnan-Bouveret's two paintings is that the conventions and
techniques he adopted allowed them to be appropriated by critics of *both* sides of the pol-
itical spectrum. Liberal critics could interpret the naturalism of these works and the con-
temporary subject-matter as aspects of a post-Courbet anti-Academic art. And by the
1880s, the annual Salon des Artistes Français, in which both these works were exhibited,
was by no means the exclusive preserve of traditional Salon pieces on historical or
mythological themes exhibiting noble sentiments. In fact there was increasing demand
among the Salon-going public for works on modern urban or rural-life themes, executed
with a naturalism full of anecdotal detail. The more conservative critics were easily able to
accommodate Dagnan-Bouveret's paintings in this light. Their naturalism allowed them to
be seen as images with a readable narrative or story-line, in the way that a work by
Gauguin, for instance, could not. Thus they were easily redefined in terms of their rep-
resentation of either a 'primitive' Breton race, or Catholic faith and piety, or both.

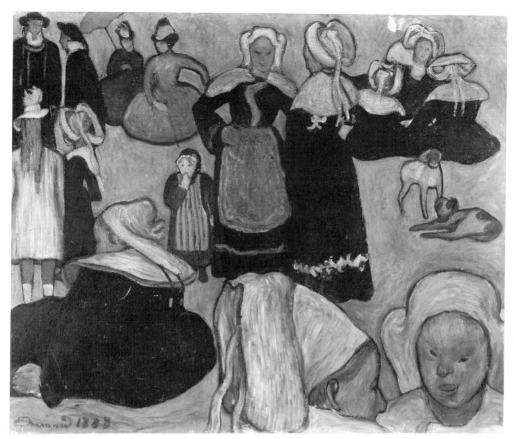

Plate 10 Émile Bernard, *Bretonnes au Pardon* (*Breton Women at a Pardon*), formerly known as *Bretonnes dans la prairie* (*Breton Women in the Meadow*), 1888, oil on canvas, 74 x 92 cm. Private collection. Photo: Giraudon. © DACS 1993.

A year after Dagnan-Bouveret exhibited his *Breton Women at a Pardon*, two artists residing at Pont-Aven, Émile Bernard and Gauguin, also worked on paintings of the Pardon (Plates 10, 11). If we compare these two pictures with those by Dagnan-Bouveret, we can see how the latter would have fitted more easily with conventional notions of Academic competence. We can also try to understand what Gauguin meant when he claimed that he was seeking a parallel in his painting to the 'primitive' life he had found in Brittany. Of course, this artistic intention could not guarantee a fixed *meaning* for his work, but it does provide us with information on how Gauguin and his contemporaries understood the function of artistic techniques. What sort of techniques and subject-matter could constitute a 'primitive' style? How could these constituents of a style match with – or represent – the supposedly 'primitive' life?

Bernard and Gauguin met in Pont-Aven and worked closely together during the period 1888–91. Bernard's *Breton Women at a Pardon* was painted during the first few weeks of his arrival at Pont-Aven in August 1888, and Gauguin's *Vision After the Sermon* was completed the following month. Gauguin's work is generally seen to mark a break from the pseudo-Impressionism of his earlier Breton subjects – and thus to be innovative. The rather schematic decorative style of both paintings has generated a good deal of controversy among art historians about the nature of Bernard's relationship with Gauguin, and the issue of who influenced whom. However, I am less interested in this issue than in how these works could – or can – be read as 'primitive' equivalents.

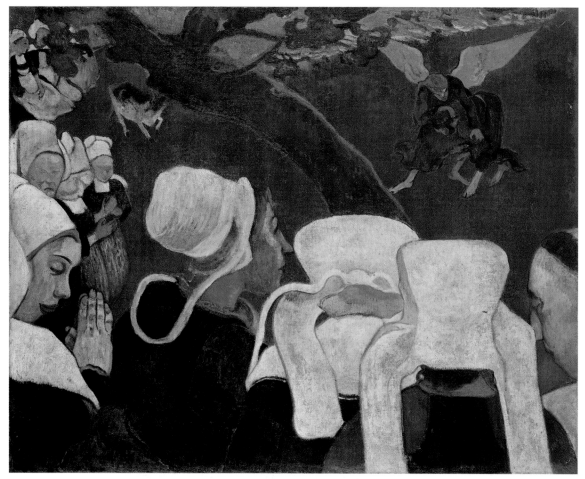

Plate 11 Paul Gauguin, *La Vision après le sermon. La Lutte de Jacob avec l'ange* (*The Vision after the Sermon. Jacob Wrestling with the Angel*), 1889, oil on canvas 73 x 92 cm. National Gallery of Scotland, Edinburgh.

A visual language of the 'primitive'?

According to statements by Bernard and Gauguin from the period, both artists saw themselves as depicting 'primitive' *subject-matter*. Bernard saw Brittany as a land characterized by a simple poverty and religion. He wrote: 'Atheist that I was, it [Brittany] made of me a saint ... it was the gothic Brittany which initiated me in art and God' (*Post-Impressionism*, p.41). Like many contemporary artists, he believed he had found a culture radically different from that of urban Paris, a culture which could directly inspire a more 'primitive' art.

Yet the visual language through which Bernard reconstructs this primitivism has a complicated pedigree. His schematic handling of the figures, which are organized across a flattish green background, distorts both scale and conventional three-dimensional space. This distortion echoed the Symbolist principles which Bernard had already adopted in works executed in 1887 (Plate 12). Formally christened in 1886 with the publication of a manifesto by the writer and poet Jean Moréas, this was an Idealist movement which championed a revolt against traditional conventions in poetry, literature and art in favour of the expression of the artist's individual perceptions and feelings. Broadly speaking, a Symbolist art (as opposed to a Symbolist literature) was one in which the artist conveyed ideas and emotions, rather than observations, through the use of lines, colours and forms.

These could be employed to reveal 'inner meanings', to abstract from nature, rather than seek to record it, as, it was argued, the naturalists had done. Such techniques are also influenced by the decorative qualities of Japanese prints, with which Bernard and Gauguin were familiar at the time (see Plate 13). It is also possible that the stylized shapes of the seated figures echo the design of Seurat's *Sunday Afternoon on the Island of La Grande Jatte*, a work which had come to symbolize an *urban* avant-garde practice. It was Van Gogh who actually called Bernard's work 'a Sunday afternoon in Brittany', thus identifying the Breton motif as similar to Seurat's image of the urban bourgeoisie congregating on the Grande Jatte on a Sunday afternoon. Study of the costumes of Bernard's Breton women reveals that, paradoxically, this was a group of relatively affluent peasants. Orton and Pollock have argued that 'Bernard travelled to what was considered to be a social system different from that to which he was accustomed, to a province which, it was thought, retained much of the character of a bygone civilization. But what Bernard, the vanguard artist, painted in *Breton Women in a Meadow* was a set of social relations very similar to those he knew in the capital' ('Les Données bretonnantes', p.298).

Thus the primitivism of Bernard's work is rooted in a set of contradictions. As part of a culture of 'the going away', Bernard pursued interests which he believed to be opposed to those of urban painting, but both the motifs and the conventions which he adopted revealed sophisticated interests and associations which were close to those of urban vanguard painters. While the technical conventions do not automatically signify 'primitiveness', they do signify a break with the forms of naturalism employed by artists

Plate 12 Émile Bernard, *Bridge at Asnières*, 1887, oil on canvas, 46 x 54 cm. Collection, The Museum of Modern Art, New York. Grace Rainey Rogers Fund. © DACS 1993.

Plate 13 Katsushika Hokusai,
The Cultivation of Rice.
Hokusai Mangwa III.5.R.
Tokyo National Museum.

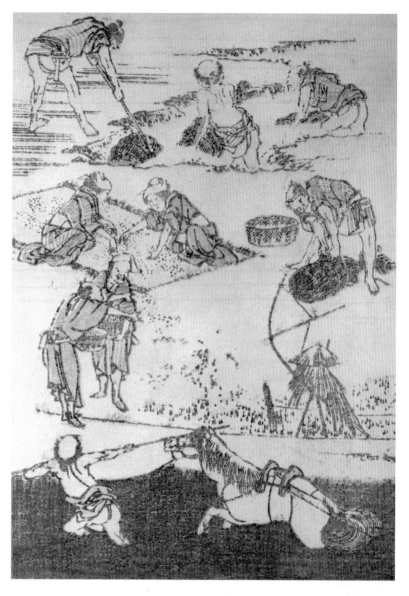

such as Dagnan-Bouveret. In so doing, they focus our attention as much on the actual processes of painting – on the surface of the canvas – as on the illusion created. And this in its turn could be construed as some kind of primitivism, for the artist has left a visible trace of the physical activity of picture-making, suggesting a more direct, unmediated mode of expression.

Gauguin, in an account of his painting on the same theme – *Vision after the Sermon* – provided a full explanation of how *he* sought to express the 'primitive' in his work:

> I believe that I have achieved a great rustic superstitious simplicity in these figures. Everything is very severe. The cow under the tree is very small relative to reality … and for me in this painting, the landscape and the struggle exist only within the imagination of the praying people, the product of the sermon. This is why there is a contrast between the 'real' people [*les gens natures*] and the struggle in the landscape devoid of naturalism and out of proportion.

(quoted in *Gauguin and the School of Pont-Aven*, p.41)

Gauguin defines his primitivism, then, in terms of the 'simplicity', severity and lack of naturalistic scale which characterize his style of painting in *The Vision*. He suggests that his formal simplifications are themselves symbolic of the 'primitive' culture which they represent. In this respect he was following a primitivist tradition which linked 'simple' people with 'purer' thoughts or modes of expression. But he is also making an implicit association between an 'unsophisticated' mode of artistic expression and the creativity – or creative potential – of the modern artist.

Gauguin's writings show that his self-image as a specifically *modern* painter involved some idea that the artist did not merely seek inspiration from a peasant culture and, occasionally, its religious rituals. Rather, he – and this was a notion that rarely included the female artist – used his creative instincts to produce pictorial *equivalents* of the 'primitive'. In other words, the artist saw himself as a direct communicator, a kind of innate savage, for whom the objects and stimulus within an unsophisticated culture *enable* rather than simply inspire the expression of what is thought to be inherent in the artist. The artist is self-defined as a superior being, as creatively endowed. In Gauguin's paintings, such self-deification was often expressed in the combination of self-portraiture and pseudo-religious imagery, as in the Breton *Self-Portrait*, and in self-depiction as Christ, as in *Christ in the Garden of Olives* (Plates 14, 15). Thus the artist's belief that he is somehow spiritually endowed is represented in the image by means of literal and symbolic associations.

The sources of Gauguin's style in *The Vision after the Sermon* are complex, as they are in Bernard's *Breton Women in a Meadow*. *The Vision* has been widely represented as a 'breakthrough' painting in which Gauguin throws off his diluted Impressionism and

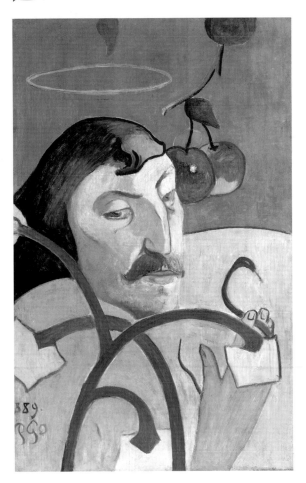

Plate 14 Paul Gauguin, *Self-portrait*, 1889, oil on wood, 79 x 51 cm. Reproduced with permission of the National Gallery of Art ,Washington, Chester Dale Collection. 1963.10.239 (A1708).

Plate 15 Paul Gauguin, *Le Christ au jardin des olives* (*Agony in the Garden: Christ in the Garden of Olives*, 1889, oil on canvas, 73 x 92 cm. Norton Gallery of Art, West Palm Beach Florida.

demonstrates a more radical primitivism. While there is little evidence to suggest that he borrowed directly from the conventions of Breton folk art, neither is it the case that the simplifications and distortions employed in *The Vision* came to him in a flash of 'primitive' inspiration. As in Bernard's painting, the flattened areas of rich colour, the use of dark outlines and the distortions and simplifications are in part influenced by Symbolist ideas and practices. Gauguin was particularly impressed with Bernard's so-called '*cloisonniste*' (or 'synthetist') style, in which dark outlines were used to surround and separate areas of rich colour. This technique had the effect of counteracting any suggestion of three dimensional space or depth and contributed to a pictorial system that was already being described by contemporaries as 'abstracting' from nature – an idea that was central to the aims of the Symbolist movement in art, literature and philosophy.

Several contemporary critics were quick to identify a Symbolist element in *The Vision*, seeing it as a measure of the artist's originality. The Symbolist critic George Albert Aurier wrote a long review in the *Mercure de France* in 1891, in which he cast Gauguin in a key role within an alternative artistic tradition, an art opposed to the 'realistic' aspects of Impressionism (i.e. those dependent on appearances), which was 'more pure and more elevated'. According to Aurier, the central components of this art were its 'Ideist, Symbolist, Synthetist, Subjective and Decorative' aspects, which were closer to those of 'the Primitives' – by which he meant the art of the Middle Ages, the Italian Quattrocento, the Greeks and the Egyptians – than to recent naturalist art.[6]

Aurier thus makes an important set of associations between his concepts of the Primitive, the Symbolist and the Decorative. In fact, the 'Decorative' emerges in Symbolist-

[6] By 'ideist', Denis means based on ideas rather than empirical observations.

influenced thought as a pivotal and value-laden concept. Aurier's belief that the artist had the right to exaggerate or deform lines, colours and forms according to the needs of the idea behind the painting was based on his understanding of various 'primitive' traditions of wall painting:

> for decorative painting in its proper sense, as the Egyptians and, very probably, the Greeks and the Primitives understood it, is nothing other than a manifestation of art at once subjective, synthetic, symbolic and ideist.
>
> (quoted in H.B. Chipp, *Theories of Modern Art*, p.92)

Although Aurier's concept of the decorative derives from his representation of mural art, the term does not simply mean ornamental or pretty, a merely superficial quality, but rather the quality through which the 'purity' and expressive potential of a work can be measured. We will return to this association between the 'primitive' and decorative with reference to the work of Matisse.

It is important to note that although *The Vision* was an easel painting, it fulfilled at least a part of Aurier's criteria for the decorative. But I mentioned another source, which also contributed to its decorative effects – the Japanese print. The influence of the Japanese print can be seen in the way the figures are cut off by the frame, in the stylized patterns of the Breton head-dresses and the lack of perspective. For many contemporary artists the conventions of Japanese art, like those of Aurier's 'Primitives', were signs of a more direct mode of artistic expression. Their inherent value depended on what was seen as their radical *difference* from more illusionistic forms of Western art. Within nineteenth-century Japanese culture the conventions employed by artists such as Hokusai were seen as skilled, sophisticated and highly taught. Gauguin's writings and his use of certain pictorial conventions suggest that he subscribed to the notion of Japanese art as 'primitive', as evidence of 'simpler means' and 'honesty'.[7] In these terms Japanese art qualified for Aurier's categories of both the 'Primitive' and the 'Decorative'.

In our discussion of the Dagnan-Bouveret paintings we saw how the religious activities of the Breton peasantry became the focus of contemporary debates about the 'essence' or 'soul' of a race. *The Vision* is one of several Breton works in which Gauguin, too, depicts a religious activity or theme. Others include *Green Christ – Breton Calvary* and *The Yellow Christ* (Plates 16, 17). While the calvary and crucifixion subjects are relatively straightforward in their biblical references, the religious implications of *The Vision* are more difficult to sort out. It combines the biblical theme of Jacob wrestling with the angel with that of a local Breton Pardon. But the wrestling takes place as if observed by the Breton women, and may also be a reference to the wrestling matches and dancing which often accompanied Pardons in lower Brittany. The possible religious meanings are confused with what we might call the *'Bretonisme'* of this work – that is the reconstruction of Breton life and rituals as superstitious and primitive.

The technical devices employed by Gauguin, the distortions and stylizations, also help to confuse our reading of the religious theme. While the naturalism of Dagnan-Bouveret's *Pardon in Brittany* allowed contemporary critics to invest it with various readable strands of meaning to do with the religious piety – or otherwise – of the peasants depicted, Gauguin's critics (among them Aurier) tended to focus on the supposed 'inner meanings'. The formal elements could thus be read as expressive equivalents for this culture of *'Bretonisme'*, rather than depictions of it. Although *The Vision* is often seen as a religious painting, I would argue that it is as much a manifesto of Gauguin's primitivism. It depicts a religious theme, yet it is not promoting religion or a piety.

[7] As described in Gauguin's manuscript *Diverses Choses*. Kirk Varnedoe has shown that Gauguin's representation of Japanese art as 'primitive' was also qualified by the parallels which he draws with Western forms of caricature, in particular the work of Daumier and Forain. According to Gauguin, Western caricaturists share a tendency to distort and to use pictorial idioms. The simplifications and distortions of both forms of art are seen as evidence of a purer, innate mode of expression. See Varnedoe's essay 'Gauguin', in *Primitivism in Twentieth-Century Art*, p.185.

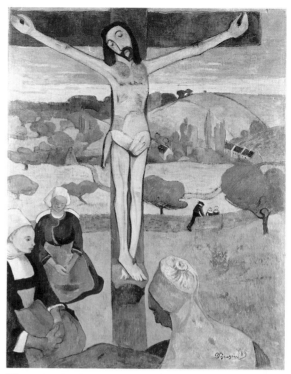

Plate 16 Paul Gauguin, *Calvaire breton, le Christ vert* (*Breton Calvary, Green Christ*), 1889, oil on canvas, 92 x 73 cm. Brussels, Musées Royaux des Beaux Arts.

Plate 17 Paul Gauguin, *Le Christ jaune* (*The Yellow Christ*), 1889, oil on canvas, 90 x 74 cm. Albright Knox Gallery, Buffalo, New York; general purchase funds, 1946.

The feminine 'other'

Nearly all Gauguin's Breton paintings discussed so far include, or are constructed around, images of local peasant women. In Gauguin's work many aspects of rural and religious life in Brittany are signified through the representation of women. In this respect he was following a well-established convention within Post-Enlightenment European art and culture, epitomized in France by the work of Jean-François Millet and Jules Bastien-Lepage, in which the rural female was represented as close to nature, as a symbol of the 'natural' peasant life.[8] Breton women are often shown tending sheep, harvesting or relaxing in nature (Plates 18, 19, 20). In these representations, their roles and activities seem to be at one with the natural cycle of things. And in *The Vision* and *The Yellow Christ*, the religious piety of the Breton peasantry is represented through kneeling, praying *women*. In all these works the '*Bretonisme*' of Gauguin's subjects is clearly signified through their local costumes, their clogs and elaborate headdresses. In *The Vision* it is through the depiction of women and their local costumes that the process of distortion appears most pronounced. The ornate head-dresses dominate the foreground of the composition, and they allow us to confuse Gauguin's primitivized image with the actual local Breton culture that it represents. At the same time, they are clearly images of *women's* costumes. Gauguin's '*Bretonisme*', then, is frequently, though not exclusively, associated with the feminine,

[8] This historical identification of Nature as 'Other' to culture, in which Nature is often (though not exclusively) identifed with woman has been explored in aspects of eighteenth- and nineteenth-century culture, in Ludmilla Jordanova's *Sexual Visions: Images of Gender in Science and Medicine between the Eighteenth and Twentieth Centuries*.

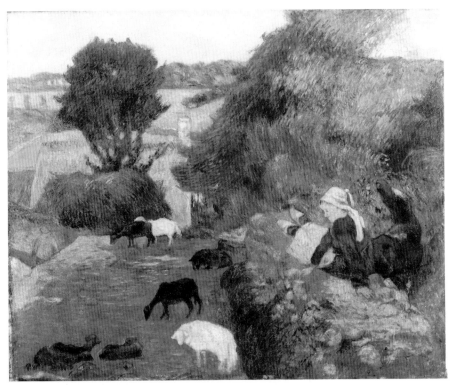

Plate 18 Paul Gauguin, *Bergère Bretonne* (*The Breton Shepherdess*), 1886, oil on canvas, 60 x 68 cm. From the collection at the Laing Art Gallery, Newcastle Upon Tyne, reproduced by permission of Tyne and Wear Museums.

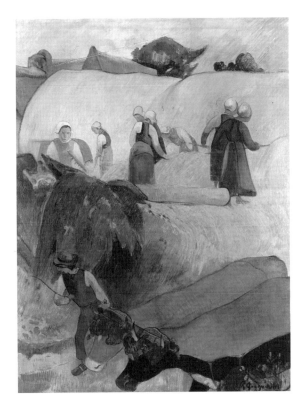

Plate 19 Paul Gauguin, *La Moisson en Bretagne* (*Haymaking in Brittany*), 1889, oil on canvas, 92 x 73 cm. Courtauld Institute Galleries.

Plate 20 Paul Gauguin,
Ramasseuses de varech (*Seaweed
Gatherers*), 1889, oil on canvas,
87 x 123 cm. Essen, Folkwang
Museum.

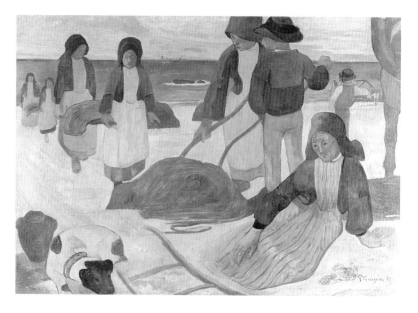

the 'other' of civilized masculine culture. As I suggested earlier, the notion of the 'primi-
tive' as the 'other' of Western culture sometimes carried with it a set of gendered
oppositions, of 'feminine' Nature against 'masculine' Culture. Such symbolic oppositions
are implicit in the imagery of many of Gauguin's Breton works, as they are in some of his
written comments.

While women's costumes feature prominently in many of Gauguin's Pont-Aven
works, in many later Breton works (from around 1889), it is naked women who come to
symbolize the opposite of a civilized urban life. His images of women executed during
this period become increasingly sexual and include a series of naked women in the waves
(Plates 21, 22), adolescent nudes, such as *The Loss of Virginity* (Plate 23), and the Eve theme
(Plate 24). In a letter to the Symbolist writer Auguste Strindberg in 1895, Gauguin actually
defines his own 'barbarism' in terms of the Eve theme. He describes

> a shock between your civilization and my barbarism. Civilization from which you suffer,
> barbarism which has been rejuvenation for me. Before the Eve of my choice whom I have
> painted in the forms and the harmonies of another world, your memories have evoked a
> painful past. The Eve of your civilized conception nearly always makes you, and makes
> us, misogynist; the ancient Eve, who frightens you in my study might some day smile at
> you less bitterly.
>
> (quoted in Goldwater, *Primitivism in Modern Art*, p.67)

Gauguin adopts the theme of Eve – the first woman – as a metaphor for his own
primitivism, opposing his uncivilized Eve to Strindberg's more civilized conception. But
Eve does not merely function as a metaphor. She is, as he suggests, both the symbol and
the subject of his primitivism, 'painted in the forms and harmonies of another world'.
Gauguin's series of naked women in the waves from 1889 seem to reinforce these intended
literal and symbolic meanings. The women are depicted naked in nature, thus reinforcing
the well-established association between woman and nature. The theme of Ondine, the
water nymph, on which both these works are based, was popular in contemporary art and
literature. The mythical associations implicit in these two works also reveal that Gauguin
had absorbed Wagnerian ideas about women, which were popular among Symbolist
writers and poets. While staying at the auberge Gloanec in Pont-Aven, Gauguin had tran-
scribed some Wagnerian ideas into the *'livre d'or'* (an annotated guest book) of the hotel.

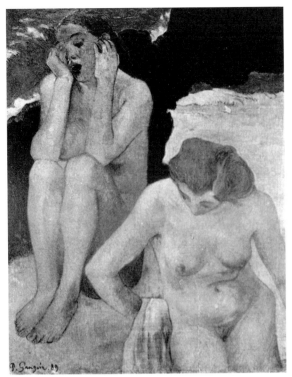

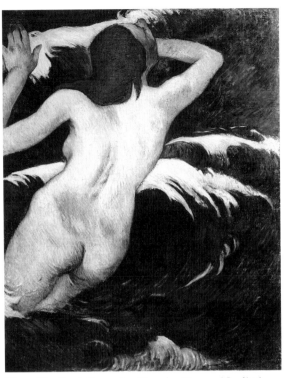

Plate 21 Paul Gauguin, *La Vie et la Mort, femmes se baignant* (*Life and Death, Women Bathing*), 1889, oil on canvas, 92 x 73 cm. Cairo, Mohammed Mahmoud Khalil Bey Museum. Photo: Chant Avedissian, by permission of the National Centre for the Fine Arts, Cairo.

Plate 22 Paul Gauguin, *Dans les Vagues* (*Ondine*) (*Woman in the Waves, Ondine*), 1889, oil on canvas, 92 x 67 cm. The Cleveland Museum of Art Gift of Mr and Mrs Powell Jones 78.63.

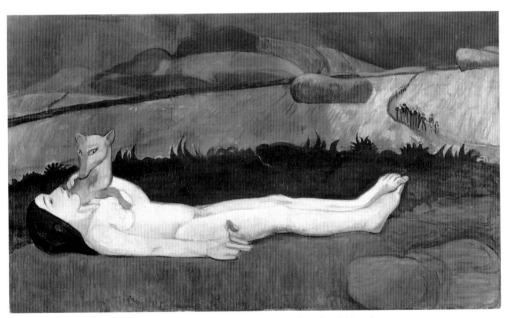

Plate 23 Gauguin, *La Perte de pucelage* (*The Loss of Virginity*), 1891, oil on canvas, 90 x 141 cm. © 1993, Chrysler Museum, Norfolk, Virginia. Photograph by Scott Wolff.

Plate 24 Paul Gauguin,
Ève – Pas écouter li li menteur
(*Eve – Don't Listen to the Liar*),
1889, pastel and watercolour on
paper, 34 x 31 cm.
Marion Koogler McNay Art
Museum, San Antonio, Texas.
The Bequest of Marion Koogler
McNay 19590.45.

He wrote of woman *'qui n'atteint sa pleine individualité qu'au moment où elle se donne: c'est l'Ondine qui passe murmurante à travers les vagues de son élément'* ('who attains her full individuality only at the moment that she submits herself: it is Ondine, who moves whispering through the waves of her elemental force'; quoted in H. Dorra, 'Le "Texte Wagner" de Gauguin', pp.281–8). According to this Wagnerian representation of woman, then, the ultimate expression of the feminine is the abandonment of the self to the elements and to man; in it woman is supposed to reach fulfilment only in her most 'natural' and most submissive state.

The influence of such attitudes is easily read out of many of Gauguin's Breton and later Tahitian work. As in *The Loss of Virginity*, completed after his return from Le Pouldu, the Breton village in which he worked in 1890, such associations are often veiled in complex symbolism. Flattened areas of bright colour and the simplified, distorted forms of the figure and the landscape conform to the idea of simpler forms supposedly expressing purer, unmediated thoughts. However the meaning of the symbolic references, such as the fox (a traditional symbol of cunning and perversity, and possibly an ironic self-portrait), and the drooping cut flower (a symbol of lost virginity), could only be sorted out with access to a more sophisticated literary culture. Gauguin was perhaps recognizing the appeal of his work to a Symbolist audience, and reshaping his primitivism to broaden its potential market.

Other features of this work would have modified its 'primitive' meanings for a contemporary audience. The composition is related to that of Manet's *Olympia* (another reclining female nude with an animal), which Gauguin had copied in the Luxembourg

museum earlier in 1891 (Plate 25), although the pose and the theme of *The Loss of Virginity* convey a more passive image of the female nude. The sexual connotations and the emphasis on a woman's 'loss' would have been reinforced to an audience familiar with Bernard's Symbolist work on a similar theme, *Madeleine au Bois d'Amour* (Plate 26), in which Madeleine lies in a similar pose with her feet touching. But while Madeleine lies fully clothed, apparently chaste, with a wistful expression on her face, Gauguin's subject (probably based on the model Juliette Huet), naked, 'deflowered', with a blank, almost dead expression on her face, embraces a symbol of the active masculine, the cunning fox.

In the Breton work of Gauguin and some of his contemporaries the discourses of primitivism can be seen to be functioning on several interrelated levels. Firstly we have seen that Gauguin's art and writing participates in reconstructing Breton culture as essentially backward, savage and superstitious, as the 'other' of sophisticated urban Paris (a culture of '*Bretonisme*'). Secondly, there is a further level of meaning in Gauguin's adoption of certain technical devices. It involves the idea of the superior expressive potential of distorted and simplified forms, and the associated idea that modern, vanguard artists were distinguished by their creative ability to produce such non-naturalistic distortions, to somehow recapture some 'primitive' essence or mode of expression. As we have seen, such assumptions ignore some of the contradictions inherent in the production of a 'modern' artistic language, addressed to a sophisticated avant-garde audience. Finally, the construction of a 'primitive' art often (though not always) involved a *gendered* concept of nature and the natural. In Gauguin's work, the female peasant and the female nude were often employed as literal and metaphorical equivalents for nature, the natural cycle or even the 'essence of a race'.

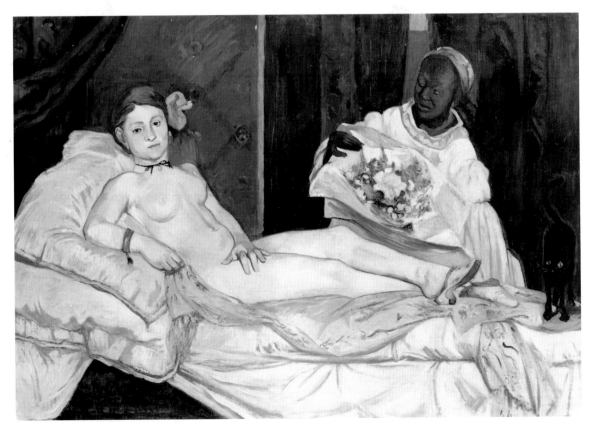

Plate 25 Paul Gauguin, copy of Manet's *Olympia*, February 1891, oil on canvas, 89 x 130 cm. Private collection. Photograph by courtesy of Prudence Cuming Associates Ltd.

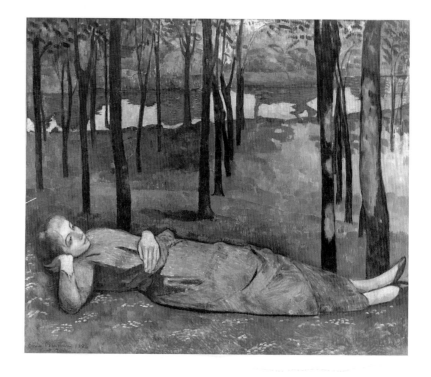

'Pillaging the savages of Oceania': Gauguin and Tahiti.

Gauguin's literal and metaphorical use of the female to represent the primitive also became an important feature of his Polynesian and Tahitian works from the 1890s. But as with his Breton primitivism, his attempts to reproduce or parallel the 'savage' life he identified in Tahitian life and culture reveal contradictions, derive from heterogeneous sources and connect with potent Western myths about life within what was then a remote colonial outpost.

By 1890, Gauguin had already become preoccupied with the idea of emigrating, with removing himself to the 'uncivilized' margins of society. He had considered two other French colonies, Indo-China and Madagascar. But after an unsuccessful application for a post in the French colonial service in Indo-China, in 1891 he finally decided to leave for the remote Polynesian island of Tahiti, returning to France only once, in 1893, for two years. On his final visit he settled on the Marquesas islands, where he died in 1903.

Tahiti: historical and colonial context

The island of Tahiti, explored by the French in 1767, had been turned from a protectorate into a colony in 1881. The wealth of literature and travel-writing following this extension of French political interests revealed a complex synthesis of colonialism and romantic primitivist ideas, both of which informed Gauguin's own 'flight' from civilization. The plan to emigrate had originally included Émile Bernard, who withdrew at the last minute. Both artists had absorbed the prevailing mythology of Tahiti as the ultimate primitive paradise. It was often represented in contemporary literature as the home of an exotic sensual culture. Pierre Loti's sentimental novel *Le Mariage de Loti* (*The Marriage of Loti*, 1880), encouraged this view, and the official travel literature represented the island as an unspoilt Eden, rich in colonists' privileges, including cheap and abundant food, and (as the imagery of the travel guides suggested) sensual native women.

Since the eighteenth-century explorations of Polynesia by Cook and the French explorer Bougainville, a variety of writings on the 'primitive' and the 'noble savage' had focused on the island of Tahiti. Bougainville had overlooked the less pleasant aspects of the local culture, such as cannibalism and infanticide, when he represented the inhabitants as a handsome, peaceful race, pursuing sensual pleasures: 'Venus is the goddess one feels ever present. The softness of the climate, the beauty of the landscape, the fertility of the soil ... everything inspires voluptuousness. Thus did I name the place La Nouvelle Cythère' (*Le Voyage autour du monde*, quoted in Varnedoe, 'Gauguin', p.188).

Bougainville's description of the island as 'La Nouvelle Cythère' fused the idea of the primitive with the myth of the antique, identifying Tahiti as the harmonious and peaceful island of Greek mythology, where Venus had emerged from the sea. A Classical myth was thus appropriated to somehow validate the newly discovered 'primitive', to remove its barbaric element, and to establish it as an (implicitly) critical alternative to Western civilized society. During a period of rapid French colonial expansion, such myths were often reworked to justify various political and imperialist interests. Relying on such images, much of the official rhetoric represented colonization as a means of avoiding cultural degeneration. Colonizing was frequently described as a mutually invigorating process through which European culture could be 'replenished', and 'primitive' culture gain through the introduction of trade, Western religion and technology. Many of Gauguin's statements about the appeal of Tahiti echo this notion of 'replenishment', of being nurtured on a fertile soil. In a letter written to J.F. Willumsen in 1890, he wrote:

> As for me, my mind is made up. I am going soon to Tahiti, a small island in Oceania, where the material necessities of life can be had without money ... There at least, under an eternally summer sky, on a marvellously fertile soil, the Tahitian has only to lift his hands to gather his food; and in addition he never works. When in Europe men and women survive only after increasing labour during which they struggle in convulsions of cold and hunger, a prey to misery, the Tahitians, on the contrary, happy inhabitants of the unknown paradise of Oceania, know only sweetness of life ...
>
> (quoted in Chipp, *Theories of Modern Art*, p.79)

Gauguin also uses the notion of 'fertile soil' as a metaphor for his desired artistic context, one that would replenish his creative instincts. In an interview published by the *Écho de Paris* on 23 February 1891, he wrote: 'I only desire to create a simple art. In order to do this it is necessary for me to steep myself in virgin nature, to see no one but savages.'

The 'going away' to Tahiti was steeped in the contemporary culture of colonialism. Like the retreat to Brittany, it also participated in the myth of a simple alien culture which could provide an ideal context for the avant-garde artist. The Impressionist Pissarro had for some time been sceptical of Gauguin's artistic ambitions, and characterized his taste for 'going away' in cynical terms when he wrote to his son Lucien in 1893: '[Gauguin] is always poaching on somebody's land, nowadays, he's pillaging the savages of Oceania' (J. Rewald, *Camille Pissarro – Lettres à son fils Lucien*, p.217).

We should note here that Pissarro had always held an ungenerous view of Gauguin as an unscrupulous plagiarist 'pillaging' from other artists and cultures and presenting them as his own innovations. Gauguin was unquestionably an efficient and egotistical self-promoter, who in his writings consistently emphasized his own missionary role and creative potential, and his style was, in part, made up of derivative elements. But he does seem to have sustained the deeply held belief that by placing himself, as an artist, within a 'savage' environment, he could somehow recover from himself a more basic, primeval mode of artistic expression. Clearly there are several possible explanatory models for the motivation behind Gauguin's 'going away', and they are not necessarily mutually exclusive. However, I want to focus on the realization of 'primitivism' in Gauguin's paintings, and what that reconstructed primitivism would have signified to a contemporary audience familiar with the various artistic languages competing for the label 'modern'.

The Tahitian canvases do not provide straightforward answers to these questions. *Ia Orana Maria* (Plate 4) was one of the earliest Tahitian canvases in which the themes of religion (both Christian and pagan) and the primitive intersect in a curious and confusing way. This is neither exclusively a tropical paradise, nor simply a scene of (Christian) religious piety. The Madonna and Child theme, embellished with haloes and a Western angel, has been transposed onto a Tahitian setting, and the religious elements function as part of the decorative design and as symbols of some kind of primitive Christianity. The composition is dominated by rich colours and archaic poses: the two central women adopt ritualistic gestures derived from those in Javanese reliefs on the Buddhist temple of Borobudur. Gauguin owned a photograph of these.

This odd fusion of pagan and Western religious imagery may have been Gauguin's response to the reality of Tahitian life as he found it. By the time Gauguin arrived on the island, the local community had virtually abandoned its own pagan religion with its symbolic imagery, adopting Western Christian rituals, attending missionary schools and often wearing Western clothes.[9] At the time he painted *Ia Orana Maria*, Gauguin was living in Mataiae, in the south of the island, where there was a well-attended Catholic church. But there are also many aspects of this image which could be seen to reinforce the romantic notion of a lush tropical paradise: the richly coloured tropical vegetation, the bowls laden with fruit and the sensual, partly-naked women. In fact, the image of woman in this painting functions as a kind of symbolic focus for both its primitivism and its religious meanings. She is both the Madonna and a 'natural' mother. Her semi-nakedness and simplified features emphasize her closeness to nature, and the fruit – a symbol of her fecundity and nature's – suggests an organic relationship between the two. The imagery of sensual, fertile women echoes the concept of 'replenishment' that was so central to many contemporary literary and colonial texts on the subject of Tahiti.

Symbolism and Gauguin as 'decorator'

This reading of some of the possible ideological associations of *Ia Orana Maria* is, of course, a modern one, partly informed by feminist art history. Among those contemporary critics who supported Gauguin's work we find some rather different emphases and explanatory models. Gauguin's Symbolist friends (among them Aurier) and many fellow artists associated with the avant-garde identified in his paintings an innovatory artistic language which was the antithesis of Impressionism. Although this support did not ensure financial success (an exhibition of Tahitian works in 1893 sold only eight pictures), Gauguin's work appealed to many critics seeking a new language for the 'modern'. And it was precisely the supposedly 'primitive' aspect of Gauguin's work that seems to have qualified it for this *modern* status.

The art critic Maurice Denis had published an article in 1890 in which he identified Gauguin as a leading figure of what he labelled 'neo-traditionism', in contrast with 'Neo-Impressionism'. Denis's arguments were rooted in Symbolist theory and were close to Aurier's ideas about the need for a non-naturalistic art close to 'the primitives'. Denis's arguments were reformulated in an important article, 'From Gauguin and Van Gogh to Classicism', published in the journal *L'Occident* in 1909. He argued that 'progressive' artists had replaced the Impressionist idea of 'nature seen through a temperament', with a 'theory of equivalence'. In this theory, artists used distortions, signs or symbols to produce pictorial *equivalents* for their *emotions* or *feelings*. Denis was thus formulating a theory of expression which privileged the artist's *feelings* as the source of meaning of the work. Such a theory provided a rationale for some of Gauguin's own claims, particularly in its implication that these *equivalents* were not merely to be *found* in the local culture and its artefacts, but would emerge independently through the artist's experiences and his refined

9 This has now been well documented by Daniellson among others (B. Daniellson, *Gauguin in the South Seas*).

sensibility in an uncivilized context. Denis asserted that the 'equivalents' could be pro-
duced without the artist executing a 'copy' of what he saw:

> Art is no longer just a visual sensation that we set down, a photograph, however refined it
> may be, of nature. No, art is a creation of our imagination of which nature is only the
> occasion. Instead of 'working outwards from the eye, we explored the mysterious centre
> of thought', as Gauguin used to say. In this way the imagination becomes once more the
> queen of the faculties, in accordance with Baudelaire's wish. And thus we set free our
> sensibility; art, instead of being a *copy*, became the subjective deformation of Nature.
>
> ('From Gauguin and Van Gogh to Classicism', p.53)

In this essay, Denis distinguishes between 'subjective' and 'objective' deformations,
claiming that the latter somehow parallels a 'Classical' method. According to him,
'objective deformations' involve the application of intuitively apprehended rules about
what gives 'pleasure to the eye', a set of aesthetic controls. This notion is central to his
characterization of Gauguin's work. Denis sometimes uses the term 'decorative deforma-
tions' to describe Gauguin's harmonious mode of arranging his compositions, which he
separates from the more exaggerated, seemingly less controlled 'subjective' deformations
of Van Gogh. And the idea of Gauguin the 'decorator' is crucial in his characterization of
the artist's primitivism:

> [With Gauguin] we are dealing with a decorator: the man for whom Aurier in the past so
> imperiously demanded walls! The man who decorated the living room of the inn at Le
> Pouldu, as well as his gourd and his clogs ! The man who, in Tahiti, in spite of worries,
> illness and poverty, cared about nothing so much as the decoration of his hut. Italian
> critics call him the *'Frescante'* [Fresco painter]. He liked the matt appearance of fresco,
> which is why he prepared his canvases with thick layers of white distemper. Yet he knew
> nothing about the Quattrocentists; and we sense that like them he made use of the flat
> application of colour and the precise contour. His art has more in common with tapestry
> and stained glass than with oil painting
>
> We are indebted to the barbarians, to the primitives of 1890, for bringing certain essential
> truths back into focus. Not to *reproduce* nature and life by approximations or by
> improvised *trompe-l'oeils*, but on the contrary to reproduce our emotions and our dreams
> by *representing* them with harmonious forms and colours – that, I continue to believe, was
> a new way of posing the problem of art.
>
> ('From Gauguin and Van Gogh to Classicism', p.54)

Denis follows Aurier, then, by representing Gauguin as the archetypal modern 'primitive'.
The man who decorated his own clogs (Plate 27) is also the man capable of evoking
through his art 'certain essential truths'. The term 'Frescante' ties Gauguin's work to a
muralist tradition which Aurier had already identified with a positive concept of the
'decorative'. Denis uses the terms 'barbarians' (*barbares*) and 'primitives' to represent

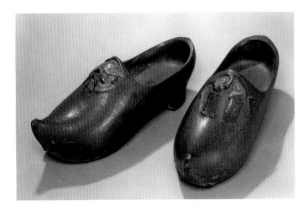

Plate 27 Paul Gauguin,
pair of wooden shoes, 1889, 33 cm
long. National Gallery of Art,
Washington, Chester Dale Collection,
1963.10.239 a + b.

Gauguin and the Symbolist painters. In the process he makes an important association be-
tween the idea of the 'decorator' and the modern 'barbarian', an association which (as I
shall argue) is later reworked and modified in criticism of Matisse and the Fauves.
Notions of the 'decorative' and the 'barbarian' were appropriated by critics and painters
with different interests, and were used to signify both a positive idea of the 'modern', and
a more pejorative one of degeneration into superficiality.

Decoration and innovation

In formulating his view of Gauguin's work, Denis had another axe to grind. At the time of
writing 'From Gauguin and Van Gogh to Classicism', he was a supporter of the extremist
right-wing group, l'Action française. Underlying the article is his view that Gauguin's
innovatory technique – his 'decorative deformations' – were evidence of some kind of
revived Classicism, of the rediscovery of an underlying order and harmony in art, albeit
one mediated or filtered through 'individual feelings'. This argument was extended by
Denis to suggest that this form of modern art could be seen to parallel a contemporary
political return to order, a revival of French traditionalism, with which l'Action française
was associated.

There were other contemporary critics who agreed on the importance of the 'decorat-
ive' as a feature of Gauguin's modernism, but attempted to explain this aspect of his work
differently. In 1904, the writer and critic Victor Segalen wrote the first in a series of 'Textes
sur Gauguin et l'Océanie', in which he described aspects of Gauguin's Tahitian works and
life in terms of his (Segalen's) concept of the 'exotic'. The late nineteenth-century culture of
colonialism had encouraged a European notion of the exotic as a remote, sensual quality
found in oriental and non-occidental art and life. In the writings of contemporary French
authors such as Pierre Loti and Claude Farrère, 'l'exotisme' had connotations of a rich
sensual culture to be found in 'uncivilized' non-Western nations.[10] Thus the dominant
concept of the 'exotic', like that of the 'oriental' (with which it was closely associated) had
more to do with Western ideas of an alien culture at odds with the civilized West than it
did with the Orient itself. From 1908 onwards, Segalen wrote a series of essays (later pub-
lished as *Essai sur l'exotisme*) in which he sought to rid the concept of its 'colonial sun-
helmet' (*casque de colonial*) and its associations with the 'tours of Cook's travel agency'
(*Essai sur l'exotisme*, p.36). These insights, however, did not prevent him from contributing
to some of the mythologies which surrounded the life and work of Gauguin in Tahiti, and
for Segalen 'Gauguin's savage genius' was still a point of reference (p.123).

The meaning of Gauguin's Tahitian primitivism then, and its associations with
notions of the decorative and the exotic, were not fixed for his contemporaries. Many of
the Tahitian canvases from the 1890s, like *Ia Orana Maria*, were confusing images. Works
such as *The Spirit of the Dead Watching*, or *Faa Iheihe* also combined complex religious
imagery and symbols with decorative motifs and ritualistic gestures from a wide range of
sources (Plates 28, 29, 30). But it was not just the 'primitive' meanings of these works that
were contested; their status as *innovatory* was also under scrutiny. Although Gauguin had
the support of many Symbolist critics, in 1891 Pissarro gave a predictably cynical expla-
nation of the appeal of his work:

> It is a sign of the times ... The bourgeoisie, frightened, astonished by the immense
> clamour of the disinherited masses, by the insistent demands of the people, feels that it is
> necessary to restore to the people their superstitious beliefs. Hence the bustling of
> religious Symbolists, religious socialists, idealist art, occultism, Buddhism etc. etc.
> Gauguin has sensed the tendency.
> (B. Thompson, *The Post-Impressionists*, p.176)

[10] Pierre Loti was a naval officer whose novels included *Désenchantées, Derniers jours de Pékin* and *Le Mariage
de Loti*. Claude Farrère was known for famous colonial novels such as *Les Civilisés* and *Fumée d'opium*.

Plate 28 Paul Gauguin, *Manao tupapau* (*Spirit of the Dead Watching*), 1894, lithograph, 31 x 24 cm. British Museum, Department of Prints and Drawings.

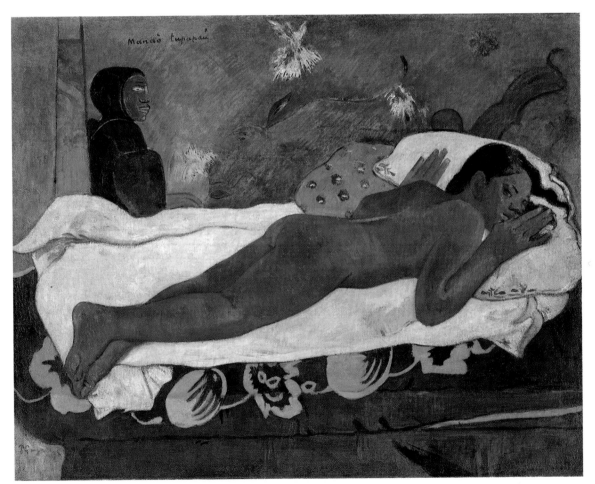

Plate 29 Paul Gauguin, *Manao tupapau* (*Spirit of the Dead Watching*), 1892, oil on burlap mounted on canvas, 72 x 92 cm. Albright-Knox Art Gallery, Buffalo, New York. A. Conger Goodyear, 1965.

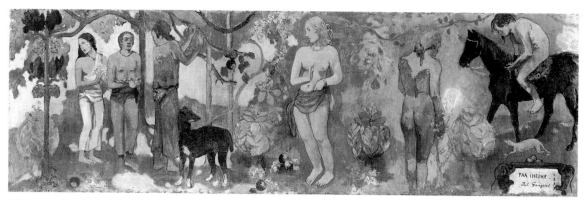

Plate 30 Paul Gauguin, *Faa Iheihe*, 1898, oil on canvas, 54 x 170 cm. Tate Gallery, London.

Pissarro is suggesting that Gauguin has jumped on a fashionable bandwagon, and is producing not original works but paintings he knew would appeal to a bourgeoisie who were rediscovering various religious and spiritual cults. Pissarro had a point, and these new interests were clearly fed by the discourses of colonialism. On one level, the confusing and *seemingly* unreadable aspects of works such as *Spirit of the Dead Watching* could be seen to reinforce a Western view of the alien superstitions and religious rituals of a 'primitive' culture.

But as paintings they are complex texts which do rather more than merely 'pillage' and misappropriate a local culture. According to Gauguin's account in his (somewhat unreliable) manuscript *Noa Noa*, this work was inspired by an incident with his young Tahitian girlfriend Tehura, when he had returned late one night to their hut to find the light had run out and that Tehura was lying naked in a state of superstitious terror. If *Spirit of the Dead Watching* was *based* on this incident, the work also echoes sources which were closer to home for its Parisian audience. The theme of a reclining adolescent girl is reminiscent of his Breton work *The Loss of Virginity*, and like that work it suggests a debt to Manet's *Olympia*. And the richly coloured, decorative design of the bed and the foreground figure are reminiscent of the rhythmic compositions of Symbolist painters such as Bernard or even Puvis de Chavannes.

While on the one hand this work suggests a frightened 'primitive' in a state of fearful superstition in front of the forces of nature, it would also have been seen in relation to a Western anti-Academic tradition which was Manet's legacy, and to a Symbolist influenced cult of decorative – even arcadian – imagery, more often than not structured around the theme of the female nude.

Primitivism and Kulturkritik: Worpswede in the 1890s

In Germany around the turn of the century the cult of the 'going away', of leaving urban centres and their art institutions in favour of rural artists' communities, was an important feature of both avant-garde art and of some more traditional forms of artistic life. Such activities were nurtured on various myths of the 'primitive' and associated nature cults, in particular a cult of the local peasant 'Volk', a term widely adopted by contemporary critics to signify an indigenous German peasant community. In his book on German artists' communities, Gerhard Wietek lists over eighteen organized groupings of artists who worked in peasant villages or remote rural contexts around the turn of the century. The better-known communities were Worpswede near Bremen and Neu-Dachau, near

Munich. Many of the communities were formed in country villages within reach, by rail, of towns which had become heavily industrialized or had experienced dramatic population explosions during the second half of the nineteenth century.

During this period the development and expansion of heavy industry in Germany was more sudden than any comparable developments in England or France, and the effects on urban and rural communities in Germany in the late nineteenth century were especially pronounced. During the period 1870–1900 large numbers of rural workers moved towards the urban centres: in 1871 two-thirds of the German population were living and working on the land, but by 1910 the same proportion constituted the urban population.

The Wilhelmine era (1871–1914) was one of profound and dramatic change within social, economic and cultural life. At the turn of the century, the processes of industrialization and urban expansion contributed to growing feelings of anti-urbanism among Germans on both the right and the left of the political spectrum. A good deal of contemporary literature and sociological writing focused on the problems of urban life. For example, in 1903 the sociologist Georg Simmel published *Die Grössstadte und das Geistesleben* (*The Metropolis and Mental Life*), in which he discussed the natural and spiritual deprivation of modern urban life and its mass culture. Julius Langbehn, a popular contemporary 'cultural critic', railed against the despiritualization of modern urban life in his peculiar but immensely successful book, *Rembrandt as Educator*, first published in 1890. Such hostility to urban industrial culture was often accompanied by an exalted view of indigenous peasant communities. The two attitudes were characteristic of a so-called *Kulturkritik* (cultural criticism), which surged during the 1890s. The term was used loosely to describe an overt or indirect form of intellectual criticism, often derived from politically diverse sources, the writings of Nietzsche, Langbehn and the anarchist Eric Mühsam, which merged together in a broad attack on the evils of a new industrial age.

Many of the currents of *Kulturkritik* were embodied in the writings of Julius Langbehn. In *Rembrandt as Educator* he argued that art must lead the struggle for a new 'freedom'. Langbehn's right-wing politics opposed modern democracy and 'bourgeois liberalism', which he believed were concepts alien to, and incompatible with, the preservation of a truly German culture. He wanted a return to spiritual values, values which he felt were still latent in the uncorrupted 'Niederdeutscher' Volk or peasant (the low German peasantry, which in this context included the Netherlands), and which were exemplified in the art of Rembrandt. Langbehn's works were widely read by artists in the 1890s, for he advocated a curious notion of 'Kunstpolitik', or art-politics, as one of the keys to change in society. While his writings were less well known after about 1905, ideas influenced by *Kulturkritik*, and reform movements and nature cults with which it was associated, had become common currency within artistic and intellectual circles. These were partly filtered through the highly influential writings of Nietzsche, whose book *Thus Spake Zarathustra* (first published in parts, between 1883 and 1892) was avidly read by German artists and intellectuals. Despite their differences, both Langbehn and Nietzsche were preoccupied with the notion that through their work artists must seek 'new freedoms' from the constraints of established society. This idea found an echo in various forms of primitivism, and in many of the earliest German theories of Expressionism, which we will be addressing later in this section.

Various currents of *Kulturkritik* overlapped with what has been called an intellectual 'anti-modernism'. The term 'anti-modernism' is being used here to describe a contemporary resistance to the forces of industrialization, urbanization and political liberalism which were seen (by some) to be undermining traditional German culture. Some historians have seen this anti-modernism as one of the sources (rather than direct *causes*) of subsequent Nazi ideology within which the modern liberal and 'the Jews' became symbols of a supposedly degenerate 'modernism'.[11] Given this ideological framework, some

[11] See, for example, G.L. Mosse, *The Crisis of German Ideology: Intellectual Origins of the Third Reich*.

notions of the 'primitive', including a mystical notion of racial purity, subsequently be-
came the focus of the radical right.

It is some of the specifically German nuances of the concept of *Kultur* that help to il-
luminate these 'anti-modernist' tendencies. After German unification in 1871 many
Germans became obsessed with seeking a national identity in a shared cultural heritage.
The cult of the Volk was one of many manifestations of this obsession. During this period,
the word *Kultur* took on some rather different shades of meaning to the English 'culture'.
An opposition was frequently set up between *Kultur* and *Zivilisation*: *Kultur* was often
identified with the expression of the inner spiritual essence of man, with a (Nietzschean)
striving towards personal expression and fulfilment, *Zivilisation* on the other hand was the
more superficial refinement of humankind, which could be traced back to eighteenth-cen-
tury values of rationalism and scepticism. *Zivilisation* was taken to be artificially devel-
oped whereas *Kultur* had supposedly evolved naturally. This reformulated opposition
appears in various strains of *Kulturkritik*, positing an alternative notion of the essential
primitivism of German *Kultur*, which was taken up by many artists and intellectuals
during the early twentieth century. Contemporary German notions of *Kultur*, like those of
Natur were subject to constant renegotiation. In fact, *Natur* which was symbolized by the
indigenous peasant, was often allied with *Kultur* in opposition to a refined and
sophisticated *Zivilisation*.[12]

Of course, we need to be cautious when we try to sort out the relationship between
intellectual ideas and artistic movements. The point I want to make is that the various
forms of *Kulturkritik* made available a set of cultural and political meanings about the
status and identity of the Volk and modern urban life, which became a part of contem-
porary artistic and intellectual discourse. In artistic practice such ideas are mediated
through a wide range of technical, aesthetic and cultural constraints and interests. As we
shall see, the range of art and activities of the Worpswede group does not encourage
simple cause and effect readings which fit any one model of intellectual history.

The Worpswede artists' community

In the early 1890s a group of ex-art students from the Düsseldorf and Munich academies
settled in Worpswede, a village largely populated by peasant farmers and turf-cutters.
Worpswede is about twenty miles north of Bremen, conveniently situated on the main
railway line. The founding members included Fritz Mackensen, Otto Modersohn, Hans
am Ende, Fritz Overbeck and Heinrich Vogeler. Paula Modersohn-Becker joined the com-
munity in 1899.

By the late 1890s most of the group were painting peasant and landscape subjects,
partly influenced by the work of Courbet and the French Barbizon painters. In both the
artists' accounts and in contemporary critical reviews, these works were represented as
related to the main preoccupations of German modernism, in particular its 'newness', its
'originality' and its 'primitive' qualities.[13] Despite some obvious parallels, the concept of
'primitivism' which dominated German cultural discourses around 1900 had some differ-
ent connotations to those we discussed in relation to Gauguin in France. Many contem-
porary reviewers saw these Worpswede artists as neo-Romantics, seeking quasi-religious
fulfilment through their art. 'Untamed Nature' became the symbol and source of their
artistic expression. In 1903 the poet Rainer Maria Rilke published a monograph on Worp-
swede, in which he directly related these artists' aims to those of German nineteenth-
century Romantic painters, such as Otto Runge:

[12] The instability of the term 'Natur' and its symbolic representations in painting is explored in relation to
the art of the Worpswede group in G. Perry, 'The ascent to Nature'.
[13] A reviewer in the *Kölnische Zeitung* of 1895 described the show of Worpswede work in Bremen that year
as 'something so new, original and primitive [*Unsprungliches*]'. Quoted in *Worpswede: Aus der Frühzeit der
Kolonie*, p.51.

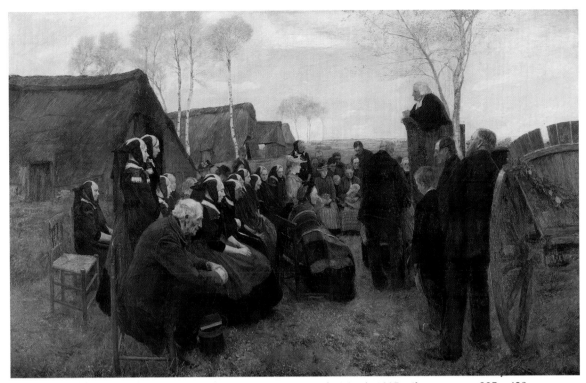

Plate 31 Fritz Mackensen, *Gottesdienst im Moor* (*Prayers in the Moor*), 1895, oil on canvas, 235 x 430 cm. Historisches Museum am Hofen Ufer, Hannover Volkskundliche Abteilung.

These young people who for years had been impatient and dissatisfied with life at the Academy, 'felt moved' – as Runge wrote – 'to go to the country, seeking something meaningful in the midst of uncertainty'. The landscape is meaningful, it is without chance, and every falling leaf, even as it falls, is imbued with a part of the great universal law of the universe.

(*Worpswede – Monographie Einer Landschaft und Ihrer Maler*, pp.19–20)

He attributes to them a belief in the 'universal law' of Nature. Their youthful anti-Academic primitivism is conflated with some kind of spiritual quest; theirs, he believes, is a spiritual mission to repair a severed relationship with Nature. This view of the Worpswede artists' mission is related to some of the writings of *Kulturkritik* in which Nature and the natural 'Volk' were represented as 'other' to modern urban life. But how do such attitudes relate to the kinds of images of local peasants and landscape which dominate the early paintings of the Worpswede group?

The first group exhibition held in Bremen Kunsthalle in 1895 included Mackensen's *Mother and Infant* and *Prayers in the Moor*, and Modersohn's *Autumn in the Moor* (Plates 31, 32, 34), all works which were singled out by critics as evidence of the 'new' and 'original' content of the show. Such labels may seem somewhat inappropriate in relation to what would have qualified as innovatory at the time in France. But the conditions and criteria of German modernism during this period were rather different. The official German art world was largely (though not exclusively) dominated by Wilhelmine attitudes which were conservative and imperialist in advocating an heroic German art which could somehow glorify or cultivate an 'ideal', preferably a national ideal.[14] The dominance of such ideas helped to force a polarization between groups with pro-French interests and official German art academies which were more directly answerable to government bodies. But

14 For a discussion of 'State Art in Imperial Berlin', see P. Paret, *The Berlin Secession*, chapter 1.

Plate 32 Otto Modersohn, *Herbst im Moor* (*Autumn in the Moor*), 1895, oil on canvas, 80 x 150 cm. Kunsthalle Bremen.

the dividing lines between these various categories were often blurred, and fashionable contemporary notions of the 'primitive' or the 'natural', despite their frequent association with the 'new', were by no means the exclusive property of pro-French art.

Both paintings by Mackensen illustrate this point. Although painted in the 1890s, the debt to a Courbet-influenced Realism gave these works an anti-establishment edge. In German art criticism at the time, the term 'realist' was often used as a broad category embracing any tendency to paint ordinary or banal subjects in a precise, detailed style influenced by Courbet (who had held a controversial show in the Munich Glaspalast in 1869). Such tendencies were generally seen to be opposed to the 'machines' of history painting favoured by the Wilhelmine regime. The German artists Wilhelm Leibl (Plate 33) and Fritz von Uhde were identified as exponents of this Courbet-influenced school.

Yet there are marked differences between the way Mackensen has represented local peasant life in *Prayers in the Moor*, and the way that Courbet depicted local village customs in, for example, *Burial at Ornans*. Courbet's unsentimental representation of rural life and the social and political readings this encouraged would seem to distance his work from that of Mackensen. Although Mackensen does not idealize the specific physical features of his peasant subjects, the relatively ordered composition and the use of aerial perspective give the assembled group a dignity which contrasts with Courbet's crowded line-up of figures. Mackensen's work could be taken to idealize the simple stoicism of this Protestant community, in which religious sentiments are conveyed in a simple, natural context: the service is taking place in the humblest of surroundings – nature. He also depicts the peasant group in local dress, thus emphasizing the community's historic roots and traditions, associating such 'primitive' cultural roots with religious piety through the theme of the painting. Mackensen's image can thus be read in relation to a Volkish ideology which identified the land – quite literally the German countryside and its indigenous people – as the only link between a new German 'spirit' and its past. W. Bradley has written:

> The Volkish writers confirmed this reactionary mentality in their condemnation of modern German society. More importantly, the attention of German conservatives and nationalists was captured by the Volkish allegiance to the ideals of the German past,

especially in the homage Volkish thought paid to the German landscape and to the intimate relationship between the land and its history.

(*Emil Nolde and German Expressionism*, p.13)

I want to argue that it is through Mackensen's use of a 'realistic' technique and his attention to detail that he creates an illusion of objectivity which, much like more conventional forms of Academic realism, actually disguises or blinds the viewer to the painterly devices which serve to idealize the subject-matter. Thus the ideological message is confused with the idea that this is exactly how a peasant service looked.

Mackensen was saturated in the writings of Langbehn, for whom Volkish ideas were of central importance. Although this sort of interest cannot guarantee any kind of fixed meanings for paintings, some of Mackensen's works can easily be read in terms of these preoccupations. His *Madonna and Infant* (Plate 34) which shows a Worpswede peasant mother suckling her child, soon became known, significantly, as the *Worpsweder Madonna*. She is shown seated on a peat cart (symbol of the local industry), and the low viewpoint, reminiscent of a Renaissance altarpiece, forces the spectator to look up at the mother and child who are, so to speak, enthroned in the cart. In the context of a north German Protestant society, this work could be seen as an attempt to bring religion down to earth, to present a religious concept in a simple form. The Virgin has become an ordinary peasant, a 'Worpsweder Madonna' who lives close to the earth. Mackensen draws on the same conventional set of gendered associations that we observed in Gauguin's work: woman is represented as a symbol of the 'primitive' and of its religious significance. In this painting her relationship with the natural cycle of things is clearly depicted. She is the nurturer, shown breast-feeding in nature, thus reinforcing her role within an organic, timeless cycle.

Plate 33 Wilhelm Leibl, *Drei Frauen in der Kirche* (*Three Women in the Church*), 1882, oil on canvas, 113 x 77 cm. Hamburger Kunsthalle. Photo: Elke Walford.

Plate 34 Fritz Mackensen,
Der Saügling (*Mother and
Infant*), also known as
Worpsweder Madonna,
1892, oil on canvas,
180 x 140 cm. Kunsthalle
Bremen.

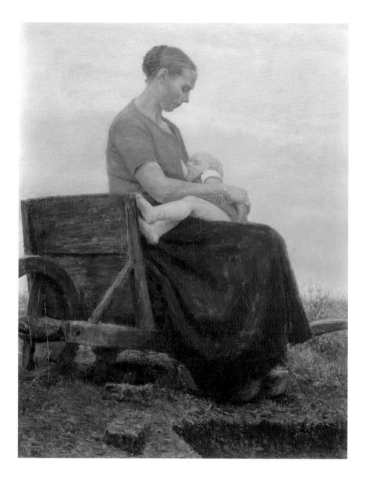

Moreover to a nineteenth-century German audience, steeped in a contemporary Romantic revival, this work and the literal and symbolic associations of the feminine which it suggests, would have been read as an explicit representation of the intimate bond between the peasant and the soil – the Volk and the land. Bradley has described this bond thus:

> Most often this bond between the Volk and the land was expressed by writers discussing the phenomenon in terms of 'roots', for example, the 'rootedness' of the Volk to its native soil. This image implies not only an exchange which proceeds from the inhabitant to the soil, but also an extraction of certain 'qualities' from the soil. Repeatedly, one finds examples of the belief that certain creative characteristics and powers of the individual are in some invisible, intangible, but nevertheless undeniable fashion the direct result of contact with the soil which the individual and his forefathers have inhabited.[15]
>
> (*Emil Nolde and German Expressionism*, p.14)

I think we can see Mackensen's choice of imagery as a visual equivalent, a metaphor for the concept of 'rootedness' which appeared in contemporary writings. The image of a breast-feeding peasant could be seen to symbolize the exchange, or life cycle 'from inhabitant to soil'.

Even within a German artistic environment, the naturalistic conventions of works like these two by Mackensen clearly confuse some of the innovatory associations of the label 'primitivism'. Modersohn's *Autumn in the Moor* in the same 1895 exhibition might seem to

[15] This belief in an exchange from inhabitant to soil led Langbehn to call for a new discipline of 'Geistesgeographie', or spiritual geography, which involved tracing the native landscape and background of important figures in German spiritual life.

have a better claim for a technical avant-gardism, in that it reveals the diluted influence of Impressionist techniques (then synonymous in Germany with innovative pro-French tendencies). Yet it is also an image through which the artist idealizes the peasant's relationship with nature. The warm autumnal shades of brown and orange and the subdued atmospheric light evoke a romantic atmosphere in which a peasant woman toils peacefully. Barely distinguishable by brushwork or colouring from the landscape around her, she's shown in harmony with nature, as part of the organic cycle symbolized by the change of seasons. The dominant view of Modersohn's work was that it was representative of a new style of poetic landscape painting, which became known as 'Naturlyrismus', literally translated as 'nature lyricism'. For Germans, the label carried strong neo-Romantic associations: these were landscapes to evoke mood and feeling.

However, other Worpswede artists' work was less obviously associated with the dominant strains of *Kulturkritik*. Heinrich Vogeler and Paula Modersohn-Becker, who both lived in the community in the late 1890s and early 1900s, developed interests influenced by, yet different from, the Volkish ideas that can be read out of Mackensen's work. During his early period in Worpswede, Vogeler worked extensively in the applied arts, advocating the arts and crafts ideals of William Morris and his followers in England. Vogeler designed furniture, fabrics and book illustrations and attempted to establish a craft workshop in his house, the 'Barkenhoff' (Plate 35). In Germany, such arts and crafts interests, and the idealization of medieval art practices involved, were easily associated with a Volkish mystification of peasant societies. Yet Vogeler's arts and crafts activities and Jugendstil designs were closer to the Romanticism of the British Pre-Raphaelites (he'd spent some time in England) than to the German brand of nature cults which feed into the painted representations of Mackensen or Modersohn. In his paintings and graphic works from around 1900, Vogeler seems to have avoided – resisted even – the idealizations of Mackensen, developing instead a Jugendstil iconography largely rooted in fairytales and romantic literature (Plate 36). While the two sets of interests were not incompatible, they tended to encourage different forms of primitivism.

Vogeler went on to develop a Marxist political outlook, but it was largely the English Utopian Socialist ideas of Morris and Ruskin which influenced his attitudes to art around 1900. For Vogeler, Ruskin's appeal lay especially in his later writings, many of which

Plate 35 Heinrich Vogeler, *Sommerabend auf dem Barkenhoff* (*Summer Evening at the Barkenhoff*), 1902–5, oil on canvas, 175 x 310 cm. Reproduced by permission of Landkreis Osterholz.

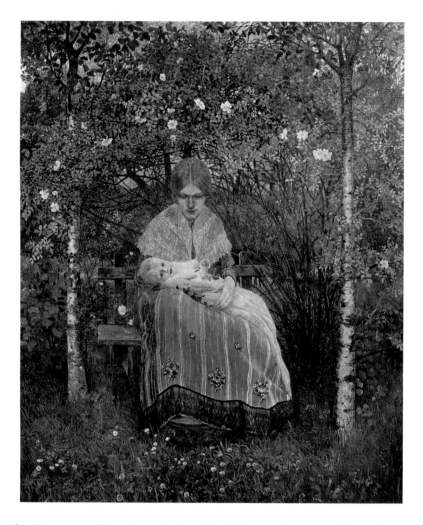

supported Pre-Raphaelite conventions in painting. Ruskin's emphasis on the faithful
representation of appearances and the 'visionary' powers of the artist's imagination, ap-
pealed to Vogeler's taste for minutely painted, mysterious Pre-Raphaelite-type canvases,
heavy in symbolic references – for example *First Summer* (Plate 36). While Mackensen's
'realism' was perceived by many contemporaries to be showing peasants as they actually
were (thus disguising the ideological meanings), Vogeler's naturalism drew on another
visionary level as a means to perceive some more 'primitive' truth. Thus, in theory at
least, the search for the 'primitive' in Vogeler's work and writings was often displaced
from the peasant subject onto the artist's capacity to see beyond the empirical world (the
world of ordinary experience) – to fall back on his/her imaginative powers. While
Vogeler's work usually avoids the iconography and some of the conventions which I have
identified with the discourses of *Kulturkritik*, it sustains and builds on the idea that
perception of the primitive 'truth' is inherent to the artist's mind, that through his/her
visionary powers it can be reproduced in painting.

The work of Paula Modersohn-Becker also seems to resist simple cause and effect
readings of the relationship between *Kulturkritik* and artistic practice. Modersohn-Becker,
who lived and worked in Worpswede between 1899 and 1907, was one of several women
artists who settled in the artists' community. Around the turn of the century such com-
munities provided women with a more tolerant environment in which to work. While
they were often excluded from educational opportunities and studio facilities within

urban academic contexts, here they were able to work alongside male artists, sometimes sharing studio space. Modersohn-Becker initially came to study under Mackensen, and later married Otto Modersohn in 1901. However, between 1900 and 1906 she also spent lengthy periods living and working in Paris, where she became absorbed in French Post-Impressionism, especially the work of Gauguin and Cézanne, and she was the only early member of the Worpswede community whose technical concerns conformed to contemporary French avant-garde notions of the 'primitive' (Plates 37, 38).[16] Despite the increasing tendency in her letters and diaries to dissociate herself from her early Worpswede interests in favour of a French influenced 'greater simplicity of form', much of her work remained firmly rooted in a German artistic and intellectual context. Her iconographical preferences, in particular her repetition of the themes of peasant women and peasant mothers, reveal the deep-seated influence of those neo-Romantic ideas which were common currency within the Worpswede community.

In paintings such as *Poorhouse Woman in the Garden*, she continues the theme of the local peasant, in this case using a model from the village workhouse. In fact, the subject was an elderly woman whose odd appearance gave her something of a freak appeal within the village. It is hardly comparable with the idealized peasants, the pseudo-religious earth mothers depicted in some other Worpswede canvases. Yet Modersohn-Becker uses various formal means to invest her painted representation of this subject with a mysterious, almost magical appeal. She employs Gauguinesque distortions and simplifications, reducing the woman's broad dimensions to seemingly flat, decorative areas of colour, and sets her against an ornamental frieze of vertical flowers. Modersohn-Becker has thus removed her peasant subject from the environment of the Worpswede workhouse. She is represented in a relatively unworldly context, a static figure removed from the traditional associations of peasant life and labour. Thus the technical primitivism of this work (i.e. the seemingly crude distortions, the decorative simplifications) serve to alienate the subject from the realities of her peasant life, but in the process they represent an alternative idealization, an ornamentalized and unworldly reconstruction of the peasant theme.

Yet works like *Poorhouse Woman in the Garden* are far removed from the more literal form of primitivism – with its ideological ramifications – of Mackensen's *Worpsweder Madonna*. By 1906, German audiences were largely familiar with anecdotal realism, or diluted forms of Impressionism, for the depiction of peasant subjects. Modersohn-Becker's paintings did not match with these accepted associations, and it was precisely this perceived disjuncture between different languages of the 'primitive' that made Modersohn-Becker's work inaccessible to a contemporary German audience. She sold few paintings during her lifetime.

Despite her use of some traditional symbolic associations, Modersohn-Becker's work also confuses some of the established conventions for gendered representations of the primitive. Like Gauguin, she uses the imagery of the female nude as a symbol of a natural, 'primitive' cycle. In her *Kneeling Mother and Child* (Plate 38) a naked, breast-feeding mother kneels on a circular pedestal-like cloth, surrounded by fruit and plants, Gauguinesque symbols of fertility. Yet this is not a sensual, erotic nude reminiscent of Gauguin's lush Tahitian scenes. Modersohn-Becker's nude is monumentalized with broad heavy proportions and an almost ugly, primitivized face. She is not an erotic object of male desire, but a life-giver or nurturer. While the associations of a fecund, primitive force are sustained in the image, the representation of the feminine which it involved avoids the connotations of sexual availability.

The various modes of painting adopted by the Worpswede artists did not simply mirror reactions to contemporary social problems or intellectual ideas. What I have suggested, rather, is that some of the concerns and cultural definitions of *Kulturkritik* mediated the way in which these German artists reconstructed the 'primitive' in their work.

[16] For further discussion of these issues see G. Perry, *Paula Modersohn-Becker*.

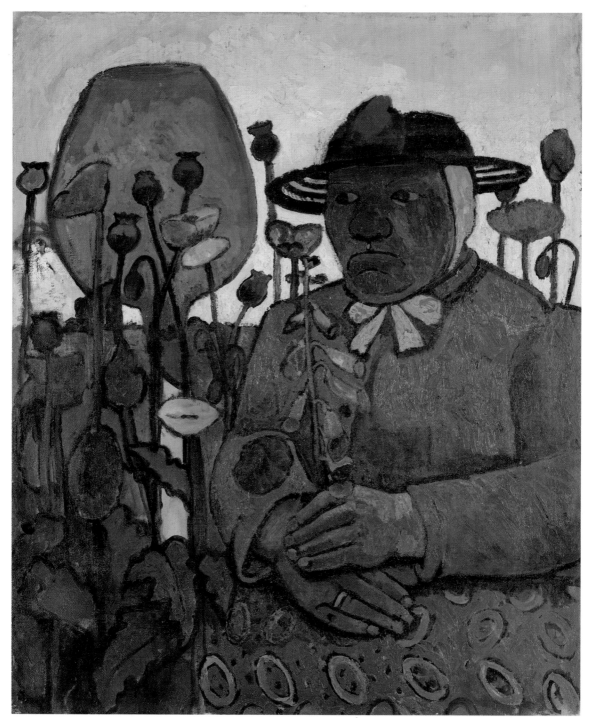

Plate 37 Paula Modersohn-Becker, *Alte Armenhäuslerin im Garten* (*Poorhouse Woman in the Garden*), 1906, oil on canvas, 96 x 80 cm. Böttcherstrasse Sammlung, Bremen, formerly Ludwig Roselius Sammlung. Photo: Lars Lohrisch.

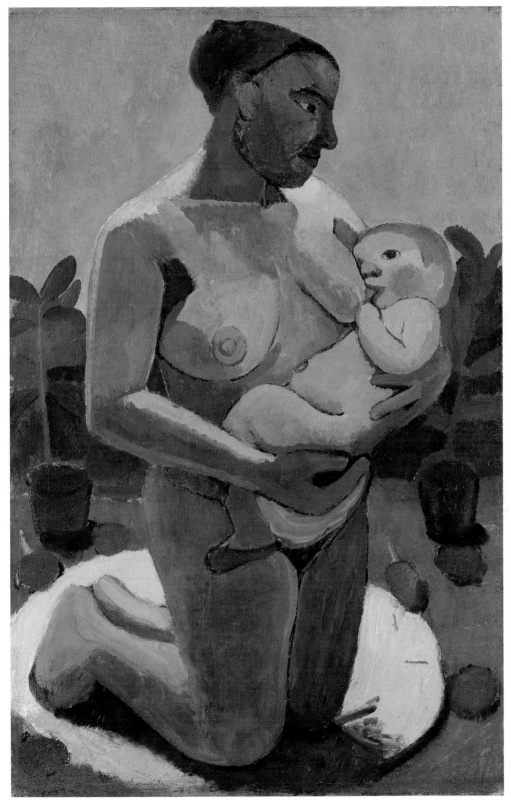

Plate 38 Paula Modersohn-Becker, *Kniende Mutter mit Kind an der Brust* (*Kneeling Mother and Child*), 1907, oil on canvas, 113 x 74 cm. Nationalgalerie, Staatliche Museen Preussischer Kulturbesitz, Berlin.

Part 2 The decorative, the expressive and the primitive

In the writings on modern art that appeared in France and Germany during the first decade of this century, concepts of the 'primitive', the 'expressive' and the 'decorative' have tended to be value-laden and have often been used (in differing ways) as indicators of the 'modern' or avant-garde qualities of the works in question. In this section I will consider some of the shifting frames of reference (aesthetic, social and political) of these terms, and the ways in which they have overlapped. I will also examine the extent to which the practices of art concerned could be seen to embody or represent such qualities.

The decorative and the 'culte de la vie': Matisse and Fauvism

Traditional histories of Fauvism describe a group of progressive young artists who burst onto the scene in 1905, with a display in Gallery seven of the now notorious Salon d'Automne of that year. According to the popular myth they outraged critics and artists alike with their daring, brightly coloured works. These unconventional paintings won them the label of 'wild beasts' (les fauves) with all its connotations of instinctive, spontaneous expression. Although this myth is partly based on actual critical responses, the notion of a radical group which suddenly shook the Parisian art world has been qualified and challenged.[17] It is now well established that many of the so-called 'Fauve' interests had been in evidence well before the 1905 exhibition, and that the critical response to the show was by no means that of universal outrage and consternation (often seen as a necessary qualification for avant-gardism). Several critics saw in their work – especially that of Matisse – evidence of an innovatory form of what Maurice Denis called 'pure art' (L'Ermitage, 15 November 1905).

The representation of Matisse as 'le fauve des fauves' – as the artist whose work embodied the most significant elements of this new art movement – was a consistent response to this and other Fauve exhibitions. His work in particular was singled out in terms of its 'originality' and its 'expressive' qualities – hence the emphasis on Matisse in this section.[18]

The problematic nature of the label 'primitive' and its shifting meanings within early twentieth-century art criticism is exemplified in both contemporary and subsequent attempts to define the primitivism of the Fauves. Critics of different political persuasions often used the term 'barbare', variously translated as 'primitive' or 'barbarian', to describe their work. In fact, in some of the more conservative reviews of the 1905 Salon d'Automne, the associations of the label sustained a nineteenth-century pejorative meaning. The seemingly naïve aspects of works such as Woman with a Hat or Open Window at Collioure (Plates 39, 40) were seen as evidence of a lack of artistic competence. Hence Marcel Nicolle's now notorious comment in the Journal de Rouen of 1905 that these works were 'nothing whatever to do with painting … the barbaric and naïve sport of a child who plays with a box of colours he has just got as a Christmas present'.

Nicolle's explicit and pejorative association between avant-garde techniques and child-like painting was a common one. The strategic avant-garde response was to appropriate the connection and invest it with value as part of a post-Gauguin re-evaluation of unsophisticated modes of painting. Many of the more liberal critics took up the 'child-like'

[17] See, for example, E. C. Oppler, Fauvism Reexamined.

[18] The debate which surrounded the concept of 'expression' as it was employed by Matisse (Notes of a Painter) and other commentators on the Fauves, is discussed by R. Benjamin in Matisse's 'Notes of a Painter': Criticism, Theory and Context 1891–1908.

Plate 39 Henri Matisse, *Fenêtre ouverte, Collioure* (*Open Window at Collioure*), 1905, oil on canvas, collection of Mrs John Hay Whitney, New York. © Succession H. Matisse/DACS 1993.

association, either satirizing the narrow philistinism it represented, or seeing it as a positive virtue. Guillaume Apollinaire for example introduced his review of the Salon d'Automne with a satirical song:

Mets ta jupe en cretonne	Put on your cotton skirt
Et ton bonnet, mignonne!	And your bonnet, my pet!
Nous allons rire un brin	We're going to have a good laugh
De l'art contemporain	At modern art
Et du Salon d'Automne	and the Salon d'Automne

(*Chroniques d'Art, 1902–1918*, p.33)

Thus the seemingly child-like qualities of the Fauve works also became the main focus of contemporary debates about their 'modern' status and, as we shall see, of their associations with the 'decorative'. The crude, unfinished appearance of some of these canvases, with areas often left unprimed and/or unpainted, characterized the style. While the critics' focus on this aspect of Fauve work has provided endless material to bolster some of the clichés about the modern artist's painful struggle against philistine attack, it also carried with it a complex cultural baggage, rooted in various contemporary discourses of primitivism.

The idea of the 'barbarian', then, with its connotations of untamed, direct expression, was frequently associated with the 'child-like' or the naïve. Both sets of associations could certainly have been read into the idea of the artist as a 'wild beast', and were implicit in contemporary critical representations of the early group as the expression of '*impétuosité*

Plate 40 Henri Matisse,
La Femme au chapeau
(*Woman with a Hat*), 1905,
oil on canvas, 81 x 60 cm.
San Francisco Museum of
Modern Art. Bequest of Elise
S. Haas. © Succession
H. Matisse/DACS 1993.

juvénile et barbare' ('a youthful, primitive impetuosity'; Oppler, *Fauvism Re-examined*, p.344). Such attitudes to artistic expression may also owe something to the cult of Nietzsche, which had already spread to France by the late 1890s. In 1898, Henri Albert's translation of the complete works, *Ainsi parlait Zarathoustra*, was met with great enthusiasm by many writers and intellectuals. For the French, this appeal lay partly in the range of intellectual interests with which his work could be associated. As Oppler has shown, Nietzsche's exaltation of life and individualism could be seen to encourage individualist and anarchist tendencies, and notions of free artistic expression. On the other hand, his defence of Mediterranean culture, of *'l'esprit latin contre l'esprit germanique*' ('the Latin spirit against the German spirit') could be seen to encourage a more traditionalist pro-French Latin culture (*Fauvism Re-examined*, p.202). (Nietzsche himself used the labels Dionysian and Apollonian to represent similar alternative modes of artistic expression.)

It is now well documented that the early Fauves, particularly Derain and Vlaminck, who worked together in Chatou in 1901, were well versed in Nietzsche's work, as were writers and critics such as André Gide, the poet Apollinaire and the art critic André Salmon, with whom members of the Fauve group associated. In fact *both* sets of Nietzschean interests summarized above could very possibly be seen to have informed

Matisse's preoccupations, and perhaps some of the technical developments which ensued in the period 1904–7. While the supposed *'impétuosité barbare'* of the Salon d'Automne exhibits could be identified with a Nietzschean cult of spontaneous individualism, Matisse's slightly later interest in a more controlled mode of painting, what he called in his *Notes of a Painter* 'an art of balance, purity and serenity' (p.135) could be seen to fit the other Nietzschean formulation.

A possible literary connection can be found in the writings of André Gide and the cult of 'Naturism'. Gide's *Les Nourritures terrestres*, published in 1897, exalts a direct, spontaneous approach to life and sexuality, a *culte de la vie* which became the distinguishing characteristic of the Naturist movement. The specifically French concept of *'joie de vivre'*, the idea of revelling freely in physical sensations and direct experiences is often associated with Naturism and with Gide's writing. In fact many supporters of the movement actually called themselves 'barbarians' to signify their joyful return to natural experiences. With such ideas in common currency the label 'wild beasts' was easily interchangeable with that of 'barbarians', with all its connotations of direct physical and sexual expression.

The interests summarized above have been associated with very different political attitudes within the culture of 'la Belle Époque'. The idea of avant-garde artists as impetuous 'wild beasts' was frequently identified with anti-establishment anarchist tendencies, already visible in France in the 1880s and flourishing in response to the Dreyfus affair. This affair, which revealed massive corruption within government institutions and the military, created a fertile climate for political and intellectual anarchism, which reached its height in the 1890s. However, the only member of the Fauve group who actively espoused anarchist causes was Vlaminck. While the other Fauves (at least during the early years of the movement) adopted a mode of spontaneous artistic expression which could be loosely associated with anarchist attitudes, this did not involve any conscious political commitment.

Attempts to relate Fauve works to specific political interests are fraught with problems, for some of Matisse's works from this period have also been associated with a more conservative bourgeois tradition. His middle-class leisure subjects, such as his Collioure landscapes and harbour scenes, or his later nudes in Mediterranean surroundings (Plates 39, 41), and his more 'Classical' pastoral scenes (which we will discuss shortly) have been represented in these terms. The other classicized 'primitive' tradition suggested by 'an art of balance and order' has been seen to embody contemporary middle-class values of order and stability, the conservative response to the destabilizing anarchism of the post-Dreyfus years. But how do we relate these sorts of interests and associations to the actual paintings, to the techniques and subject-matter employed?

Several critics have associated the seemingly naïve painting of early Fauve works with a political anarchism, although this may involve a crude causal relationship.[19] But Matisse himself does seem to have encouraged some less overtly political associations. In the choice of title and subject-matter for his Fauve work *Bonheur de vivre* (Plate 43; sometimes also called *Joie de vivre*) he was indirectly acknowledging Naturist connotations. The work depicts naked women and men dancing, embracing and reclining in nature, a theme which recurs in the work of other Fauve painters such as Derain (Plates 44, 46). Matisse's interpretation emphasizes a lack of inhibition; there are figures dancing wildly in the background (a group later reworked in *La Danse* 1910), while others embrace and many of the women recline in relaxed, erotic poses. But this work is also rooted in pastoral and arcadian themes popular among Symbolist painters (Plate 42), which can be traced back to Poussin's pastoral subjects, in which mythological themes are enacted in carefully composed landscapes (Plate 45). In *Bonheur de Vivre* Matisse reworks the theme of a Classical arcadia, a peaceful idyllic environment which is also reminiscent of Bougainville's 'La Nouvelle Cythère'. In its subject-matter at least, Matisse's painting combines two 'primitive' traditions: a classicized 'primitive', and a (supposedly) more

19 See, for example, J. P. Crespelle, *Les Fauves*, and C. Chassé, *Les Fauves et leur temps*.

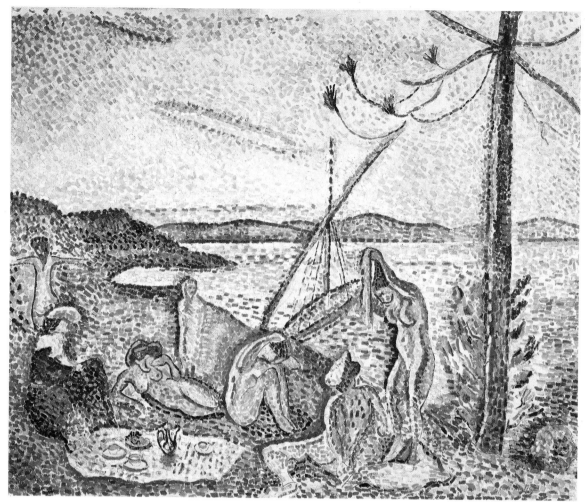

Plate 41 Henri Matisse, *Luxe, calme et volupté* (*Luxuriance, Calm and Sensuality*) 1904–5, oil on canvas, 99 x 118 cm. Musée d'Orsay, Paris. Photo: Réunion des Musées Nationaux Documentation Photographique. © Succession H. Matisse/DACS 1993.

spontaneous *culte de la vie*. And both sets of associations are evoked through the relationship of the *figure* to the landscape. When Matisse includes the human figure (both male and female) in his Fauve landscapes, the landscape theme becomes inflected with many other layers of meaning.

 Landscape painting was well established as a dominant genre in both the official Salon and the independent exhibiting societies. The Fauve painters, however, were seen to be developing a form of *paysage décoratif* (decorative landscape), which, as Roger Benjamin has argued, appears 'to have been a modernist addition to the traditional Academic division between the historic landscape (*paysage historique*) with figures in heroic action and the rural landscape (*paysage champêtre*) with its more initimate country setting' (*The Fauve Landscape*, p.254). While the former was often associated with the work of Poussin, the early Impressionist landscape developed from the latter. For contemporary critics the *paysage décoratif* was one in which the subject-matter need not be of a recognizable location; it was increasingly seen as a means to a more 'decorative' end. In this context the adjective 'décoratif' signified a schematic or abstracted image, and could be connected with concepts of the *barbare* or *naif*, whether these terms were being used pejoratively or as a measure of the innovatory status of the work.

Plate 42 Charles Maurin, *L'Aurore de l'amour* (*The Dawn of Love*), 1891,
oil on canvas, 80 x 100 cm. Private Collection.

Plate 43 Henri Matisse, *Bonheur de Vivre* (*Joy of Life*), 1905–6, oil on canvas,
171 x 234 cm. Photograph © 1993 The Barnes Foundation, Merion, Pennsylvania.
© Succession H. Matisse/DACS 1993.

Plate 44 André Derain,
L'Age d'Or (*The Golden Age*),
1905, oil on canvas,
176 x 189 cm. Museum of
Modern Art Tehran, Iran.
Photograph by courtesy of Perls
Galleries, New York. © ADAGP,
Paris and DACS, London 1993.

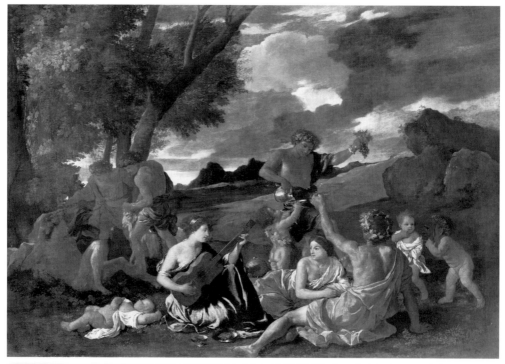

Plate 45 Nicolas Poussin, *Les Andriens*, known as *Grande Bacchanale à la joueuse de luth*
(*Bacchanalia with Luteplayer*), 1630, oil on canvas, 121 x 175 cm. Musée du Louvre, Paris. Photo:
Réunion des Musées Nationaux Documentation Photographique.

Plate 46 André Derain, *La Danse* (*The Dance*), 1906, oil on canvas, 185 x 209 cm. Courtesy of the Fridart Foundation. Photo: John Webb. © ADAGP, Paris and DACS, London 1993.

Matisse exhibited *Bonheur de Vivre* at the Salon des Indépendants of 1906, where it became the focus of debate about the value of 'decoration'. While Fauve landscapes without figures (Plate 39), which seemed to contemporaries to be 'abstracted' landscapes, were easily assimilated into the category of the 'decorative', the imagery of *Bonheur de Vivre* made it more difficult to categorize. For some critics the echoes of a reworked Classicism evoked by the frolicking and reclining figures must have jarred with the formal handling of the work. The distorted scale and perspective, the stylized rhythms, loosely painted and flattened areas of colour caused Vauxcelles, for example, to blame the influence of Derain and his dreams of 'pure decoration'.[20] Despite his general support of the Fauves, Vauxcelles seems to hold an ambivalent view of an art which is exclusively 'decorative'. By 1906 the term had become unstable, and was used *both* as a marker of the work's modernity, and in a more pejorative sense to signify the *ornamentation* of the applied arts.

I will return to the problem of these shifting associations later in this section. The point I want to make here is that for critics and artists the debate about the value or otherwise of 'decorative' painting seems to have found a focus in Fauve landscape painting.

[20] I am especially indebted to Roger Benjamin whose material on the *'paysage décoratif'* has informed my own discussion; see his 'Fauves in the landscape of criticism: metaphor and scandal at the salon'. His constructive criticism of my early draft of this text has been invaluable.

Bonheur de Vivre was only one of several landscapes by Fauve artists which reworked traditional pastoral themes, giving them a modern edge and thereby provoking critical debate. Matisse's earlier *Luxe, calme et volupté* (c.1904–5) suggests a similar combination of meanings. The title is from the chorus of Baudelaire's poem about a sensual arcadia, *L'Invitation au Voyage*:

Là, tout n'est qu'ordre et beauté　　　　*Everything there is order and beauty*
Luxe, calme et volupté　　　　　　　　*Luxuriance, calm and voluptuousness*

The classicized 'primitive' is evoked, then, by this notion of calm and order in a remote land. Yet it is also a modern leisure scene dominated by figures: women bathers are picnicking naked on a beach at St Tropez, a fishing village and holiday resort. Moreover, despite the Classical references, Matisse's use of the word *'luxe'* in this and other titles of works on similar themes suggests an association with a contemporary cult of *'joie de vivre'*. The French word *'luxe'* has some slightly different resonances to its English equivalent 'luxury' – it could also suggest voluptuousness, self-indulgence and sensuality. Thus it could be seen to relate to a cult of sensual self-indulgence identified with Naturism and the *'culte de la vie'*. And it is not without significance that in Matisse's work the word *'luxe'* is usually applied to the image of nude women, with its connotations of eroticism and sexual desire.

The handling of *Luxe, calme et volupté* also helped to place it as 'modern': although Matisse does not employ the loose spontaneous application of paint which later provoked the label 'wild-beasts', the somewhat crude adaption of Neo-Impressionist techniques and the rhythmic distortions and simplifications disrupted some of the more conventional associations of a pastoral theme.

Plate 47　Maurice de Vlaminck, *Les Baigneuses* (*Bathers*), c.1907, oil on canvas, 89 x 116 cm. Private collection. © ADAGP, Paris and DACS, London 1993.

African sources

The production of so-called Fauve paintings around 1905–7 also involved a more literal form of primitivism. By 1906 Matisse, Vlaminck and Derain had all started collecting non-Western art. Vlaminck (Plate 47) claimed (in *Dangerous Corner*) to have been the first to 'discover' African art, when he bought three statuettes in a bistro in Argenteuil around 1905; however, he was notorious for embellishing accounts of Fauve activities to give himself a leading role. The issue of which artist, or groups of artists, first 'discovered' African art in ethnographical museums has been endlessly argued over by art historians. However, I want to focus on how these works were perceived by the artists and on how they were absorbed into a culture of the modern associated with the Fauves.

The mythologized 'discovery' of 'primitive' sculpture raises a related problem. What aesthetic or technical aspects of three-dimensional sculptures (largely figures and masks) could be translated into the two-dimensional medium of painting? For those critics who focus on the 'formal affinities' between 'primitive' sculpture and modern art, this is clearly a crucial issue. It is often argued that the increased emphasis on modelling – the suggestion of sculptural effects through facetted planes – which appears in the work of Matisse and Picasso around 1906 was one of the effects of this new interest (see Plate 54). At the same time the stylized, distorted forms of African art could also suggest aesthetic possibilities for surface design, for which the various styles from different regions in Africa offered a range of formal types (see for example Plate 48 and 49).

For some artists this sculptural alternative ran counter to the Fauve emphasis on surface and the optical effects of colour. But for Matisse, African art was one of many artistic sources (of which Islamic art became increasingly important to him) which encouraged him to develop his notion of the 'decorative' and his belief in the importance of surface

Plate 48 *Fang Mask*, Gabon, Musée National d'Art Moderne, Centre Georges Pompidou, Paris, Documentation Photographique. (Formerly in the Maurice de Vlaminck Collection.)

Plate 49 *Téké-Tsaayi mask*, Republic of the Congo, painted wood, height 34 cm. Musée Barbier-Muller Museum. Photo: P.A. Ferrazzini, Geneva. (Formerly in the André Derain and Charles Ratton collections.)

Plate 50 Henri Matisse, *Jeune Matelot* (*Young Sailor II*), 1906, oil on canvas, 101 x 83 cm. The Jacques and Natasha Gilmore Collection, courtesy of the Metropolitan Museum of Art. © Succession H. Matisse/DACS 1993.

design. In the work of Matisse, Derain and Vlaminck there is little direct borrowing from specific African or Oceanic objects. Like most non-Western 'primitive' sources, African art could be 'pillaged' to reinforce prevailing aesthetic interests. Thus there was much in the formal structures and seemingly abstract forms of such works that could be seen to echo the already established symbolic languages of the Post-Impressionist painters, upon which Matisse and the Fauves were already building. It's no coincidence that 1906, the year in which conventions influenced by 'tribal' masks (such as lozenge-shaped eyes and stylized faces) begin to appear in Fauve works (Plate 50) was also the year of a huge Gauguin retrospective at the Salon d'Automne. The show included a large collection of paintings, sculptures and woodcuts from Gauguin's Polynesian period (Plate 51). In fact several of the wood reliefs in this exhibition directly influenced cylindrical wood carvings produced by Matisse at the time (Plates 52, 53).

The appeal of African and Oceanic objects for the Fauves was rooted in those same interests and assumptions which underpinned the appeal of Gauguin's work for the group. They signified the exotic or the 'primitive', redefined according to a Western avant-garde artistic code. Moreover, the absence of an accessible iconography or history to these objects allowed them to be easily absorbed into a modern artistic culture. This decontextualization is one of several reasons why modern artists have been accused of responding to African and Oceanic art ethnocentrically, attributing to its appearances (signifiers) twentieth-century Western meanings (signifieds).

Plate 51 Paul Gauguin, doorframe of *La Maison de jouir* (*The House of Pleasure*), 1902, redwood,
 lintel 242 x 39 cm, right upright 159 x 40 cm, left upright 200 x 39 cm, right base 205 x 40 cm,
left base 205 x 40 cm. Musée d'Orsay. Photo: Réunion des Musées Nationaux Documentation
Photographique.

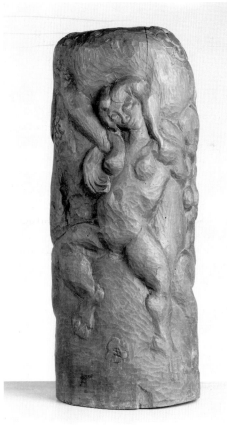

Plate 52 Paul Gauguin, cylinder decorated
with figure of Hina and two attendants,
1891–93, tamann wood with painted gilt,
37 x 13 x 11 cm. Hirschorn Museum and
Sculpture Garden, Smithsonian Institution.
Museum Purchase with funds provided
under the Smithsonian Institution collections
acquisition program 1981. Photo: Lee
Stalsworth.

Plate 53 Henri Matisse, *La Danse*
(*The Dance*), *c*.1907, 44 cm high.
Musée Matisse, Nice, Inv. 63.2.103.
© Succession H. Matisse/DACS 1993.

However, I think it's important to note that this does not involve a conscious 'conspiracy' on the part of Western artists such as Matisse or Picasso to distort and misappropriate the original roles and symbolic meanings of non-Western objects. It was rather the case that they had limited ethnological knowledge or interests, and what knowledge they had was filtered through the institutional machinery, taxonomies, selection processes and colonial politics of contemporary museums, and through various popularized anthropological and academic writings and contemporary political debates. Moreover, Patricia Leighten has suggested that Picasso's use of African art suggests a further level of meaning, which engages with contemporary debates about French colonial activity. She has argued:

> The popular image of Africa in pre-First World War France (embraced by modernists as an imagined primal spiritism), the response on the left to French colonial theory, and the inflammatory debates in the press and the Chamber of Deputies in 1905–6 following the revelations of abuses against indigenous populations in the French and Belgian Congos, form an inextricable part of the power of an allusion to 'Africa' in the period 1905–9 and reveal that the preference of some modernists for 'primitive' cultures was as much an act of social criticism as a search for a new art.[21]
>
> (P. Leighten, 'The white peril and l'art nègre: Picasso, primitivism, and anticolonialism', p.609)

A late Fauve work which is based on a North African theme, and in which a range of 'primitive' interests seem to converge, is Matisse's Blue Nude, Souvenir of Biskra (Plate 54), completed in 1907 and first shown in the Salon des Indépendants of that year. Matisse travelled in Algeria in 1906, visiting the oasis of Biskra, one of the towns of the Ouled Naïl tribes on the northern side of the Sahara. Biskra was one of several North African towns which had featured prominently in the French colonial literature of the time, including André Gide's The Immoralist, first published in 1902. Gide describes a fertile settlement of orchards, palm trees and cassia trees amidst a bleak desert, 'a place full of light and shade; tranquil; it seemed beyond the touch of time; full of silence; full of rustlings – the soft noise of running water that feeds the palms and slips from tree to tree' (p.41). A similar image of lush fertility in the barren desert is evoked by Matisse's retrospective account of Biskra as 'a superb oasis, a lovely and fresh thing in the middle of the desert, with a great deal of water which snaked through the palm trees, through the gardens, with their very green leaves, which is somewhat astonishing when one comes to it through the desert' (quoted in J. Flam, 'Matisse and the Fauves', p.226). Although the painting was not intended as a reconstruction of the place he had seen, the image is full of literal and symbolic references to the environment and culture of Biskra, including palm trees, lush green grass and flowers. The colour blue was often used in the Matisse's depiction of North African scenes, but without his explanation we can only speculate about reasons for the dominant use of blue in this painting. It has been suggested that it may be a reference to the blue-tinged skin of the local Berber tribe, the Tuareg, who used indigo dye in their clothing (see The Open University, A315, 'Cubism: Picasso and Braque', and D.C Gordon, Women of Algeria). But such literal references are difficult to prove, and it could also have been chosen by the artist for reasons associated with Symbolist aesthetics, or for a combination of reasons, including some of its local associations.

Matisse, then, has chosen an explicitly colonial subject. Since the conquest of Algiers in 1830 the country had been actively colonized by the French, and the primitivism of the work is tied to the contemporary rhetoric of colonialism. The suggestion of a lush peaceful paradise, with its connotations of 'replenishment' for the civilized traveller is implicit in accounts by both Gide and Matisse, as it is in Matisse's painted image in which a reclining sensual woman (in this case blue-skinned rather than dark-skinned) functions as another symbol of this 'primitive' oasis.

[21] Leighten's argument is focused on those artists, like Picasso and Vlaminck, whose anarchist backgrounds would have encouraged them to subvert colonial stereotypes.

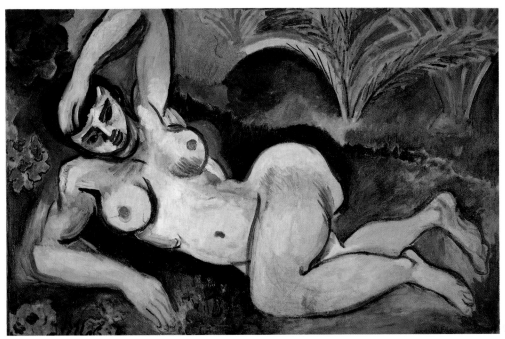

Plate 54 Henri Matisse, *Nu bleu. Souvenir de Biskra* (*Blue Nude. Souvenir of Biskra*), 1907, oil on canvas, 92 x 140 cm. Baltimore Museum of Art, Cone Collection, formed by Dr Claribel Cone and Miss Etta Cone of Baltimore, Maryland BMA 1950.228. © Succession Henri Matisse/DACS 1993.

In fact Matisse reworks a set of well-established nineteenth-century conventions; the female nude or 'odalisque' in an oriental setting – often suggesting the harem or prostitution – was a popular Salon theme, given historic status by artists such as Delacroix and Ingres (Plate 55) and reworked by Salon artists such as Gérôme, Lecomte du Noüy and Dinet, whose paintings on this theme we discussed earlier (Plates 2, 3). And photographic reproductions of Algerian or Arab women, posed partly nude or in 'oriental' dress had become a resource for various forms of popular culture, in particular the colonial postcard (Plate 56). However, the various technical devices employed by Matisse upset some of the conventional expectations (both artistic and ideological) aroused by the subject of an oriental nude. The technique appears both crude and artful. Space is ambiguous, combining a mixture of modelling – or facetting – with flatter areas of colour. This spatial ambiguity is further emphasized by the odd distortions in the woman's body, which frustrate some of the associations of the odalisque pose. These distortions are indirectly related to the forms of 'tribal objects', and some details, such as the bulbous breasts and exaggerated shape of the buttocks, are common features of African statuettes. The nude woman also assumes an impossible pose, a dramatic form of contrapposto, which further confuses the conventional sexual connotations of the theme.

 This is not to say that some of the conventional associations are missing. On one level, this is still a voluptuous female nude luxuriating in fertile nature. The 'primitive' – or colonial – subject is still implicitly gendered. Yet Matisse's image cannot be read *simply* as an exotic luxury item for male consumption. In this painting the means of representation are to the fore, and they serve to confuse or frustrate an easy reading of the woman as a passive (and primitive) sexual object. The distortions, the artfulness, help to produce an image which is less obviously erotic, and less clearly 'feminine', in which the sexual relations are less explicitly conveyed than in the manner of Ingres' *Bain Turc*, or Dinet's *Clair de lune* (Plates 2, 55).

Plate 55 Jean-Auguste-
Dominique Ingres, *Le Bain Turc*
(*The Turkish Bath*), 1862,
oil on canvas, 108 cm diameter.
Musée du Louvre, Paris. Photo:
Giraudon.

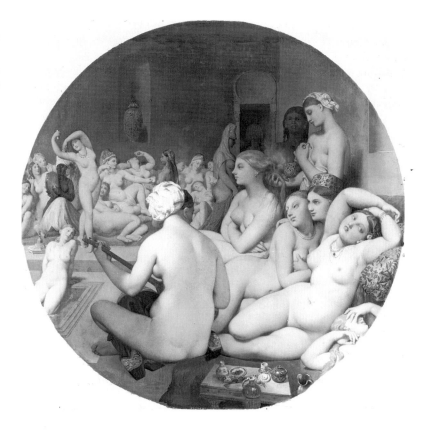

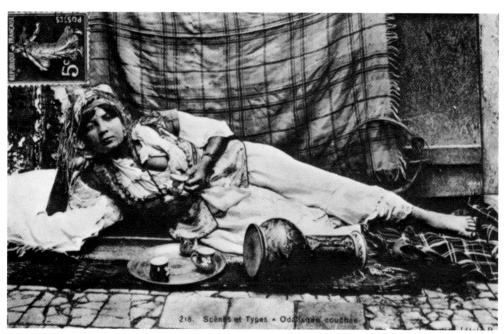

Plate 56 *Scènes et types: Odalisque*, postcard from Algeria, from Malek Alloula,
The Colonial Harem, University of Minnesota Press,1986.

I think it is precisely this ambiguity which provoked Louis Vauxcelles to write of this painting when it appeared in the Salon des Indépendants in 1907: 'A nude woman, ugly, spread out on opaque blue grass under some palm trees' (*Gil Blas*, March 20 1907, quoted in Rubin, *Primitivism in Twentieth-Century Art*, p.227–8). Despite the elements of a traditional odalisque pose, this woman was not desirable, but ugly. Over thirty years later, Matisse defended the work as follows: 'If I met such a woman in the street, I should run away in terror. Above all I do not create a woman, *I make a picture*' (quoted in *Primitivism in Twentieth-Century Art*, p.228).

The theory of the 'decorative'

Matisse then is anxious to emphasize the actuality of the painting. Before we read it as a woman or an *ugly* woman we are encouraged to read it as a painted *surface* upon which a woman is depicted. For many contemporaries, and for Matisse himself, this emphasis was itself an indication of the painting's innovatory or 'modern' quality. It was also this emphasis on reading the surface *design* independently of the object depicted that had been encouraged by various Symbolist writers, including Aurier and Denis, in their formulation of the 'decorative' as a positive indication of the 'primitive' and the 'modern'.

Although it is not until Matisse's work from the 1910s and 1920s, with titles such as *Decorative Figure*, that the issue of the decorative and 'decorativeness' seems to be addressed more self-consciously in his paintings, I think that in some of his late Fauve works, including the *Blue Nude*, Matisse can already be seen to be addressing some of the associations of the concept of the 'decorative'. We have seen that in his Fauve works, in particular in his use of the 'paysage décoratif', the debt to a Gauguinesque, post-Symbolist conflation of the primitive with the decorative is in evidence. However, Matisse's work seems to build on various formulations of the concept.

Denis's idea of 'decorative deformations', despite the emphasis it placed on the surface of the painting, was also underpinned by a theory of inner meanings or 'resonances', by the idea that these deformations could evoke 'essential truths'. Such a concept of the 'decorative' was conspicuously at odds with that of some other contemporary theorists. It will probably come as no surprise to learn that Pissarro often used the term pejoratively, to mean something more superficial and something associated with applied ornamentation. For example, he referred to some landscapes by Monet exhibited in 1888 as 'skilful decorations'. But by 1906 the term could not easily sustain its qualitative Symbolist associations, and it seems that in both his writings and his paintings Matisse was seeking to reinvest the concept with value, but value which could be defined principally in relation to *surface*, more than 'inner meanings'. In his *Notes of a Painter*, he formulated a theory of expression based on the interrelationship of the formal components of a painting. The inherent value of a painting was to be derived from a 'harmonious' combination of the various formal elements:

> Expression, for me, does not reside in passions glowing on a human face or manifested by violent movement. The entire arrangement of my picture is expressive; the place occupied by the figures, the empty spaces around them, the proportions, everything has its share.
> Composition is the art of arranging in a decorative manner the diverse elements at the painter's command to express his feelings. In a picture every part will be visible and will play its appointed role, whether it be principal or secondary.
> (*Notes of a Painter*, p.132)

But in the same essay Matisse also distinguished between 'the superficial existence of beings and things' and his own 'search for a truer, more essential character', an emphasis which reveals the diluted legacy of Symbolist ideas in his theory.

Subsequent Modernist theorists have also grappled with the problem of the decorative and its potential slippage towards the superficial. Clement Greenberg's emphasis in 'Modernist Painting' on the criteria of 'flatness' and the need for a modern art to

address itself critically to all 'that was unique to the nature of its medium', would seem to encourage a positive concept of the decorative. But Greenberg also sought to reframe the concept, setting up an opposition between the 'pictorial' and the 'decorative'. He wrote that for a modern painting to be adequately 'pictorial', the decorative qualities (i.e. those of colour, line, composition, rhythm etc.) must be combined with those of the painting as a material object (a two-dimensional canvas etc). While the Symbolists sought to invest the decorative with primitive and metaphysical values, Greenberg, like Matisse, sought to validate the concept with recourse to 'pictorial' values.

But for Matisse these 'pictorial' values were still rooted in a post-Symbolist theory of 'primitive' equivalents. Greenberg frequently addressed the issue of the decorative in his critical essays, but formulated the problem rather differently. For him, the 'decorative' could have a dialectical function. While on the one hand it could degenerate into superficial ornament, into the pejorative status or the negative decorative, it was also the element which could articulate the abstractness of the work, which could structure an art of 'pure surface'. Thus Greenberg wrote, in 1957: 'Decoration is the spectre that haunts modernist painting, and part of the latter's formal mission is to find ways of using the decorative against itself' (quoted in D. Kuspit, *Clement Greenberg, Art Critic*, p.63).

Greenberg came to see Matisse as an artist who successfully achieved this dialectical process. Although Matisse did not produce a work of 'pure surface' in that his canvases are never entirely abstract (i.e. non-figurative), Greenberg argued that Matisse had achieved this transformation by 'flattening and generalizing his motifs for the sake of a more abstract, 'purer' and supposedly soothing effect' (quoted in *Clement Greenberg*, p.63). In the process Matisse was actually increasing 'the tension between decorative means and non-decorative ends' (*Clement Greenberg*, p.63). In relation to Matisse's works then (particularly those from the 1910s and 1920s) Greenberg formulates – or at least allows for – a concept of the 'decorative' which is not exclusive to an abstract surface, but which is enhanced by the tension between the decorative surface and the figurative elements. Although Greenberg has discarded the spiritual values and inner meanings, we are reminded, once again, of the important legacy of Symbolist ideas according to which the 'decorative' was a 'deformation of nature', and crucial to 'a theory of equivalence' which I discussed earlier. The concept of the 'decorative' then has been constantly reshaped in modern aesthetic theory, and through its associations with the discourses of primitivism has consistently informed the theory and practice of a *modern* art.

The expressive and the Expressionist

In the earlier section 'Primitivism and *Kulturkritik*' I suggested that the conventional na-ture/culture opposition which underpinned contemporary European notions of the 'primitive' is *both* sustained and confused in some of the theory and practices of modern German art at the time. In the following section I want to consider this issue in relation to the work of Ernst Ludwig Kirchner and the Brücke group, and the emergent ideology of 'Expressionism' with which the group is associated. In the preceding section I suggested that the idea of the 'decorative' was central to the contemporary French understanding of a 'primitive' (i.e. modern) art. Recent research has shown that the Brücke group were also interested in concepts of decoration, and both Erich Heckel and Kirchner worked on deco-rative schemes for their studios which were influenced by 'primitive' motifs.[22] But I also want to suggest that in pre-war German avant-garde art the 'primitive' was more often predicated on the related idea of the art (and by implication the artist) as 'expressive', as directly conveying some 'authentic' or unmediated expression.

22 This issue is discussed in Jill Lloyd, *German Expressionism: Primitivism and Modernity*.

The belief that the artist could directly convey some kind of inner feeling – emotional or spiritual – through art was a fashionable idea in German artistic and intellectual circles at the beginning of the twentieth century. We have seen how a revival of nineteenth-century Romantic philosophy, the legacy of *Kulturkritik* and the writings of Nietzsche had already encouraged artists to seek 'new freedoms', to break free from civilized constraints and Academic conventions and somehow express themselves more freely; these ideas are fundamental to what we call German 'Expressionist' art.

The term 'Expressionism' has been used with different emphases in modern art history. As as stylistic label it has often been used retrospectively to denote, and implicitly to account for, a quality of distortion and exaggeration of forms found in the work of any artist or period. However, when used to describe *German* Expressionism it also takes on specific historical and cultural meanings, some of which I will be considering in this section.

There's a sense in which all artists are 'expressing' themselves, in that their own perceptions, personalities and interests are involved in the process of painting or the production of an art work. But how do we distinguish between this general notion of expression and an 'Expressionist' art? On what grounds do we decide that a painting is directly expressive of some inner feeling, that it is 'Expressionist' in the sense described above? In the case of the Brücke artists, their works have been described as 'Expressionist' for several reasons. Firstly, because the artists claimed at the time of producing their pictures that they were communicating more direct emotion or feelings (although many of them subsequently resisted the label Expressionist). Secondly, critics and art historians have consistently described Brücke works as 'Expressionist' because of the way they look.

Let's consider these two points in relation to two early Brücke works, Erich Heckel's *Seated Child* and Ernst Ludwig Kirchner's *Clay Pit* (Plates 57, 58) both of which have been seen as examples of early Expressionist painting. The first point raises the problem of artistic intention. But because the artist claims that he is directly expressing some kind of emotion in paintings like these it does not automatically follow that the painting then contains some kind of fixed meaning (which is the emotion in question). On the second point (that is the issue of labelling the work according to what it looks like), we can suggest reasons why these two paintings have been labelled Expressionist. In both works the brushwork appears crude and unfinished; individual brushstrokes are visible and seem to have been loosely applied. In addition, non-natural colours are often employed, as in the face of Heckel's child or in Kirchner's landscape. As a result, the subject-matter appears distorted; there is an uncomfortable tension between the images depicted and the visible brushwork on the canvas surface. In contemporary Academic terms this mode of painting revealed a lack of competence, a crude unfinished technique. But for those who subsequently used the label 'Expressionist', it was valued according to a different criteria. It was seen to be expressive of much more than the subject-matter depicted; it was seen as clear evidence of the artist's physical and emotional involvement with the medium, of a rejection of sophisticated forms of artistic competence in pursuit of the direct expression of the artist's feelings or emotions onto the canvas.

Clearly these implications of the label raise some problems. Many of the technical aspects of these works can be attributed as much to the influence of French Neo-Impressionist and Impressionist techniques (such as the individual brushstrokes of bright colour) as to the artist's 'expressive urges'. And how do we distinguish between supposedly 'authentic' expression and technical incompetence? One of the problems is that many of the popular meanings of the label Expressionist which I have discussed above are untestable. They are largely based on subjective claims for what a work expresses, or on a personal response to what a work looks like. What we *can* do is assess the artistic and cultural context in which such art emerged, and then try to sort out some of the more difficult or complex meanings that these Brücke works held both for their contemporaries and hold for us today.

Plate 57 Erich Heckel, *Sitzendes Kind* (*Seated Child*), 1906, oil on canvas, 70 x 92 cm. Brücke Museum, Berlin.
© DACS 1993.

In 1906 the Brücke painters, who then included Kirchner, Heckel, Fritz Bleyl and Karl Schmidt-Rottluff, produced their group manifesto. It was printed in the opening pages to the (incomplete) catalogue of their first group exhibition held in the Löbtau district of Dresden in 1906:

> With faith in progress and in a new generation of creators and spectators we call together all youth. As youth, we carry the future in us and want to create for ourselves freedom of life and of movement against the long-established older forces. We claim as our own

Plate 58 Ernst Ludwig Kirchner, *Die Lehmgrube* (*The Clay Pit*), oil on cardboard, 51 x 71 cm. Thyssen-Bornemisza Collection, Lugano, Switzerland. Reproduced by permission of Galleria Henze.

everyone who reproduces that which drives him to creation with directness and authenticity.

There's a sense in which this short manifesto, printed in pseudo-primitive lettering, helped to set the agenda for what is now loosely labelled an Expressionist ideology. It echoes the concerns of many contemporary artists, writers and intellectuals who, during the pre-war period saw their work as a radical alternative to bourgeois culture and its values. According to the few surviving letters and documents the Brücke notion of progress was inseparable from a muddled sense of rebellion against industrialized bourgeois society. It was steeped in Nietzschean ideas of the need to destroy sterile middle-class values in order to facilitate an artistic renewal, to enable new forms of creative expression.

For many artists and writers Nietzsche's writings offered quasi-philosophical solutions and alternatives to contemporary currents of anti-materialism and religious scepticism, solutions which placed special emphasis on the role of the 'individual' and the artist in seeking out creative freedoms. Despite some of the contradictions in his writings (produced during the years 1872–88) 'modernity' is consistently associated with cultural decadence, which is to be overcome by a dialectical process of 're-valuation' and 'self-overcoming' (see, for example *Beyond Good and Evil* and *The Case of Wagner*). What is involved in these processes is explored in *Thus Spake Zarathustra* (published in parts in the 1890s), a book regularly cited by members of the early Brücke group to justify their declared attitudes to art. In it Nietzsche uses the figure of Zarathustra to explore and counter modern cultural conditioning. He declares the death of religion and the loss of conventional 'meaning' of life (in the sense of supernatural purpose), advocating an

attempt to 'overcome' this conditioning, to seek out other forms of expression and meaning. Zarathustra calls the man who has overcome these forces of decadence the *Übermensch* (overperson or overman), an idea subsequently popularized by Bernard Shaw's somewhat ironic translation of 'superman' (Nietzsche's texts are exclusively addressed to men, who are seen by him as the agents of cultural change). The idea that the individual could overcome the constrictions of a culture was irresistible to the early Brücke artists, who probably took their group name from *Thus Spake Zarathustra*. The metaphor of the bridge (*die Brücke*) is used by Zarathustra in the book to represent man's journey from absorption in a decadent culture to a state of freedom and 'overcoming'. In the prologue Neitzsche writes in his characteristically epigrammatic style:

> What is great in man is that he is a bridge and not an end: what can be loved in man is that he is an *overture* and a *going under* …
> I love him who does not hold back one drop of spirit for himself, but wants to be entirely the spirit of his virtue: thus he strides over the bridge as spirit
>
> (in W. Kauffman, *The Portable Nietzsche*, p.127)

The bridge then could symbolize the group's journey towards, and pursuit of, 'new freedoms'. For the Brücke group this idea of rebellion is inextricably tied up with an understanding of the value of 'primitive' sources. The group's interest in these sources, many of which came from the Dresden Ethnographical Collections, was predicated on the belief that these were 'truthful' unsophisticated forms of art, uncorrupted by modern bourgeois culture. And the evidence for this lay partly in the (seemingly unsophisticated) distortions and simplifications which they observed in 'primitive' artefacts. They could thus be identified with what the manifesto calls 'authenticity' (*Unverfälscht*). Similarly, this 'new generation of creators' is laying claim to a new more direct mode of creation, a form of expression which can somehow deny its conditioning in the way that Nietzsche's *Übermensch* overcame his decadent culture.

The manifesto tells us that this more 'authentic' mode of expression was also seen as the prerogative of youth. The founder members of the Brücke were architectural students studying at the Sächsische Technische Hochschule. As students, all in their early twenties, they shared a sense of youthful rebellion. For the Brücke, as for many other Germans at the time, youth was seen as the vehicle of less corrupt modes of expression, and as standing in the front line of attack against prevailing bourgeois values.

It is important to qualify this notion of rebellion and its implications for a supposedly radical or 'modern' art. In turn-of-the-century Germany, to be against modern bourgeois culture often meant little more than to be against modern industrial society and aspects of urban life, especially petty bourgeois commercialism and its associated values. Thus in 1934 the Hungarian writer Georg Lukács described 'the complete emptying of the concept of 'revolution' among 'Expressionists'.[23] The early Brücke group were idealistic young students with controversial and anti-establishment views, but there is no evidence that they adopted coherent political positions or belonged to any left-wing political movements. But as we have seen, their ideas were not exclusively tied to theories of artistic expression. For the Brücke artists they were expressed and developed in an attempted fusion of art and life. In both their social activities and in their painted and graphic work the group set about undermining contemporary bourgeois sexual mores, and a revaluation of 'primitive' sources and lifestyles (largely African, Oceanic and Medieval). Contemporary discourses on sexuality, like those on the meaning and value of the 'primitive', were the focus of much cultural and political debate in Germany at the time. How far these interests were, or could be embodied in Brücke art will form one of the themes of the following section.

[23] Lukács's views on the subjective and potentially reactionary aspects of Expressionism became the focus of a series of articles by Lukács and Ernst Bloch, published in *Das Wort* in 1938. The articles are reproduced in R. Taylor, *Aesthetics and Politics*, pp.16–27 and 28–59.

NATUR-FEST *Reinh. Max Eichler (München)*

Plate 59 *Naturfest*, double page spread in *Jugend*, 1903.

Expression and the body

One of the subjects which predominates in Brücke painted and graphic work was the female and, on occasion, the male nude (for example, Plates 60, 61, 62, 63, 75). This preoccupation owed much to Jugendstil art interests, in which the theme of the nude came to represent a wide range of decorative, symbolic and cultural interests (Plate 59). For the Brücke artists, the nude female body in particular became a central motif, laden with various literal and symbolic meanings. In singling out the repetition of this subject-matter I am, of course, developing a theme explored earlier in this essay, the implicit and explicit association often made in Western art and culture between the female nude and the 'primitive', between woman and nature, by contrast with a more masculine 'culture' or, in this context, *Zivilisation*.[24] But I want to argue that in Brücke work the nude also becomes the symbolic focus of a wider range of interests and debates, both cultural and aesthetic. These include the groups' claims for technical radicalism, for sexual liberation and anti-bourgeois activities, and for more 'authentic' modes of social and artistic expression. I want to look at some of the slippages and displacements of those symbolic meanings which I believe are suggested in several Brücke paintings of the nude theme from the period *c.*1909–1916.

[24] The symbolic relationship between woman and nature in turn of the century German art is discussed in G. Perry, 'The ascent to nature'.

Plate 60 (a) Ernst Ludwig Kirchner, *Sam und Milly* (*Sam and Milli*), black chalk and wash, 1911, 46 x 58 cm; (b) *Das Paar am Strande* (*The Couple on the Beach*), 1912, etching 12 x 18 cm; (c) *Badende* (*Bathers*), 1910, etching, 17 x 12 cm. Ernst Ludwig Kirchner Archive, Galleria Henze, Campione d'Italia.

Plate 61 Ernst Ludwig Kirchner, *Badende am Moritzburg* (*Bathers at Moritzburg*), 1909, reworked 1926, oil on canvas, 151 x 199 cm. Tate Gallery London. Reproduced by permission of Galleria Henze.

Plate 62 Ernst Ludwig Kirchner, *Liegender Akt vor Spiegel* (*Reclining Nude in Front of Mirror*), 1909–10, oil on canvas, 83 x 95 cm. Brücke Museum, Berlin. Photo: K. Moragiannis. Reproduced by permission of Galleria Henze.

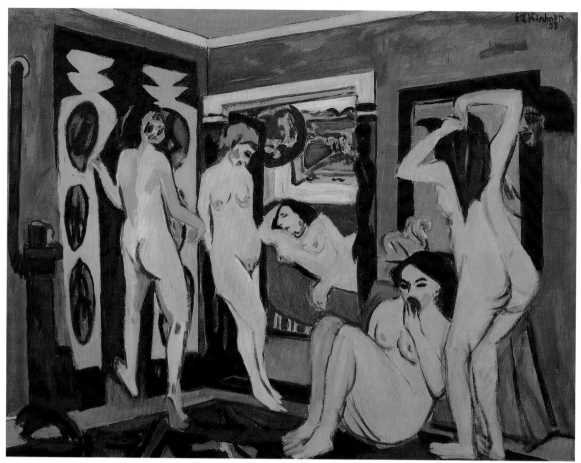

Plate 63 Ernst Ludwig Kirchner, *Badende in Raum* (*Bathers in a Room*), 1909–10, oil on canvas, 151 x 198 cm. Saarland Museum, Saarbrucken. Reproduced by permission of Galleria Henze.

Around 1910 Kirchner produced several nudes in interiors which seem to raise questions about meaning and symbolic function. *Reclining Nude in Front of a Mirror*, *Bathers in a Room*, and *Standing Nude with a Hat* (Plates 62, 63, 64) were all painted during the period 1909–10, although the *Bathers in a Room* was reworked in 1920 (in the 1920s Kirchner reworked many paintings from this pre-war period). Each of these works is painted in a style rather different from the freely applied brushwork and vibrating surface effects of the earliest Brücke paintings. Although there are areas of loose brushwork, the paint seems to have been applied in flatter areas with forms reduced to more angular, almost spikey shapes, a style influenced by the techniques of the woodcut medium which the Brücke artists were using extensively at the time (Plates 65, 66, 67). The use of vibrant, often non-natural colour, as in the lurid green body of the *Reclining Nude,* contributes to the sense of distortion and awkwardness conveyed by most of these nudes. Technically at least, these works could be read as a rejection of the conventions and competences associated with two strands of contemporary German painting: the Courbet-influenced school of naturalist painters (which included many of the Worpswede painters) and the so-called German Impressionists (notably Liebermann, Corinth (Plate 68) and Slevogt). Around the turn of the century both broad groups had laid claim to radical objectives and a shared opposition to Wilhelmine Academicism.

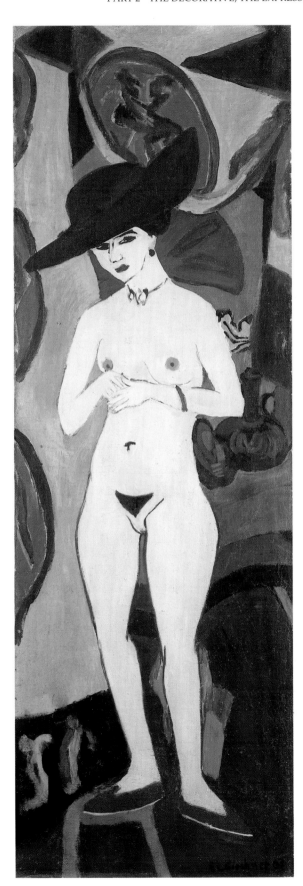

Plate 64 Ernst Ludwig Kirchner, *Nackte Frau mit Hut (Standing Nude with a Hat)*, 1907/9, oil on canvas, 195 x 69 cm. Städtische Galerie in the Städelisches Kunstinstitut, Frankfurt am Main. Reproduced by permission of Galleria Henze.

Plate 65 Erich Heckel, *Portrait of Friedrich Nietzsche*, 1905, woodcut. Brücke Museum, Berlin. Photo: K. Moragiannis. © DACS 1993.

Plate 66 Ernst Ludwig Kirchner, text of the Brücke Programme, 1910, woodcut. Brücke Museum, Berlin. Photo: K. Moragiannis. Reproduced by permission of Galleria Henze.

Plate 67 Erich Heckel, *K.G. Brücke*, cover page of Brücke exhibition catalogue, Galerie Arnold, Dresden, September 1910, woodcut. Brücke Museum, Berlin. Photo: K. Moragiannis. © DACS 1993.

Plate 68 Lovis Corinth, *Matinée*, 1905, oil on canvas, 75 x 62 cm. Saarlandmuseum, Saarbrucken.

The relative technical radicalism of these Brücke works draws on another source: 'primitive' and exotic artefacts and designs. The decorative motifs in the drapes and background of the *Bathers in a Room* and the *Standing Nude* are influenced by African and Oceanic objects available in the Dresden Ethnographical Museum, including carved and painted house beams from the Palau Islands, a German colony in the South Seas. Such references, however vague and unspecific, would have been recognized by contemporary viewers as an indication of the paintings' 'modern' qualities, of the explicit association of Kirchner's work with artefacts deemed to be the product of 'uncivilized' and therefore more 'authentic' expression.

As in France, the growth of artistic interest in 'primitive' or tribal objects coincided with the founding and expansion of German ethnographical collections around the end of the nineteenth century. During this period German colonial acquisitions in Africa and more importantly Oceania, and the political and economic competition for world markets which accompanied it, were represented by the founding of ethnographical collections in Berlin, Hamburg, Leipzig and Dresden. Public exhibitions of colonial art became increasingly popular and Dresden hosted a series of shows of 'primitive' and 'exotic' cultures which began in 1909. These included an African village and dancers, shown in the Dresden zoological gardens in 1910, on which Heckel and Kirchner reported with enthusiasm (see J. Lloyd, *German Expressionism – Primitivism and Modernity*, pp. 30–31).

As with contemporary French readings of African and non-European works, the idea that objects in museum collections and contemporary exhibitions were somehow more

'authentic' forms of expression was, of course, part of a Western fantasy of 'primitive' culture, which gave meaning to – or could be identified with – its own 'modern' modes of artistic expression. But at the same time this alien culture was also represented as the 'other' of civilized Western culture. In the German context, the Nietzschean notion that 'genius resides in instinct' (*Will to Power*), in unfettered personal expression, was easily projected onto works which were thought to be the products of a less civilized and therefore more instinctive culture.

However, references to supposedly 'primitive' techniques and sources contribute only a part of the possible meanings of these paintings. The *Bathers in a Room* is a large canvas (151 x 198 cm) which reworks an established art-historical theme. Kirchner's nude women assume graceful poses reminiscent of many Symbolist bathers, and of Matisse's pastoral compositions (Plates 41, 43). Yet there are several aspects which confuse the art-historical precedents. The bathers theme is conventionally associated with an outdoor setting – the nude in nature – but these women are contained within an artificial interior space, albeit one decorated with pseudo-primitive designs and carvings. In spite of the indolent pastoral poses, other aspects – the use of greenish tones, the distortions and angularities in some of the bodies and their positions in relation to the decorative surround – draw the viewer's attention to the artifice of painting, to the complex processes of representation, rather than to its potential as instinctive expression. This emphasis is reinforced by the inclusion both of a painting within a painting at the back of the bedroom annexe in the centre, and by what seems to be a deliberate ambiguity in the painting of the annexe. The scale of the reclining woman on the bed does not quite seem to fit her position at the back of the scene. And the opening with its carved door jambs also serves as a frame for this nude, in her reclining odalisque pose. Thus this figure can also be read as a fictional painting within a painting, an ambivalence which is reinforced by the inclusion of a fictional painting on the wall behind her. While it's impossible to prove that this pictorial ambivalence was intended by the artist, the likelihood that Kirchner was concerned with the nude *both* as a symbol of 'primitive' associations *and* as a problematic image in the history of representation, is also suggested by other works from this period. The *Reclining Nude in front of a Mirror* (Plate 62) reworks the art-historical theme made famous by Velasquez's *Rokeby Venus* (late 1640s) in which the female nude reclines holding a mirror to her face. We are invited to gaze both at the body and its mirror image. Yet in Kirchner's work there is once again a seemingly deliberate pictorial ambivalence: the mirror image does not quite match the pose or the distortions of the body which it supposedly reflects. It seems to function both as a mirror image and as another painting of a nude within a painting of a nude.

Kirchner's *Standing Nude with Hat* also plays on art-historical precedents. The pose, necklace and shape of the body are influenced by Cranach's *Venus* of 1532 (Plate 69). However, Kirchner's reworking of this theme helped to produce an image which contemporary German viewers would have found hard to read. The 'primitive' references in the background seem to jar with the sophisticated, urban nature of the nude. She is naked yet heavily made up, wears jewellery, a fashionable hat and shoes. Much like Manet's *Olympia* of fifty years earlier, her nudity is not of the conventional odalisque kind; she carries evidence of her sophisticated, possibly morally corrupt life. Prostitution, dancing and modelling were the 'careers' implicated by her fashionable state of undress. This implied public invasion of feminine privacy is further suggested by the starkly painted pubic hair which has been shaved into a triangle shape, a fashion at the time among dancers. Moreover she is shown standing and engages the viewer with her eyes, rather than passively reclining as the object of his gaze. For the contemporary German audience for whom the nudes of Impressionist painters such as Corinth (Plate 70) still held some progressive or 'modern' status, Kirchner's *Standing Nude* posed some problems of interpretation and meaning.

The sexual connotations of Kirchner's work also contributed to its controversial 'modern' status. The model was the artist's girlfriend, the dancer Doris Grohse, and the

Plate 69 Lucas Cranach the Elder, *Venus*, 1532, oil on wood, 37 x 25 cm. Städelsches Kunstinstitut, Frankfurt. Photo: Ursula Edelmann.

Brücke group's overt association with the world of dancers, prostitutes and performers, who were often the subjects of their works, was a part of their sexual revolution. Sexuality, and its representation in both female and male subjects, was central to their notion of free self-expression, as was their association with various forms of modern dance. From the bourgeois point of view such open sexuality, associated with social groups such as prostitutes, bohemians and dancers, was condemned as decadent or deviant. In his works Kirchner often combined overt references to this 'decadent' sexuality, with references to a more 'primitive' sexuality. In the *Bathers* for example, the drapes which protect the room to the left contain figure groups in the roundels, including couples making love. Similar drapes decorated with scenes of copulating couples appear in the background of other works from this period, including *Girl under Japanese Umbrella* (Plate 71), and were probably based on painted drapes in Kirchner's own studio. They were influenced by erotic scenes on carved and painted house beams from the Palau Islands which Kirchner saw in the Dresden Museum.

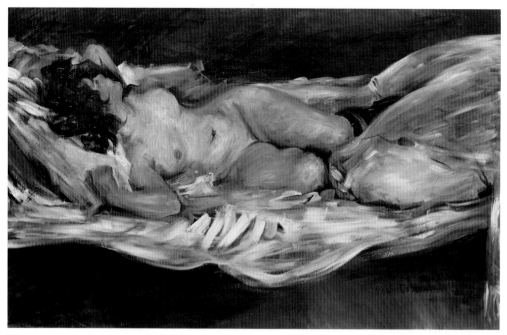

Plate 70 Lovis Corinth, *Liegender weiblicher Akt* (*Reclining Nude*), 1896, oil on canvas, 75 x 120 cm. Kunsthalle Bremen.

Plate 71 Ernst Ludwig Kirchner, *Mädchen unter Japanschirm* (*Girl with a Japanese Umbrella*), 1909, oil on canvas, 92 x 80 cm. Kunstsammlung Nordrhein-Westfalen, Düsseldorf. Reproduced by permission of Galleria Henze.

The overtly sexual imagery on these beams and other African and Oceanic sources also encouraged prevalent Western myths about black sexuality, 'natural rhythms', and instinctive expression. Such myths are evoked, or at least suggested, in Kirchner's use of male and female negro dancers and models in his works from around 1909–11 (Plate 72). And in a now famous studio photograph he combined the 'primitive' with its painted representation when he posed his black models Sam and Milli in the nude amidst the same decorative drapes as those depicted in the background of the *Bathers* (Plate 73).

For Kirchner in particular, the representation of the nude was a *potential* weapon in the refutation of contemporary bourgeois sexual mores. I am not arguing, however, that through his work Kirchner was somehow able to escape a prevalent system of Eurocentric values through which both black people and nude women came to symbolize some fantasy of free 'primitive' expression. His liberal sexuality also reinforced Western myths. I am suggesting rather that when this primitivism was combined with a visible concern with the technical and art-historical problems of representation, he could on occasion produce works which upset contemporary artistic expectations, and which cannot be read easily in terms of a crude nature/culture opposition.

In some ways this opposition is more easily read into the many nudes in nature and bather subjects produced by members of the Brücke group between *c.*1909 and 1914. For example, the association between nude woman, the 'primitive' and nature is made ex-

Plate 72 Ernst Ludwig Kirchner, *Negertanz* (*Negro dance*), 1911, oil on canvas, 151 x 120 cm. Kunstsammlung Nordhein-Westfalen, Düsseldorf. Photo: Walter Klein. Reproduced by permission of Galleria Henze.

Plate 73 Sam and Milli from 'Zirkus Schumann' in Kirchner's Dresden studio, 1910.
Photo by Ernst Ludwig Kirchner. Fotoarchiv Hans Bollinger/Ketterer, Galleria Henze,
Campione d'Italia.

plicitly and (I would argue) somewhat crudely, in Heckel's famous *Day of Glass* (Plate 74).
In this work, woman is shown naked against an awesome nature of snowy mountain
peaks, reflected in a lake. Her arms are raised to display a body painted to resemble an
African sculpture. She has a pot belly, pendulous breasts and partly visible face. Denied
recognizable features, she functions as both a literal and symbolic representation of the
'primitive', of 'woman as nature'.

Yet there are several bathers subjects from around the same period in which the sym-
bolic meanings are less clear cut. During the summers of 1909, 1910 and 1911 members of
the group, accompanied by girlfriends and models (often including Sam and Milli) made
regular expeditions to the Moritzburg lakes, in the countryside north of Dresden, and
within easy reach of the town by train (Plates 60, 61). On these expeditions, they would
often bathe, sunbathe and sketch in the nude. Thus the Moritzburg paintings represent
both a record of those summer activities and a critical engagement with a long-established
art-historical theme.

Paintings such as Kirchner's *Bathers at Moritzburg* or Heckel's *Bathers* (Plates 61, 75)
show both men and women bathing naked and participating in nudist cults (*Nacktkultur*
or *Freikörperkultur*) which were especially popular among the younger generation in Ger-
many at the time. Such cults were often associated with vegetarianism, dress reform and
nature cures, and fed into early Expressionist ideas of direct and unsophisticated ex-
pression. Although Naturism and nudist cults tended to be represented as 'alternative'
movements their political associations were often contradictory, for they attracted both
progressive and conservative supporters, reinforcing once again the confusing political
sources of Expressionist ideology.

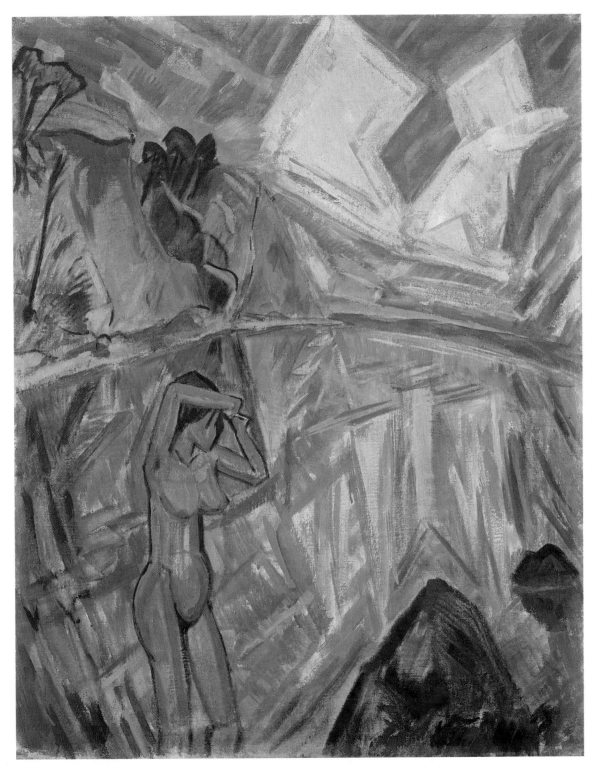

Plate 74 Erich Heckel, *Gläserner Tag* (*Day of Glass*), 1913, oil on canvas, 138 x 114 cm.
Bayerische Staatsgemaldesammlungen, Staatsgalerie Moderner Kunst, Munich.
Photo: Joachim Blauel-Artothek. © DACS 1993.

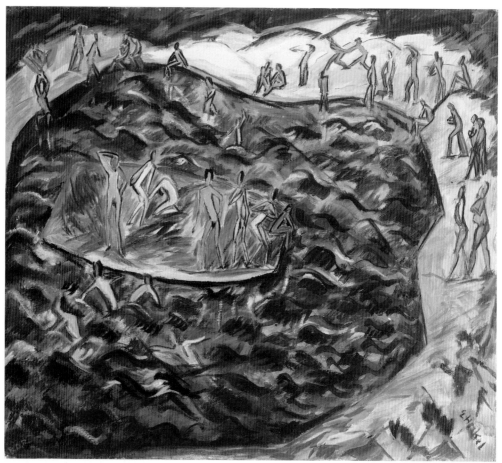

Plate 75 Erich Heckel, *Bathers*, *c*.1912–13, oil on canvas, 81 x 95 cm.
The Saint Louis Art Museum, bequest of Morton D. May. © DACS 1993.

It is no coincidence that the Brücke group emerged in Dresden, a town then famous for its provision of sanatoria and health resorts, promoting a culture of natural medicine and bodily revitalization through nudity (Plate 76).[25] Sexual freedom was more often than not a part of this culture of the body. Like the experience of nudity within nature, open expressions of sexuality and eroticism were seen to be tapping the more instinctive needs of the individual. Thus many of the Moritzburg sketches and paintings show naked couples, often in erotic poses (Plate 60). The theme of the naked couple and the frequent inclusion of male nudes, often with their sexual organs clearly displayed, did not conform to some of the historical conventions for the bathers theme. Moreover the sexual implications would have been read by some as a defiant refusal of contemporary bourgeois sexual mores.

The *Bathers at Moritzburg* was probably intended as a companion piece to the *Bathers in a Room*. It is identical in size (151 x 199cm), and was repainted around the same time. Given these dimensions, it is reasonable to presume that both works were intended as 'modern' statements on a grand scale. The tension between the epic pretensions of such

[25] I am indebted to the research of Paul Reece whose (largely unpublished) work charts the relationship between the Brücke group and local nudist groups in Dresden. See 'Edith Buckley, Ada Nolde and die Brücke: Bathing, Health and Art in Dresden 1906–1911', *German Expressionism in the UK and Ireland*, edited by B. Keith Smith. Jill Lloyd's *German Expressionism: Primitivism and Modernity* also discusses some of these associations (see especially Chapter 7, pp.102–29).

Plate 76 Dr Lahmann's sanatorium, Dresden Weisser Hirsch (Dresden Rest Hall), *c.*1910, postcard. Collection Paul Reece.

large scale canvases, and the unconventional reworkings of the bathers theme evident in each canvas, is still accessible to a modern audience. Although the Moritzburg work is out of doors, the crude distortions, the use of greenish skin colour (perhaps intended as a literal association with the green of nature?) and the combination of full frontal male and female nudity do not fit even with Cézannesque conventions for the bathers theme, which were then regarded in France and Germany as progressive interpretations of the subject. The technical distortions and angularities, the crowding of figures to the left of the canvas, seem, moreover, to undermine the pastoral associations which are sustained in, for example, many of Matisse's reworkings of the theme.

Brücke primitivism, then, could be double edged. The interpretations of the imagery of bathers which recur in pre-war painted and graphic work by the group, seem to reinforce the nature–culture opposition central to contemporary Expressionist theory. On the other hand, I have suggested that, in Kirchner's work in particular, some of the pictorial conventions associated with the representation of woman in nature are critically analysed – or at least reworked – and take on different meanings. Kirchner's deliberate combination of the sophisticated and urban with 'primitive' and tribal imagery, of female and male nudity, contribute to this reworking of conventions. In some of the paintings discussed I suggested that the use of technical distortions, spatial confusion, and the play on conventions for the representation of the nude, contribute to a pictorial ambivalence, focusing our attention both on issues of pictorial representation, and on the modern associations of a supposedly 'primitive' subject-matter.

Conclusion

We have seen how in French and German art of the pre-war period the theory and production of primitivist art was inflected with notions of the 'decorative', 'expressive' and the 'authentic'. All were value-laden concepts frequently used to discriminate in favour of a supposedly modern art. Whatever their cultural and artistic sources, such concepts were also underscored by a privileging of the artist's role and status, whether as 'savage', as creative individual championing artistic freedoms, as instinctive communicator of feeling, or as spiritually endowed Symbolist painter. You will recall that Gauguin, like many Expressionist artists, saw his avant-garde role as involving a rediscovery of innate expressive powers. And we saw that various technical devices, such as formal distortions and simplifications, and exaggerated or non-natural colour, are often read (and intended) as evidence of these expressive powers, as 'primitive' equivalents. The perceived 'originality' of the work is thus directly attributed to the special powers of the artist.

'Originality' is a central concept within much Expressionist theory, and within Modernist writing in general. Many concepts of twentieth-century avant-gardism draw on an evaluative concept of 'originality', according to which a work is deemed original if it includes novel features which are seen to be qualitatively different from previous or existing art. This takes me back to points raised in the introduction to this essay. If the 'primitive' was to be developed as a *critical* concept in modern art theory and practice, it could not be seen merely to *inspire* the modern artist, to provide imagery to be simply borrowed or plagiarized. To have some claim to 'originality', it must also be being produced from *within* modern art. Hence the privileging of the artist's role. According to this view, the truly modern artist (for example, the 'savage' described by Gauguin) was not merely being inspired, but exploiting his (occasionally her) deeper creative instincts. Even in the 1984 MOMA catalogue cited in the introduction, William Rubin writes that what Picasso 'recognized in those [primitive] sculptures was ultimately a part of himself, of his own psyche'. But we have seen that such an emphasis on the artist's subjective urges as the source of meaning for paintings rests on untestable assumptions. What, if anything, can be salvaged from this concept of 'originality' underpinning various forms of primitivism?

It is indisputable that references to the 'primitive' in the work of many modern artists were intended as a critique of certain artistic conventions, and of the values they were seen to embody. Thus the violently distorted forms of Picasso's *Demoiselles d'Avignon* could be interpreted as effecting a break with dominant systems for the representation of three-dimensional space and the female body, as a rejection of some of the conventions of bourgeois art. Of course, with the benefit of hindsight and historical study we can see that the borrowings which encouraged such 'innovations' were informed (to a greater or lesser degree) by the gendered discourses of colonialism. But this is not necessarily to undermine the *relative* radicalism of the work. Within specific artistic and historical contexts, references to alien sources and cultures could, on occasion, have a critical edge. As we saw in the discussion of several works by Kirchner, references to 'primitive' objects or culture could be used to undermine both the artistic conventions associated with certain themes or genres of painting, and the value systems with which they were connected. But this critical potential is effectively undermined if we seek to explain the works in terms of the artist recognizing the 'primitive' 'in his own psyche'. This is to fall back on the idea of the superior powers of the individual artist, to ignore some of the pictorial and cultural contradictions which had to be addressed if a modern artist was to represent a 'primitive' subject, or construct a 'primitive' style.

References

ALLOULA, M., *The Colonial Harem*, Manchester, Manchester University Press, 1986.

APOLLINAIRE, G., *Chroniques d'art, 1902–1918*, ed. L.C. Breunig, Paris, Gallimard, 1960.

BENJAMIN, R., 'Matisse's *Notes of a Painter*: criticism, theory and context 1891–1908', Ann Arbor, Michigan, UMI Research Press, 1987.

BENJAMIN, R., 'Fauves in the landscape of criticism: metaphor and scandal at the Salon', in *The Fauve Landscape*, exhibition catalogue, Royal Academy, 1991.

BLOCH, E., 'Discussing Expressionism', in R. Taylor (ed.), *Aesthetics and Politics*, New Left Books, London, 1977 (first published in *Das Wort*, 1938).

BRADLEY, W., *Emil Nolde and German Expressionism: A Prophet in his own Land*, Ann Arbor, Michigan, UMI Research Press, 1986.

BROUDE, N., *World Impressionism: The International Movement*, New York, H.N. Abrams, 1990.

BURGARD, T.A., 'Picasso and appropriation', *The Art Bulletin*, vol. LXXII, no.3, September 1991 (pp.415–30)

CHASSÉ, C., *Les Fauves et leur temps*, Paris, 1960.

CHIPP, H.B., *Theories of Modern Art*, Berkeley, University of California Press, 1968.

CRESPELLE, J.P., *Les Fauves*, Paris, 1962.

DANIELLSON, B., *Gauguin in the South Seas*, London, Allen and Unwin, 1965.

DENIS, M., 'From Gauguin and Van Gogh to Classicism' in Frascina and Harrison (eds) *Modern Art and Modernism* (first published in *L'Occident*, Paris, 1909).

DORRA, H., 'Le "Texte Wagner" de Gauguin', *Bulletin de la Societé de l'histoire de l'art français*, Paris, 1984.

ELDERFIELD, J., *The 'Wild Beasts': Fauvism and its Affinities*, exhibition catalogue, New York, Museum of Modern Art, 1976.

Équivoques: Peintures françaises du XIXe siècle, exhibition catalogue, Paris, Musée des Arts Décoratifs, 1973.

FLAM, J., *Matisse on Art*, Oxford, Phaidon, 1973.

FLAM, J.,'The spell of the primitive: in Africa and Oceania artists found a new vocabulary', *Connoisseur*, 214, September 1984.

FOSTER, H., 'The expressive fallacy and the "primitive" unconscious of modern art, or White skin, black masks', in *Recodings*, Seattle, Washington, Bay Press, 1985.

FOUCAULT, M., *The Archeology of Knowledge*, London, Tavistock, 1982.

FOUCAULT, M., *Discipline and Punish: The Birth of the Prison*, New York, Random House, 1979; first published as *Surveiller et Punir*, 1975.

FRASCINA, F. and HARRISON, C. (eds), *Modern Art and Modernism*, London, Harpers & Row in association with The Open University, 1982.

GAUGUIN, P., *Noa Noa*, 1893; a version of the manuscript in the collection of J. Paul Getty, edited by P. Petit, was published in Paris, 1988.

GAUGUIN, P., *Diverses Choses*, 1896–97, manuscript in the collection of the Musée d'Orsay, Paris.

Gauguin, exhibition catalogue, Paris, Grand Palais, 1989.

Gauguin and the School of Pont-Aven, exhibition catalogue, London, Royal Academy of Arts, 1989.

German Art in the Twentieth Century: Painting and Sculpture 1907–1985, exhibition catalogue, London, Royal Academy of Arts, 1990.

GIDE, A., *The Immoralist*, translated by D. Bussy, London, Penguin, 1970; first published as *L'Immoraliste*, Paris, 1902.

GOLDWATER, R., *Primitivism in Modern Art*, New York, Vintage, 1967 (first published 1938).

GORDON, D., *Expressionism: Art and Idea*, New Haven and London, Yale University Press, 1987.

GORDON, D., *Ernst Ludwig Kircher*, Harvard, Harvard University Press, 1968.

GORDON, D., 'Content by contradiction', *Art in America*, December 1982 (pp.76–89).

GORDON, D., 'On the origin of the word "Expressionism"', *Journal of the Warburg and Courtauld Institutes*, no.29, 1966, pp.368–85.

GREENBERG, C., 'Modernist Painting' (first published in 1961), Frascina and Harrison (eds), *Modern Art and Modernism*; reprinted in Harrison and Wood (eds), *Art in Theory 1900–1990*.

GREENBERG, C., 'Influences of Matisse', *Art International*, 17 November 1973.

HARRISON, C. and WOOD, P. (eds), *Art in Theory 1900–1990*, Oxford, Blackwells, 1992.

HILLER, S., (ed.), *The Myth of Primitivism: Perspectives on Art*, London and New York, Routledge, 1990.

JACOBS, M., *The Good and Simple Life*, Oxford, Phaidon,1985.

JAWORSKA, W., *Gauguin and the Pont-Aven School*, London, Thames and Hudson, 1972.

JORDANOVA, L., *Sexual Visions: Images of Gender in Science and Medicine between the Eighteenth and Twentieth Centuries*, London, Harvester, 1989.

KAUFMANN, W. (ed.), *The Portable Nietzsche*, New York, Viking, 1968.

KUSPIT, D., *Clement Greenberg, Art Critic*, London, University of Wisconsin Press, 1979.

LANGBEHN, J., *Rembrandt als Erzieher*, Leipzig, 1890.

LAUDE, J., *La Peinture française et 'l'Art nègre' 1905–14*, Paris, 1968.

LEE, J., *Derain*, Phaidon, Oxford, 1990.

LEIGHTEN, P., 'The white peril and *l'art nègre*: Picasso, primitivism, and anti-colonialism', *The Art Bulletin*, vol. LXXII, no. 4, December 1990 (pp.609–630).

LLOYD, J., *German Expressionism: Primitivism and Modernity*, New Haven and London, Yale, 1991.

MALINGUE, M. (ed.), *Lettres de Gauguin à sa femme et à ses amis*, Paris, 1946.

MATISSE, H., 'Notes of a Painter', first published in 1908; extracts in H.B. Chipp (ed.) *Theories of Modern Art*, Berkeley, University of California Press, 1968; an edited version is reprinted in Harrison and Wood (eds), *Art in Theory 1900–1990*.

MOSSE, G., *The Crisis of German Ideology: Intellectual Origins of the Third Reich*, New York, Grosset and Dunlap, 1964.

NEWMAN, M., '"Primitivism" and modern art', *Art Monthly*, May, 1985.

THE OPEN UNIVERSITY , A315, *Modern Art and Modernism*, Block 5, 'Cubism, Picasso and Braque', Milton Keynes, The Open University Press, 1983.

OPPLER, E.C., *Fauvism Re-examined*, New York, Garland, 1976.

ORWICZ, M., 'Criticism and representations of Brittany in the early Third Republic', *Art Journal*, vol.46, no.4, 1987.

OSTERHOLZ, L., *Worpswede 1889–1989: Hundert Jahre Kunstlerkolonie*, Worpswede, Worpsweder Verlag, 1989.

PARET, P., *The Berlin Secession: Modernism and its Enemies in Imperial Germany*, Harvard, Belknap, 1980.

PERRY, G., '"The ascent to nature": some metaphors of "nature" in early Expressionist art', in *Reassessing Expressionism*, Manchester, Manchester University Press, 1993.

PERRY, G., *Paula Modersohn-Becker: Her Life and Work*, London, The Women's Press, 1979.

POLLOCK, G. and ORTON, F., 'Les Données bretonnantes: la prairie de la représentation', *Art History*, vol.3, no.3, September 1980.

Post-Impressionism, exhibition catalogue, London, Royal Academy of Arts, 1979–80.

REECE, P., 'Edith Buckley, Ada Nolde and die Brücke: bathing, health and art in Dresden 1906–11', in B. Keith Smith (ed.), *German Expressionism in the UK and Ireland*, Bristol, University of Bristol Press, 1985.

REINHARDT, G., *Die frühe Brücke*, exhibition catalogue, Berlin, Brücke Museum, 1977–78.

REWALD, J., (ed.), *Camille Pissarro: Lettres à son fils Lucien*, Paris, 1950.

RILKE, R.M., *Worpsweder: Monographie einer Landschaft und Ihrer Maler*, Bremen, Carl Schunemann Verlag, 1970.

RUBIN, W. (ed.), *'Primitivism' in Twentieth-Century Art: Affinity of the Tribal and the Modern*, exhibition catalogue, MOMA, New York, 1984.

SAID, E., *Orientalism*, London, Penguin, 1978; extract in F. Frascina and J. Harris (eds), *Art In Modern Culture: An Anthology of Critical Texts*, London, Phaidon, 1992, pp.134–42.

SEGALEN, V., *Essai sur l'exotisme: une esthétique du divers*, Paris, Livre de Poche, 1978.

SELZ, P., *German Expressionist Painting*, Berkeley, University of California Press, 1974.

STEVENS, M.A. and DORA, R., *Émile Bernard 1868–1941: A Pioneer of Modern Art*, Stadtische Kunsthalle, Mannheim, 1990.

VARNEDOE, K., 'Gauguin', in Rubin (ed.) *'Primitivism' in Twentieth-Century Art.*

VLAMINCK, M., *Dangerous Corner* (translated by M. Ross), London, Elek, 1961; first published as *Tournant dangereux: souvenirs de ma vie*, Paris, 1929.

WERENSKIOLD, M., *The Concept of Expressionism: Origin and Metamorphosis*, translated by R. Walford, Oslo, Universitetsforlaget, 1984.

WHITFIELD, S., *Fauvism*, London, Thames and Hudson, 1991.

WIETEK, G., *Deutsche Künstlerkolonie und Künstlerorte*, Munich, Verlag Carl Thiemig, 1976.

WOLLEN, P., 'Fashion, Orientalism, the body', *New Formations 1*, Spring 1987, p.533.

Worpswede: Aus der Frühzeit der Kolonie, exhibition catalogue, Kunsthalle Bremen, 1970.

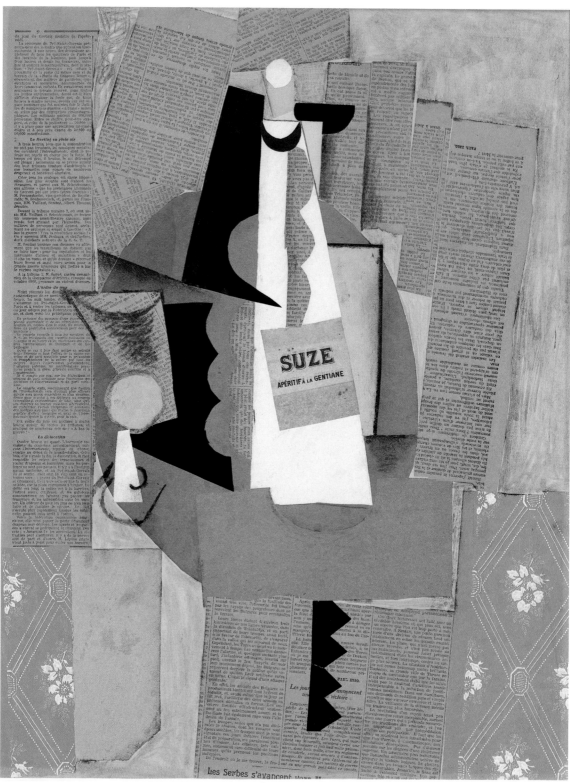

Plate 77 Pablo Picasso, *La Suze* (*Glass and Bottle of Suze*), November 1912, pasted papers, gouache, and charcoal on paper, 65 x 81 cm. Washington University Gallery of Art, St. Louis. © DACS 1993.

CHAPTER 2
REALISM AND IDEOLOGY: AN INTRODUCTION TO SEMIOTICS AND CUBISM

by Francis Frascina

Introduction

Raising questions

Between the autumn of 1912 and spring 1913, Pablo Picasso and Georges Braque produced a series of works that raised several questions about the status of the art object. Some of these, like *La Suze* and *Still-life 'Au Bon Marché'* (Plates 77 and 78), are made out of 'scrap' materials, such as newspaper, labels and cardboard. Words, letters and typeface are also constituent parts. As these works could not be categorized as conventional art objects, a 'new' category was coined: *papiers collés*, 'pasted papers', or 'collages'.

In conventional artistic terms the materials were worthless items of a kind often associated with 'mass culture'. References to 'mass culture' in avant-garde art were not new. In the nineteenth century, artists from Courbet and Manet onwards had engaged with a wide range of sources, especially in so far as they were indebted to Baudelairean notions of 'modernity'; mostly though, they worked in the media of 'high' art, such as oil on canvas. While many of Picasso's and Braque's Cubist paintings of this time included references to contemporary 'mass culture', and were thus within the tradition of such an engagement, their collages introduced a new dimension by the use of common everyday materials, like newspaper and advertisements, usually extraneous to 'high art'. The accepted criteria for artistic media were being questioned if not revised. So too, it seemed, were conventional notions of 'representation'.

If we consider the ostensible genre of many of the collages, the still-life, the relationship between the material 'art' object and the viewer is different from that established by the traditional still-life, say, Chardin's *Rayfish* (Plate 79). The 'form' of the art object is different: actual collaged elements replace the illusionism of oil on canvas. In the Chardin, resemblance to the depicted objects – a jug, a cat, a rayfish – is accorded a high priority. The painting offers a paradigm of representation in which the image could be read by spectators used to the conventions associated with resemblance to 'things' in the world. An image with a high degree of illusionistic likeness to, or identity with, the world of 'things' is often referred to as *iconic*. Examples of the iconic from other systems of representation are the *straight* line on a map signifying '*straight* road' by virtue of a shared property, or the curve on a traffic sign, signifying 'bend in the road'.

Chardin's painted marks and shapes signify specific objects. But just as a 'curve' on a traffic-sign signifies not only 'bend in the road', but also 'potentially dangerous', so too *The Rayfish* conveys a particular meaning within a set of conventions. Traditionally, many still-life paintings were *symbolic* compositions designed to signify *vanitas* (the emptiness of

Plate 78 Pablo Picasso, *Nature morte 'Au Bon Marché'* (*Still-life 'Au Bon Marché'*), spring 1913, oil and pasted paper on cardboard, 24 x 36 cm. Ludwig Collection, Aachen. © DACS 1993.

possessions and the frailty of human life). Often this was indicated by a skull as a symbol linked by convention to 'death', a *memento mori* reminding us that we must die. Here, a similar symbolic meaning is signified by the gutted rayfish with its mocking grin. There is also a sexual significance. The gonads of the rayfish extend nearly the full length of the body trunk – such is the explicitness of its sexual organs, that it was frequently displayed in the rear of fishmongers' shops on grounds of moral decorum. To the right of the composition are marks signifying a particular type of jug, which is also a traditional symbol of the uterus (when broken or cracked it signified loss of virginity), and on the left a cat is depicted, with its hackles raised as a symbol of licentiousness. The relationship between these elements within an illusionistic composition evokes *vanitas* and signifies the supposed emptiness of venal passion; these ideas are rooted in Dutch and Flemish secular symbolism and in bourgeois ideals and values.[1] It's clear, therefore, that paintings like *The Rayfish* can be read in iconic ('jug', 'cat', 'rayfish') and symbolic (*vanitas*, sexual desire) terms. In fact, there is a powerful relationship between both readings.

Let's consider a work in the same genre, this time by a modernist artist with whom Picasso's Cubism is often associated. At first sight, Cézanne's *Still-life with Plaster Cast of Amour* (Plate 80) appears to be concerned with resemblance, with the iconic, in the same way as Chardin's painting is. *The Rayfish*, however, has a higher degree of painterly 'finish' and a centralized perspectival viewpoint – qualities that, to many modernists, signified the Academic approach. Cézanne's painting is characterized by paradoxes of viewpoint and pictorial scale: consider the effect of the similar scale given to both the round object in the 'background', and the apples and onions on the table, supporting the

[1] See E. Snoep-Reitsma, 'Chardin and the bourgeois ideals of his time'.

Plate 79 Jean-Baptiste-Siméon Chardin, *La Raie* (*The Rayfish*), 1728, oil on canvas, 114 x 146 cm. Musée du Louvre, Paris. Photo: Réunion des Musées Nationaux Documentation Photographique.

plaster figure. These depicted objects, too, can be read symbolically: the plaster cast of the seventeenth-century sculptor Puget's *Amour,* for instance, as a symbol of the 'god of love'. The art historian Meyer Schapiro has shown, too, that apples were associated in Classical poetry and images with an offering of love and were used as a metaphor for women's breasts. In the Cézanne 'the apples are grouped with onions – contrasted forms as well as savours, that suggest the polarity of the sexes' ('The apples of Cézanne', p.11).

Despite significant differences, the Chardin and Cézanne paintings adhere to a paradigm of resemblance and maintain a relationship between the iconic and symbolic which Picasso's Cubist collages do not. If the former are regarded as exemplary works, it's clear why many doubted whether the collages counted as 'art' at all. However, there is an approach to representation which can shed light on all these works. By examining this approach, which considers the *way* that meaning is conveyed in images and the role of the viewer in this process, we should be able to assess whether collage was some sort of *critique* of the kind of 'art' object represented by the Cézanne or the Chardin. We have already begun to use the terminology of this approach, which is based on the relationship between *sign*, *signifier* and *signified*.

Plate 80 Paul Cézanne, *Nature morte avec l'Amour en pâtre (Still-life with Plaster Cast of Amour)*, *c*.1895, paper mounted on panel, 70 x 57 cm. Courtauld Institute Galleries, London.

A visual *signifier* can be both the material object itself and the material marks and shapes upon its surface. In the Chardin, it's the oil painting itself and the painted marks which constitute the depictions of individual objects and things, as well as the relationship between these depictions, such as between jug, cat and rayfish. In the Picassos, it's not only the individual elements, the cut-out advertisement, the newspaper and schematic pencil lines, but also the relationship between these elements that constitutes a whole collage. The *signified* is the meaning, what the signifier stands for. In the Chardin the signified is both iconic (paint and shapes signifying a type of 'jug', etc.) and symbolic ('jug' signifying uterus). Thus the signified is (i) 'a collection of objects', (ii) their individual symbolism and – more importantly – (iii) the effect of their combination, the particular moral and social meaning of the whole picture. While we can distinguish between signifier and signified for the process of analysis, in practice they act together, they are materially inseparable. *Together* they constitute the *sign* as a whole, which has a particular meaning for an audience or community. In Chardin's painting as a *sign*, a moral symbolic message is read *at the same time* as the iconic resemblance, as though the moral message is as 'natural' as the depicted objects. This raises the question of its audience, the class and gender of its community of 'readers', a question also relevant to Cézanne's and Picasso's works as 'signs'.

Analysis in terms of signs, signifiers and signifieds is known as *semiotics*. This form of analysis has been applied to language and works of literature as well as to visual representations such as paintings, films and advertisements. Through semiotics, theorists in different areas of culture have had (and still do have) much to say of significance to each other. In exploring semiotics and assessing its potential for 'decoding' Cubist works, we will consider whether visual representation in general can usefully be analysed as a system of codes and assess the sort of social and cultural values encoded in such signifying systems.

Introductory readings of two Cubist collages

La Suze

The materials used in this collage are clearly identifiable. In the centre is a label from a bottle of the common aperitif, Suze; at bottom left and right the same wallpaper is used as in *Guitar, Sheet Music and Glass* (Plate 81); there are various cut-out pieces of coloured paper, notably the blue oval in the middle and printed columns cut from newspaper. All

Plate 81 Pablo Picasso, *Guitare, feuille de musique et verre* (*Guitar, Sheet-music and Wineglass*), autumn 1912, pasted papers, gouache and charcoal on paper, 48 x 37 cm. Marion Koogler-McNay Art Museum; bequest of Marion Koogler-McNay 1950.112. Photo: Michael Smith. © DACS 1993.

these elements have been glued to a paper base with the addition of charcoal drawing and gouache paint.

We cannot rely on a likeness to a 'glass' or a 'bottle', the objects mentioned in the title. Rather we infer 'bottle' by identifying an actual label as *part* of the object, which is pictorially constructed by the tapering, almost triangular, white shape, the curve of the top of the bottle's neck and its 'stopper'. We can infer a *whole* bottle from a contiguity between its depicted parts. The 'glass' too, to the left, is highly schematic. Such pictorial shapes (which are signifiers) and the use of newspaper and charcoal (also signifiers) relate the pictorial *sign* for a glass to the actual object by bonds of Cubist convention, established in Cubist paintings. Once we 'identify' a glass, we might go on to infer that the blue oval is a round table top in elliptical perspective.

But what of the newspaper? In three places it is used as part of the sign for 'glass' (its upper section) and part of the sign for 'bottle' (its fluted shape), but elsewhere it's used cut into columns. Here, it seems to signify different things: perhaps a pictorial 'texture' and tone; perhaps shallow space, particularly where shading is added, or where the type goes in different directions; possibly a table-cloth at the bottom falling from the edge of the blue 'table'; perhaps the refraction of light through a glass, indicated by a change in the direction of the typeface. It can, of course also be literally *read* – reading the newsprint is an activity with which any half-curious spectator might engage.[2] These extracts are from a specific newspaper, *Le Journal*, dated 18 November 1912 (Plate 82). Picasso cut pieces from the front page and page two, all with references to the Balkan War. There are war reports by Paul Erio, dated 12 and 17 November, and by Henri Barbi, dated 16 November. Several extracts from the latter are pasted across the top, detailing the Serbian advance toward Monastir in Macedonia. Here we can read about the wounded, about battle movements, and the threat of famine in besieged Adrianople. On the far right, pasted *upside down* is Paul Erio's account of a devastating cholera epidemic – an effect of inhuman war conditions – which had killed thousands of Turkish soldiers.

The gruesome account of death and the automaton response of marching soldiers is counterposed on the far left by the column containing a very different report, pasted the right way up. Next to it, the shading schematically signifying 'glass' is underneath a curve for its rim and a sharp angle signifying both the meeting of side and rim, and an 'arrow' pointing to a sub-heading '*L'ordre du jour*' ('the day's agenda') half way down the column. The report is the continuation of one started at the bottom right of the front page of *Le Journal*. In contrast to the report of a furious battle, this details 'The Meeting at Pré-Saint-Gervais Against the War', and illustrates a very different crowd, a demonstration of '40,000–50,000' pacifists, syndicalists, trade unionists and socialists, which took place on the afternoon of 17 November, in a working-class community near Belleville, in the nineteenth *arrondissement* of Paris. It describes the numerous chantings of 'down with war', 'long live the social revolution' and several speeches including one by the Socialist Deputy Sembat, who ended 'asserting that workers ought not kill "for capitalists and manufacturers of arms and munitions" ... they must "conserve their forces and also their arms for the great interior war which will bring down the capitalist regime"'.

[2] Art historians began to do this in the 1960s. See, for example, the unpublished M.A. thesis by J. Charlat Murray, *Picasso's Use of Newspaper Clippings in his Early Collages* and R. Rosenblum, 'Picasso and the typography of Cubism'. The following discussion of the *Suze* collage is based on a close examination of the work itself and an elaboration of readings to be found in P. Daix and J. Rosselet, *Picasso: The Cubist Years 1907–16*, p.289; The Open University, A315 *Cubism: Picasso and Braque*, pp. 75–6 (written for the course team by F. Frascina); R. Cranshaw, 'Notes on Cubism, war and labour', p.3; P. Leighten, 'Picasso's collages and the threat of war 1912–13', p.665, and her *Re-Ordering the Universe: Picasso and Anarchism, 1897–1914*, pp.126–7.

PETIT PARIS. — CINQ CENTIMES
FILS SPÉCIAUX : LONDRES, BERLIN
AGENCE DE LONDRES : 190, FLEET STREET, E. C.
AGENCE DE BERLIN : 59 et 60, Friedrichstrasse
LE JOURNAL, 100, RUE DE RICHELIEU, PARIS
Téléphone, 3 lignes : 101-63, 101-65, 101-67
Adresse télégraphique : JALJOUR-PARIS

LE JOURNAL

F. XAU, Fondateur.

ABONNEMENTS
SEINE & SEINE-ET-OISE
FRANCE & COLONIES

Un Cortège de Cholériques

UN AFFREUX CHARNIER

L'ENVOYÉ SPÉCIAL DU "JOURNAL" aux Avant-Postes Turcs

PAUL ERIO.

Les journaux turcs annoncent une grande victoire

Les Serbes s'avancent vers Monastir

HENRY BARBY.

LA BATAILLE S'EST ENGAGÉE FURIEUSE
sur les Lignes de Tchataldja

UNE SOUDAINE OFFENSIVE DES BULGARES EST VIGOUREUSEMENT REPOUSSÉE

Monastir est serrée de près par les Serbes et les Grecs

UN CAMP SERBE SUR UNE HAUTEUR DEVANT MONASTIR (Photo de notre envoyé spécial Henry BARBY)

LA SITUATION

PAUL ERIO.

SAINT-BRICE.

Pourquoi l'Horloger a-t-il coupé le cou à sa Femme?

Le Meurtrier

Deux cris dans la nuit

ÉCHOS

"LE BOUCHON DE CRISTAL"

Le Meeting du Pré-Saint-Gervais contre la Guerre

Au retour, une Bagarre s'est produite, place du Combat, entre Anarchistes et Agents

Un coin du meeting du Pré-Saint-Gervais

Plate 82 *Le Journal*, 18 November 1912, whole of front page. Bibliothèque Nationale.

The use of text does not end there. While Picasso might have chosen for the 'bottle' a 'Bass' label or one from *Vieux Marc* (a kind of brandy), as he did in other works, in this one he placed *Suze* at the centre of the collage. As the label makes clear, this is an aperitif made from the herb gentian, often used at a tonic and stomachic. But it signifies more than this. The herb was named after Gentius, an Illyrian king of the second century before Christ, who is said to have discovered the herb's virtues. Illyria, the centre of Slavic languages, was on the eastern shore of the Adriatic, precisely the area which, at the time of Picasso's collage, made up the Balkan League (an alliance of Bulgaria, Serbia, Greece and Montenegro which fought the first Balkan War against Turkey, from 1912 to 1913). In the process of selecting, cutting and combining pieces of paper, Picasso alludes to contemporary political and moral issues in a form which suggests the custom or ritual of café talk, references and connections understood by a particular social group.

I'm suggesting that this work signifies in a social way. Artists, like other individuals, relate and react to each other and the material world through forms of social intercourse. This is the basis and source of their 'consciousness', their active awareness and engagement with the forces and relations in society, as they are manifested in representations – political, juridical, philosophical, religious, literary, artistic, etc. The means of communication and visual systems – the forms of intercourse – with which they engage, including visual ones (art, newspapers, adverts, books, rituals, etc.) correspond to particular forms of social organization and are necessary to their existence. For instance, mass advertising is a product of a market-driven economic system which can exploit modern technology. Advertisements seek to sell products and values by feeding on and establishing desires, expectations and consumerism. Words and images often encode past and present values to ensure the maintenance not only of the economic system but also of the values and beliefs which encourage a passive consumer audience.

The above assumptions about society and meaning derive from Marx and Engels. They often described 'ideology' as those ideas, values and beliefs about society and social life that we (wrongly) take for granted. They sometimes treated ideology as an *inversion* of the reality of social relations. In this explanation, inequalities in the distribution of power, goods and wealth in society, between classes, ethnic groups and genders, are sustained by dominant groups – ruling classes. Dominant groups construct 'representations' of the real world (i.e. descriptions, which might be encoded in law, or literature, as much as in images) that maintain the interests of their power by making these inequalities seem somehow 'natural'. Two examples might be the representation of the working class as a dangerous rabble or as grateful recipients of 'aristocratic' wealth and value; of women as idealized sexual objects or as maternal domestics. In both cases, power over others is invested in particular inheritors. Marxists claim that such a process is an 'inversion' of the truth of real relations:

> If in all ideology men [sic] and their relations appear upside down as in a *camera obscura*, this phenomenon arises just as much from their historical life-process as the inversion of objects on the retina does from physical life-process.
>
> (*The German Ideology*, p.42)

One traditional way to signal a resistance to the effects of domination is to represent the 'world turned upside down'; to signal ideology as 'false consciousness', as an inversion or refraction of 'truth'. Representing the world as 'upside down' is also an anarchist strategy and one that Picasso would have known from his familiarity with anarchist groups. In this collage, several of the newspaper cuttings of the horror of the Balkan war, seen by many at the time and since as serving the interests and power of capitalism and imperialism, are inverted. This inversion is, as we have seen, in contrast to the report of the pacifist demonstration pasted the right way up for reading and indicated by the 'arrow/glass'.

Clearly, Picasso's selection and use of newspaper, wasn't arbitrary. Nor was his use of the Suze label as a signifier both of 'an aperitif', with all its social connotations, and of 'the Balkans' with all its socio-political significance. Importantly, too, not only may parts of the collage act as signifiers but also the particular *relationships* between them, as with the case of inversion, is crucial for an understanding of what is signified by the work as a whole.

Some important questions arise here. Is the way that we 'read' Picasso's collage distinctly different from the way that we 'read' the Chardin or Cézanne examples; and what does this tell us about the signifying systems in which they worked? Was *Still-life with Bottle of Suze* a 'one-off' or are there other examples which reveal a similar complexity of potential 'signs' and a particular structural relationship between them? The first question is a larger one for the chapter as whole, but the second can be considered by looking at another collage, *Still Life 'Au Bon Marché'* (Plate 78).

Still-life 'Au Bon Marché'

We can see Cubist 'signs' for a glass, on the right, and for a decanter, on the left, with what appears to be a labelled box in the centre. Many of the other elements refer to the work's specific contemporary context. One is the small newspaper cutting, underneath the 'decanter', which is of a dispatch from Constantinople, giving an account of the assassination of the Minister Nazim Pasha on 23 January, 1913 – another Balkan War reference. A second example is the centrally placed label from the Au Bon Marché department store in Paris, which not only signifies the contemporary merchandise of such a modern institution, but also serves to play 'games' with the relationship of perceiver to perceived, and with notions of 'the real' and of 'illusion'. The real label is positioned illusionistically so as to appear to recede like the top of a box, with a patterned front and one side in shadow. Yet the same patterned paper is used throughout the work to suggest a vertical pictorial plane. This contradicts the illusion by prompting the viewer to read the label as another vertical plane.

Above the *Au Bon Marché* label there is an extract from page nine of *Le Journal*, dated 25 January 1913 (Plate 83). It is cut so that selected parts of three *different* advertisements are combined to form a new and particular relationship in the collage. The first is the top left-hand corner of an illustrated advertisement for a lingerie sale at Samaritaine, another Parisian department store. Above it is the bottom-right part of an advertisement for a typewriter, the 'Torpedo', advertised in *Le Journal* as a 'MACHINE FOR MODERN WRITING'. And to its right, the left-hand side of an advertisement for 'MASSAGE', 'medical' and 'aesthetic'.

In addition to combining these advertisements, Picasso alters some. He has painted over areas of the one for a lingerie sale, leaving just the upper torso of the woman, the price '2 francs 85 centimes' and the letters SAMA. The latter could signify a part of the word SAMA[RITAINE], which the viewer is expected to complete. Picasso often used nicknames, for instance, '*Ma Jolie*' ('my pretty one', for the woman he lived with) is inscribed in many of his works at this time. Is SAMA also a nickname for a person or for the department store, or some private pun? Right at the top he has cut off the 'A' of '*agents*', so the letters now read '*gents*'. '*Gent*' means 'tribe' or 'race'; at this time it was still used humorously to refer to women, after the manner of La Fontaine, the seventeenth-century writer of fables and verses (often licentious ones) – '*gent féminine*' means 'the fair sex'. In the *context* of the other words and the image of the woman advertising lingerie, the words '*gents sérieux demandés Partout*' could be read 'serious women (the 'fair sex') needed everywhere'. If so, it wouldn't have been the first time Picasso expected viewers to enter into word play, to complete sexual 'jokes' or to notice innuendoes in his works.

Plate 83 *Le Journal*, 25 January 1913, page 9 (top half of page). Bibliothèque Nationale.

The collage engages the viewer actively in other ways. Below the *Au Bon Marché* label, a patch of ripolin (commercial) paint appears to be a white gap, as does the 'glass' to the right with its gouged 'detailing'. But, like the 'glass', it is a *positive* textured shape, a fact contradicting the visual expectation of seeing the white as a gap or illusionistic 'hole' and contradicting also the words 'TROU' (hole) and 'ICI' (here), in black typeface. Further, the illusionistic effect of white on black (the letters SAMA) or black on white ('TROU', 'ICI') is an element of the 'language' of newspaper typography –this is another case of mixing signs from 'mass culture' with those from 'high art'.

Au Bon Marché: *'Reading' Cubism*

Picasso's collages play with existing conventions and invite speculation and debate. Is there a particular meaning to Picasso's use of words and texts; is one reference more likely than another? Do we just read the words emphasized in a literal way or is it appropriate to invoke either the original context of the news report, the advertisement or the label, or the *new* structural relationship between parts of the collage, the new 'text'? The original context is dislocated, transformed, worked over in the making of the collage; the new relationship produces various meanings in terms both of the conventions of 'high art' and the conventions of the original sources – the modern 'mass-produced' commodity.

One reading of the innovative combination of elements in *Au Bon Marché* is that they signify the powerful, consumption-orientated socialization of the department store. The decade after 1900 had seen important innovations – the Metro, telephones, electric light,

the cash register and the escalator – which facilitated shopping in the department store. The product range was wide, from the bicycle to the cinematograph; expensive individual objects or mass produced items could be bought, including the wallpaper, wrapping paper, decorator's wood-grain paper and oil-cloth used by Picasso and Braque in their collages. Bon Marché was the first department store to open in France (its cornerstone was laid in 1869). In 1912 it opened a major extension, and at the time of Picasso's collage it was enjoying its golden years. In 1910 it sold merchandise worth 227 million francs, while its nearest competitor, the Louvre store, sold about 152 million francs worth, and Samaritaine (founded in 1870), had a turnover of 110 million francs. It had its own illustration industry with catalogues, agendas and illustrated cards depicting adults and children. It provided a picture of the 'proper household, the correct attire, the bourgeois good life' and a vision of bourgeois culture, persuading middle-class people that this was the way they *should* live their lives in a modern society:

> The Bon Marché opened its doors to everyone, but most often it was the bourgeoisie who passed through them. A working-class clientele undoubtedly existed, but its numbers were limited by the cash-only policy ... There was, in fact, something distinctively *respectable* about the Bon Marché that could make it forbidding to those who lacked middle-class pretentions, let alone middle-class means. The store drew its tone from the quarter that enveloped it, one that was known for its affluence, its Catholic orders, and it *bienpensant* ways ...
> (M. Miller, *The Bon Marché*, pp.178–9)

Picasso's '*Au Bon Marché*', combines a 'SAMA[RITAINE]' sale advertisement with one for credit facilities over twenty months. The latter was actually for the 'Torpedo' typewriter, but in the context of the collage it apparently signifies the possibility of credit at Samaritaine. Yet it is the label for 'Lingerie, Broderie' from the cash-only Bon Marché store that accompanies it thus setting up a social and economic contrast.

A different reading of the collage centres around possible sexual punning and what may be signified by the image of the female. Edward Fry has claimed that:

> ... the scene may be understood as a café with a bottle and glass on a table. Seated behind the table is a woman of apparently easy virtue, whose head is indicated by a newspaper advertisement, body (conflated with the table) by a clothing store label and legs beneath the table by clippings with the pun 'LUN B TROU ICI'. The full pun thus read, 'AU BON MARCHÉ LUN B TROU ICI', which may be translated as 'One may make a hole here inexpensively'. This sexual, verbal and visual *double entendre* is also particularly notable for its nonillusionistic indication of pictorial depth and space relations ...
> ('Picasso, Cubism and reflexivity', p.301)

Christine Poggi, on the other hand, draws attention to irony and ambiguity, a difference which suggests that the collage as sign does not have a fixed private or public meaning. Allusions are made in the collage, she argues, to the 'promiscuity of the commodity' both by the materials used and by the references to department stores:

> ... Picasso constructs an image of the bourgeois female which ironically conforms to that of the mass media. She appears in this collage in her exemplary dual role as both consumer of goods and as object of desire, that is, as intimately involved in the world of commodities.
> ('Mallarmé, Picasso and the newspaper as commodity', p.140)

Poggi argues that Picasso may be making a private reference to the first pornographic novel, *Mirely, ou le petit trou pas cher* ('Mirely, or the inexpensive little hole'), of his friend Guillaume Appollinaire, a poet and critic who supported the Cubists, but that the erotic

allusions more probably refer to an obsessive contemporary fascination with, and low humour about, the sexuality of the department-store sales 'girls'. Writers fantasized that such 'naïve girls' might succumb to the depraved life of inner cities; some hinted that the girls were ready to seduce 'respectable' men, others protested that they 'could not be easily distinguished from the *bonne bourgeoise* and this threatened to lead to undesirable social and moral confusion' (Poggi, p.40). Picasso's inclusion of a glass and a decanter with a stopper may add to this reading in so far as such objects were read as gendered receptacles, like the breakable jug in *The Rayfish*. Does the patterned paper, signifying both background 'wallpaper' and decorated 'box', and the lingerie advertisement, establish this as a private feminine space? Depending upon the gender of the viewer is this a voyeuristic invasion of that space? Or, by contrast, do the wineglass and decanter evoke a more public café scene, with the sexual interchange suggested by Fry? A further reading might associate the gluing of a label and advertisements with billposting, with a public Parisian wall covered in posters, advertisements and announcements as photographed by Atget, or as in Picasso's *Landscape with Posters* (Plates 84, 85).

Plate 84 Eugène Atget, photograph of Rue St Jacques, Paris, 1906, Musée Carnavalet. Photo: Habouzit/Photothèque des Musées de la Ville du Paris © DACS 1993.

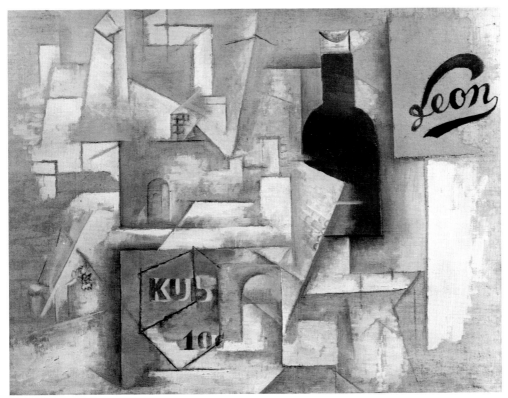

Plate 85 Pablo Picasso, *Le Paysage aux affiches* (*Landscape with Posters*), summer 1912, oil on canvas, 46 x 61 cm. National Museum of Art, Osaka. © DACS 1993.

Summing-up

One conclusion from this introductory discussion is that meaning is produced by viewers reading a painting in both iconic and symbolic terms. This is the case even when, like Chardin's *Rayfish*, it follows a paradigm of representation in which resemblance to objects is accorded a high priority. It might be argued that in the latter case viewers are expected to be relatively passive consumers of the ideas, values and beliefs conveyed – pictorial resemblance, after all, serves to naturalize the encoded ideological message and to dissemble the power relations on which it depends, usually those of gender (for example the assumed male viewer) and of class (*vanitas*, for example, was a bourgeois preoccupation rooted in the Protestant work ethic). Does Cubist collage serve as a critique of such a paradigm of representation? By confounding the expectation of resemblance, are viewers forced to become more self-reflexive? That is, to become aware not only of collage as a coded representation but also of the *relationship* between the codes and the viewer's process of 'reading'? In collage, this awareness is produced by the use of various 'materials' – literally (newspaper, labels, advertisements) and metaphorically (high art and mass culture, political debate, the modernity of Parisian social life). What does such a self-reflexive awareness reveal about the particular signifying systems, codes or 'languages' of different visual representations? What does this imply about the knowledge, social class and gender of viewers? These are problematic and contested questions, especially as they relate to the relationship between notions of realism and representation.

For some, such as Patricia Leighten and Christine Poggi, the collages are an avant-gardist assault on bourgeois notions of high culture. For those, such as Rosalind Krauss and Yves-Alain Bois, whose concern is the traditions of representation in Western art,

collage is akin to developments in semiotics, it is 'the first instance within the pictorial arts of anything like a systematic exploration of the conditions of representability entailed by the sign' (Krauss, 'In the name of Picasso', p.16).[3] What meanings are systematically encoded in Cubist collages? Are they fixed and ahistorical (like the lexical meanings of words) or variable and contingent on specific social and historical conditions?

Representation: language, signs, realism

As is commonly the case in the twentieth century, the status and dominant interpretation of Cubism was entrenched by exhibition, particularly by *Cubism and Abstract Art*, at the Museum of Modern Art (MOMA), New York, in the spring of 1936. In terms of curatorial validation and the production of a 'classic text' of interpretation, the exhibition and its accompanying catalogue represent a discernible shift in the discussion and display of modern art and its conventional history. Both were largely the work of Alfred H. Barr Junior, the first Director of the new and prestigious museum, which had been established in 1929 and was funded by the financial élite of East Coast capitalism. On the cover of Barr's guide and catalogue to the exhibition appeared a diagram of lines of influence in the development of Abstract Art (Plate 86).

Barr rightly draws attention to an important aspect of art in the early years of the twentieth century – its technical radicalism. It's easy to place, in chronological order, a Bouguereau, a Cézanne, a couple of Picasso's Cubist paintings and a Mondrian from just before the first World War (Plates 98, 101, 1, 114, 167) and posit a progressive abandonment of attempts to imitate natural appearance and a disengagement from 'descriptive' functions which leaves the 'language' of artistic representation concerned with the expressive possibilities of 'pictorial configurations' of colour, shape and line, and the artist's own compositional sensibility. Such a proposal would be consistent with Roger Fry's privileging of 'disinterested intensity of contemplation' ('An essay in aesthetics', 1909, p.32) and Clement Greenberg's notion of modern specialization in the production and the 'authentic' reception of *modern* works of art.[4] In such accounts, we encounter assumptions about the *language* of illusionistic representation and claims for the gradual refinement of the 'language', until, devoid of external visual associations and social and intellectual allusions, it reaches a state of 'purity' through 'self-criticism'. In this view, the technical and expressive potential of the *formal* elements of modern art are the most significant measure of their function as representations.

However, here we come across the mistaken distinction which many Modernists make between 'representational' or 'realistic' and abstract works of art, disputed by Schapiro in his critique of Barr's catalogue:

> The logical opposition of realistic and abstract art by which Barr explains the more recent change rests on two assumptions about the nature of painting, common in writing on abstract art – that representation is a passive mirroring of things and therefore essentially non-artistic, and that abstract art, on the other hand, is a purely aesthetic activity, unconditioned by objects and based on its own eternal laws … These views are thoroughly one-sided and rest on a mistaken idea of what a representation is. There is no passive, 'photographic' representation in the sense described … All renderings of objects, no matter how exact they seem, even photographs, proceed from values, methods and viewpoints which somehow shape the image and often determine its contents.
>
> ('Nature of abstract art', pp.85–6)

[3] For Yves-Alain Bois, see 'Kahnweiler's lesson'.

[4] Greenberg, 'The pasted paper revolution' and 'Modernist painting'.

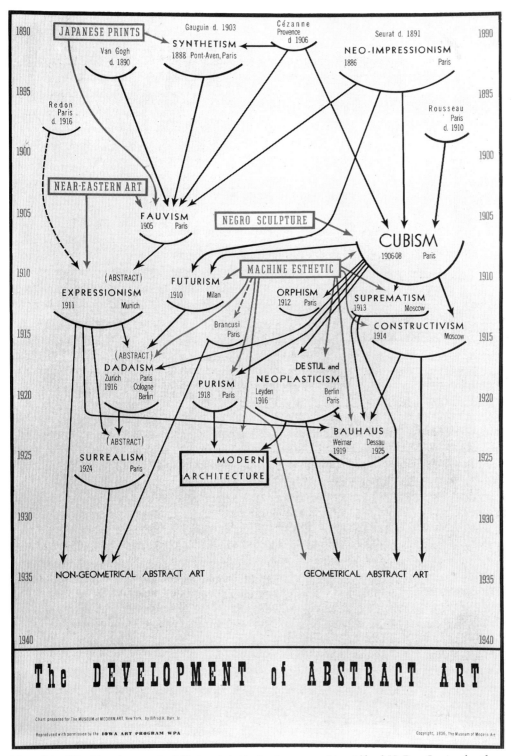

Plate 86 'The Development of Abstract Art', chart prepared by Alfred H. Barr Junior for the jacket of the catalogue *Cubism and Abstract Art* published by The Museum of Modern Art New York, 1936. Photo: courtesy The Museum of Modern Art, New York.

Schapiro argues that *all* art is a practice of representation: 'all fantasy and formal construction, even the random scribbling of the hand, are shaped by experience and by non-esthetic concerns' ('Nature of Abstract Art', p.86). As we saw with Chardin's *Rayfish*, works of art do not reflect or provide a transparent illusion of 'reality' or the 'world', even where the painting seems iconic. From this perspective all paintings, even one as seemingly intractable as Picasso's *Ma Jolie* (Plate 114), constitute produced allusions to 'reality' or the 'world'. As representations of ideas, values and beliefs, they are *mediated* or worked representations of reality.[5]

'Realism' and representation

Schapiro's argument about realism and representation was echoed a decade later, in 1948, by Daniel-Henri Kahnweiler, Picasso and Braque's dealer during the Cubist period. As a friend as well as dealer, Kahnweiler had an intimate, though interested, knowledge of Cubist practice. These painters turned away from 'imitation', he argued,

> because they had discovered that the true character of painting and sculpture is that of a *script*. The product of these arts are signs, emblems for the external world not mirrors reflecting the external world in a more or less distorting manner. Once this was recognized, the plastic arts were freed from the slavery inherent in illusionistic styles.
>
> (quoted in Y.-A. Bois, 'Kahnweiler's lesson', p.40)

Kahnweiler's characterization of works of art as 'scripts' or 'signs', raises issues and problems with which Picasso and Braque engaged in *practice*. Their techniques paralleled the word play and grammatical and syntactical experiments in, for example, the poetry of Mallarmé (Plate 142) and Apollinaire, and the absurd juxtapositions used in Alfred Jarry's writings to dislocate the familiar. However, it is highly unlikely that either Picasso or Braque had any theoretical interest in the linguistic analysis that formed the basis of semiotics. Some contemporaries, though, did make connections between one formative text in that development, Ferdinand de Saussure's *Course in General Linguistics*, (first published in 1916, but based on lectures given between 1906–11), and Cubism. Roman Jakobson, a major contributor to modern linguistics and literary theory, was one of these.

 Jakobson was a member of the influential Moscow and Prague linguistic circles of the inter-war period. He claimed that his encounter with Cubist works in the Shchukin and Morozov collections in Moscow was important to his work and that of other members of the school of literary and linguistic theory known as Russian Formalism. In their commitment to the analysis of art and literature, including modern and avant-garde work, one of the Formalists' concerns was 'literariness' – the quality that differentiated the literary 'work of art' from other kinds of texts. Jakobson recalled that Saussure emphasized not the meanings of individual words but the similarities and differences between them, and the effect of their *combination* rather than their individual appearance.[6] Saussure's treatment of language as a 'system of differences' relates, too, to the concept of 'defamiliarization', put forward by another Russian Formalist, Victor Shklovsky. Shklovsky argued that a novel way of *saying* surprises us into a new way of *seeing*; a novel *medium* (rather than the message) enables us to realise what is familiar, habitual and expected in any given context. The technique of Cubist collage, one that differentiates itself from both Academic and earlier modernist art, thus becomes a form of 'defamiliarization'. (Many of these linguistic and

5 On Barr, Schapiro, Greenberg and the 'Barr paradigm' see F. Frascina, introduction to *Pollock and After: The Critical Debate*.
6 See 'Structuralisme et téléologie', 1975, in *Selected Writings*, vol.7, 1985, quoted in Bois, 'Kahnweiler's lesson', p.49.

semiotic ideas were taken up in Paris after the Second World War, by theorists such as Roland Barthes and Claude Lévi-Strauss, who became known as 'structuralists'.)[7]

For Jakobson, both Saussure and the Cubists seemed interested in the nature of the relationship between 'signifiers' (words and visual forms) and their significance (what they stand for, or what is signified by them):

> Perhaps the strongest impulse toward a shift in the approach to language and linguistics … was – for me at least – the turbulent artistic movement of the early twentieth century. The extraordinary capacity of these discoverers to overcome again and again the faded habits of their own yesterdays … is intimately allied to their unique feeling for the dialectic tension between the parts and the uniting whole, and between the conjugated parts, primarily between the two aspects of any artistic sign, its *signans* and its *signatum* [signifier and its signified]
>
> (quoted in Bois, 'Kahnweiler's lesson', p.64)

Both Kahnweiler and Jakobson discuss analogies between Cubist art and language: the view that artistic signs, ranging from a conventional symbol (such as the cat for licentiousness) to a brush mark, function in the same way that words do within a sentence; the sentence corresponds to the united whole of a picture. In interviews first published in 1961, Kahnweiler argued that something which is fundamental 'to the comprehension of Cubism and of what, for me, is truly modern art [is] the fact that *painting is a form of writing* … that creates signs':

> A woman in a painting is not a woman; she is a group of signs that I read as 'woman'. When one writes on a sheet of paper 'f-e-m-m-e', someone who knows French and who knows how to read will read not only the word *'femme'* ['woman'], but he will see, so to speak, a woman. The same is true of paintings; there is no difference. Fundamentally, painting has never been a mirror of the external world, nor has it ever been similar to photography; it has been a creation of signs, which were always read correctly by contemporaries.
>
> (Kahnweiler interviewed by F. Crémieux, *Mes galeries et mes peintres*, p.57)

Contemporary responses indicate that *not* all contemporaries could read the signs and references in Cubist works. Yet there is evidence that Picasso and Braque desired to produce a form of 'realism' (which had traditionally been thought of as a paradigm of legibility). The issue of realism and legibility is explicitly expressed in *Du 'Cubisme'*, a pamphlet written by two painters, Albert Gleizes and Jean Metzinger, published in 1912. Towards the end of their essay (which is indebted to Nietzsche's notion of the 'superman'), the authors claim:

> That the ultimate end of painting is to reach the masses, we have agreed; it is, however, not in the language of the masses that painting should address the masses, but in its own language, in order to move, to dominate, to direct, and not in order to be understood. It is the same with religions. The artist who abstains from all concessions, who does not explain himself and who tells nothing, accumulates an internal strength whose radiance enlightens all around … For the partial liberties conquered by Courbet, Manet, Cézanne, and the Impressionists, Cubism substitutes a boundless liberty.
>
> (*Du 'Cubisme'*, pp.74–5)

At the start of their argument, they invoke Courbet, who 'inaugurated a realist aspiration in which all modern efforts participate' (p.38). Why Courbet? One critical element of his 'Realism' lay in the implicit claim that those types of Academic or official paintings which

[7] On Barthes, see p.119; for Lévi-Strauss on Cubism see G. Charbonnier, *Conversations with Claude Lévi-Strauss*; on this whole development see J.G. Merquior, *From Prague to Paris*.

glossed over the divisions of class society were *ideological* and therefore *false* representations of reality. He was allying himself to contemporary notions of Realism in art and literature (including Baudelairean *Modernité*) and to positivism, the philosophical movement of the mid-nineteenth century which accepted as knowledge nothing but matters of fact based on the 'positive' sense data of experience (not on metaphysics, theology, uncritical speculation or any 'transcendent' knowledge). His notion of Realism in *art* was concerned with the problem of truthfulness and the ways in which artistic traditions and conventions could generate misrepresentations of the subjects of images. It was an aim of Realism in general to expose the workings of such traditions and conventions.

The view of realism proposed in *Du 'Cubisme'*, however, is not a notion influenced by positivism. Rather it is a reaction *against* it. Gleizes and Metzinger split 'realism' into 'superficial realism' and 'profound realism': the former belongs to Courbet and the Impressionists and the latter to Cézanne. Gleizes and Metzinger claim that reality exists essentially as *consciousness*. Whatever exists is known to individuals through and as *ideas*. Cézanne's work they saw as an example of *modern* traditions and conventions in art *mediated* by his 'individual consciousness', or as they so obscurely put it, 'the art of giving our instinct a plastic consciousness' ('plastic', here, means physical).

'Realism', then, is a changeable concept, and underwent cultural transformations in the nineteenth century. The notion of 'realism' in *Du 'Cubisme'* is closer to that of Plato, who held that the properties of objects, such as redness or squareness, existed independently of the objects in which they were perceived. Further, these properties or 'Ideas', were 'more real' than the objects in which they were found, and they constituted the 'essence' or underlying reality that knowledge seeks to grasp. This is close to many Cubist critics' emphases on 'universals', 'essences' and the 'underlying reality' of objects and experiences. Such a view is more consistent with a form of what we now call Idealism and is different from the meanings which 'Realism' developed in the nineteenth century.

Realism in art and literature had been used by, for example, Courbet, to characterize new theories about the independence of the physical world from mind or spirit; this was an attitude or method that favoured a demonstration of things 'as they actually existed'. As we have seen, such representations are referred to in semiotic terminology as iconic. Towards the end of the nineteenth century, there were several objections to this view of realism. One, often associated with Symbolism, was that what is described or represented is seen only superficially, that is, in terms of its outward *appearance* rather than its inner *reality*. Another was that there are many *real* forces, from inner feelings and psychic states to underlying social and historical movements, which are neither accessible to ordinary observation nor adequately, if at all, represented in how things appear. With different emphases, the theories of Marx and Freud, who both stressed social conditioning, underpinned many of these objections. A third objection was that the medium in which the representation occurs (painting, collage etc.) is radically different from the objects *represented* in it, so that the effect of 'life-like representation', 'the reproduction of reality', is at best a particular artistic convention, or at worst a falsification, making us take the forms of representation as *real*.

Art and semiotics

It is in the context of these wider cultural transformations of the concept of realism that we find the parallels which Jakobson identified between Cubism as a practice of representation and the development of semiotics. We began to explore some of these parallels with respect to Picasso's collages. In order to continue this exploration and to

examine the explanatory potential of semiotics, I want to look at some exemplary cases beginning with Picasso's *Les Demoiselles d'Avignon* (Plate 1).

This painting provides a useful case study partly because it enables us to examine critically a work designated as canonical in dominant histories of modern art. In such histories the painting is itself a sign with a particular value – equal to other 'canonical' works and superior to 'non-canonical' works. *Les Demoiselles's* status was secured by a further catalogue and exhibition of Barr's *Picasso Forty Years of His Art*, of 1939, which coincided with MOMA's acquisition of the painting in that year. *Les Demoiselles* is displayed in the Museum as a canonical work, a token not only of its Modernist collection but also of the Museum's curatorial representation of the development of Cubism. The painting is a sign in a powerfully influential set of official and unofficial rules which constrain the reception of 'high art'.

Another reason is that, from what we know of the planning and production of the painting, it was designed to be a 'major' intervention in contemporary practice. As such, it is revealing about the painting as a sign within rules constraining production. Although not exhibited until 1916, it had a considerable impact within a particular group *c.*1907, when small-scale, brightly coloured Fauvist depictions of themes such as coastal towns and the imagined and actual sites of pleasure were in vogue among self-styled 'progressives' (Plate 87 and Plates 41, 43). The production and display of these works were also wrapped up in the politics of 'independent' Salons and the developing

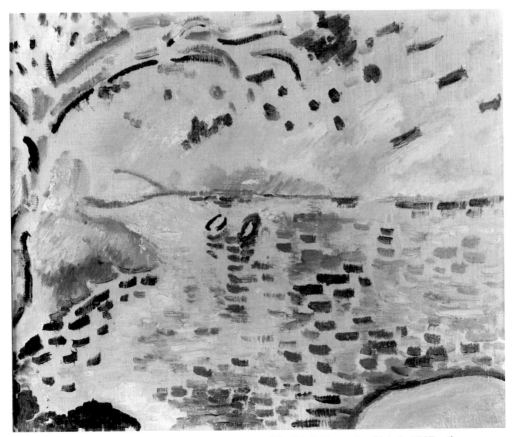

Plate 87 Georges Braque, *Petite Baie de la Ciotat* (*The Little Bay at La Ciotat*), 1907, oil on canvas, 36 x 48 cm. Centre National d'Art et de Culture Georges Pompidou, Musée National d'Art Moderne, Paris. © ADAGP, Paris and DACS, London 1993.

entrepreneurial dealer network. In scale and theme, *Les Demoiselles* evoked different traditions: that of the major official Salon work on a legitimated subject such as the 'harem' theme of Ingres's *Bain Turc* (Plate 55), and, by contrast, that of modernist versions of traditional subjects such as the more sexually ambiguous depiction of a group of nudes in the 'open air' (e.g. Cézanne's 'bathers' series).

For this project Picasso ordered, as many Academic artists had done, a large specially made wooden stretcher of unconventional dimensions (standard mass-produced ones, used by the Impressionists and Fauves, only went to about 190 centimetres). During the autumn of 1906 through to 1907 he followed what seems like normal Academic preparatory procedures for a Salon 'set piece' with numerous sketches and studies on paper, canvas and wood, often in colour. There are dozens of these, both individual works and *carnets*, or sketchbooks. Though there were significant exceptions, this procedure was at odds with many modernist or avant-garde practices of the late nineteenth century which valorized 'directness' and 'spontaneity'. It was thus equivalent to, but different from, perhaps a token of exchange with, Academic 'history paintings' (Plates 97 and 98) and modern history paintings such as those by Seurat.

Since 1900, Picasso, who was Spanish, had been working in Paris establishing himself within the social networks of the art world. He exhibited in private galleries, including Vollard's, and made contacts with critics such as Apollinaire and with collectors such as Gertrude and Leo Stein (North Americans who were soon to have the most renowned collections of contemporary paintings in Paris). Politically and socially his community was rooted in the leftist 'bohemian' legacy of the nineteenth century; the themes of Picasso's work in the early years of the twentieth century can be linked to those aspects of Baudelairean modernity which highlighted the social outcast or marginalized activity: the prostitute, circus artist or absinthe drinker, the 'heroic' poor.

An example is *Two Sisters* (Plate 88) which signifies interest in the representation of poverty, psychological depression and prostitution. Picasso wrote to the French poet Max Jacob that a preliminary drawing for this picture was of a 'whore of St Lazare and a mother'. St. Lazare, in Paris, was a hospital-prison for prostitutes suffering from venereal disease. This disease and the risk of contracting it was both a personal concern for Picasso and, like AIDS in the 1980s and 1990s, a wider issue in medical and social discourses. In format, though, the painting signifies an earlier pictorial schema: it resembles a Renaissance fresco of the 'visitation', with the child in the arms of the woman on the right.[8]

The representation of a contemporary theme of prostitution combined with the use or the evocation of earlier sources and formats is also central to his large painting *Le Harem* (Plate 89) which draws on the legacy of Ingres's famous example (Plate 55). In Academic terms the painting can be read as a representation of Classical 'nymphs', or an idealized harem, watched over by a male figure in the pose of a Classical river god. Here, the amphora, the large water vessel, is both a reference to the Classical world and a symbol of the uterus with the traditional associations of sexuality and *vanitas*. However, it's possible to read contemporary Spanish references, perhaps even to Gosol, the town where Picasso worked on this and other paintings. The amphora was a common everyday utensil in the area, as was the carafe held by the male figure (Picasso had depicted both in various images). The woman in the background, too, is probably modelled on his painting of *Celestina, The Procuress* of 1904. *Le Harem*, therefore, can be said to evoke two discourses – one on the Academic representation of the harem, and another on a 'contemporary' theme, brothels and prostitution, with its roots in alternative nineteenth-century images.[9]

[8] On the issue of medical discourses and Picasso's work see M. Léja, '"Le vieux marcheur" and "les deux risques": Picasso, prostitution, venereal disease, and maternity, 1899–1907'. See, too, W. Rubin 'La Genèse des *Demoiselles d'Avignon*'.

[9] See F. Frascina, 'Picasso's art: a biographical fact?'

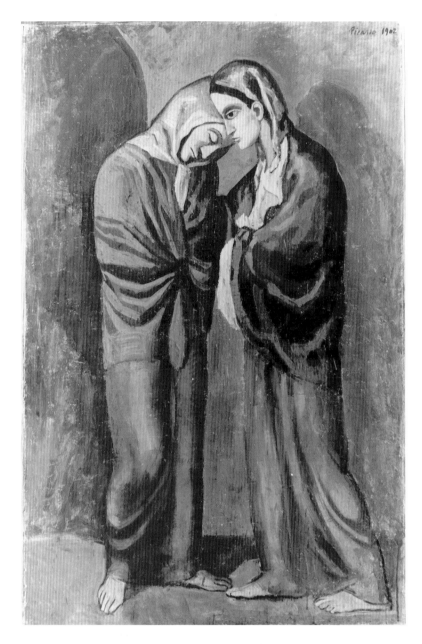

With *Les Demoiselles* Picasso adopted a similar 'Baudelairean' theme, this time ambitiously envisaging a monumental painting in the 'great tradition', something that would be on a par with the Salon set-pieces of Ingres or Bouguereau, but which would also provide some critical distance from the subjects and techniques of Fauvism. This ambition was also related to psychological and social concerns, in particular to Picasso's morbid fascination with prostitution and venereal disease; his interest (shared with contemporaries) in the images and meanings of 'primitive' sculpture, and his experience of existence in a bohemian community textured by ethnic difference, anarchism, philosophical ideas and notions of sexual liberty.

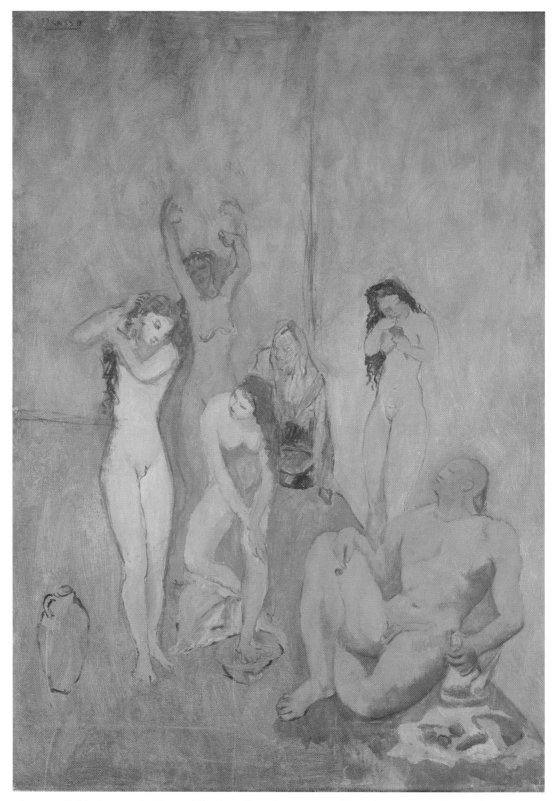

Plate 89 Pablo Picasso, *Le Harem* (*The Harem*), early summer 1906, oil on canvas, 154 x 110 cm. The Cleveland Museum of Art. Bequest of Leonard C. Hanna Jnr 58.45. © DACS 1993.

In 1933 Picasso talked to Kahnweiler about the theme of the painting:

> *Les Demoiselles d'Avignon*, how that title irritates me! You know very well that [André] Salmon [poet and art critic] invented it. You know very well that the original title from the beginning had been *The Brothel of Avignon*. But do you know why? Because Avignon has always been a name I know well and it is a part of my life. I lived not two steps from the Calle d'Avignon [Carrer d'Avinyo, a street in the notorious red light district of Barcelona, the city where Picasso attended art school], where I used to buy my paper and my water-colours and also, as you know, the grandmother of Max [Jacob] came originally from Avignon. We used to make a lot of jokes about the painting. One of the women was Max's grandmother. Another Fernande [Olivier, his partner at the time], another Marie Laurencin [the painter], all in a brothel in Avignon ... According to my original idea, there were supposed to be men in it, by the way – you've seen the drawings [Plate 90]. There was a student holding a skull [a *memento mori*, Plate 91]. A sailor too [Plate 92]. The women were eating, hence the basket of fruit which I left in the painting. Then I changed it, and it became what it is now.
>
> (quoted in Kahnweiler, 'Huit entretiens avec Picasso', p.24)

The first plans for the painting may have originated in Picasso's drawings and paintings of two sailors on shore leave going into a brothel (Plate 93). However these and all male figures (Plates 91, 92, 94) were omitted from the final composition, which focuses on five women and the bowl of fruit, traditionally symbolic of abundance, of summer (one of the four seasons), of taste (one of the five senses) etc. In this arrangement, the envisaged viewer is male with the final painting consistent with the available representations of actual brothels and erotic photographs (Plates 95 and 96).

Plate 90 Pablo Picasso, study for *Les Demoiselles d'Avignon*, spring 1907, pencil and pastel on paper, 48 x 63 cm. Oeffentliche Kunstsammlung Basel Kupferstick Kabinett. © DACS 1993.

Plate 91 Pablo Picasso, study for
Les Demoiselles d'Avignon, also known as
Student with a Skull in his Hand (sketch-
book page), winter–spring 1907, pencil on
paper, 24 x 19 cm. Musée Picasso, Paris. Photo:
Réunion des Musées Nationaux
Documentation Photographique. © DACS 1993.

Plate 92 Pablo Picasso, study for *Les
Demoiselles d'Avignon* (also known as *Sailor
Rolling a Cigarette*), winter–spring 1907,
gouache on paper, 62 x 47 cm. Berggruen
Collection on loan to National Gallery,
London. © DACS 1993.

Plate 93 Pablo Picasso, *Marins en bordée*
(*Sailors on Shore-leave*), winter–spring 1906–7,
pen and ink on paper, 20 x 14 cm. Heirs of
the Artist. Picasso Estate. Photo: by courtesy
of Ediciones Poligrafa S.A. from Joseph Palau
i Fabre *Picasso 1887–1907*, 1980. © DACS 1993.

Plate 94 Pablo Picasso, study for *Les Demoiselles d'Avignon*, spring 1907, oil on wood, 19 x 24 cm. Heirs of the artist. © DACS 1993.

Plate 95 François Gauzi, *Les Salons de la rue des Moulins*, c.1900 Photograph © 1987 Sotheby's Inc.

Plate 96 Anonymous photographer, c.1900. Reproduced from *Le Nu 1900* by Philippe Julian, André Barret, Paris.

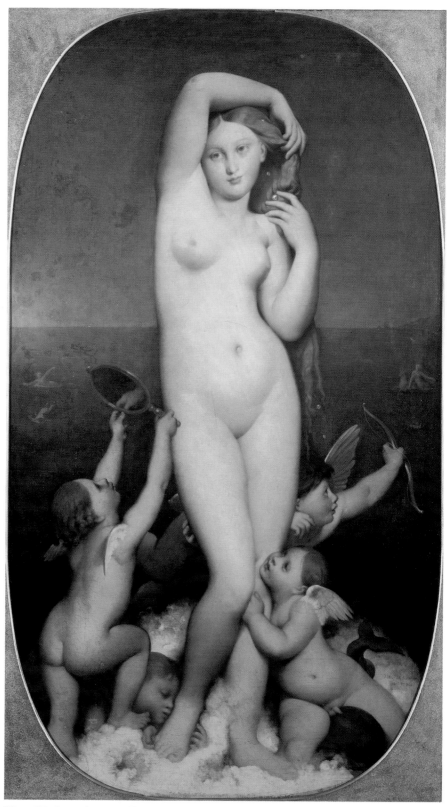

Plate 97 Jean-Auguste-Dominique Ingres, *Vénus Anadyomène*, oil on canvas, Musée Condé, Chantilly. Photo: Lauros-Giraudon.

The 'Vénus Anadyomène' pose: the '*langage*' of representation

The central figure of *Les Demoiselles* follows the conventions associated with numerous representations of the female nude in the nineteenth century. Ingres's *Vénus Anadyomène* (Plate 97) was widely regarded as exemplary by those who held the traditional view that the representation of the female nude entailed the production of a declassed and personified version of the feminine, one which enabled the male artist to display his power to transform the 'decadence' of the female body into either 'ideal beauty' or 'sensual love'. 'Vénus Anadyomène' (Venus rising from the sea) represents the Roman goddess of love and fertility after her mythological birth. This pose was found in Classical sculpture and thought to derive from a lost work by Apelles, who was regarded as the greatest painter of Greek antiquity. Ingres used the pose to particular effect in the mid-nineteenth century. T.J. Clark makes the following observation:

> Most writers and artists knew that the nude's appeal, in part at least, was straight-forwardly erotic … the body was attended and to some extent threatened by its sexual identity, but in the end the body triumphed. To make the language less metaphorical: the painter's task was to construct or negotiate a relation between the body as particular and excessive fact – that flesh, that contour, those marks of modern woman – and the body as a sign, formal and generalized, meant for a token of composure and fulfilment. Desire appeared in the nude, but it was shown displaced, personified, no longer an attribute of woman's unclothed form.
>
> (*The Painting of Modern Life*, pp.123–6)

Ingres's 'Vénus Anadyomène' is a paradigm of 'the body as sign … formal and generalized'. 'Venus' is in a contrapposto pose, long hair trailing down her back and both arms held up to display her unblemished body. Several artists, including Bouguereau, used it in their paintings (Plate 98). It was also used in quasi-pornographic photographs and colonial postcards (Plates 96 and 112, 113). Picasso 'quotes' the pose in the central nude (the nude to her right is a variation), just as he 'quotes' from a small Cézanne, *Three Bathers*, in the squatting figure to the right, which also evokes Degas's use of similar figures in his 'keyhole' views of women washing themselves (Plates 99 and 100). In terms of Picasso's immediate community of discourse, it is significant that variations of the 'Vénus Anadyomène' pose were used by Cézanne in his *Five Bathers* (Plate 101), by Matisse in *Le Bonheur de Vivre* (Plate 43), and Derain in *Bathers* (Plate 102).

In at least one crucial relationship, *all* these paintings encode a gendered commercial exchange – between men with the relative socio-economic freedom to purchase or take their pleasure where they wished, and women whose relative lack of social and economic choice is evidenced in the sale of their bodies, actually or in representations. Implicit in such a commercial exchange is the existence of a control mechanism or system specific to the culture, a system of thought in which the exploitation of women is normalized – made to seem unexceptional, normal, familiar. Implicit, too, are the words, images, or discourse through which the thought is presented. Ingres's 'Vénus Anadyomène' pose is a 'token' of that exchange. It presupposes two encounters, an imaginary one, which is pictured, and an actual one between viewer and image. Both rely on an acceptance of particular class and gender relations and meanings.

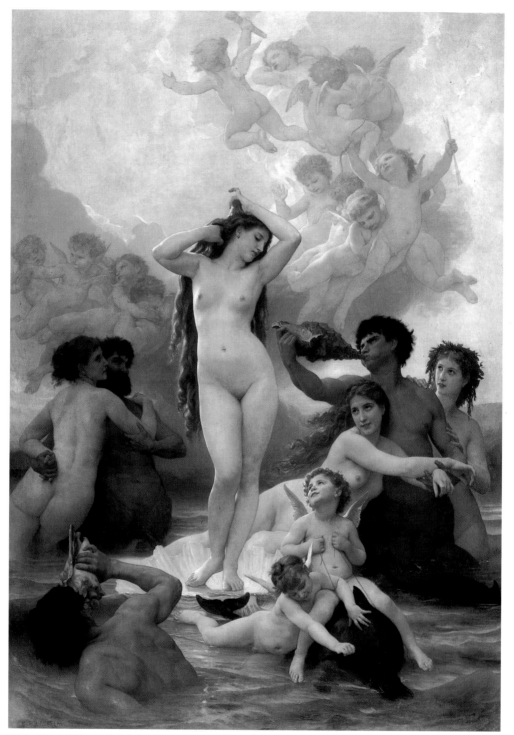

Plate 98 William-Adolphe Bouguereau, *La Naissance de Vénus* (*The Birth of Venus*), 1863, oil on canvas, 300 x 217 cm. Musée d'Orsay, Paris. Photo: Réunion des Musées Nationaux Documentation Photographique.

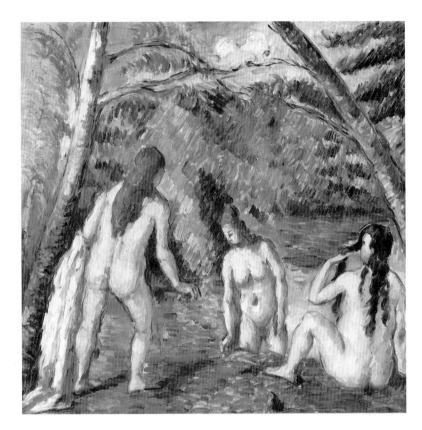

Plate 99 Paul Cézanne, *Trois Baigneuses* (*Three Bathers*), 1879–82, oil on canvas, 52 x 54 cm. Musée du Petit Palais, Paris, Gift of Henri Matisse 1936. Photo: P. Pierrain/Photothèque des Musées de la Ville de Paris. © DACS 1993.

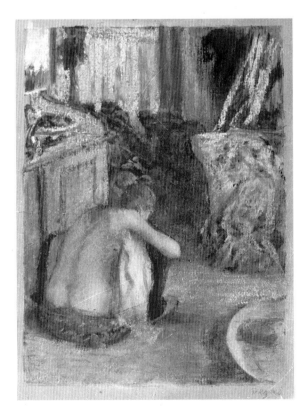

Plate 100 Edgar Degas, *Femme nue accroupie de dos* (*Crouching Female Nude, Rear View*), 1879, pastel on monotype, 18 x 14 cm. Musée du Louvre, Paris. Photo: Réunion des Musées Nationaux Documentation Photographique.

Plate 101 Paul Cézanne, *Cinq Baigneuses*
(*Five Bathers*), 1885–87, oil on canvas,
65 x 65 cm. Oeffentliche Kunstsammlung,
Basel.

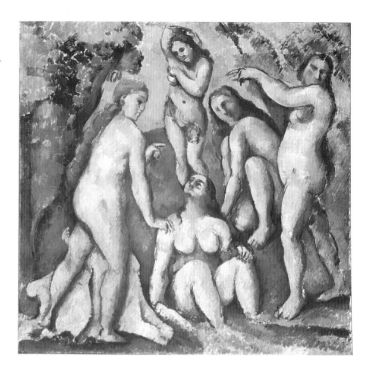

Plate 102 André Derain, *Baigneuses* (*Bathers*), 1907, oil on canvas, 132 x 195 cm. The Museum of Modern Art, New York. William S. Paley and Abby Aldrich Rockefeller Funds. © ADAGP, Paris and DACS, London 1993.

The legitimation of the representation of naked women in these ways – ways which suggest or specify 'harems' or brothels and imply the voyeuristic gaze of a male viewer – relies on a system of rules. These rules prescribe the conditions for both the production and reception of meanings: they specify who can claim to produce and communicate meanings or know, receive and understand them; what topics may be introduced, under what circumstances and with what modalities (how, when, why). The rules of such a system are underpinned by a set of classifications: of people, topics, subjects, themes, circumstances, and so on. But these classifications ultimately derive from the interests and ideas – from capitalism and patriarchy, for example – of dominant or powerful groups. This means that a set of supplementary messages arises out of the interaction between viewers and between object and viewer, which indicates the status of relations between dominant and dominated viewers and groups. For instance, when a system 'allows a statement offensive to women to be read as "joke", this signifies a particular structure of gender relations, one in which males are dominant as a group in relation to females but need to mask their hostility and aggression towards them' (R. Hodge and G. Kress, *Social Semiotics*, p.5). It might be countered by those keen to preserve the autonomy of art that the connotations of a 'joke' are not the same as those of a visual image, a 'painting' doesn't operate like a 'joke'. But despite the differences of the particular signs (a statement understood as a joke and a painting of naked women), a set of messages and assumptions, which are part of an ideological complex, may permeate, if not govern, both of them. The social and psychological processes of power and domination seek to legitimate and to ameliorate – disguise and make acceptable – feelings such as hostility and aggression and actions such as exploitation. Similar ideological meanings are generated through a range of forms which make up everyday life. To neglect or to deny this may be to collude with a dominant power system.

The 'Vénus Anadyomène' pose, as a paradigm of the body as sign, may vary in *some* of its formal characteristics in the Ingres and Picasso paintings. But does it have a similar moral function within a signifying system? For many Modernists, for whom the visual experience is a special category, these variations of the pose are primarily 'aesthetic' and largely autonomous. But this is a view that attracts criticism such as that based on Max Weber's observation on the 'refusal of modern men to assume responsibility for moral judgements of taste ([things are designated] 'in poor taste' instead of 'reprehensible')'. He continues, 'the inaccessibility of appeal from esthetic judgements excludes discussion' ('Religious rejections of the world and their directions', *From Max Weber*, p.342). How, then, might we explain the variations of the 'Vénus Anadyomène' pose in terms of the social and moral organization of the participants involved (producers and viewers) and by the immediate conditions, including gender relations, of their interaction?

'*Langage*' and '*langue*'

We can start by applying a linguistic model to the practice of art, as proposed by Kahnweiler. In theory, all of the elements, conventions and rules of picture making in the Western tradition were available to Picasso in 1907. This was the pictorial language that Picasso had culturally inherited and systematically practised in early training. In semiotic terms, the possibilities for visual representation available at any one time equate with *langage* ('language'), Saussure's term for the biologically inherited capacity for language. In his terms, it is distinct from *langue* ('*a* language'), which is a particular language system, such as English or French. In visual art it may be equated with, say, an Academic system of pictorial representation which is distinct from, for instance, the 'language' of 'folk' art.

In his original lectures, Saussure emphasized that the words which constitute language are verbal signs. These have two sides, an acoustic image or sound pattern and a concept ('Nature of the Linguistic Sign', pp.65–70). These two elements are intimately linked and each triggers the other. The image or sound pattern he called the *signifiant*,

signifier, and the concept he called the *signifié*, the signified. Saussure's basic insight was that the connection between signifier and signified is not natural but arbitrary. There is no 'natural' reason why the sound-image 'tree' or its shape on a page must stand for the concept of a tree (after all, in French it is 'arbre', in Italian 'albero' and in German 'baum'). But it *does* stand for that concept in English because there is a convention among speakers of the language that it *will* stand for that concept. It is only because we have such a convention that we can talk to each other about trees at all. Conventions are social arrangements, sets of rules. To learn them is to enter into, or to accept, a 'collective contract' with other speakers of the particular language. We 'contract' to abide by the rules in order to communicate. So our individual acts of communication, or utterances, which may have the character of spontaneity and inventiveness, rest upon or presuppose sets of social conventions which the lone individual can *apparently* do little or nothing to change (I'll return to this problem in the next section).

Just as there are innumerable words in a language, so too there is a huge range of linguistic conventions. But what ensures that they relate to one another and don't 'get in each others' way'? And how are we to grasp them all? Saussure claims that language has a

Plate 103 Georges Braque, *Grand Nu* (*Large Nude*), December 1907–June 1908, oil on canvas, 140 x 100 cm. Collection Alex Maguy, Paris. © ADAGP, Paris and DACS, London 1993.

systematic structure. As the French semiologist Roland Barthes put it in *Elements of Semiology* in 1964, verbal or other signs are like different coins in a currency. Signs, like coins, form a system of values. A fifty pence piece has the value of a certain amount of goods which the individual can buy, but also has a value in relation to other coins, in this case equal to five ten pence pieces, or more or fewer other coins. Linguistically, the signs 'rational animal', for instance, can be exchanged for the signs 'human being'. There are, though, other systematic relations of value between signs, unlike relations between coins. In particular, there are relations of difference and exclusion: black/white, cultural/natural, female/male, active/passive, for example (see 'Language (*langue*) and speech', pp.81–3).

These ideas can illuminate Picasso's use of the 'Vénus Anadyomène' pose in at least two ways. Firstly, with respect to art as a 'language', Picasso entered into a 'collective contract' in which there was a given set of rules (including those governing what constituted 'meaningful' signs), which he learned in order to communicate with others. (Academies, art schools and Salons are institutions for the maintenance of the rules in such production regimes; peer groups – Academicians, Fauves, Cubists – perform a similar function.) The 'Vénus Anadyomène' pose is one of these learned 'meaningful signs' within Academic discourse. But, as we have seen, by 1907 it was also used by non-Academicians, by Cézanne and by Matisse, Derain and Picasso. And by late 1907, Braque had abandoned Fauvism (reportedly after seeing *Les Demoiselles* in Picasso's studio) to produce paintings such as *Large Nude*, a *particular* variation of the 'Vénus Anadyomène' pose (Plate 103).

Plate 104 Pablo Picasso, *Reclining Nude* (*Fernande*), spring-summer, 1905, gouache on paper, 47 x 61 cm. The Cleveland Museum of Art. Gift of Mr and Mrs Michael Straight. 54.865. © DACS 1993.

Secondly, each of the elements of this language, such as the 'Vénus Anadyomène' pose, has a value within a particular system of values. The value of the 'Vénus Anadyomène' pose, as sign, is equal to other signs in the same system of tokens ('like a coin'), for which it can be 'exchanged'; in other words there is a currency of signs within a system. The totality of modifications of the body, *can* be considered as a language, a 'system'. For instance, we have identified the 'Vénus Anadyomène' pose, as one element. Another one with equal 'value' is the 'odalisque pose', used in Picasso's portrait, *Fernande* (Plate 104). It is used by Ingres in *Le Bain turc* and a variation of it in Matisse's *Blue Nude* (Plates 55 and 54). Like the Venus pose, the odalisque pose is a gendered signifier of unblemished availability. As a token of possession, a colonization of the 'other', it was also used in photographic representations from the colonies (Plate 110). Significantly, in *Le Harem* this signifier is rendered specific through difference: the body and pose of the male 'river god' is differentiated from that of an 'odalisque' by the artist depicting the arms down, not in the position of *display*.

The 'Vénus Anadyomène' and 'odalisque' poses can be considered as elements of the 'language' system known as 'the body': each has particular meanings within that language. Or they may be versions of 'the body' which is itself a sign in other systems such as 'woman', 'the feminine' or 'Classical myth' or 'history painting'. In history painting, for example, the 'Vénus Anadyomène' pose signifies the mythical birth of the Roman goddess of love and fertility. In Greek poetry (Hesiod, *Theogony*), Gaea (Mother Earth) and her son Uranus (Heaven) coupled and produced the first human race, the Titans. Uranus threw his sons into the underworld but Gaea in revenge gave the youngest of them, Cronus, a sickle with which he castrated his father. Venus was born of the sea from the foam produced by the genitals of the castrated Uranus when they were cast upon the water. Venus floated ashore on a scallop shell. 'Vénus Anadyomène' is a variation where she is represented standing and wringing water from her hair.

Parole: the 'act of speech' and its context

An artist's *use* or articulation of this 'Vénus Anadyomène' pose (or one of its variations) in an image, may be compared with a linguistic utterance (a statement), an instance of *parole*. *Parole*, or speech, is the act of an individual speaker or artist, an act of selecting signs from the *langue*, or the particular language system, and combining them for specific purposes. The meaning of the 'utterance' or work of art depends not only on the meaning of the signs in the 'code' of the language, but also on the context in which they are used. For instance, the identical sign 'woman' can recur in different 'acts of speech', where it may be combined with other signs; within each combination it will evoke different ideas, perhaps different individual women, specific to the context of a particular utterance.

There is a difference in the *use* of the language in the Ingres, the Bouguereau and the Picasso. Technically and formally, however, the difference between *Les Demoiselles* and the Venus paintings appears relatively major. This is not to say that we can lump Ingres and Bouguereau together: their paintings were produced in specific circumstances, as were the meanings of their paintings as signs.[10] For my purposes (introducing semiotics), despite

[10] However, I want to distance myself from those who argue for a distinction between Ingres and Bouguereau on grounds of 'quality', between Ingres as an inheritor of the elevated ideals of 'high art' and Bouguereau, a *pompier* artist (this term was used for those 'official artists' of the nineteenth century who enjoyed great public popularity, gained prestigious government commissions and were favoured by the Academy and Salon juries). For Modernists, *pompier* artists produced *kitsch*, by which they mean debased, fashionable, tugging-at-the-emotions versions of 'real art' (see Greenberg 'Avant-Garde and Kitsch' and the critical discussion of such a view in Frascina, *Pollock and After*). Thus, Ingres is regarded as having high ideals and major talent, however ideologically compromised his paintings were, whereas Bouguereau's ideals are considered to be debased by fashion and his talent minor. We have to be wary of such distinctions, which may be ideological impositions of retrospective evaluations.

the specificity of their utterances, Ingres's and Bouguereau's uses of the 'Vénus Anadyomène' pose are both within the Academic discourse of the 'ideal' version of the 'female nude', with its social and psychological notions of 'woman'. With the Ingres:

> The unavoidable sexual force of this nakedness is transposed into various actions and attributes, and made over into a rich and conventional language. What is left behind is a body, addressed to the viewer directly and candidly, but grandly generalized in form, arranged in a complex and visible rhyming, purged of particulars, offered as a free but respectful version of the right models, the ones that articulate nature best.
>
> (Clark, *The Painting of Modern Life*, pp.126–7)

In *Les Demoiselles*, Picasso uses the 'Vénus Anadyomène' pose as an element of a language system, but Clark's description of Ingres' use does not fit here. Picasso's particular 'selection and actualization' (to use Barthes's terms) becomes a *contribution* to the existing Academic discourse (an instance of the 'recurrence of identical signs') exemplified by Ingres's and Bouguereau's usage. However, because Picasso's individual 'utterance' is technically and formally different – in the heavy paint texture on particular heads and hands, the visible brush lines on the central poses which indicate both the direction of planes and body areas and skin tone – from such earlier usage, it is a repetition of that 'sign' in a *'successive'* discourse: a development out of the Academic one. We might call the 'successive' discourse 'modernist' in so far as its 'speaking' members (Matisse, Derain, Picasso, Braque etc.) constituted a 'social grouping' entering into a 'collective contract'.

There's an important issue here. I said earlier that, according to Saussure and Barthes, we contract to abide by rules and conventions in order to communicate; thus, *langue* is the result of a social collective contract. The individual act, *parole*, is an 'utterance', a product within that system. Critics of this definition have argued that it can lead to an overemphasis on the systematic in which 'speakers' are regarded as being governed or 'structured' by language because they are users of a system of forms which *delimits* their possibility to act by means of linguistic behaviour or manifestation in society. In much 'mainstream semiotics' there has been a stress on the complexity of an underlying formal system (socially contracted) and the particular product (such as the art work) seen as governed by elements in this system, their relations one to another and the diversity of their combination. This has been at the expense of studying historically contingent be- haviour, events, and objects whereby participants in semiotic activity (speakers, writers, artists etc.) are regarded as *interacting* in a variety of ways in particular social contexts. The Saussurean perspective is useful in illuminating parallels and connections between verbal and non-verbal (e.g. 'visual') sign systems. But its interest in *langue*, the conventional system, rather than *parole*, the individual act within that system, produces an emphasis on that which is stable over long periods. This emphasis is unhelpful in considering the social and political aspects of a particular instance of semiotic activity.

So, to apply Saussure's model helps to explain how Picasso produced the individual utterance of *Les Demoiselles*, a modern history painting, by contracting into a social 'language system' of visual representation, which is relatively stable over a long time. The elements in this system include 'modern history painting' and the 'Vénus Anadyomène' pose; which is a sign, *within* another sign, the painting itself. Saussurean semiotics enables us to make a systematic exploration of 'the conditions of representability entailed by the sign' (Krauss, 'In the name of Picasso', p.16). From such a perspective, the sign is regarded as autonomous in so far as no historically specific meaning can be attributed to an element within a system which is claimed to transcend contingent social demands. Such an em- phasis has parallels, methodologically, with Modernist emphases on the autonomy of the medium and formal characteristics of those works of art placed within its canon. However, the Saussurean model of explanation (as well as the Modernist model) is

unhelpful in accounting for the significance of *Les Demoiselles*, as a *social* 'utterance', a specific sign, within what we might call the 'rhetoric' of visual representation in 1907.

Social semiotics

An hypothesis

In this section I want to examine the following hypothesis. *Les Demoiselles* is not just an individual articulation within a system which includes the 'Vénus Anadyomène' pose as a sign. It is also a social phenomenon which disrupts the relations between the signs of the system. That is, there are characteristics of the painting which reveal the sign's ideological meaning. This is partly through the process of the viewer being deprived of the safety of expectation; the effect of 'defamiliarization'. In representations such as those by Ingres and Bouguereau the real relations between specific types and classes of people are obscured by the way that the subject is treated; by signs which signify not a particular 'woman' but an ideal, consumable, possessable body as commodity. Social particulars are absent from the picture. An idealized naked body is transposed into mythological actions and attributes which make 'acceptable' an ideological relationship between the represented 'nude' (a category of aesthetic discourse) and the viewer, normally envisaged as male. Culturally specific norms of 'beauty' are sustained by the rich conventional language, of colour, paint texture, compositional frontality etc., exemplified by the 'rhetoric' of Ingres's and Bouguereau's images.

The rhetoric of the 'ideal' in artistic discourses of the nineteenth century is, as Jennifer Shaw argues, predicated on notions of mastery and control; male creativity was regarded as capable of transforming women who were characterized as 'out of control of their own bodies, as debilitated, sick, mutilated'. This negative view of 'woman' was encoded in a range of discourses, one of which (on the department-store saleswoman) we saw in considering interpretations of Picasso's *Au Bon Marché*. Nineteenth-century obsessions about menstruation, venereal disease, sexuality and social class were bound up with fantasies about prostitution, the feminine as maternal, and the female as 'spider' tempting the 'honest bourgeois' into a disreputable web. This gained particular force after the Commune of 1871, in which many communards were women. Subsequently, there was much debate about working-class women as sexually and politically unpredictable, resulting in the powerful and oppressive articulation of male ambivalence. This relates to Shaw's analysis of the figure of 'Vénus' which 'served as a locus through which man's control of woman's body, or lack thereof, could be variously articulated' in representations where she could 'incarnate either Madonna or whore'. She refers to the *Grand Dictionnaire universel*, 1875, where ten pages were devoted to 'Vénus':

> We learn that her name was used to signify the sexual act, 'les plaisirs de Vénus', colloquially to refer to venereal disease, 'un coup de pied de Vénus', and in medical terminology to signify the female genitalia, 'le Mont de Vénus'. The many variations of the word 'Vénus' which appear in Alfred Delvau's *Dictionnaire érotique moderne* [1864] as descriptions for the sexual act demonstrate the extent to which she was equated in popular usage with sensual pleasure.
>
> (Shaw, 'The Figure of Venus', p.553).

This powerful idealized goddess of generation could fall from grace, a supposed 'feminine weakness', to become a 'Vénus populaire', a woman of the street corrupting and debauching the elevated 'gods' and mythological figures of high art.

In contrast to the rich conventional language of the Ingres and Bouguereau, the signifiers in *Les Demoiselles* appear 'crude', 'dissonant', 'ugly', 'ambivalent': mask-like faces; blackened eyes; angular bodily forms; areas of thick paint texture; a flattened pictorial

space etc. Signs from the same signifying system are used, but disrupted; social issues such as 'sex', 'violence', 'power', 'class', 'gender', which are encoded deeply and *safely* in the Ingres and Bouguereau, become either unavoidable or repressed in accounting for *Les Demoiselles*. How might we examine this hypothesis in terms of semiotics?

Voloshinov, Bakhtin and the origins of 'social semiotics'

In the late 1920s, a group of linguists in Leningrad drew upon Saussure's work and that of the Russian Formalists (Moscow Circle), but they departed, crucially, from the systematic and formal emphases of both, developing a 'social semiotics'. Before we consider its usefulness in examining our hypothesis about *Les Demoiselles*, I need to alert you to a mystery about the texts produced by this group. Two of its members were Mikhail Bakhtin and Valentin Voloshinov, both of whom published important works in the twenties. Voloshinov seems to have disappeared in the thirties, as did many Marxists under Stalin's purges. In 1973, when Bakhtin was 75, it was claimed that he was the author of works signed V.N. Voloshinov, as well as those signed P.N. Medvedev, another member of the group, who published a critique of Formalism in 1928. This has been a matter of dispute with some claiming that these works may have been co-authored. What matters to me here are the ideas and methods contained in the works, many of which have a common direction.

In 1929, in *Marxism and the Philosophy of Language*, Voloshinov argued that Saussure's *Course in General Linguistics* contained a central mistake: its emphasis on *parole*, speech or utterance, as a thoroughly individual entity. Saussure's system leads us away from the 'living, dynamic reality of language and its social functions' and underlying his theory are 'presuppositions of a rationalistic and mechanistic world outlook' (p.82): for Voloshinov, the utterance is a *social phenomenon* .

Bakhtin also argued that the utterance is social because it is 'born in a dialogue as a living rejoinder within it; ... every word is directed toward an *answer* and cannot escape the profound influence of the answering word it anticipates' (*The Dialogic Imagination*, p.279). Both Voloshinov and Bakhtin emphasize how an utterance is oriented to a response; it aims to provoke an answer and structures itself, in anticipation, to that response. Bakhtin argued that language in use is '*dialogic*' with each speech act rooted in previous utterances and being structured in expectation of a response:

> All rhetorical forms ... are oriented toward the listener and his [sic] answer. This orientation towards the listener is usually considered the basic constitutive feature of rhetorical discourse ...
>
> The listener and his response are regularly taken into account when it comes to everyday dialogue and rhetoric, but every other sort of discourse as well is oriented toward an understanding that is 'responsive' ... Responsive understanding is a fundamental force, one that participates in the formation of discourse, and is moreover an *active* understanding, one that discourse senses as resistance or support enriching the discourse.
>
> (*The Dialogic Imagination*, pp.279–81)

This emphasis on dialogic exchange is markedly different from the Saussurean tradition which not only claims an arbitrary link between sound/image and concept but also emphases the systematic aspects of language in contrast to the *individual* character of speech/image. For Voloshinov/Bakhtin the utterance, in sound or vision, is regarded as the product of a *social* and *dialectic* interaction. As such a product, it is a carrier of ideas, values and beliefs some of which are consciously intended, others which are mediated by unconscious desires, wishes and expectations. Ideas, values and beliefs are the province of ideology. Voloshinov, in particular, argued that in visual representations, as in spoken or written dialogue, it is necessary to investigate the ideological character of the utterance or visual image. This means treating both *langue* and *parole* as socially grounded.

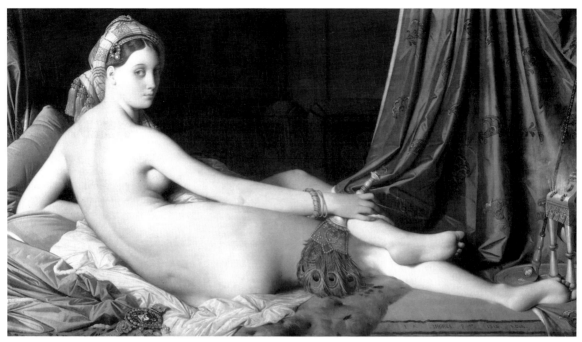

Plate 105 Jean-Auguste-Dominique Ingres, *Grande Odalisque*, 1814, oil on canvas, 91 x 162 cm. Musée du Louvre, Paris. Photo: Lauros-Giraudon. (*Grande Odalisque* was hung beside *Olympia* at the Louvre in 1907.)

Following emphases in the writings of Marx and Engels, Voloshinov argued that everything 'ideological possesses *meaning*: it represents, depicts or stands for something lying outside itself. In other words it is a *sign*' (*Marxism and the Philosophy of Language*, p.2). Furthermore every phenomenon functioning as an ideological sign has some kind of material embodiment, whether in sound, physical mass, colour, movements of the body, or the like. In this sense it reflects and refracts another reality outside itself. Voloshinov elaborated Marx's and Engel's view of ideology as illusion, false consciousness, reality turned on its head. He also argued that the way various social classes use the same language, the same signs in different ways and contexts is indicative of class struggle: 'various different social classes will use one and the same language. As a result, differently oriented accents intersect in every ideological sign. Sign becomes an arena of class struggle' (p.23). By 'accents' he meant the way that different and competing social classes evaluate the sign differently.

Let's ground this theoretical discussion in an example. In January 1907, when Picasso was working on preparatory studies for *Les Demoiselles*, Manet's *Olympia* was installed in the Louvre alongside Ingres's *Grande Odalisque* (Plates 105 and 106). *Olympia*, the scandal of the Salon of 1865, was regarded as a landmark of avant-garde practice: using a sign of Academic discourse, the pose of Titian's *Venus of Urbino*, together with signs signifying the perceived reality of a contemporary prostitute. On the other hand, the *Grande Odalisque* was an ambivalent exemplar of the elevated ideals of the Academy and the Salon.

I want to consider *Olympia* as an ideological sign in which, in Voloshinov's terms, 'differently orientated [*social*] accents intersect': it thus becomes 'an arena of class struggle'. To explore these possibilities, we can seek the signs of such an intersection in the contemporary reception of the painting. T.J. Clark argues that, in the context of Haussmann's transformation of Paris, *Olympia* did not have a fixed significance or social

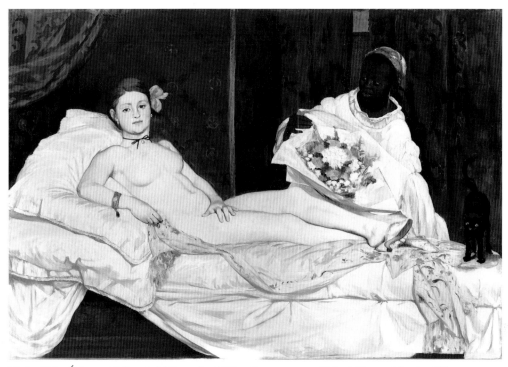

Plate 106 Édouard Manet, *L'Olympia*, 1863, oil on canvas, 130 x 190 cm. Musée d'Orsay, Paris, Photo: Réunion des Musées Nationaux Documentation Photographique.

meaning.[11] He quotes Ravenel's criticism of the Salon of 1865, which both in its references and 'staccato' form gets near to the politics of the picture as a 'stew of half-digested significations'. Ravenel reels off a succession of connections: Baudelaire and the poems of *Les Fleurs du Mal*, six of which had been legally 'suppressed' as 'obscene and immoral'; Goya, the Spanish painter renowned for political paintings and 'nightmare' images; the *faubourienne*, a 'common' girl from a working-class suburb; Eugène Sue's Parisian low-life stories, the *Mysteries of Paris* (1847); Poe's tales of the macabre, translated by Baudelaire, and a specific all-night bar, Paul Niquet's, frequented by the prostitutes of Les Halles, the market district of Paris:

> Each passer-by takes a stone and throws it at her face. *Olympia* is a very crazy piece of Spanish madness, which is a thousand times better than the platitude and inertia of so many canvases on show in the Exhibition.

> Armed insurrection in the camp of the bourgeois: it is a glass of iced water which each visitor gets in the full face when he sees the BEAUTIFUL *courtesane* in full bloom.

> Painting of the school of Baudelaire, freely executed by a pupil of Goya; the vicious strangeness of the little *faubourienne*, woman of the night from Paul Niquet's, from the mysteries of Paris and the nightmares of Edgar Poe. Her look has the sourness of someone prematurely aged, her face the disturbing perfume of a *fleur du mal*; her body fatigued, corrupted … The cat arching its back makes the visitor laugh and relax; it is what saves M. Manet from a popular execution …
> (Ravenel, quoted in Clark, *The Painting of Modern Life*, p.139–40)

[11] 'Olympia's choice', in *The Painting of Modern Life*, and 'Preliminaries to a possible treatment of *Olympia* in 1865'.

Olympia disrupted the relationship between the variable social codes for conventionally separate discourses. Manet evoked, on the one hand, the discourse of aesthetic judgement for 'artistic nudity' through the paradigm of Titian's *Venus of Urbino* and many contemporary Academic exemplars of 'the reclining nude' or 'odalisque' in a mythical or exotic setting, and, on the other hand, the discourse of female nakedness 'in which the relations and disjunctions of the terms Woman/Nude/Prostitute were obsessively rehearsed' (Clark, 'Preliminaries to a possible treatment of "Olympia" in 1865', p.23). The black cat is a traditional symbol of licentiousness (as in the Chardin) and the black servant, with the bouquet as a metaphor for 'flourishing' genitalia, is a sign of French colonialist fantasies about the exotic and erotic. These combine with those of the conflicting social meanings of the figure of *Olympia*.

In Voloshinov's terms, the *multiaccentuality* of *Olympia* revealed the misrepresentational character of the ideal 'Venus' or 'odalisque'. Here, 'multiaccentual' does not simply mean that a sign can have ambiguous or polysemic meanings. Voloshinov argues that some signs are 'multiaccentual' because they have a potential *social* variability which necessarily challenge the idea of a 'correct' or 'proper' meaning. For instance, an aristocrat may take 'social class', as in 'little *faubourienne*', to refer to distinctions of rank, a proletarian socialist, on the other hand, to distinctions of power and the exploitation of working-class women. For Voloshinov, signs which do not have such social potential are *uniaccentual*, conforming to a 'correct' or 'proper' meaning as socially and politically valued by dominant groups or classes.

To return to *Les Demoiselles*: in the contect of 1907, it too can be considered as socially multiaccentual, though we do not have a text comparable to the Ravenel. What we can examine though is whether the use of the 'Vénus Anadyomène' pose in this particular utterance indicates an attempt to avoid the single social evaluation. Voloshinov argues that a sign that has been withdrawn from the 'pressures of the social struggle ... inevitably loses force, degenerating into allegory and becoming the object not of live social intelligibility but of philological comprehension' (*Marxism and the Philosophy of Language*, p.23). From the little we do know of contemporary reaction to *Les Demoiselles* such as by the Steins and Matisse the general response was a mixture of horror, outrage and offence. One response, reported in different ways, is that of Braque on seeing the painting in late November 1907: '*C'est comme si tu buvais du pétrole en mangeant de l'étoupe enflammée*' ('It's as if you drank petrol while eating flaming tow'). As Leighten points out, *l'étoupe* means 'tow' in the sense of 'fuse' or 'wick', which with gasoline constitutes a Molotov cocktail, an anarchist bomb, affirmed by the common phrase '*mettre le feu aux étoupes*' ('to light the fuses') (*Re-Ordering the Universe*, p.91). Braques's *Large Nude* (Plate 103), from the following spring, is evidence of his attempt to constitute a comparable Molotov cocktail. In Voloshinov's terms, then, *Les Demoiselles* has not, apparently, withdrawn from the pressures of the social struggle. Like *Olympia* it has resisted the 'allegory' of Ingres and Bouguereau.

Voloshinov argues that in periods of ideological dominance, the ruling class strives to impart an eternal or absolute character to the ideological sign, to strip it of its multiaccentuality, to suppress the accents which characterize the social evaluations of suppressed or marginalized groups. In the ordinary conditions of life, the dominant ideology and its associated thinking and assumptions have no role for suppressed meanings, which are therefore neglected or erased. For instance, mothers 'at home' have understood 'work' in a different way from most social administrators, for whom a 'working mother' is one in a 'paid occupation'. The meaning of 'work' has thus been officially constricted so that those activities which one group (mothers not in a paid occupation) call 'work' have not been recognized as such, and this group's understanding of the term has been marginalized. In times of revolutionary or social crisis the suppressed group may reassert its interpretation and the suppressed accent may reemerge in struggle with the

dominant accent. One example of this is the critique of power structures and demands for sexual equality of the late 1960s, especially with the rise of the Women's Movement and feminism.

Polarities: the meaning of differences

Let's consider the accents in *Les Demoiselles*. I want to do this by looking at the mask-like faces of the two figures on the right in relation to the two in the centre, at the squatting figure displaying a rear torso and a full face, at the contrast between the two central variations on the 'Vénus Anadyomène' pose and the poses of the other three 'women', and lastly at the use of 'profile' and 'frontal' views.

In a semiotic analysis, Meyer Schapiro has demonstrated how the opposites of profile and frontal have operated in particular systems of visual representation. For example, in Western medieval art the profile is conventionally attributed to Judas in the Last Supper, in contrast to Christ and the apostles, who are represented in full or three-quarter face. The asymmetry of the profile was used to signify the demonic while the 'full-face has an ideal closure and roundness – smooth regular and symmetrical'. At other times,

> [in the] same styles the pious donor [who commissioned the picture] kneels in profile before a majestically enthroned frontal Christ or Virgin. And Satan as a ruler among his subjects may appear in as strict frontality ... Two senses of the same view may exist then in one style like the variable senses of a word, a grammatical category, or syntactical form in different contexts.
>
> ('Frontal and profile as symbolic forms', p.45)

What we see here is an example of the way in which signs often operate as pairs or couplings, as carriers of opposed qualities in the same work. It is their *relationship* in the specific work (like the combination of words in a particular sentence) rather than any fixed quality that carries meaning:

> One of the pair is the vehicle of the higher value and the other by contrast, marks the lesser. The opposition is reinforced in turn by differences in size, posture, costume, place and physiognomy as attributes of the polarized individuals. The duality of the frontal and profile can signify then the distinction between good and evil, the sacred and less sacred or profane, the heavenly and the earthly, the ruler and the ruled, the noble and the plebeian, the active and the passive, the engaged and the unengaged, the living and the dead, the real person and the image.
>
> ('Frontal and profile as symbolic forms', p.43)

The matching of these qualities and states varies in different cultures and contexts but what is common is the contrasted positions setting up a polarity:

> Sometimes the body as a whole rather than the face is the carrier of the frontality or profile, sometimes the head more than the body, and there are examples in which the contrast is of profile and three-quarters, of full-face and near-profile, of three-quarters and full-face.
>
> ('Frontal and profile as symbolic forms', p.43)

In *Les Demoiselles* profile and frontality, in body and face, may be regarded as frameworks within which Picasso reinforced a particular quality of the figures through associated features, achieving a powerful expression of polar meanings. For instance, consider the 'frontal eye' and 'profile nose' of the faces of the figures – the variations are significant, including the figure top right whose half turned face includes profile nose with one blackened frontal eye and one in profile. Taking into account the *context* of the painting, a rep-

resentation of a brothel, with its social and sexual meanings, there are several potential couplings of opposed social and psychoanalytic contrasts related to variable notions of 'Venus' such as 'Madonna' or 'whore' which, as we have seen, were rooted in nineteenth-century discourses. The face of either: a particular 'woman' as person or a generalized 'body' as commodity; authentic feeling or alienated work; sex as good and sacred (as associated with love) or evil and profane (as associated with lust); desire as heavenly fulfilment or as earthly pleasure; active engagement or passive disengagement; a real person or an 'image', a 'fantasy', a 'substitute'.

This polarity is continued throughout the work. On the left, a woman in profile lifts up a drape or curtain to display the two 'Vénus Anadyomène' poses which are frontal; the other figures on the right are also variations of the frontal (one slightly turned, the other full face, full back). The skin tone of the profile face is different from the others, perhaps signifying greater age or different ethnic origin, and the 'pink drape' down her right side suggest she is semi-dressed. In contrast to the other four figures she might represent the procuress or madame of the brothel. Here, too, there is a polarity. The two central figures are versions of the idealized 'Venus'. The two on the right framed by the blue drapes have faces heavily marked by textured paint and by force of contrast suggest mask-like qualities. These faces are carriers of at least two possible references. The first is to so-called 'primitive' African masks and ancient Iberian heads as signifiers of a contemporary obsession among artists with notions of the 'primitive' and, in the wider sphere, of new ethnographic collections and museums as public symbols of the 'benign' side of Colonialism and Imperialism. There was as we saw in the previous chapter, contradiction in these obsessions and in public and private collections which systematically categorized the objects of different, exploited and plundered cultures, by means of their own signifying systems; systems alien to those of the production and reception regimes in which the objects originally signified meaning. On the one hand, the arts of societies and cultures 'discovered' by Europeans in colonizing the world acquired the special prestige of the 'time-less' and 'instinctive'; a fantasized 'other' to a modernized Western world and its seeming subjection of the individual to alienating processes. On the other, official designations classified these as 'backward' or 'uncivilized' products of savage 'primitive' people benefiting from modern Western social organization. The values of exploitation and commodification struggle with those of projected feelings as fantasy or dream. As they do with male projections of 'Venus' signifying 'whore' or 'Madonna'.

The second reference is not unrelated to the first. Those returning from 'exotic' areas brought back diseases including those sexually transmitted. Venereal disease was carried to the colonies and spread through Western style brothels, filled with local women, which were often set up for the military agents of colonialism and then brought back to the home country. Some of Picasso's preparatory studies for *Les Demoiselles* were of sailors who like soldiers were peripatetic carriers of such disease (Plates 92, 93). If we look at French photographs of those suffering from the effects of syphilis (Plate 107), and at examples of the kind of African art that Picasso admired (Plates 49, 108, 109), we can see that the faces on the right of Picasso's painting may be pictorial signifiers for primitive masks or for the deformed faces of those, especially prostitutes, suffering from venereal disease; or, importantly for *both*. As we saw from *Two Sisters* the dilemmas of the relationships between sexual attraction, prostitution and venereal disease had been a theme in Picasso's work and continued at the time to be both an active personal concern and the subject of a furious public controversy.

Plate 107 Two photographs (frontal and profile) of a head of a person suffering from advanced stages of syphilis, from E. Besnier, A. Fournier *et al.*, *Le Musée de l'Hôpital Saint-Louis: Iconographie des maladies cutanées et syphilitiques avec texte explicatif*, Paris, Fueff et Cie., 1896–97, pp.194, 195. Bibliothèque Nationale.

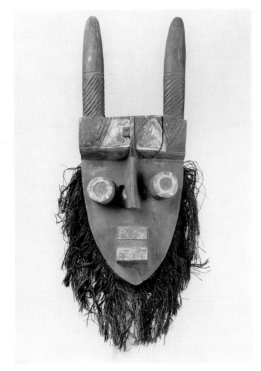

Plate 108 Grebo mask, Ivory Coast or Liberia, painted wood and fibre, 64 cm high. Musée Picasso. Photo: Réunion des Musées Nationaux.

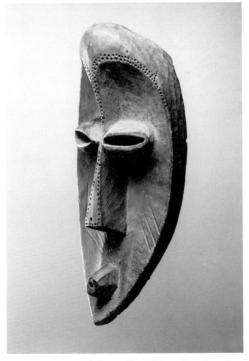

Plate 109 Mask from Etombi region, border of Gabon and Congo Republic, *c.*1775, wood, 36cm high. Photo: P.-A. Ferrazzini, Musée Barbier-Mueller, Geneva.

In terms of our discussion, the faces have variable meanings which would have been consistent with Picasso's attempt at a living rejoinder to other art practices. He included explicit references to particular sources such as to the 'Ingres' paradigm and to Cézanne and Degas in the squatting figure on the right. Here we find the full face of the figure and the 'full face' of her back, that is without the display of breasts which is such an important aspect of the 'Vénus Anadyomène' pose. The polarities of the sensual or erotic, associated with 'authentic' love, and of the risk of illness if not death, associated with bodily pleasures and *vanitas* add to other polarities in the work. Some of these contrasts are rooted in the doctrines and redemption/damnation polarities of Picasso's Catholic origins.

Schapiro makes a further observation about the significance of profile and full face, suggesting that they might signify different relationships between a subject and observer, with strong metaphoric and psychoanalytic overtones. Discussing medieval art, he notes that the profile face is 'detached from the viewer' and belongs with the body 'in action':

> It is, broadly speaking, like the grammatical form of the third person, the impersonal 'he' or 'she' with its concordantly inflected verb; while the face turned outwards is credited with intentness, a latent or potential glance directed to the observer, and corresponds to the role of 'I' in speech, with its complementary 'you'.
>
> ('Frontal and profile as symbolic forms', pp.38–9)

Schapiro observes that the pairing of frontal and profile views was also used in various contexts in painting of the late nineteenth and early twentieth century where it 'returned as elements of a strong expressionist trend, both in portraits and narrative themes' (p.61), such as by Munch, Ensor and Vuillard. In *Les Demoiselles* Picasso pairs the 'impersonal' profile face belonging with the body 'in action', drawing back the drapes, and the frontal face and body with a 'glance directed to the observer'. For Schapiro, in medieval examples such a role of 'I'/'you' 'seems to exist both for us and for itself in a space virtually continuous with our own, and is therefore appropriate for the figure as symbol or as a carrier of a message' (p.39).

As with Olympia's face, the message carried by the full faces in *Les Demoiselles* depend upon a *context* – both the general one of a period in which the socio-economic realities and relations of a market-economy operate and the specific one of the viewer's gender within those realities and relations. While the semiotic polarity of frontal and profile is a resource within a language of visual representation that goes back at least to the medieval period, its specific *use* has particular social and psychological meaning. The interaction 'I'/'you', identified by Schapiro, is rendered problematic by the full faces in Picasso's and Manet's images as alienated blank expressions and as 'looked at'. Is the message carried by the full face in these images that of the relationship involved in the alienated work of prostitution in modern metropolitan life? If the frontal eyes, in Schapiro's words, 'hold our gaze', whose gaze (what class, gender, race) is actually doing the holding?

Earlier, we saw evidence, in the nineteenth century, of the simultaneous existence of contradictory tendencies, attitudes or feelings in the relationship to the single object with the name 'Venus'. On the one hand, 'madonna', the feminine as maternal, idealized sexual desire and fulfilment; on the other, 'whore', the feminine as commodity, coitus as the carrier of venereal disease. Here we have the ground for psychoanalytic ambivalence: the coexistence of love and hate, desire and fear, possession and rejection. These are socially specific. But so too are they gender specific. Laura Mulvey argues that, traditionally, the scopophilic instinct (the pleasure taken in looking at another person as an erotic object) acts as a mechanism which moulds formal attributes in representation (such as the use of 'profile' and 'full face' in narrative images) and sets up a particular version of the 'passive'

and 'active' polarity. The actual image of woman as 'passive' raw material for the 'active' male gaze is structured into the system of representation:

> In a world ordered by sexual imbalance, pleasure in looking has been split between active/male and passive/female. The determining male gaze projects its fantasy onto the female figure, which is styled accordingly. In their traditional exhibitionist role women are simultaneously looked at and displayed, with their appearance coded for strong visual and erotic impact so that they can be said to connote *to-be-looked-at-ness*. Woman displayed as sexual object is the *leitmotif* of erotic spectacle: from pin-ups to strip-tease, from Zeigfeld to Busby Berkeley, she holds the look, and plays to and signifies male desire.
>
> ('Visual pleasure and narrative cinema', p.19)

Mulvey is concerned with narrative cinema, but aspects of her analysis can be usefully applied to paintings. For instance in *Les Demoiselles* there is no male character, only 'woman' as 'erotic spectacle'. Yet an active male character is obviously envisaged by Picasso by the very nature of the brothel scene and the representation of women on display for a client. The spectator of the painting is thus placed in a position of identifying with the invisible client, the main male protagonist in the transaction between woman as idealized commodity and male purchaser bearing the look of erotic consumption. The active power of the actual spectator's erotic look coincides with the identification, consciously or unconsciously, with this ideal male protagonist who 'controls' the events of the pictorial narrative of the 'brothel experience'. Both give the male spectator a satisfying sense of omnipotence. The painting works differently if the spectator is female.

But, as Mulvey argues, the erotic look and sense of male omnipotence is conventionally triggered in the narrative illusionism of a three dimensional space. In paintings, the equivalent space is to be found in Ingres's or Bouguereau's use of 'mirror' likeness. This is important, because for Mulvey the power of the erotic male look is bound to the convention of three dimensional illusionism in a particular psychoanalytic moment of ego development. She explains:

> Jacques Lacan has described how the moment when a child recognises its own image in a mirror is crucial for the constitution of the ego ... The mirror phase occurs at a time when children's physical ambitions outstrip their motor capacity, with the result that their recognition of themselves is joyous in that they imagine their mirror image to be more complete, more perfect then they experience in their own body. Recognition is thus overlaid with misrecognition ...
>
> ('Visual pleasure and narrative cinema', p.17)

Here the recognized image in the mirror, fantasized as actual, is conceived as the 'superior' body of the self, with its own ideal ego. This idealized and powerful reflection is internalized by the child as an ego ideal, preparing for the way in which the individual identifies with others in the future. In terms of our discussion, in representations such as the Ingres or Bouguereau, the male spectator identifies with 'woman' by means of an idealized erotic spectacle, which signifies a reassuring, imaginary existence for the ego ideal. All of this assumes a male 'recognition' (of the ideal self), overlaid with misrecognition of actual relations and experience within patriarchy. In contrast, *Les Demoiselles* does not use the sign for an unblemished ideal body, but that for a fragmented body with multiple significations which do not easily allow the gaze its omnipotent security. This configuration 'destroys' the conventional illusion of depth and space 'demanded by the narrative'. However we need to be aware that the fragmented body parts which have a quality of a cut-out image in *Les Demoiselles*, may integrate into conventional narrative what Mulvey calls a 'different mode of eroticism', which is encoded in the painting's particular semiotic polarities.

The Blue Nude

In order to examine this possibility, let's look at another of the semiotic polarities of *Les Demoiselles*: 'red' (hot)/'blue' (cold). The two figures on the right with the primitive mask/syphilitic heads are framed by blue drapes. 'Blue' had several connotations in this context. Picasso had used the colour in his earlier work to signify 'melancholia' and the 'socially marginalized', Another is its association with representations of the Madonna (Virgin Mary) because it was originally an expensive pigment. But it had also been used recently. Picasso was aware of the fuss caused by Matisse's *Blue Nude*, with its use of the 'odalisque pose', when exhibited in the Indépendants of 1907. The painting was bought by Leo Stein, adding to its status within a particular Parisian community, and 'complemented' by Derain's *Bathers* with its use of strong blue to frame the figures on the left, including that of the 'Vénus Anadyomène' pose (Plates 54 and 102).

In Academic discourse, colour had been regarded as 'feminine', as the antithesis of intellectual control. By contrast (conscious or otherwise) the use of vivid colour had become an important element in recent art practice. Gauguin's *Vision after the Sermon* and his *Yellow Christ*, both exhibited at the Salon d'Automne of 1906 (Plates 11, 17), were reminders of Symbolist and modernist signifiers in that they used non-naturalistic colour in broad areas tending toward flatness (i.e. denying the depth required by narrative), incorporated angular 'primitive' forms and an intensification of the non-narrative image, again by limiting the illusion of depth. The Fauves used aspects of these devices and they formed part of Picasso's pictorial grammar. Matisse's *Blue Nude* is an instance of speech in this system. It comes from an orientalist tradition of painted 'odalisques', linked by the sub-title 'Souvenir of Biskra' to one of the towns of the Ouled-Naïl tribe in Algerian North Sahara which Matisse visited in 1906. The word 'souvenir' evokes the postcard or a memento (Plate 110); it could also signify, perhaps, a disease contracted physically.

In using the 'odalisque pose' Matisse invoked the various social value judgements which it involved. One of these legitimized Western interpretations of the harem, including the view that it was a form of organized prostitution. According to David Gordon,

Jeune Mauresque et Femme Kabyle.

Plate 110 *Jeune Mauresque et Femme Kabyle* (*Young Moorish Woman with Kabyl Woman*), undated, Algerian postcard. Reproduced from Malek Alloula, *The Colonial Harem*, Minnesota University Press, 1986, p.99.

women of the tribe, the so-called 'daughters of the Naïl' traditionally entered into private prostitution without shame; they did not solicit but indicated consent by lowering their eyes, as does the figure in the *Blue Nude*. However, their particular dignified rituals were corrupted during French colonialism to serve tourism: belly dances and nudity were introduced – as in this representation – and even when open and public houses of prostitution were made illegal in France, they were retained in Algeria.[12]

As discussed in chapter one, colonialism was regarded by many right-wing organizations such as Action française as a potential resource of power for French nationalism especially in confrontation with Germany, then perceived as the country's traditional enemy. Colonies were seen as a reservoir of unquestioning soldiers, 'barbaric and submissive forces', 'bayonets who don't reason, don't retreat and don't pardon' (Melchior de Vogüé, 1899, quoted in R. Girardet, *L'Idée coloniale en France*, p.102). While the colonized male was thought of in terms of military potential, many women became conscripts into 'bizarre caravans' (Gordon, *The Women of Algeria*, p.42) of mobile military brothels. The latter were patronized by French military conscripts and recruits, or 'bleus' ('blues') as they were commonly called. The skin of the local Tuareq, another tribe from the region conscripted to fight for France in World War One, was often blue tinged because of the heavy use of indigo dye in clothing.

One powerful strategy of French colonialism was the absorption of women into civil and military prostitution. This not only undermined the traditional values of the Algerian family, but was also intended to open the colonies to French cultural assimilation. This is scopophilia, the power of the gaze, at a larger public level. Artists and photographers colluded in this process. In his analysis of photographic representations of Algerian women by the French in colonial postcards, Malek Alloula argues that these are scopic metaphors:

> The first thing the foreign eye catches about Algerian women is that they are concealed from sight … Draped in the veil that cloaks her to her ankles, the Algerian woman discourages the *scopic desire* [the voyeurism] of the photographer [Plate 111]. She is the concrete negation of this desire and thus brings to the photographer confirmation of a triple rejection: the rejection of his desire, of the practice of his 'art', and of his place in a milieu that is not his own.
>
> (*The Colonial Harem*, p.7)

This, though, does not prevent the photographer, or the painter in a studio, constructing a representation in which: 'he will unveil the veiled and give figural representation to the forbidden'; this will be his 'symbolic revenge upon a society that continues to deny him any access and questions the legitimacy of his desire' (p.14). In the controllable space of the studio, 'his desire, his scopic instinct, can find satisfaction', not least by submitting his Algerian models to poses within a Western signifying system, like the variations on the 'Vénus Anadyomène' (Plates 112, 113). Matisse, in his studio, uses the 'odalisque pose', another element in a French (and arguably Western) sign system, and here he also omnipotently removes the actual and metaphoric 'veil'. And we should be aware of our role here: in viewing these photographic and painted images, we may be voyeuristically colluding with, and legitimating, a sexual and colonial 'scopic instinct'.

In *Les Demoiselles*, which has some common gound with this system, prostitution is also made 'exotic' by the represented location, Barcelona. There is a 'veil', in the form of drapes, and it is being 'drawn back'. In representing a woman doing this, Picasso metaphorically implicates 'woman' in his own and the male viewer's scopic desire. The central 'Vénus Anadyomène' poses *still* hold 'the look', and are used so as to play to and signify 'male desire'.

[12] D. Gordon, *Women of Algeria: An Essay on Change*. See, too, The Open University, *Cubism: Picasso and Braque* (by Francis Frascina), pp. 34–8.

Plate 111 *Mauresque en promenade* (*Moorish woman taking a walk*), undated, Algerian postcard. Reproduced from Malek Alloula, *The Colonial Harem*, Minnesota University Press, 1986, p.14.

Plate 112 *Femme Kabyle se couvrant de son Haïck* (*Kabyl woman covering herself with her Haïck*), undated, Algerian postcard. Reproduced from Malek Alloula, *The Colonial Harem*, Minnesota University Press, 1986, p.15

Plate 113 *Scènes et types – Jeunes Mauresques* (*Scenes and Types – Young Moorish Women*), undated, Algerian postcard. Reproduced from Malek Alloula, *The Colonial Harem*, Minnesota University Press, 1986, p.101.

Realism, ideology and the 'discursive' in Cubism

We have considered *Les Demoiselles* as a social utterance with respect to *aspects* of an existing sign system. In terms of Voloshinov's social semiotics, the painting's *multiaccentuality* tells us much about the limits of the signifying system within which it operates. However, while the painting as a sign may be a site of social struggle, it is still deeply problematic, not least in terms of issues of gender and class. By comparison, Picasso's *'Ma Jolie' Woman with a Zither or Guitar* (Plate 114) departs from this previous sign system. This is not the body required by narrative illusionism. It seems 'veiled' by an emphasis on technical and compositional signifiers (paint marks, faceted structure etc.). And the 'fragmented body' of *Les Demoiselles*, in which a different mode of eroticism is encoded in the painting's polarities, has been developed to a point where a wholly different signifying system seems to operate. We can call this a Cubist sign system, a successive modernist discourse to the one within which *Les Demoiselles* operates. Braque's *Le Portugais* (Plate 115) is clearly in this same Cubist sign system.

By 1911, Picasso and Braque were producing work almost as a collective project, joking that they were like two mountaineers roped together. They saw each other most days, were intellectually and socially sustained by a particular cosmopolitan group, and enjoyed an informal contract with Kahnweiler, which was formalized late in 1912. Similar interests are evident from their work, two major themes of which are figure compositions, including portraits, and the still-life. *Girl with a Mandolin*, *Portrait of Daniel-Henry Kahnweiler* and *The Accordion Player* (Plates 116, 117, 118) are examples of Picasso's figure paintings in the two years prior to *Ma Jolie*. *Man with a Mandolin* and *Woman Reading* (Plates 119 and 120) show comparable paintings by Braque prior to *Le Portugais*. Parallel examples of still-life works abound: *Violin and Palette*, *Composition with Violin* and *Clarinet and Bottle of Rum on a Mantelpiece* (Plates 121, 122, 123) indicate Braque's interests in this genre during this period. These paintings become chronologically more difficult to decipher without knowledge of the systematic *langue* that the artists appear to be using. For many Modernists, the works are on the 'threshold' of a formal development to abstraction. However, judging by later statements, the artists were pursuing a 'realistic' orientation. In 1917, in the magazine *Nord-Sud*, Braque talked of painting as a 'method of representation' (quoted in Goldwater and Treves, *Artists on Art*, p.422) and in an interview in 1954 he recalled: 'as I always wished to get as near as possible to reality, in 1911 I introduced letters into my pictures' (quoted in D. Vallier, 'Braque, la peinture et nous', p.16).

We saw earlier the notions of 'reality' and 'realism' which informed Cubist ideas. One influence was the philosophy of Henri Bergson which had an enormous cultural impact in France and beyond. His open lectures at the prestigious Collège de France were always packed and his articles and books avidly read, particularly by educated young people in France, a large number of whom became militant advocates of 'Bergsonism'.

Bergson's philosophy was profoundly anti-materialist and idealist. He claimed that 'reality' was that which 'we all seize from within', that it is made up of each individual's experience and intuition of the world rather than external objectivity or 'simple analysis'. In 1903, in *Introduction de la Métaphysique*, he wrote that intelligence could only come to grips with the ceaselessly changing direction of 'mobile reality' by means of 'intuition':

> The mind has to do violence to itself, has to reverse the operation by which it habitually thinks ... in this way it will attain to fluid concepts, capable of following reality in all its sinuosities and of adopting the very moment of the inward life of things.
>
> (*An Introduction to Metaphysics*, p.51)

Plate 114 Pablo Picasso, *'Ma Jolie': Femme à la guitare ou cithare* (*'Ma Jolie': Woman with Zither or Guitar*), winter 1911–12, oil on canvas, 100 x 65 cm. The Museum of Modern Art, New York. Acquired through the Lillie P. Bliss Bequest. © DACS 1993.

Plate 115 George Braque, *Le Portugais*, summer 1911, oil on canvas, 117 x 82 cm. Kunstmuseum Basel. Colour photo: Hans Hinz. © ADAGP, Paris, DACS, London 1993.

Bergson saw reality as something in constant flux and change. Each person's notion of reality is made up of memories, experiences of the past, which are simultaneously present in individual consciousness. There is a simultaneous flow of past and present, into future; time is essentially intuitive 'experience', flow or what Bergson calls 'duration'. Consciousness of the present is thus composed of a number of shifting, transforming, interpenetrating states of being. Bergson maintained that analytic reasoning or conceptualizations destroy an individual's sense of 'inner consciousness' because they lead to separate states which are deprived of their unique inner life. This idealist notion of 'reality' was highly influential; it is evident, for example, in the novels of Proust, whose first volume of

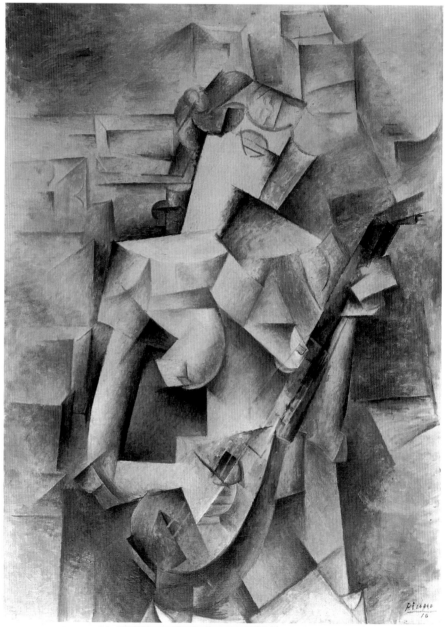

Plate 116 Pablo Picasso, *Femme à la mandoline 'Fanny Tellier'* (*Girl with a Mandolin 'Fanny Tellier'*), late spring 1910, oil on canvas, 100 x 74 cm. Collection, The Museum of Modern Art, New York. Nelson A. Rockefeller Bequest. © DACS 1993.

Remembrance of Things Past was published in 1913. As early as 1908 Apollinaire was writing in Bergsonian terms in a catalogue preface to an exhibition which included Braque, Derain, Matisse, Metzinger, Vlaminck and other contemporaries. He emphasizes the painter's individual instincts and need to 'be aware of his own divinity'. Spectators should also be able to experience 'their own divinity' through paintings, and 'To do that, one must take in at a single glance the past, the present, and the future … reality will never be discovered once and for all. Truth will always be new' ('The three plastic virtues', pp.48–9). This essay, with minor alterations, subsequently formed the first part of his *Les Peintures Cubistes: Méditations esthétiques*, 1913.

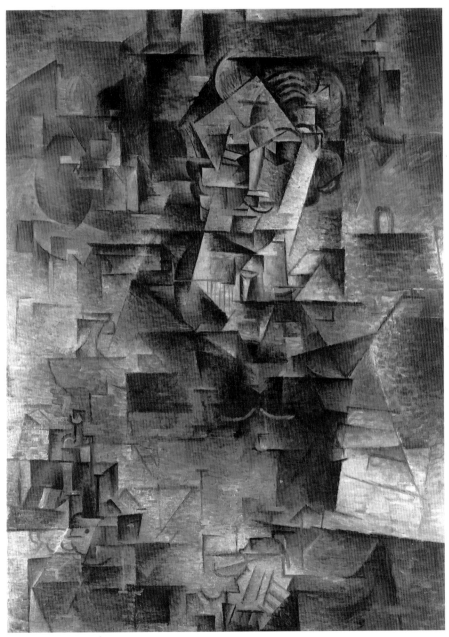

Plate 117 Pablo Picasso, *Portrait de Daniel-Henry Kahnweiler (Portrait of Daniel - Henry Kahnweiler)*, autumn 1910, oil on canvas, 1016 x 73 cm. The Art Institute of Chicago. Gift of Mrs Gilbert W. Chapman, 1948.561. © DACS 1993.

Plate 118 Pablo Picasso,
L'Accordéoniste (*The Accordion
Player*), summer 1911, oil on
canvas, 130 x 89 cm. The
Solomon R. Guggenheim
Museum, New York. Gift of
Solomon R. Guggenheim.
Photo: David Heald. © DACS
1993.

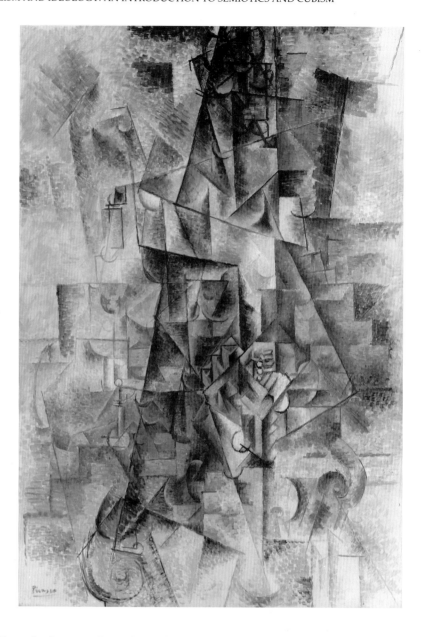

Bergson's philosophy has now been discredited, but at this period it provided a body
of ideas, evident in much contemporary Cubist criticism, consistent with concerns about
'inner essences', metaphysical alternatives to positivism, and poetic evocations of reality.
Some of these, as we will see, were related to the experience of taking opium. Another
influential set of beliefs centred around the mystical and 'spiritual' ideas of Theosophy,
which attracted artists such as Kandinsky and Mondrian. This can be broadly charac-
terized as the emergence of doctrines in which psychological process, what people
thought existed, had replaced external reality as the most pressing topic for investigation.

It's evident that the technical processes of Picasso's and Braque's works from 1909 to
1911 had been developed at the expense of conventional depiction. The later paintings are
furthest away from iconic dependence and conventional notions of realism, as something
dependent upon resemblance. There are, however common elements, exemplified in *Ma
Jolie*, that assist in identifying the *langue* of the works – the particular language system.

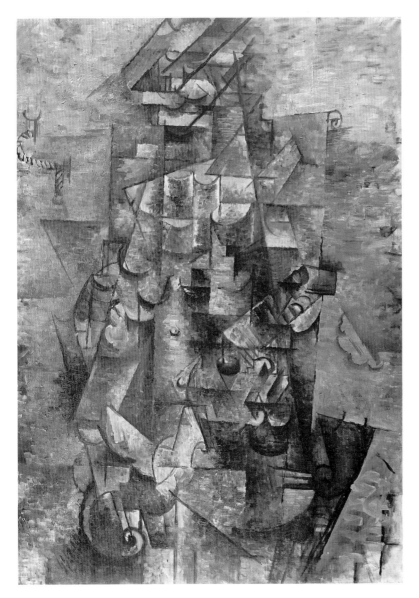

Plate 119 Georges Braque, *Homme à la mandoline (Man with a Mandolin or Guitar)*, summer 1911, oil on canvas, 116 x 81 cm. Collection, The Museum of Modern Art, New York. Acquired through the Lillie P. Bliss Bequest. © ADAGP, Paris and DACS 1993.

'Ma Jolie': metaphor, metonym, synechdoche

There is a Cubist sign for a head at top centre which is devoid of physiognomic detail save for an indication of hair to the right. Below is a narrow plane signifying a neck, ended by an almost horizontal line for the shoulders. On the right is a sign for the woman's left 'arm' bent at the elbow; in the lower centre are those for part of a sound hole and curved strokes defining the fingers of the figure's left hand, below six vertical and parallel 'strings'. An oblique line of light and dark brush-marks just above the strings signify the fingers of the woman's right hand. It is also possible to identify the overall shape of an angular 'zither or guitar' body and neck. Curved forms signifying the woman's breasts are echoed throughout the picture. A curved form on the right stands for the arm of a chair, with its decorative tassels visible just below. On the far left, half way down, there is the outline of a music stand. At the bottom, to the left of the words 'Ma Jolie', a 'wineglass' is readable; to the right of the painted words, there is a treble clef and musical staff.

Plate 120 Georges Braque,
Femme lisant (*Woman Reading*),
1911, oil on canvas 130 x 81 cm.
Private Collection, Basel. Photo:
Courtesy of Oeffentliche
Kunstsammlung Basel. © ADAGP,
Paris and DACS, London 1993.

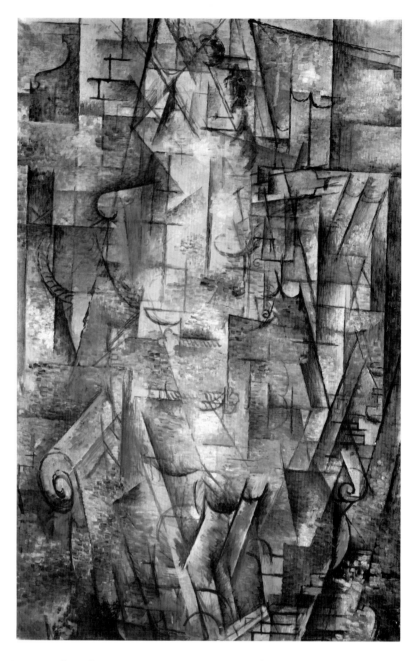

The clues or 'parts' are combined so as to give the spectator enough information to *construct* an *idea* of a figure and objects.

Roman Jakobson argued that we can understand the nature of these clues by reference to linguistic figures of speech like metaphor and metonymy ('The metaphoric and metonymic poles', pp.67–73). He saw metaphor and metonymy as alternative processes which fluctuate in predominance in semiotic behaviour. In a well-known psychological test children are confronted with a noun and asked to give the first response that occurs to them:

> To the stimulus *hut* one response was *burnt out*; another, *is a poor little house.* ... the first creates a purely narrative context, while in the second there is a double connection with the subject *hut*: ... a positional (namely syntactic) contiguity and ... a semantic similarity.

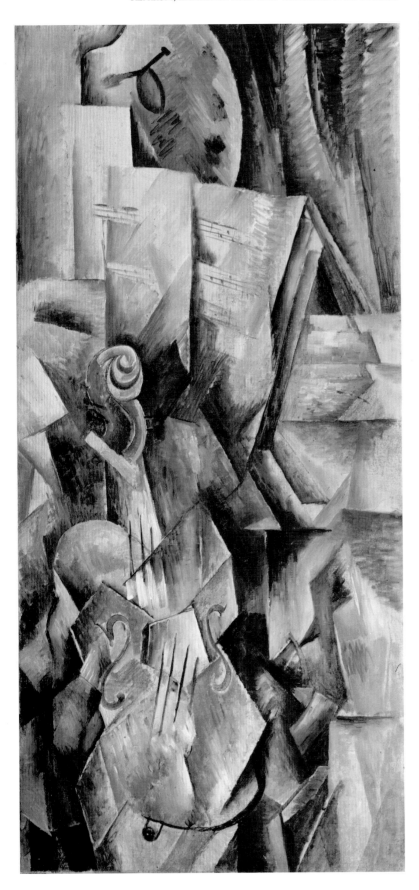

Plate 121 Georges Braque, *Violon et Palette* (*Violin and Palette*), 1909–10, oil on canvas, 92 x 43 cm. The Solomon R. Guggenheim Museum Collection, New York. Photo: David Heald. © ADAGP, Paris and DACS, London 1993.

Plate 122 Georges Braque, *Composition au Violon* (*Composition with Violin*), 1910–1911, oil on canvas, 130 x 89 cm. Musée National d'Art Moderne, Centre Georges Pompidou. © ADAGP, Paris and DACS, London 1993.

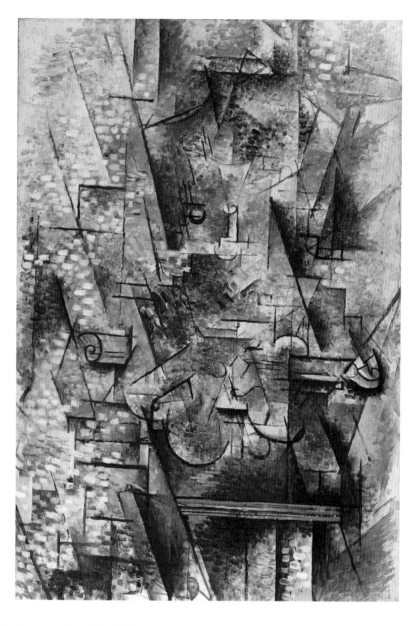

… The same stimulus produced the following substitutive reactions: the tautology *hut*; the synonyms *cabin* and *hovel*; the antonym *palace* and the metaphors *den* and *burrow*. Metonymical responses to the same word, such as *thatch*, *litter* or *poverty*, combine and contrast the positional similarity with semantic contiguity'.

('The metaphoric and metonymic poles', p.68)

By means of these processes, the 'speaker' makes a number of connections with the subject, and 'under the influence of a cultural pattern, personality and verbal style, preference is given to one of the two processes [metaphorical or metonymic] over the other'. Where the relationship is metonymical 'positional similarity' and 'semantic contiguity' are combined and contrasted.

By metonymy, the figure of 'Venus' means 'beauty', 'charm', 'the power of love', as we have discussed – and also 'the sexual act', 'venereal disease' etc. In a subspecies of metonym, synechdoche, a part (a sound hole, for example) of something (a guitar) is used

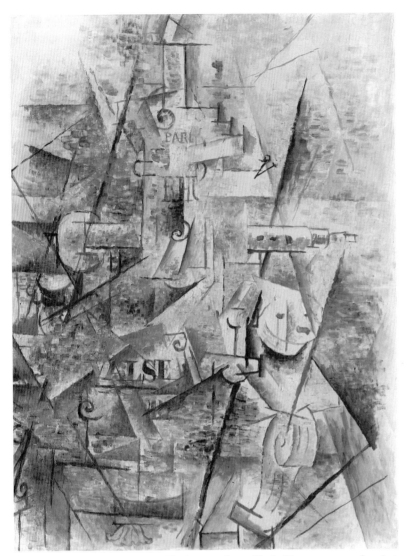

Plate 123 Georges Braque, *Clarinette et bouteille de Rhum sur une cheminée*
(*Clarinet and Bottle of Rum on a Mantelpiece*), 1911, oil on canvas, 81 x 60
cm. The Tate Gallery, London. © ADAGP, Paris and DACS, London 1993.

to refer to the whole, or the whole to the part. Jakobson gives the example from Tolstoy's
War and Peace, where 'the synechdoches "hair on the upper lip" and "bare shoulders" are
used to stand for the female characters to whom these features belong' (p.69). With respect
to painted marks, those forming the curved shape at bottom right of Braque's *Clarinet and
Bottle of Rum on a Mantelpiece* (Plate 123) constitute a metonym for the corbel of a marble
mantelpiece, for a bass clef, for a scroll of music. In *Le Portugais* the short horizontal brush
marks are metonyms for light on the glass of a café window, for the print surface of
posters, for the dust moats of a smoke filled room. All of these signs are, of course, de-
pendent for their meaning on the *context* of their combination with other signs signifying
'music', 'café life' etc. We will look, shortly, at further examples of metonym and synech-
doche in Cubism.

Jakobson's identification of metaphoric and metonymic polarity relates to a basic principle of Saussure's linguistics. The use of sign systems involves two distinct operations: the *selection* of words or visual signs from the *langue* and their *combination* in a sentence or image. So, to produce the sentence 'the ship crossed the sea' we select the words needed from the appropriate conventions of the English language and combine them according to the rules of grammar and syntax of that language. To produce *The Rayfish*, Chardin selected the images (cat, rayfish, jug etc.) and format (for the genre of still-life painting) from the appropriate paradigms and conventions of 'Academic language' and combined them according to the rules of that language. Jakobson argued that the figures of metonym and synechdoche depend upon *contiguity* in space and time and thus emphasize the significance of the *combination axis* of language. In Picasso's *Ma Jolie* the metonymic marks for a 'sound hole' and for 'strings' are connected to a 'zither' or 'guitar', the 'treble clef' and 'music stand' to the reading and playing of music. Metaphor, on the other hand, depends upon analogy or imaginative similarity between things *not* normally contiguous, Chardin's 'jug' shares the shape of the uterus, thus it is selected to act as a symbol of virginity, intact or broken. Metaphor thus emphasizes the *selection axis* of language.

Jakobson writes that Romanticism and Symbolism (and later Surrealism) are generally associated with the metaphoric process. But he associates the metonymic process with realism; it 'underlies and actually predetermines the so-called "realistic" trend ... A salient example from the history of painting is the manifestly metonymic orientation of cubism, where the object is transformed into a set of synechdoches' ('The metaphoric and metonymic poles', pp.69–70). Thus, according to Jakobson, Cubism belongs to the 'realistic trend'; it is a sign-system in which the use of synechdoche predominates. In synechdoche 'positional similarity' and 'semantic contiguity' are combined and contrasted. Let's explore this further.

Composition and technique

Though *Ma Jolie* is a portrait, the whole image, the 'figure', the 'interior' and the 'objects', have been treated similarly, to produce an illusion of shallow interlocking or inter-penetrating planes and an emphasis on short brush-strokes using a limited range of colours and tones. Without the synechdoches that enable the identification of a figure and musical activity, the image would be of elusive shadowy forms in a shallow space. However, there is a contiguous relationship, between the lines, forms and facets. The 'scaffold-like' lines and shadows are combined to suggest a central figure, on either side of which is a simpler arrangement of forms and shapes enhancing the sense of a shallow space while also differentiating the central figure in an illusion of relative prominence. A narrow pyramidal 'scaffold' structure of the central figure 'anchors' the faceted structure to the top and bottom of the canvas. This signifies both 'figure' and the painting as an object. Overall, space and mass are conveyed by the use of light and shade on the faceted planes. The light source from the right-hand side throws certain facets into light, with pronounced contrasts of shade, and leaves the left-hand side of the painting in relative shadow. The short brush-strokes are used to give a sense of direction, as with the hair at the top, or to give the impression of planes parallel to the vertical canvas surface. The surface itself creates an optical tension between *depicted* pictorial planes and the *literal* painting surface or 'flatness'. Here we have *metaphoric* possibilities: 'flatness' and surface marks as metaphors of paint and the *work* of painting.

Colour

In early Cubism, there is a reliance on a limited number of tones and colours, differentiating this from Fauvist language. In 1917 Braque said 'I like the rule that corrects the emotion' ('Thoughts and reflections on painting', p.423). Here, there is a 'rule' antithetical to colour as a sign of hedonism. But, what do these muted tones signify? In the late nineteenth century, avant-garde artists such as Pissarro regarded the use of vibrant colour, an equivalent to the complexity of vision, as a sign of difference from what they regarded as bourgeois Salon art, which was thought to promote a 'dull', tonal and hence 'repressed' kind of vision. Does Cubism somehow relate to the latter? A major lesson of Voloshinov's and Schapiro's social semiotics is that meanings are not fixed, that context is crucial. From around 1908 Picasso's and Braque's works were distinctly different from both what Apollinaire identified as the pervasive popularity of Impressionism and from marketable Fauvism. In 'Notes of a painter', 1908, Matisse wrote that he dreamed of an 'art of balance, of purity and serenity devoid of troubling or depressing subject-matter' which had an 'appeasing influence ... something like a good armchair' (Barr, *Matisse: His Art and His Public*, p.122). This position was not inconsistent with the bourgeois attitude towards Impressionism. By this date, Impressionism had been appropriated by the bourgeoisie as a style which delighted in the sensuousness of the painting's rich surface and colour and which provided an apparent opportunity to treat pictures as apart from 'life', as somewhere the mind could be free of 'troubling or depressing' issues, themes and concerns. On the one hand, the synechdoche of the Cubist sign system seems to encourage viewers to make their own connections, to be active readers. On the other, its negative relationship to conventional systems of signification, including conventional use of colour, and its reliance on a particular self-reflexive reader suggests a systematic form of address. One in which 'desire', 'hedonism', 'a good armchair' are *not* easily realized.

Lettering

The use of letters, words or part words are innovations and typical of Picasso's and Braque's work from this period. Here the two words 'MA JOLIE' are out of line, adding to the suggestion of shallow shifts of depth. They also appear as a mock title to the painting, positioned just above the place normally given by curators or collectors for titles. The phrase 'Ma jolie' is often used in French as a general phrase of endearment but the words have other signifying functions. They are part of the opening lyrics of *Dernière Chanson*, a popular love song of 1911, which begins '*O Manon, ma jolie, mon coeur te dit bonjour!*' As such, 'Ma Jolie' is a synechdoche; the words are a part of a contemporary song and evoke its acoustic sound, echoed in the picture by the references to a zither or guitar. But they also have a private significance, one familiar to Picasso's closest friends. 'Ma Jolie' was Picasso's nickname for Éva Gouel, also known as Marcelle Humbert; they became lovers at the time and this was the first instance of Picasso's use of the words to signify his personal feelings. He wrote to Kahnweiler on 12 June 1911: 'Marcelle is very sweet. I love her very much and will write this on my paintings' (quoted in Monod-Fontaine, *Daniel-Henry Kahnweiler*, p.110). In other works he included the words 'Jolie Éva', 'J'aime Éva', and 'Ma Jolie' all as metonyms for the person 'Éva' (Plates 124, 125).

This painting is not a portrait of 'Éva' as in a photograph (Plate 126) or a conventional portrait. It resists iconic and narrative structures. The utterance operates within a language system in the process of being established by Picasso and Braque. The painting is a sign which maintains its multiaccentuality with reference to existing discourses (the musical portrait, Plate 127) and to one in which the 'collective contract' was marked by a particular bohemian community.

Plate 124 Pablo Picasso, *La Table de l'architecte* (*The Architect's Table*), spring 1912, oil on canvas mounted on oval panel, 73 x 60 cm. Collection, The Museum of Modern Art, New York. Gift of William S. Paley. © DACS 1993.

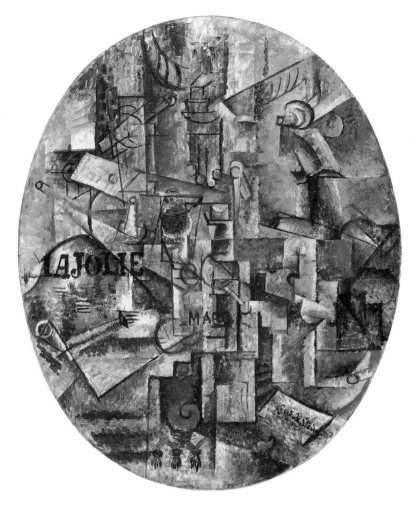

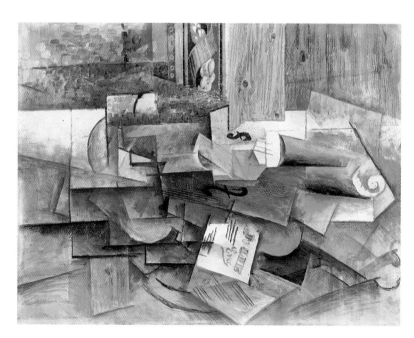

Plate 125 Pablo Picasso, *Violon, 'Jolie Éva'* (*Violin, 'Jolie Éva'*), spring–summer, 1912, oil on canvas, 60 x 81 cm. Staatsgalerie, Stuttgart. © DACS 1993.

Plate 126 Photograph of 'Éva Gouel' (Marcelle Humbert), Paris, *c*.1911. Reproduced from *Picasso. Documents Iconographiques*, Éditions Pierre Cailler, Geneva.

Plate 127 Camille-Jean-Baptiste Corot, *Portrait de Christine Nilsson* (*Portrait of Christine Nilsson*), 1874, oil on canvas, 80 x 57 cm. Museu de Arte, Sao Paolo. Photo: Giraudon.

Synechdoches: private and public

Picasso produced *Violin, Wineglass, Pipe and Anchor* and *Souvenir of Le Havre* (Plates 128, 129) as a 'pair', in May 1912 after he and Braque had visited Le Havre, Braque's birthplace, in April. They are full of allusions to their trip: in the former we find '[H]AVRE' and '[HON]FLEUR', the names of the towns either side of the Seine estuary, referring to the 'place' of their trip; in the latter 'HONF[LEUR]', connecting with FLEUR in the other work and on a 'ribbon scroll', not unlike that attached to trinkets, is 'SOUVENIR DU HAVRE'. Unusually for their paintings of this time, the monochrome is in contrast to areas of bright colour: the beginning of the souvenir scroll in blue and a French tricolour above, echoing the naval port, which is also picked up in the colours at the top of the other painting.

In the former work (Plate 128), the 'parts' for a whole violin can be identified: its 'scroll' toward the top, three lines for its strings and two 'f' sound holes just right of centre. To the right and left, we can identify Cubist signs for a glass. A 'pipe', smoked by both artists, is to the left. Parts of the anchor are depicted at top right and one of its curved 'hooks' in the centre sweeps round like an 'arrow' pointing to the area above in which there are several letters. There's a possible pun on *'ancre'* (anchor). Zervos, a close friend of Picasso's who compiled the standard *catalogue raisonné* of the artist's work made the 'mistake' in the catalogue of titling the work *'encrier'* (inkpot, inkstand, inkwell). No doubt the joke on his friend, caused by the closeness in the *sound* between the two words,

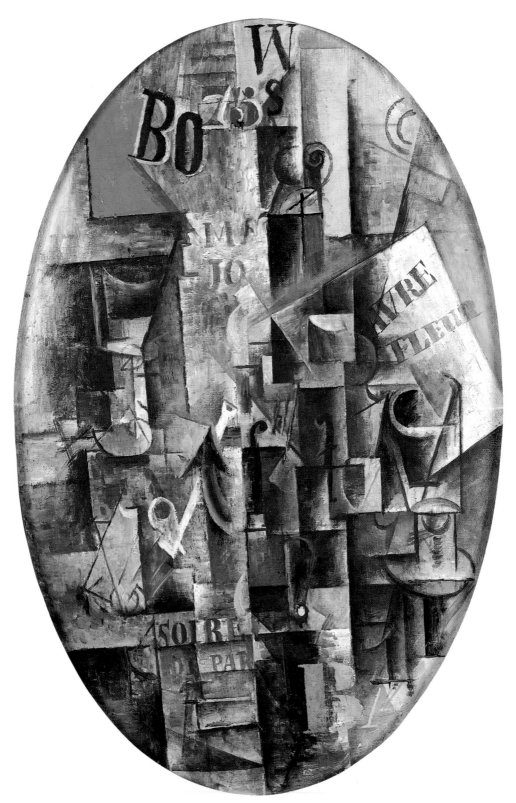

Plate 128 Pablo Picasso, *Violon, verre, pipe et ancre* (*Violin, Wineglass, Pipe and Anchor*), spring 1912, oil on oval canvas, 81 x 54 cm. National Gallery, Prague. © DACS 1993.

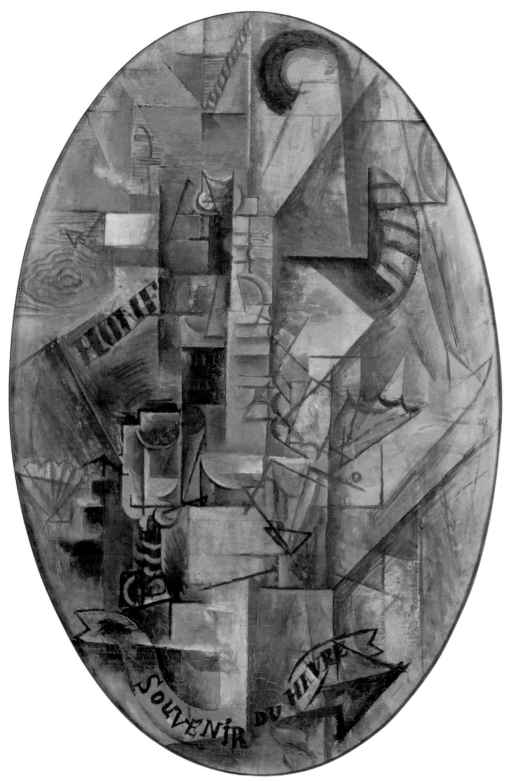

Plate 129 Pablo Picasso, *Souvenir du Havre*, spring 1912, oil on oval canvas, 92 x 65 cm.
Private Collection. Photo: by courtesy of Thomas Ammann Fine Art. © DACS 1993.

would have amused Picasso. It also suggests other punning possibilities: *'encrer'*, 'to ink' as in typography (see the words and letters painted to 'look like' printed, inked, versions); *'écrire'*, 'to write', with the painting as a visual and verbal message; *'s'écrier'*, to exclaim or shout out. Used as in the phrase *'idée* ancrée *dans la tête'*, 'an idea deep rooted in the mind', it would connect with the word *'souvenir'* in the other painting, which translates as 'to remember', 'to occur to the mind', or, as a noun, 'a token of remembrance'. The punning possibilities continue with *'s'ancrer'* meaning 'to establish oneself', 'to get a firm footing'. We know that Picasso and Braque competed intensely to out-do each other in the complexity of their communications: upon seeing this pair of paintings Braque is reported as saying half bitterly, half sweetly: 'The weapons have been changed' (J. Cousins, 'Documentary chronology', p.390). One of the possible reasons for his response is Picasso's use of simulated wood grain (*faux bois*) in the *Souvenir* painting, made by using a steel comb. This was a method Braque had learned as an apprentice decorator, then used in his paintings and demonstrated to Picasso. Once a mark of difference between them, it was now appropriated.

There are other personal references. The letters 'W' and 'BO' together form a synechdoche for 'WILBOURG', a transformation of 'Wilbur Wright', the name of the pioneering aviator, which was used by Picasso as a nickname for Braque (see, for instance, his letter to Kahnweiler, 11 August 1912, quoted in Monod-Fontaine, *Daniel-Henry Kahnweiler*, p.112). Braque even occasionally signed himself 'Wilburg'. The two artists jokingly referred to themselves as brotherly pioneers, as were the Wright brothers. There's a memento here, too, in that Wilbur Wright died on 30 May 1912, when Picasso was painting these two works.

The letters 'SOIRE DE PAR' have at least two possible meanings. The first is the 'evening of departure'. Braque wrote to Marcelle, 'Éva', from Le Havre: 'Our stay ends tomorrow night [28th April]. We'll be back at 11.50 p.m. ... Tomorrow we are going to Honfleur. This morning, I awoke Picasso with the sound of the phonograph. It was charming' (quoted in J. Cousins, 'Documentary chronology', p.387). Towards the top of the painting appear the letters 'MA JO[LIE]' a metonym for 'Éva' and for the popular song which is evoked by, perhaps even played on, the phonograph. The second meaning of the words is a reference to *Les Soirées de Paris* a short-lived radical monthly review founded by Apollinaire, René Dalize, André Salmon and André Tudesq which first appeared in February 1912. Its audience was small, never more than forty subscribers between 1912 and autumn 1913 (circulation was increased when the review was relaunched in November 1913, with this painting on the front cover). The very first article was Apollinaire's 'Du sujet dans la peinture moderne' in which he wrote: 'The new painters paint pictures where there is no real subject' in the traditional sense of the 'perfect representation of the human figure, voluptuous nudes, highly finished details'. He went on to say that the success of the art of today, such as Cubism, comes from its 'austerity' and that 'verisimilitude no longer has any importance'. The only contemporary he cites is Picasso who 'studies an object like a surgeon dissects a cadaver' (pp.1–4). In subsequent editions, April and May, he published a continuation with two articles both titled 'La peinture nouvelle'. These were reworked as the basis for his book *Les Peintres Cubistes: Méditations esthétiques*, published in 1913. Picasso's critical view of the book is contained in a letter to Kahnweiler, dated 11 April: 'I am really grieved by all this gossip', he wrote (quoted in Monod–Fontaine, *Daniel-Henry Kahnweiler*, p.113).

There are two other possible references to articles in *Les Soirées* which evoke the *antithesis* of Apollinaire's claim for 'austerity'. In the first number René Dalize wrote an article 'La Littérature des intoxiques' (pp.9–18) which opens with the claim that of all 'the vegetable extracts capable of reacting upon the human organism, the essence prepared from the brown flower of the Asian poppy [*'la* fleur brune *du pavot d'Asie'*, my emphasis]

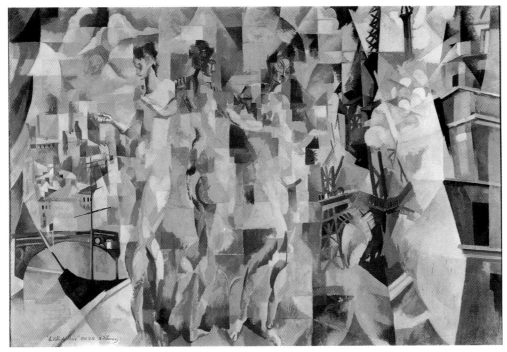

Plate 130 Robert Delaunay, *La Ville de Paris* (*The City of Paris*), oil on canvas, 267 x 406 cm. Centre Georges Pompidou, Musée National d'Art Moderne. Documentation Photographique. © ADAGP, Paris and DACS, London 1993.

is the most efficacious and singular'. The article discusses figures and authors indebted to the habit of taking opium as a way of providing a new non-rational perspective on the world. He offers his own 'perspective' where even in the hours after taking opium 'an imprecise notion of the reality of images exists'. The sub-sections are entitled 'La cité enchantée' ('the enchanted city'), 'Le festin' ('the feast'), 'Le bal' ('the ball'). In Picasso's painting not only is there a combination of [LES] SOIRÉ[ES] DE PAR[IS], of FLEUR painted in *brown*, and of the 'stencilled' BA[L] but also both paintings offer signs for the intoxicated living associated with feasting and entertainment in visiting an 'enchanted city', both literal and metaphorical (note, too, the words for OLD JAM[AICA] rum in *Souvenir*). Picasso had smoked opium from an early age.

In the second issue of *Les Soirées* Dalize continued this theme with his 'Sur le bâteau de fleurs' ('On the boat of flowers', pp.51–8) an evocation of a 'trip' to the Orient in which on a boat of flowers 'there is reunited the game, love, belles-lettres, good living, songs, dance, music and this opium which soothes all things, man's highest enjoyment and his infinite downfall!' (p.55). There's playful irony on Picasso's part here. In 1912 Apollinaire was wheeler-dealing not only with respect to the various Cubists, eventually in the autumn supporting the *Section d'Or* group (Plates 130, 131, 132), but also in trying to account for Cubism as the most up to date art in a particular way. He characterized it as 'austere' in opposition to his own hedonistic poetry and the 'Bacchic' meetings of the editors of *Les Soirées*. Dalize, who was the managing editor of the magazine, regarded Apollinaire's first article 'The subject in modern painting' as 'stupid' and 'absurd': 'You'll ruin us with your Cubism. The *Soirées* was not founded to support the ignorant and pretentious painters you like to be with because they flatter you. Except for four or five, they are completely worthless.'[13]

13 See F. Steegmuller, *Apollinaire*, pp.199–201, and H. Buckley, *Guillaume Apollinaire as an Art Critic*, p.72 ff.

Plate 131 Albert
Gleizes, *Les Moisson-*
neurs (*Harvest*
Threshing), 1912,
oil on canvas, 271 x
354 cm. The Solomon
R. Guggenheim
Museum, New York.
© ADAGP, Paris and
DACS, London 1993.

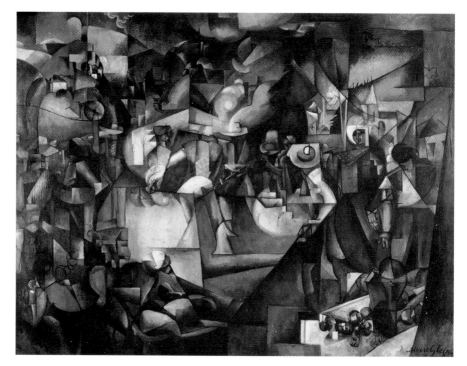

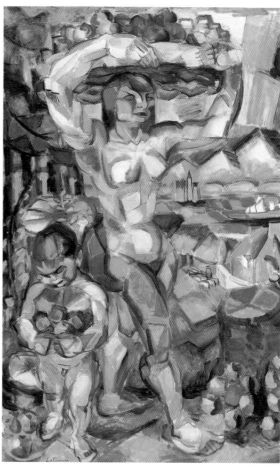

Plate 132 Henri Le Fauconnier,
L'Abondance (*Abundance*), 1910–11, oil
on canvas, 191 x 123 cm. Collection
Haags Gemeentemuseum, The Hague.
© ADAGP, Paris and DACS, London

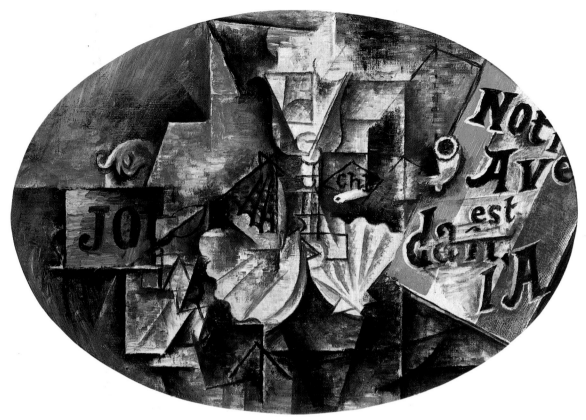

Plate 133 Pablo Picasso, *Coquille Saint-Jacques 'Notre Avenir est dans l'air'* (*The Scallop Shell 'Our Future is in the Air'*), spring 1912, oil on canvas, 38 x 55.5 cm. Private Collection. © DACS 1993.

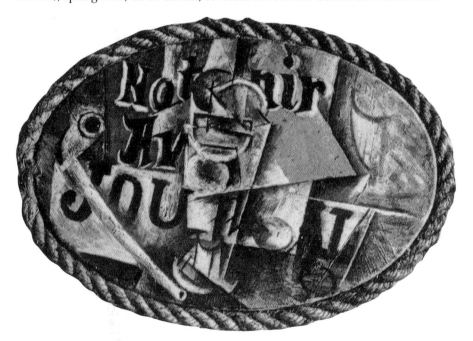

Plate 134 Pablo Picasso, *'Notre Avenir est dans l'air'* (*'Our Future is in the Air'*), spring 1912, oil on oval canvas framed with rope, 22 x 33 cm. The Picasso Estate. © DACS 1993.

The pun

Many of Picasso's works involve puns – verbal, aural, visual – as elements of a Cubist sign system. In both the realm of puns (relations between signs in a language at a particular moment) and the realm of etymology (historical relations between signs from different periods), Derek Attridge writes 'two similar sounding but distinct signifiers are brought together, and the surface relationship between them invested with meaning through the inventiveness and rhetorical skill of the writer'.[14] This can act to destabilize the notion of fixed meanings or an enforced distinction between 'real' and 'false' connections.

In *The Scallop Shell, 'Our Future is in the Air'* (Plate 133) the shells refer back to *Souvenir of Le Havre*, and thus signify his trip with Braque. The letters 'ChB' are a synechdoche for *Chebli* tobacco, which together with the central 'wineglass', the pipe and the root of JOURNAL (newspaper) all suggest a café encounter. On the right is a tricolour, with words illusionistically in front. In terms of colour and treatment this section is a polar opposite of the monochrome of the rest of the oval. One of three related works in which parts of the words '*Notre Avenir est dans l'air*' ('Our Future is in the Air') appear (Plate 134), these imitate typeface.

The right-hand side depicts relatively illusionistically the cover of a contemporary patriotic pamphlet (Plate 135) which was a compendium of military officers advocating the development of the aeroplane as the ultimate weapon. Picasso only provides parts of the words, expecting the viewer to complete the reference. Are the truncations significant? Do they make a new combination?

'Not' (from *notre*) is also the root of 'Nota' (note, note well); 'Ave' (*avenir*) makes 'Hail' as in 'Ave Maria'; 'dan' (part of *dans*) is not cut off by the frame but abbreviated by the apostrophe of 'l'a' (from *l'air*), it forms the root of '*danger*' (danger); 'l'a' is the definite article and beginning of a word, or *là*: 'there' or 'then'. As an anarchist, Picasso saw great dangers in the militaristic rhetoric of the years before the First World War. One nationalist faction was euphoric in the belief that with a bi-plane a war could be won in three days. Exclaiming 'Ave Maria' and making the sign of the cross would have been an apt response to 'danger' or disbelief for someone brought up in Catholic Spain.

In all three images there appear the letters 'JOU' from the title of the newspaper '[LE] JOU[RNAL]'. This truncation evokes the way in which newspapers were displayed (Plate 136): when folded in racks only the root of the paper's names are readable. In Picasso's work some or all of these letters often appear. Apart from being a reference to the newspaper, these letters have other connotations. Picasso is known to have been interested in puns throughout his life as Françoise Gilot recalls.[15] The letters 'JOU' are often combined by him with depictions of musical instruments, alcoholic drinks, tobacco (cigarette papers) and references to women (either directly or indirectly by means of the traditional association of guitars and violins with the female figure). They are possible abbreviations for several slang words:

[14] Quoted by J. Culler, *On Puns: The Foundation of Letters*, p.2.

[15] 'One never mentioned a proper name. One never referred directly to an event or a situation; one spoke of it only by allusion to something else. Pablo and [Jaime] Sabartès [Picasso's secretary] wrote to each other almost every day to impart information of no value and even less interest, but to impart it in the most artfully recondite fashion imaginable. It would have taken an outsider days, weeks, to fathom one of their arcane notes. It might be something relating to Monsieur Pellequer, who handled Pablo's business affairs. Pablo would write (since Monsieur Pellequer had a country house in Touraine) of the man in the tower (*tour*) of the château having suffered a wound in the groin (*aine*) and so on, playing on words, splitting them up, recombining them into unlikely and suspicious-looking neologisms, like the pirate's torn-up map that must be pieced together to show the location of the treasure. He would sometimes use up three pages writing about a spade in such a way as not to be obliged to refer to it as a spade, lest the letter fall into the hands of Inès [Sassier, Picasso's chambermaid] or Madame Sabartès and reveal something to one or the other. He worked so hard at being hermetic that sometimes even Sabartès didn't understand and they would have to exchange several more letters to untangle the mystery' (F. Gilot and C. Lake, *Life with Picasso*, pp.165–6).

Plate 135 Cover of the Michelin brochure *Notre Avenir est dans l'Air* (Clermont-Ferrand), 1 February, 1912. Photo: courtesy of The Museum of Modern Art, New York.

jouailler: to play a musical instrument badly

jouasse: the kick or thrill from drugs

jouer: to play or to fool

jouet: toy or playing

joueur: player of game.

jouir: to have an orgasm, to 'come'

jouissance: orgasm

joujou: toy, plaything.

It mays even suggest 'J'ouis sens' (I heard meaning), with a similar sound to 'jouissance'. Visual, verbal and aural punning, and the relationships between them runs through this signifying system.

Consider the metaphor in *Guitare: El Diluvo* (Plate 137) Picasso later confirmed William Rubin's reading of this collage:

> The curvilinear guitar body ... is here associated with the female torso, the newsprint sound hole assuming the role of the naval. And since, by extension of the metaphor, the rectilinearity of the rear plane of the guitar suggests a masculine torso, the motif as a whole may be seen as expressing the union of male and female anatomies.

(*Picasso In the Collection of the Museum of Modern Art*, p.82)

Plate 136 Newspaper display, Paris, before 1914. Photo: Harlingue-Viollet.

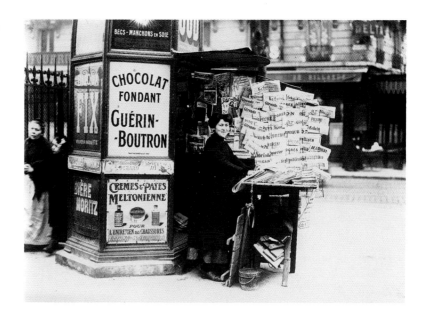

Plate 137 Pablo Picasso, *Guitare: El Diluvo*, 1913, cut and pasted paper, charcoal and white chalk on blue paper mounted on board, 66 x 50 cm. Collection, The Museum of Modern Art, New York. Nelson Rockefeller Bequest. © DACS 1993.

The content of the selected newspaper shapes adds credence to this. They come from the Barcelona newspaper *El Diluvio* (*The Deluge* or *Flood*) and include advertisements for a Doctor Casasa, a specialist in venereal diseases, and for a Doctor Dolcet, an oculist. Rubin suggests that 'DILUV' hints at the Louvre but just as plausibly Picasso could be punning on 'Louve', 'she-wolf'. In relation to *Les Demoiselles* we saw polarities both with the group of nudes and the 'mask'/syphilitic faces. The idea of sex as potential death or serious illness had been a general social issue and a particular concern of Picasso's: the reference to Dr Dolcet may imply that eyesight alone cannot be relied upon in guaranteeing safe sexual encounters.[16] Again we see evidence of a sign system which undermines existing expectations of stable meanings, and, importantly, which enters into dialogic exchange with particular social, sexual and cultural issues. The use of the pun is one way of maintaining the multiaccentuality of collage as sign.

The pun as social signifier

The pun also appears in portraits, with social signifiers such as *The Aficionado*, painted in Sorgues, 1912 (Plate 138). We know from Picasso's letter to Braque (10 July) that he had 'transformed an already begun painting of a man into an *aficionado*; I think he would look good with his banderilla in hand, and I am trying to give him a real southern face' (J. Cousins, 'Documentary chronology', p.399). For both Picasso and Braque, at this time, bullfights were a significant ritual in their lives. Picasso wrote to Kahnweiler on 9 July: 'I have been to Nîmes and I saw the bullfight. It's something rare to find the intelligence peculiar to an art in an art. Only Mazantinito did anything of note ...' (quoted in Monod-Fontaine, *Donation Louise et Michel Leiris*, p.169).

We can identify parts of attributes for a 'reconstruction' of Picasso's 'aficionado': a trilby-type black hat, a moustached and goatee-bearded face, a white dicky-bow with a formal wing-collared shirt, a bottle with the letters 'MAN' on it, the words, 'LE TORERO', which was the name of a bullfight paper, a banderilla (the dart with a streamer which bullfighters stick into the bull's neck) in the centre foreground, the letters 'TOR', the place-name 'Nîmes' (a southern French town famous for bullfights as well as a tourist attraction for its Roman remains) upright guitar with its pegs level with the man's head and the sound hole and strings just below the letters 'TOR'. These probably refer to the root of *toréador* or *toréer* ('to fight in the bull-ring'). However they are also the root of *tortiller*, which is to twirl or twiddle one's moustache, or *tortueux*, meaning crooked or underhand with respect to conduct. The letters 'MAN' on the bottle probably signify a drink label, maybe Manzanilla, a very dry, light sherry. They also form part of *manade*, a herd of bulls driven by herdsmen. It's even possible that they are synechdoche of 'Mazantinito' the bullfighter mentioned in Picasso's letter to Kahnweiler.

Picasso chose to paint a pleasure-seeker, a bourgeois *aficionado*, in a Nîmes café surrounded by the tokens of his enthusiasm for the local bull-ring. This enabled him to exercise a degree of irony or indulgent wit. As a proud Spaniard, for whom the bullfight was shrouded in the rituals of machismo and notions of cultural and artistic chauvinism, the normal French versions of bullfighting would have appeared as *imitations*, enjoyed by enthusiastic 'fans'. Traditionally it did not involve killing the bull, but rather the performance of acrobatic feats around it, playing an important part in the popular culture of southern France, often providing the focal point of a feast day, and closely linked to local customs and long-standing traditions of hospitality and communal amusement. This began to change in the mid-nineteenth century. Bull fighting became commercialized, with the introduction of the Spanish form, the *corrida*, in which the bull is killed. However,

[16] See Corbin, 'Commercial sexuality in nineteenth-century France'.

Plate 138 Pablo Picasso, *L'Aficionado*, summer–autumn 1912, oil on canvas, 135 x 82 cm. Kunstmuseum, Basel. Colorphoto: Hans Hinz © DACS 1993.

these commercial projects, turning the small-town festival bullfight into large spectacles, ran into serious debt and killing the bull was strictly illegal. Consequently the organization of the *corrida* fell into the dubious area between popular entertainment and petty crime and became increasingly associated with malpractice.

In this context what class of aficionado 'with a real southern face' is signified here? Bullfighting in the south attracted a range of spectators including workmen and small-holders. Some of these had moved to the towns, others travelled in on the new railways especially around the time of a *fête populaire*: an opportunity for the petit bourgeois or socially aspiring to dress up for a holiday and a bullfight, and at the same time transact some business. However, there was also a more aristocratic audience for the *corrida* as distinct from the cheaper and less prestigious indigenous events. Hispanophilia was a mark of social difference in the thought and behaviour of the upper-class from southern France; no doubt for Picasso this was ironically signified by such an aficionado carrying 'a banderilla in his hand':

> In 1889 aristocrats and rich bourgeois from Avignon formed the Franscuelo club and called themselves 'aficionados' ... in imitation of the passion of the Spanish nobility for the *corrida* ... It is almost as if the upper classes could not resist the occasional public appearance to reassert their social primacy in front of the masses, especially at a contest intimately linked to a reactionary Catholic state.
>
> (R. Holt, *Sport and Society in Modern France*, p.111)

Holt points out that the *corrida* (and cockfighting), as a violent spectacle with consequent turbulent audience behaviour, became a significant site of contested social and political positions. This fact would not have escaped Picasso and his community, though their combination of leftist politics with a passion for the *corrida* involved contradiction. Bull-fighting and cockfighting were criticized by, among others, Protestant churches, animal protection groups and left-wing Republicans and socialists. The *corrida* became associated with parties of the extreme right, including Maurice Barrès' anti-Republican, anti-Semitic Action française. The *corrida* came to serve as a rallying point for anti-Dreyfusard agitation.[17] Those supporting Dreyfus were not only attacked as socialists; it was also noted that many were outspoken opponents of the *corrida*, controversy over which reached a climax around the same time.

> *Le Toréro* [14 August 1910] wrote that 'apart from the life of a career officer in the army, the art of the bullfighter is the last refuge of the chivalric tradition'. Support for the *corrida* merged easily into a wider, sub-Barrèsian cult of heroism, individuality, 'roots' and death. Opponents of the killing of bulls and the disembowelling of horses were branded as deracinated metropolitan intellectuals or sentimental socialists with 'unFrench' inter-nationalist sympathies.
>
> (Holt, pp.117–18)

The context of *The Aficionado* is one in which there are contesting social and political evaluations. Picasso was involved in a dialectical contradiction: the satisfaction of his Spanish roots in the rituals of the *corrida* at the cost of being erroneously associated with right-wing French groups, epitomized by the southern *Aficionado*, and the transformation of an aspect of popular culture into a commodity. The use of a Cubist 'language' in which, for instance, the letters TOR are a synechdoche for at least three distinct French words signal the various social accents embedded in the painting as sign.

17 Dreyfus, a Jewish army officer, was wrongly convicted of selling military secrets to the Germans; all his convictions were quashed in 1906. The case, which raised issues of anti-Semitism, anti-clericalism and anti-republicanism, dominated French political life from 1894 to 1906 and preoccupied commentators on French social and cultural life for many years after.

A culture of signs

The Aficionado is an example of a 'speech act' structured by a Cubist sign system which had become a highly developed resource by 1912. The viewer who engages with this particular discourse is made aware of the selection, combination and structuring of elements by which the communication is constructed. This discourse constitutes the reversal of iconic illusionism and requires the viewer to have an active consciousness of the way in which socially specific signifiers convey meaning. This is also the case with the collages which date from the same period.

We noted in the introductory discussion of *Glass and Bottle of Suze*, that the majority of the newspaper extracts were reports on the Balkan War, including an anti-war demonstration. However, those which form parts of the 'bottle' (the two pieces cut into three curves) and that which signifies the top half of the glass are from a different source, they are extracts from a serialized *roman-feuilleton* about romance and love affairs. This new form of commercial novel, in daily instalments, was a nineteenth-century phenomenon used to increase the sale of newspapers (they were printed in the bottom quarter of the front page). By the 1880s there were seventy daily newspapers available in Paris, attesting to the new mass audience for printed matter. This had major implications for notions of class and cultural difference:

> With the advent of nearly universal literacy by the end of the nineteenth century … mere reading could no longer provide a stable ground for class differences or cultural hierarchies. A new hierarchical opposition, however, gradually displaced the older one, now marking the differences between those who read newspapers and those who read books, especially poetry. This opposition became a determining one for the Symbolist generation of writers and poets, who conceived their writing as a form of protest against the penetration of the values and logic of the marketplace into the very structure and reception of Literature.
>
> (Poggi, 'Mallarmé, Picasso and the newspaper as commodity', p.135)

There was a vigorous neo-Symbolist movement in Paris in the years 1905–8 with supporting reviews. We know from Maurice Raynal that Picasso had books by Verlaine, Rimbaud and Mallarmé in his studio in the rue Ravignan (before 1909) and, from various sources, that he constantly read the newspapers. For Mallarmé and the Symbolists the newspaper was debased literary journalism in contrast to 'the book', which was a 'Spiritual Instrument' – the title of a Mallarmé essay from 1895. For Mallarmé the newspaper is already defiled – the flat open pages of the commodity which, as with the prostitute, is available to all comers. The book, which in France was sold with the pages uncut, by contrast is a site of 'virginal' possession. In his essay of 1895, *Le Livre: instrument spirituel*, he wrote:

> The virginal folding back of the book, once more, willing lends for a sacrifice [sic] from which the red edges of ancient tomes once bled; the introduction of a weapon, or paper knife to establish the taking of possession. How much more personal later, will be our consciousness without this barbaric simulacrum: when it joins the book, taken here, there, varied melodically, guessed like an enigma – almost recreating it. The folds will perpetuate a mark, intact, inviting one to open or close the page, according to the master. So blind and negligible a process, the crime that is consummated, in the destruction of a frail inviolability.
>
> (quoted in Poggi, 'Mallarmé, Picasso and the newspaper as commodity', p.136)

The new poetry, too, Mallarmé argued, should be the antithesis of the vertical columns of the mass market newspaper: the overall effect of such poetry would be based on the aural and optical effects of words in 'pure', formal relationships (see Plate 142). As Poggi points out, Mallarmé's ideas were prevalent among Symbolist poets, artists and critics who

shared his aspiration to create an 'autonomous art free of all reality'. Maurice Denis for instance, claimed in 1896 that the followers of Impressionist painting do 'nothing more than note sensations, art is nothing more than the newspaper of life ... It is journalism in painting ... It is the eye that devours the head' (quoted in 'Mallarmé, Picasso and the newspaper as commodity', p.138).

We can see from photographs of his studio, that Picasso's collages and constructions were themselves like instant broadsheets (Plate 139). If we take one of these, for example *Bottle, Wineglass and Newspaper on a Table* (bottom of Plate 139a, and Plate 140), we can see how Picasso's negation of Symbolist values of this kind is achieved: by rendering unstable the conventional boundaries for 'art' and for 'mass culture'. Picasso has used part of a headline from *Le Journal* 4 December 1912 (Plate 141) reading 'UN COUP DE THÉ[ATRE]',

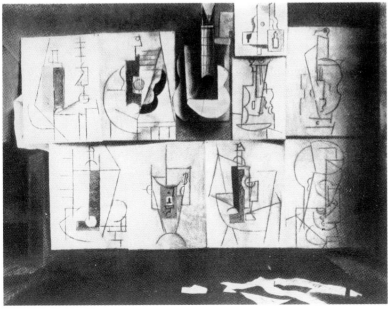

Plate 139 (a) above and (b) below: Picasso's studio, Boulevard Raspail. Paris, autumn 1912. Reproduced by courtesy of Éditions Cahiers d'Art, Paris.

Plate 140 Pablo Picasso, *Bouteille, verre et journal sur une table 'Un Coup de thé' (Bottle, Wineglass and Newspaper on a Table 'Un Coup de thé'),* pasted paper, charcoal and gouache on paper, 62 x 48 cm. Musée National d'Art Moderne, Centre Georges Pompidou, Paris. Documentation Photographique. © DACS 1993.

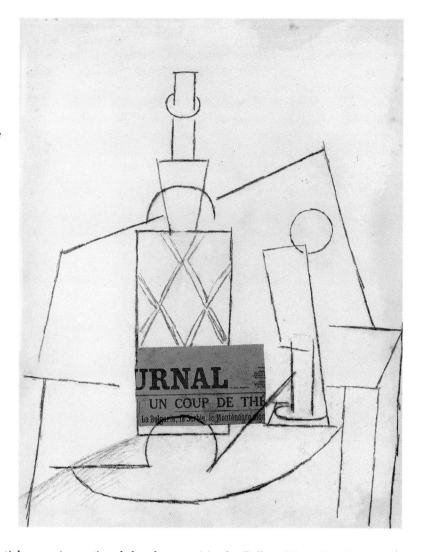

announcing an article on a 'sensational development' in the Balkan Wars. In other works further Balkan War reports (Plate 82) are used. In *Guitar, Sheet Music and Glass* (Plate 81), for example, the words to be read are LE JOU (the game, the play etc.) and LA BATAILLE S'EST ENGAGÉ ('the battle has begun'), a phrase that has often been interpreted as referring to the beginning of the novel pictorial practice of collage. But the phrase 'UN COUP DE THÉ'[18] is also a pun on the title of Mallarmé's famous poem 'Un Coup de Dés Jamais n'abolira le Hasard' ('A Dice Throw will never Abolish Chance'), in which the title of the poem is spread out across several pages within the unconventional typographical layout of the text (see Plate 142). The poem was held dear by a contemporary artistic milieu dominated by élitist Symbolist values; Picasso makes his point by incorporating in *his* art work what was most despised by this group as the everyday, the commercialized, the debasement of an 'art' form. A fragment, 'URNAL', of the newspaper's title LE JOURNAL is also used. It could be a synechdoche for Maurice Raynal, one of the earliest critics to write favourably about collage as an 'art' form which 'corrupts' the 'purity' sought by Mallarmé. But it is also situated above the possible reference to Mallarmé's poem and it could be UR[I]NAL: a place to 'take a piss'.

[18] In French 'thé' ('tea') can suggest 'tea-party'; it is also slang for marijuana. The phrase may thus evoke a 'hit' ('coup') or dose of marijuana.

Plate 141 *Le Journal*, 4 December, 1912, top half of front page. Bibliothèque Nationale.

The various readings of the possible puns in this collage would have enabled Picasso to deflate – for all those in his sub-group who were in a position to understand the jokes – the seriousness of Mallarmé's cultural purity. And, precisely because of the socially variable nature of the sign, Picasso could also keep in with those cultural aesthetes for whom Mallarmé's modernism was exemplary. Through the subversive nature of laughter, Picasso could have it both ways.

Picasso's and Braque's collages and *papiers collés* from this time incorporate elements which are the antithesis of autonomous or 'pure' art: newspaper cuttings on contemporary socio-political events, serialized romantic fiction, scientific innovations, all sorts of advertisements. Many of these works are based on the traditional still-life, but the materials give the method of depiction and the subjects a meaning not found in conventional representations. In the same way as Picasso, Braque produced paintings and *papiers collés* that appear to be directly related to one another. His *Composition with the Ace of Clubs* (Plate 144) has several compositional and thematic similarities to *Compotier et verre* (Plate 143), which is traditionally regarded as the 'first' *papier collé*. Both compositions create the illusion of looking through a café window and seeing details of the interior. The 1912 work is drawn in charcoal with pasted wood-grain paper. In *Composition with Ace of Clubs* Braque used the decorator's trick of 'combing' to simulate wood-grain; it is used as an equivalent for the wood-grain paper in the *papiers collés*. This sign, too, derives from a system (commercial painting and decorating) normally extraneous and antipathetic to 'high art'.

Plate 142 Stéphane Mallarmé, 'Un Coup de Dés Jamais n'abolira le Hasard', *Cosmopolis*, May 1897. From *Stéphane Mallarmé: Oeuvres complètes*, 1945 Gallimard.

Plate 143 Georges Braque, *Compotier et verre 'Bar'* (*Fruit dish and Glass 'Bar'*), charcoal, imitation wood and pasted paper on paper, 61 x 44 cm. Private Collection. © ADAGP, Paris and DACS, London 1993.

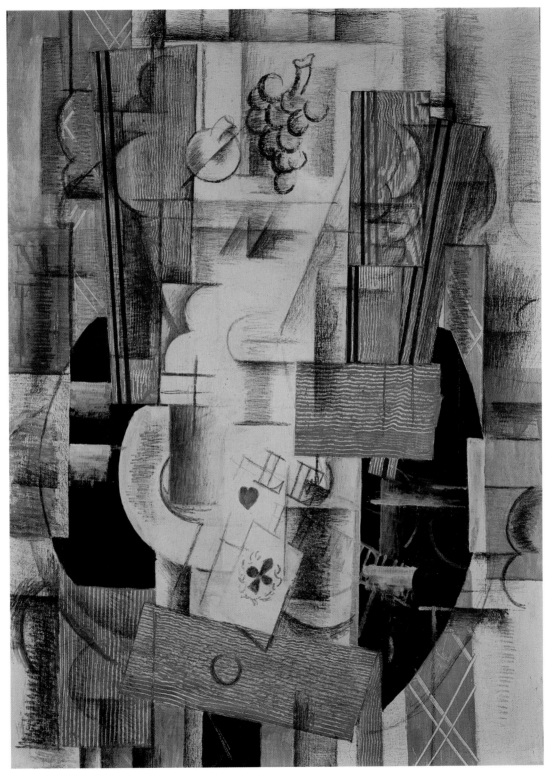

Plate 144 Georges Braque, *Composition à l'as de trèfle* (*Composition with Ace of Clubs*), 1912–1913, oil, gouache and charcoal on canvas, 80 x 59 cm. Musée National d'Art Moderne, Centre Georges Pompidou, Paris. © ADAGP, Paris and DACS, London 1993.

Plate 145 Georges Braque, *Verres et Bouteille 'Fourrures'* (*Glass and Bottle 'Fourrures'*), 1913, charcoal, imitation wood pasted paper and newspaper on paper, 48 x 62 cm. Private Collection, Basel. © ADAGP, Paris and DACS, London 1993.

Braque's *papiers collés* (Plates 145, 146, 147) also evokes the consumer world of entertainment and the department store. His newspaper cut-out in *Glass and Bottle 'Fourrures'* (Plate 145) advertises the 'supreme elegance' of fur coats which women can purchase by means of credit facilities. Yet the word 'fourrures' also means a filling or lining material, i.e. the very function of the newspaper cut-out in the work itself.

The function of puns in Cubism reveals some of the limits of the more systematic aspects of mainstream semiotics. In Saussure's account signs are defined by their differential relation to one another: for instance if 'blue' is uttered, the 'concept' which might ensue from the sound/image is perhaps best represented by 'not-white', 'not-red' etc. Each linguistic unit, each sign is what others are *not*. There is an arbitrary link between the idea 'blue' and the sequence of sounds or actual pigment which acts as a signal; the sign 'blue' does not have a fixed meaning but is dependent upon the context in which it is used. For example, when 'blue', 'white' and 'red' are combined as in Picasso's *Our Future is in the Air* (Plate 133) each becomes part of the sign for the French tricolour. In such a context, the combination may signify patriotism, national identity, the military etc. And the 'blue' in *The Blue Nude* might, in the context of French North Africa at least, signify a military conscript. However, as we have seen in the case of puns, within one system of relations a linguistic unit or sign may signify more than .one thing. The potential

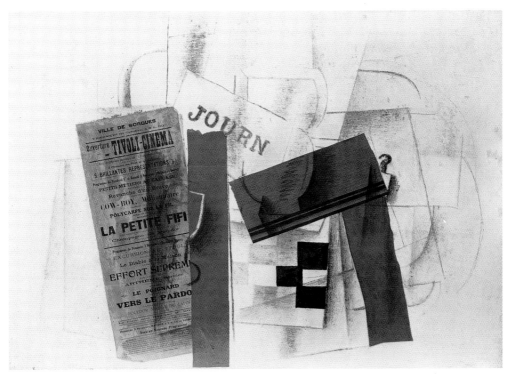

Plate 146 Georges Braque, *Le Programme du 'Tivoli Cinéma'*, (*Programme of the 'Tivoli Cinema'*), 1913, gouache, charcoal, plain and imitation wood pasted paper and poster on primed canvas, 28 x 42 cm. Collection Galerie Rosengart, Lucerne. © ADAGP, Paris and DACS, London 1993.

disruption of a signifying system by punning can be humorous but also may convey deeper meaning, whether conscious or unconscious, as in Voloshinov's notion of the multiaccentual: contested social evaluations embedded in the same sign: 'each living ideological sign has two faces, like Janus. Any current curse word can become a word of praise, any current truth must inevitably sound to many other people as the greatest lie' (Voloshinov, *Marxism and the Philosophy of Language*, p.23).

Apart from using puns, Picasso and Braque included signifiers culled from the social base of their experience which questioned high art practice and sites, in particular those from mass and popular culture, including advertisements, everyday commodities and fetish masks. For example, Jane Atché's poster for 'JOB' cigarette papers (Plate 148) is used in works by Braque and Picasso (Plates 152, 153). In all of these the letters follow the typography of the advertisement, while in the Picasso the *packet* of cigarette papers, with its letters and attached string, is depicted. 'JOB' could also be a synechdoche for Max Jacob. Picasso became Jacob's godfather in 1915 on the poet's baptism (Catholic symbolism abounds here). The 1914 painting and Braque's dry-point also refer to gambling items. Similarly, in Picasso's *Landscape with Posters* (Plate 9), an urban landscape features a poster advertising 'KUB' stock cubes with its price of ten centimes. There is also a bottle with the words 'PERNOD FILS', and on the right 'LÉON', letters copied from a 'hat' advertisement. The letters 'KUB' more than likely also refer to 'Kubismus', Kahnweiler's German for Cubism. No doubt as a joke, the word is depicted on an outlined cube. Other works included references to social customs, particularly those of Picasso's own circle of friends (Plates 149, 150, 151). The first two include the calling cards of André Level (a collector) and Gertrude Stein; both cards have the corners bent over to signify that the caller found no-one in. In fact in the Level piece the 'turned over' corner is a piece of illusionism in pencil.

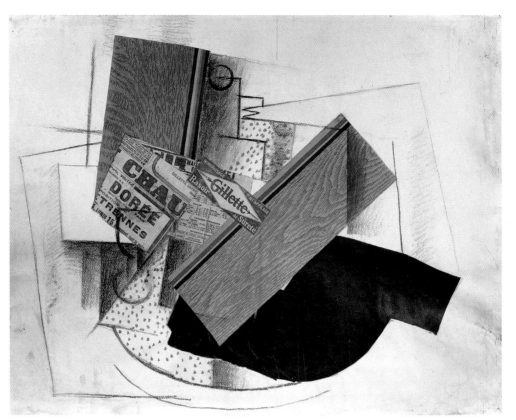

Plate 147 Georges Braque, *Nature morte sur la table, 'Gillette'* (*Still-life on a Table, 'Gillette'*), 1913, pasted papers, charcoal, ink, gouache, and pencil, 47 x 62 cm. Private Collection, Paris. Photo: Giraudon © ADAGP, Paris and DACS, London 1993.

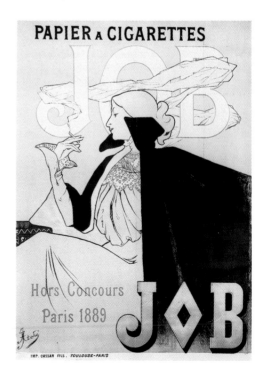

Plate 148 Jane Atché, poster for 'Job' cigarette papers, *c*.1911, Musée d'Affiche et de Publicité, Paris.

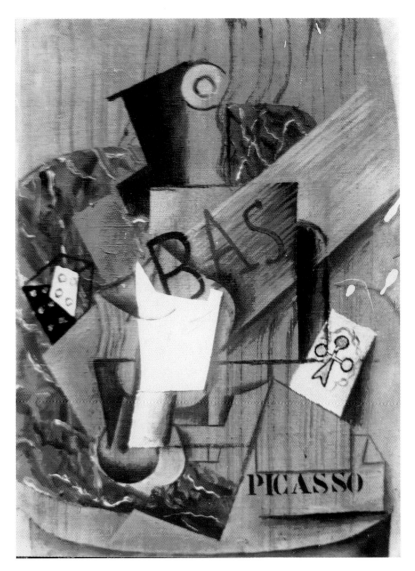

Plate 149 Pablo Picasso, *Dés, verre, bouteille de Bass, as de trèfle et carte de visite* (*Dice, Wineglass, Bottle of Bass, Ace of Clubs and Visiting Card*), 1914?, oil on canvas, 33 x 24 cm. Private Collection. © DACS 1993.

In *Dice, Wineglass, Bottle of Bass, Ace of Clubs and Visitng Card* (Plate 149) Picasso again depicted a calling card with a bent corner, but this time with his own name spelt out in stencilled letters. Not only does this act as a 'signature' for the work, but also, as in the work with the Stein calling card, the inclusion of a depicted dice refers to contemporary preoccupations with chance in art, poetry and literature.

There is an irony here. Picasso's sub-group, an introverted élite, use the signs of *mass* or *popular* culture as root-stock for a group language. They have to use this resource because the existing sign system of 'high art' is part of an established dominant ideology which cannot be used to represent the group's experience of social crisis or revolutionary change. Mixing up the signs from different systems *can* reveal what Voloshinov describes as the Janus-like '*inner-dialectical quality* of the sign'. The contradiction is that though they may see themselves not as an hierarchical élite, but as a resistant separate social grouping, their work can be appropriated and commodified thereby reintegrating the signs from a potentially subversive source into the system of 'high art'. This is the risk, and perhaps the trap, of producing resistant or oppositional work in modern capitalism, which thrives on commodifying and thus neutering dissent.

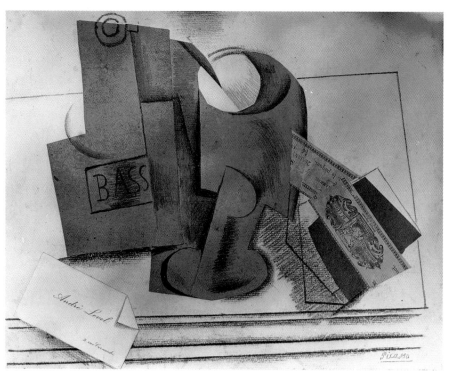

Plate 150 Pablo Picasso, *Bouteille de Bass, verre, paquet de tabac et carte de visite 'André Level'* (*Bottle of Bass, Wineglass, Packet of Tobacco, and Calling Card 'André Level'*), early 1914, pencil, calling card, tobacco label and pasted papers on paper, 24 x 30 cm. Musée National d'Art Moderne, Centre Georges Pompidou, Documentation Photographique. © DACS 1993.

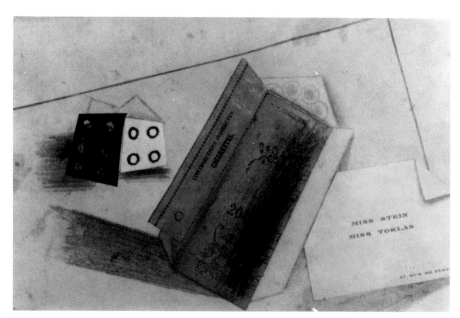

Plate 151 Pablo Picasso, *Dés, paquet de cigarettes et carte de visite* (*Dice, Packet of Cigarettes and Visiting Card*), 1914, pencil, calling card, cigarette packet and pasted paper on paper, 14 x 27 cm. Private Collection. Photo: Archives Galerie Louise Leiris © DACS 1993.

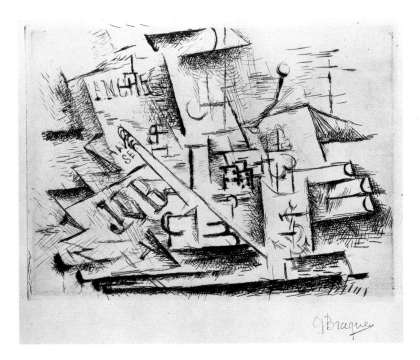

Plate 152 Georges Braque, *Job*, 1911, published 1912, dry-point, 14 x 20 cm. Collection of The Museum of Modern Art, New York. Gift of Victor S. Riesenfeld. © ADAGP, Paris and DACS London 1993.

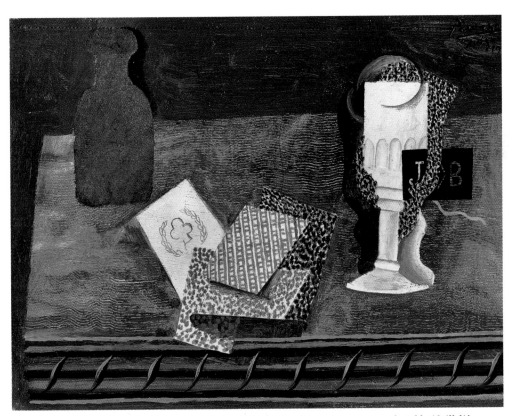

Plate 153 Pablo Picasso, *Nature morte: bouteille, cartes à jouer et verre sur la table* (*Still-life: Bottle, Playing Cards and Wineglass on a Table*, 1914, oil on panel, 32 x 43 cm. Philadelphia Museum of Art. A. E. Gallatin Collection. © DACS 1993.

Artistic subcultures: signs and meaning

What was the public for Cubist signs? Clearly it was not a mass audience. The Cubists' 'public' was what sociologists describe as a subculture – in this case a 'bohemian' one. Within sub-cultural groups, rituals, styles and rules of behaviour are defined as collective responses to those of a wider social world. They set up some degree of collectively defined 'freedom' for the group and define its conditions of production amidst a world of alienation and imposed normalizing rules. They are instances of ways in which, under capitalism, groups resist being assimilated by what they regard as repressive social and cultural systems.[19] Typically, members

> explore 'focal concerns' central to the inner life of the group: things always 'done' or 'never done', sets of social rituals which underpin their collective identity and define them as a 'group' instead of a mere collection of individuals. They adopt and adapt material objects – goods and possessions – and reorganize them into distinctive 'styles' which express the collectivity of their being-as-a-group. ... Sometimes, the work is marked out, linguistically, by names or an *argot* which classifies the social world exterior to them in terms meaningful only within their group perspective, and maintains its boundaries. This also helps them to develop, ahead of immediate activities a perspective on the immediate future – plans, projects, things to do to fill out time, exploits ... They too are concrete, identifiable social formations constructed as a collective response to the material and situated experience of their class.
>
> (J. Clarke, S. Hall *et al.*, 'Subculture, cultures and class', p.47)

The bohemian subcultures of the avant-garde have been a major characteristic of the development of the modernized city. Although distinct from the urban culture of the middle class intelligentsia, sub-cultural groups have also been a part of it, sharing such characteristics as a modernizing outlook, higher standards of education and a privileged position in relation to productive labour. Since at least the mid-nineteenth century one of the preoccupations of artists within such groups has been how to produce images which are readable by their immediate community without resorting to stock solutions readable by others – in Voloshinov's terms, how to preserve the multiaccentuality of their signs as a mark of struggle with, and difference from, the 'accent' of dominant classes. Many who thought of themselves as 'avant-garde', in the original political sense of the term, rather than 'modernist', signifying cultural radicalism, had to work through the contradiction of a 'realist' ambition while operating in a 'modern' system of representation which marginalized and specialized the knowledge required for reading their works.

Many accounts of Picasso's and Braque's works from around 1909 onwards, when they operated as an isolated community, seeing each other practically every day, explain them in terms of a refinement of the possibilities and complexities of formal characteristics. Some historians have even seen the life that these two artists led as a commitment to 'art for art's sake', as an insulated aesthetic and conservative retreat from the world.[20] They were certainly uninvolved in the public side of artistic life, particularly after becoming informally contracted to Kahnweiler's private gallery. Indeed, it is possible to construct an argument which puts an emphasis on the privileged position enjoyed by Picasso and Braque (as a result of a dealer contract and mediated contact with wealthy collectors) and their consequent retreat into an hermetic world of signs which had a possible 'meaning' only to a small group of collectors and critics.

[19] For extended discussion of what follows, see The Open University, *Cubism: Picasso and Braque* (by F. Frascina), pp.40–58.
[20] See, for example, D. Cottington, 'What the papers say: politics and ideology in Picasso's collages of 1912'.

Certainly, Kahnweiler cornered the market for Picasso's and Braque's works, and later claimed that his contracted artists maintained a 'certain aristocracy' by working away from the pressures of exhibition and of critical reception. It is customary and not inaccurate to treat Picasso and Braque as a sort of 'avant-garde' within the broader groupings of modernists; they stood in relation to the more publicly known Cubists, like Léger, Delaunay, Le Fauconnier, Gris, Gleizes and Metzinger (Plates 130, 131, 132) as the various Cubist groups stood to the art world at large. Their audience was not the broader art public but the subculture of the avant-garde. This small group had its own hierarchies, notions of status and divisions analogous to class divisions. Picasso, Braque and their immediate community effectively formed a subculture within a subculture.

Generally, subcultures maintain relations with the shared public sign systems of society that are different from those of more mainstream groups; this characteristic illuminates Picasso's and Braque's 'play' with signs. The social experience of members of a subculture is typically contradictory; they are resistant to but dependent upon a social system which they find inhospitable. In relation to available sign systems, subcultures typically 'play games' with them, breaking their rules in various ways. Much of the time, all that results is a rapid turnover of minority-group styles: the music of youth culture, for example 'punk' in the late 1970s, is a typical area of 'semiotic play'. Often marginalized as socially eccentric, such styles are essentially defensive of the group's identity. Sometimes, however, the merely defensive is transformed into an active engagement with dominant social groupings. Breaking or modifying the rules of shared public sign systems in these cases becomes a symbolic form of resistance to the dominant groups. Those feminists who reject decorative and impractical clothes offer a symbolic resistance to dominant patriarchal ideas of the feminine; such resistance is unlikely to emerge, however, unless it derives from the material and social circumstances of a particular group's experience. Symbolic resistance deals with those public signs which come into some relationship with the sub-group's own socio-economic life.

What did Picasso and Braque respond to? And what were the social and material conditions of their life? Like the rest of the avant-garde, they responded to the material and historical experience of French society in general, but also to the experience of the avant-garde itself; one of social isolation and public incomprehension. As for their own social situation, Picasso was a Spaniard living in Paris, Kahnweiler was German and Braque came from the working-class provinces. Paris, like Vienna, Berlin, London and New York, was a centre of new imperialism which offered endless border-crossings for the restlessly mobile *émigré* or exile, the international anti-bourgeois artist.

The dealer contract as contradictory sign

Kahnweiler was the most astute of the modern monopoly dealers, who included Vollard and Uhde. Picasso's portrait of him (Plate 117) marks Kahnweiler out as having a particular identity in Cubism. Slightly younger than the artists he showed in his gallery, opened in Paris in 1907, Kahnweiler capitalized on a well-entrenched cultural and financial structure, based on the relationships between 'radical' art, private speculators and dealers and 'collectors' with particular social and financial interests in 'modern art'. Like Uhde, but unlike many other dealers, Kahnweiler concentrated on *contemporary* works, acquiring them as they were produced. This was a sign of difference in the culture of artistic competition.

Being new to dealing, and from the same age-group as his artists, Kahnweiler had from 1907 informal contracts with them. In retrospect we know that he was as much a close friend as he was a financial agent. As Moulin and Gee have demonstrated, this differed from some nineteenth-century artist–dealer relationships which maintained formal address and procedures.[21] Kahnweiler made informal verbal agreements with

21 R. Moulin, *Le Marché de la peinture en France*, and M. Gee, *Dealers, Critics, and Collectors of Modern Paintings.*

artists in the first years of his gallery, but between 1912 and 1913 he drew up written contracts with Picasso, Braque, Gris, Léger, Derain and Vlaminck. Although he claimed not to have advertised, the growth of critical attention in papers and journals helped create a reputation for his artists. With a number of foreign purchasers, Kahnweiler could guarantee to control the supply, and therefore the price, of works by his contracted artists.

The Kahnweiler contracts are informal and clear. Picasso's and Braque's reveal a level of intimacy, while the Derain and particularly the Léger are relatively formal and businesslike. Each contract includes the condition that Kahnweiler was to be their *exclusive* dealer; he was promised Braque's and Derain's total production, almost all of Picasso's and all Léger's oil paintings, plus at least a certain number of drawings. On his part he agreed to purchase their paintings at a fixed price according to *size*. This commercial deal took no account of any identifiable notion of relative *quality*, such as that which characterizes retrospective Modernist accounts. Kahnweiler was also keen to obtain the reproduction rights to all the works he bought.

Picasso was the only painter to insert conditions allowing him some degree of flexibility and the right to retain particular paintings and drawings, though not to sell. Picasso's contract also reveals a significant difference in agreed prices. In Picasso's and Léger's contracts certain formats were grouped together, perhaps because of the painter's or dealer's opinion about the saleability of those particular sizes for that artist. Léger's canvas list also shows that, unlike the others, he was definitely working in large sizes of 100, 120 and above – those geared to the more public Salon-type format. However, the startling difference is in the prices paid. For instance, size 25: Picasso, 1000 francs; Derain, 300 francs; Braque, 250 francs; Léger, 75 francs. Comparing the other sizes a similar difference is maintained, even for the drawings. At only thirty-one Picasso had established a marketable reputation which could secure a high price for his works from Kahnweiler, a price comparable with those secured by the older and more established artist Matisse in his contracts with Bernheim-Jeune (size 25: 1,275 francs, plus 25% of the profit on the sale price), which are much more precise, comprehensive and formal than the Kahnweiler contracts (Bernheim-Jeune had been established for some time). In comparison, a house-painter could expect to earn 170 francs per month (200 hours at 0.85 francs per hour) and a typesetter 160 francs (0.80 francs per hour). As for professional wages, the critic André Salmon found the offer of 200–250 francs a month too good to refuse when it was made to him in 1908 by *L'Intransigeant* (Gee, *Dealers, Critics and Collectors of Modern Painting*, p.229). With a 100% dealer mark-up, it would thus have cost Salmon his fees for 8–10 months to buy a size 25 canvas of Picasso's at 1912 prices. A house-painter would have had to spend his entire gross annual earnings to buy the same canvas from a dealer.

What do these contracts signify? We can begin to answer this with reference to Marx's distinction between *productive* and *unproductive labour*: 'Milton, who wrote Paradise Lost for five pounds, was an *unproductive labourer*. On the other hand, the writer who turns out stuff for his publisher in factory style, is a *productive labourer*. Milton produced *Paradise Lost* for the same reason that a silk worm produces silk. It was an activity of *his* nature' (*The Theories of Surplus Value*, p.401). Marx was concerned to distinguish between writers being productive in terms of ideas and in terms of capital, the author as a wage-labourer for a capitalist publisher.

In these terms, Picasso's and Braque's contracts signify a contradiction in their economic situation. On the one hand, the contracts enabled them to continue working on representations which signified a sense of difficult and contradictory experience and a resistance to conventional notions of the art object. From this perspective their works have a use value in expanding the critical consciousness of their immediate community, or sub-group. This would seem to suggest that they were not, in Marx's words, '[turning out] stuff for [their] publisher in factory style'. On the other hand, the contracts dealt with

works of art as objects, offering payment for them in terms of size, not in terms of relative 'quality'. For Kahnweiler, as agent, the use value of the works permitted him to treat them as objects with an exchange value, to treat them as commodities in a capitalist economy which had a *different* use value for the works. This was at odds with their difficult and 'resistant' nature but is typical of assimilation. From the artist's position, there is a dichotomy between appearance and concealed reality. The contracts explicitly dissociate 'quality' and price, thereby giving the appearance of an attempt to resist the commodification of the original use value of the works. However, in reality the contract process alienated artists from their work, by turning their products into something they were not intended to be. The agent creates a profit, the surplus value, which is the difference between contract price and that obtained in the process of exchange in the market. This is to describe a contradiction in which they were all, including Kahnweiler, caught.

Thus entrepreneurial dealing and commodity fetishism typically tightened the financial cord which tied avant-garde artists to conventional society. Avant-garde work in art often became a kind of 'estranged labour', alienating artists from their own products, and from what Marx called free 'conscious life-activity'. But Picasso's and Braque's project seems to have signified a sense of this threatened freedom and an attempt to disengage from estranged labour. They attempted a critical strategy, to create a social space where they produced works that questioned the conventions associated with 'productive labour' in art – the kind of work that can be easily assimilated and marketed in the Salon/dealer network. Signs of this are Picasso's insistence in his contract that he retain drawings necessary for his 'work' and his association with Braque in their Cubist project.

As we have seen, the strategy involved the investigation, subversion and modification of signs, signs that had meanings to a group within which Kahnweiler had a powerful material effect and within which he and others found a leftist political and social identity in the early years of the century. Kahnweiler's leftism, however, does not mean that we can simply align Picasso's and Braque's work with a leftist audience. Certainly Kahnweiler's cultural inheritance was the ideas, values and beliefs, of the liberal intelligentsia, just as Picasso's early years in Spain were characterized by anarchist sympathies and activities. In the reality of Paris, though, both occupied social positions in which potentially contradictory signifiers were in play. For example in the autumn of 1909 Picasso moved from the relative squalor of the Bâteau Lavoir into a comfortable apartment on the Boulevard de Clichy, indicating his more settled financial status. From Fernande Olivier, we learn that Picasso attended the fashionable avant-garde *soirées* that characterized the cosmopolitan life of Paris. This could lead to claims such as those by Cottington that such a life-style was a process of artistic *embourgeoisement* and that encoded within Cubist works was a conservative aesthetic ideology which encompassed the well-heeled bourgeois retreat from contemporary politics (the liberal collector's pursuit of pleasure as a substitute for moral and political engagement), the neo-Symbolism of contemporary writers (Apollinaire, Salmon and Jacob) and a 'formalism' derived from Cézanne's late work. Possible evidence includes the bourgeois social and cultural values of contemporary 'enlightened' collectors, who had secure incomes and belonged to the literary intelligentsia. Their values moved from Syndicalist or Socialist tendencies to a defensive preoccupation with aesthetics and art. How much these movements affected Picasso's and Braque's *practice* is open to debate.

From what we know about the specifics of Cubist practice and the workings of subcultural groups another reading is possible. In the negative reaction from agents of authority and guardians of decorum and morality (social administrators, cultural managers, the official press etc.) a subculture can develop an identity which can continue to be resistant to appropriation for some time. Picasso's and Braque's 'collective contract' with a particular social grouping, within which their works and the original meanings

were produced, represents a crossing of settled boundaries of the sign systems of different classes and class factions. It is true that their works have since been appropriated within the capitalist system and located, for the most part, in museum sanctuaries which treat these 'ideological signs' as autonomous aesthetic 'Art' objects. This is the process whereby 'the ruling class strives to impart a supra-class, eternal character to the ideological sign, to extinguish or to drive inward the struggle between social value judgements which occur in it, to make the sign uniaccentual' (Voloshinov, *Marxism and the Philosophy of Language*, p.23). We can, though, recover these Cubist works from such a process by examining them as signs, as specific social utterances by people who experience and respond to the contradictory representations of modern capitalist society. In doing so we learn much about historically specific instances of representation and generally, about the way in which the spectator's recognition of a sign may be overlaid with misrecognition of actual relations and experience.

Conclusion

We have explored some of the parallels Jakobson saw between early studies in semiotics and linguistics, and Cubism as a system of signs which engaged the spectator in a social dialogue about the nature of representation itself. In doing so, we have considered Voloshinov's criticism of 'mainstream semiotics' – that it tends towards 'propositions of a rationalistic and mechanistic world outlook' which deny the 'living, dynamic reality of language and its social functions' (*Marxism and the Philosophy of Langauge*, p.82). Voloshinov argues, by contrast, that the utterance or visual sign enters into a dialogic exchange in which there may be a struggle between social value judgements in the sign itself.

Those texts which have discussed Cubism in terms of semiotics tell us much about the dangers of looking for fixed meanings, especially in works which problematize the nature of visual representation. However, some have been criticized for using Saussurean theory to defend the autonomy of visual representation, and have therefore neglected the social dimension of the sign except at the level of *langue*. Critics of semiotics rightly point to the danger of placing too much stress on 'signifying system' (*langue*) and 'product' rather than on 'speakers' in semiotic activity which interact in a variety of ways in particular social contexts. This stress on 'system' can lead to a radical analysis of the autonomy of the signifying system itself, but an implicit or explicit separation of semiotics from social and political thought. This may not have been Saussure's intention but some uses of his work have led to a radical formalism in semiological analysis, following in the tradition of comparable emphases in Modernist criticism and history in which autonomy is central. In this chapter, I have attempted to examine Cubist works as operating in a sign system which is social at the level of *both langue and parole*. In this respect they are not regarded as fetishized objects securing the autonomy of 'high art', but as historically revealing instances of social dialogue, which include a questioning of the category of 'high art', within a specific context.

One of the legacies of Cubism was the development of photomontage. In this technique, used, for example, by Hannah Hoch and John Heartfield (Plates 154, 155), the linguistic processes of 'selection' and 'combination' were manipulated to keep alive the '*inner dialectical quality* of the sign' (Voloshinov, *Marxism and the Philosophy of Language*, p.23), that is, the struggle between social value judgements which occurs in it. Hoch and Heartfield hoped to reveal, through irony and the pun, the way in which a dominant

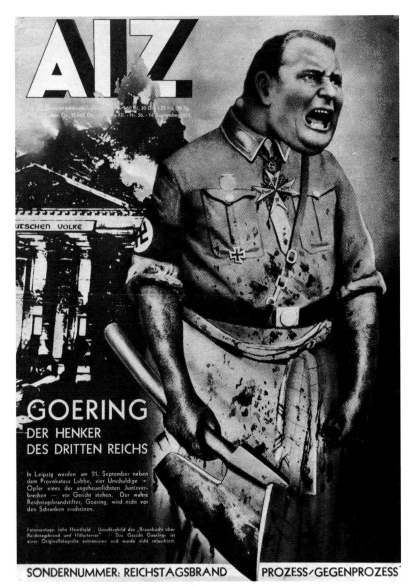

Plate 154 John Heartfield,
*Goering Der Henker des Dritten
Reichs* (*Goering the Executioner of
the Third Reich*), cover of *AIZ*
(*Arbeiter Illustrierte Zeitung*
[*Workers' Illustrated Paper*]), XII,
36, 14 September, 1933,
photomontage. Photo:
Bildarchïv Preüssischer
Kulturbesitz Berlin. © DACS 1993.

group tries to make the sign 'uniaccentual', in order to stabilize social struggles and
contradictions for their own ideological purposes.

Another legacy of Cubism was the development of abstraction, and with it claims for
the autonomy of 'high art' as a sphere of specialized aesthetic experience, which may or
may not represent a form of social and political resistance. This is vividly represented by
Malevich's book *The Non-Objective World*, published in 1927. Writing in the context of
competing claims by Social Realists and Russian Formalists, he claimed that every social
idea 'stems from the sensation of hunger' as every art work 'originates in pictorial or
plastic feeling'; he continues: 'It is high time for us to realize that the problems of art lie far
apart from those of the stomach or the intellect' (in Chipp, *Theories of Modern Art*, p.346;
see Plate 183). On the other hand, Brecht, for whom social struggle existed at the level of
the sign in, for example, Heartfield's photomontages, saw 'non-objective' or abstract art as
'uniaccentual', to return to Voloshinov's terms. In his notebooks from 1935 to 1939 he

Plate 155 Hannah Höch, *Cut with the Cake Knife*, 1919, collage, 114 x 90 cm. Nationalgalerie, Staatliche Museen Preussischer Kulturbesitz, Berlin. Photo: Jörg P. Anders. The central quotation at the bottom of the image reads: 'Cut with the cake-knife of Dada through the last beer-swilling cultural epoch of the Weimar Republic'. © DACS 1993.

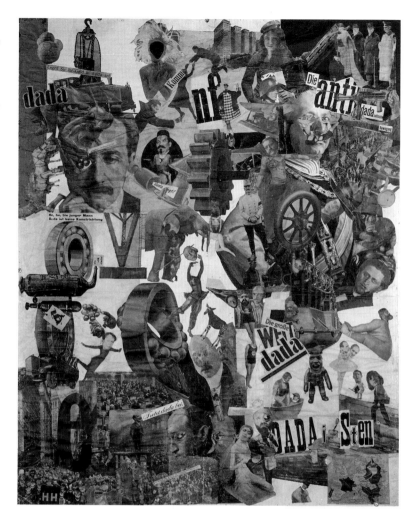

wrote that the emphasis on formal system, no matter how internally radical, led to social closure and an implicit acceptance of the status quo:

> As painters and subject spirits of the Establishment, you could proclaim that the most beautiful and important perceptions are composed of lines and colours ... And as court painters, you could drag all objects out of the world of perception, everything that is of value, all needs, anything substantial. You would require as painters for the ruling classes no specific perceptions, like anger in the face of injustice no perceptions bound to knowledge which call up other perceptions of a changing world – but just quite general, vague, unidentifiable perceptions, available to everyone, to the thieves and to their victims, to the oppressors and to the oppressed.
>
> (Brecht, 'On non-objective painting', p.143)

This is part of a debate, not unlike that about the 'social' basis of semiotics, which still continues. If Voloshinov was correct in his analysis, and I think he was, at the heart of this debate is a struggle between social and political value judgements, and, as many have argued, this struggle involves the rhetoric of power (class, gender, race) in all its utterances.

References

ALLOULA, M., *The Colonial Harem*, translated by M. and W. Godzich, Manchester, Manchester University Press, 1987.

APOLLINAIRE, G., 'The three plastic virtues' in Breunig (ed.), *Apollinaire on Art*.

APOLLINAIRE, G., *The Cubist Painters: Aesthetic Meditations*, translated by L. Abel, New York, Wittenborn, 1949.

BAKHTIN, M., *The Dialogic Imagination: Four Essays*, edited by M. Holquist, Austin, University of Texas Press, 1981.

BARR, A.H., *Cubism and Abstract Art*, New York, The Museum of Modern Art, 1936.

BARR, A.H., *Picasso: Forty Years of His Art*, New York, The Museum of Modern Art, 1939.

BARR, A.H., *Matisse: His art and His Public*, New York, The Museum of Modern Art, 1951.

BARTHES, R., 'Language (*langue*) and speech' in *Writing Degreee Zero and Elements of Semiology*.

BARTHES, R., *Writing Degree Zero and Elements of Semiology*, translated by A. Lavers and C. Smith, London, Jonathan Cape, 1984.

BERGSON, H., *An Introduction to Metaphysics*, translated by T.E. Hulme, London, 1949.

BRECHT, B., 'On non-objective painting' in Frascina and Harris (eds), *Art In Modern Culture*.

BOIS, Y.A., 'Kahnweiler's lesson', *Representations*, no.18, spring 1987, pp.33–68.

BRAQUE, G., 'Thoughts and reflections on painting' in Goldwater and Treves (eds), *Artists on Art*.

BREUNIG, L.C. (ed.), *Apollinare on Art: Essays and Reviews 1902–1918*, translated by Susan Suleiman, London, Thames and Hudson, 1972.

BUCKLEY, H., *Guillaume Apollinaire as an Art Critic*, Ann Arbor, UMI Research Press, 1981.

CHARBONNIER, G., *Conversations with Claude Lévi-Strauss*, translated by J. and D. Weightman, London, Jonathan Cape, 1969.

CHARLET MURRAY, J., *Picasso's Use of Newspaper Clippings in his Early Collages*, unpublished M.A. thesis, Columbia University 1967.

CHIPP, H., *Theories of Modern Art: A Source Book by Artists and Critics*, Berkeley, Los Angeles and London, University of California Press, 1968.

CLARK, T.J., 'Preliminaries to a possible treatment of *Olympia* in 1865', *Screen*, vol.21, no.1, spring 1980, pp.18–41; an edited version is reprinted in Frascina and Harris, *Art in Modern Culture*.

CLARK, T.J., *The Painting of Modern Life: Paris in the Art of Manet and his Followers*, London, Thames and Hudson, 1985; an extract is reprinted in Frascina and Harris, *Art in Modern Culture*.

CLARKE, J., HALL, S. *et al*, 'Subculture, cultures and class' in Hall and Jefferson (eds), *Resistance Through Rituals*.

CORBIN, A., 'Commercial sexuality in nineteenth-century France: a system of images and regulations', *Representations*, no.14, spring 1986, pp.209–19.

COTTINGTON, D., 'What the papers say: politics and ideology in Picasso's collages of 1912', *Art Journal*, winter 1988, vol.47, no.4, pp.350–59.

COUSINS, J., 'Documentary chronology' in Rubin (ed.), *Picasso and Braque: Pioneering Cubism*.

CRANSHAW, R., 'Notes on Cubism, war and labour', *Art Monthly*, no.85, April 1985, pp.3–5.

CULLER, J. (ed.), *On Puns: The Foundation of Letters*, Oxford, Blackwell, 1988.

DAIX, P., and ROSSELET, J., *Picasso: The Cubist Years 1907–16: A Catalogue Raisonné of the Paintings and Related Works*, London, Thames and Hudson, 1979.

FRASCINA, F., 'Picasso's art: a biographical fact?', *Art History*, vol.10, no.3, September 1987, pp.401–15.

FRASCINA, F., *Pollock and After: The Critical Debate*, London and New York, Harper and Row, 1985.

FRASCINA, F., *Cubism: Picasso and Braque*, see The Open University.

FRASCINA, F. and HARRIS, J. (eds), *Art in Modern Culture: An Anthology of Critical Texts*, London, Phaidon Press, 1992.

FRY, E., 'Picasso, Cubism and reflexivity', *Art Journal*, Winter 1988, vol.47, no.4, pp.296–310.

FRY, R., 'An essay in aesthetics', *Vision and Design*, Harmondsworth, Penguin Books, 1937.

GEE, M., *Dealers, Critics and Collectors of Modern Paintings: Aspects of the Parisian Art Market Between 1910 and 1930*, New York and London, Garland, 1981.

GILOT, F. and LAKE, C., *Life with Picasso*, London, Nelson, 1965.

GLEIZES, A. and METZINGER, J., *Du 'Cubisme'*, Saint-Vincent-sur-Jabron, Éditions Présence, 1980 (first published 1912).

GOLDWATER, R., and TREVES, M. (eds), *Artists on Art: from the Fifteenth to the Twentieth Century*, London, Kegan Paul, 1947.

GORDON, D., *Women of Algeria: An Essay in Change*, Harvard, Harvard University Press, 1968.

GIRARDET, R., *L'Idée coloniale en France 1871–1962*, Paris, La Table Ronde, 1972.

GREENBERG, C., 'Avant-garde and kitsch', *Partisan Review*, vol.VI, no.5, Fall, 1939, pp.34–49; reprinted with discussion in Frascina (ed.) *Pollock and After*.

GREENBERG, C., 'The pasted paper revolution', *Art News*. vol.LVII, September 1958, pp.46–9.

GREENBERG, C., 'Modernist Painting' (1961) in Frascina and Harris, *Art in Modern Culture*.

HALL, S. and JEFFERSON, T. (eds), *Resistance Through Rituals: Youth Subcultures in Post-War Britain*, London, Hutchinson, 1976.

HODGE, R., and KRESS, G., *Social Semiotics*, Cambridge, Polity Press, 1988.

HOLT, R., *Sport and Society in Modern France*, London and Basingstoke, Macmillan, 1981.

JAKOBSON, R., 'The metaphoric and metonymic poles' in *Studies on Child Language and Aphasia*, The Hague and Paris, Mouton, 1971

KAHNWEILER, D.H. and CRÉMIEUX, F., *My Galleries and Painters*, translated by H. Weaver, London, Thames and Hudson, 1971.

KAHNWEILER, D.H., 'Huit Entretiens avec Picasso' (dated 1933–1952), *Le Point* (Souillace), vol.VII, no.XLII, October 1952, pp.22–30.

KRAUSS, R., 'In the name of Picasso', *October* 16, spring 1981, pp.5–22; an edited version is reprinted in Frascina and Harris, *Art in Modern Culture*.

LANG, B., and WILLIAMS, F., *Marxism and Art: Writings in Aesthetics and Criticism*, New York and London, Longman, 1972.

LEIGHTEN, P., 'Picasso's collages and the threat of war 1912–13', *Art Bulletin*, vol.LXVII, no.4, December 1985, pp.653–72.

LEIGHTEN, P., *Re-Ordering the Universe: Picasso and Anarchism 1897–1914*, Princeton, Princeton University Press, 1989.

LÉJA, M., '"Le vieux marcheur" and "les deux risques": Picasso, prostitution, venereal disease and maternity, 1899–1907', *Art History*, vol.8, no.1, pp.66–81.

Les Soirées de Paris, tome 1, nos 1–17, Geneva, Slatkine Reprints, 1971.

LODGE, D. (ed.), *Modern Criticism and Theory: A Reader*, Burnt Mill, Harlow, Longman, 1988.

MARX, K., *The German Ideology*, translated by C. Arthur, London, Lawrence and Wishart, 1970.

MARX, K., *The Theories of Surplus Value, Capital*, vol.IV, part 1, translated by E. Burns, London, Lawrence and Wishart, 1969.

MERQUIOR, J.G., *From Prague to Paris: A Critique of Structuralist and Post-Structuralist Thought*, London, Verso, 1986.

MILLER, M., *The Bon Marché: Bourgeois Culture and the Department Store, 1869–1920*, London, George Allen and Unwin, 1981.

MONOD-FONTAINE, I. (ed.), *Daniel-Henry Kahnweiler: marchand, éditeur, écrivain*, Paris, Centre Georges Pompidou, 1984.

MONOD-FONTAINE, I. (ed.), *Donation Louise et Michel Leiris: Collection Kahnweiler-Leiris*, Paris, Centre Georges Pompidou, 1984.

MOULIN, R., *Le Marché de la peinture en France*, Paris, Les Éditions de Minuit, 1967.

MULVEY, L., 'Visual pleasure and narrative cinema', in *Visual and Other Pleasures*, London, Macmillan, 1989.

OLIVIER, F., *Picasso and his Friends*, translated by Jane Miller, London, Heinemann, 1964.

THE OPEN UNIVERSITY, A315 *Modern Art and Modernism*, Block V *Cubism: Picasso and Braque*, Milton Keynes, The Open University Press, 1983 (written for the course team by F. Frascina).

ORTON, F. and POLLOCK, G., 'Les Données bretonnantes: la prairie de la représentation', *Art History*, vol.3, no.3, September 1980, pp.314–44.

ROSENBLUM, R., 'Picasso and the typography of Cubism', in Penrose R. and Golding, J. (eds), *Picasso: 1881–1973*, London, Elek, 1973.

POGGI, C., 'Mallarmé, Picasso and the newspaper as commodity', *Yale Journal of Criticism*, fall, 1987, pp.133–51.

RUBIN, W., *Picasso in the Collection of the Museum of Modern Art*, New York, The Museum of Modern Art, 1972.

RUBIN, W., 'La Genèse des *Demoiselles d'Avignon*', in Seckel, H. (ed.), *Les Demoiselles d'Avignon*, vol.2, Paris, Musée Picasso: Éditions de la Réunion des musées nationaux, 1988.

RUBIN, W. (ed.), *Picasso and Braque: Pioneering Cubism*, New York, The Museum of Modern Art, 1989.

SAUSSURE, F. DE, 'Nature of the linguistic sign', in *Course in General Linguistics*.

SAUSSURE, F. DE, *Course in General Linquistics*, translated by W. Baskin, London, Peter Owen, 1974.

SCHAPIRO, M., 'Nature of abstract art', *Marxist Quarterly*, vol.1, no.1, January–March 1937, pp.77–98.

SCHAPIRO, M., 'The apples of Cézanne: an essay on the meaning of still-life', *Modern Art Nineteenth and Twentieth Centuries, Selected Papers*, vol.2, London, Chatto and Windus, 1968.

SCHAPIRO, M., 'Frontal and profile as symbolic forms' in *Words and Pictures: On the Literal and Symbolic in the Illustration of a Text*, in the series *Aproaches to Semiotics*, T. Sebeok (ed.), The Hague and Paris, Mouton, 1973.

SECKEL, H. (ed.), *Les Demoiselles d'Avignon*, vols 1–2, Paris, Musée Picasso: Éditions de la Réunion des musées nationaux, 1988.

SHAW, J., 'The figure of Vénus: rhetoric of the ideal and the Salon of 1863', *Art History*, vol.14, no.1, December 1991, pp.540–70.

SNOEP-REITSMA, E., 'Chardin and the bourgeois ideals of his time', *Kunsthistorisch Jaarboek*, 1973, no.24, pp.147–243.

STEEGMULLER, F., *Apollinaire: Poet Among the Painters*, Harmondsworth, Penguin, 1973.

VALLIER, D., 'Braque, la peinture et nous: propos de l'artiste recueillis', *Cahiers d'Art*, Paris, vol.XXIX, no.1, October 1954, pp.13–24.

VOLOSHINOV, V.N., *Marxism and the Philosophy of Language*, translated by L. Matejka and I.R. Titunik, Cambridge, Massachusetts and London, Harvard University Press, 1986.

WEBER, M., 'Religous rejections of the world and their directions' in H.H. Gerth and C. Wright Mills (eds), *From Max Weber: Essays in Sociology*, London, Routledge, 1991.

The author would like to thank Nigel Blake for his comments on an earlier version of this chapter.

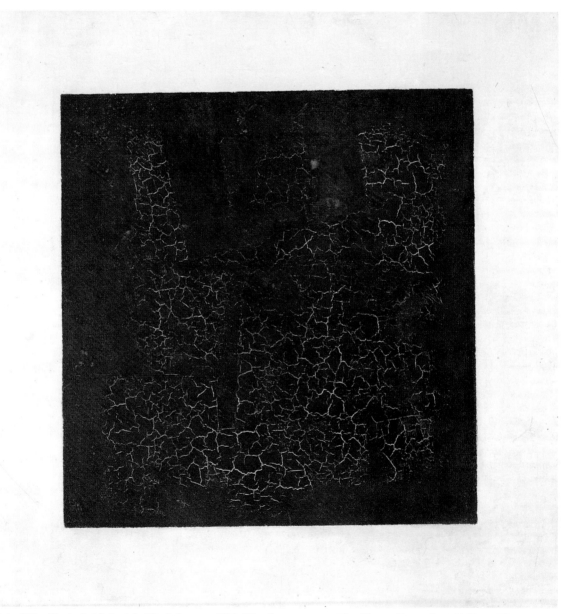

Plate 156 Kazimir Malevich, *Black Square*, 1914–15, oil on canvas, 80 x 80 cm. Tretyakov Gallery, Moscow. Photo: Society for Co-operation in Russian and Soviet Studies.

CHAPTER 3
ABSTRACTION

by Charles Harrison

Abstraction, figuration and representation

Abstract and abstraction

This essay is primarily concerned with the emergence of forms of abstract art in Europe during the second decade of the twentieth century, and with some problems of interpretation and evaluation which they raise. To talk about 'emergence' is to claim that these were somehow *new* forms of art. In due course I shall be considering the nature of this novelty and examining some of the claims made for early abstract art. But to understand the significance of these claims we need first to appreciate what was involved, at a particular moment in history, in putting the two terms 'abstract' and 'art' together.

The term 'abstract' is now widely used and since the early twentieth century it has been applied as a label to many different forms of art apart from those which will form the principal subject-matter of this chapter. In writing about art, the related noun 'abstraction' tends to be used in two connected though distinct senses: to refer in the case of certain works of art to the *property* of being abstract or 'non-figurative'; and to refer to the *process* whereby certain aspects of subjects or motifs are emphasized in works of art at the expense of others.

Plates 156–161 show examples of abstract art from the decade 1910 to 1920, produced by artists of Russian, Czech, Dutch and Swiss extraction. In describing all these works as abstract we are implying that however they look, what they look *like* is not to be explained by reference to some depicted subject. Despite some evident differences, they have that much in common.

In fact, though in common-sense usage we refer to works as 'abstract' in the absence of any evident likeness to the world, it can happen that a work is thought of as abstract not so much because there is nothing that it looks like, as because its subject or motif is hard to identify. And this may well be because some process of abstraction has led to the suppression of certain easily recognizable characteristics of the original subject. In 1932 the English painter Paul Nash referred to Pablo Picasso as 'the greatest of all abstract painters' (Nash, 'Abstract art'; see Plate 162). We might call this a 'weak' sense of abstraction, since according to the stricter criteria which will be applied in this essay, Picasso could not be said to have made a single abstract painting during his long working life. On the other hand, the processes of abstraction which he practised on his subjects were often such as to make it hard to perceive just *how* those subjects were represented in his pictures. It's easy to see how a painting such as Picasso's *Guitarist* of summer 1910 might be thought of as abstract in this weak sense (Plate 163). By comparison the work shown in Plate 160 could be called abstract in the strong sense of the term: that is to say it is a work which makes no apparent pretence to being a picture of any scene or thing or person. It presents itself simply as a 'Composition'.

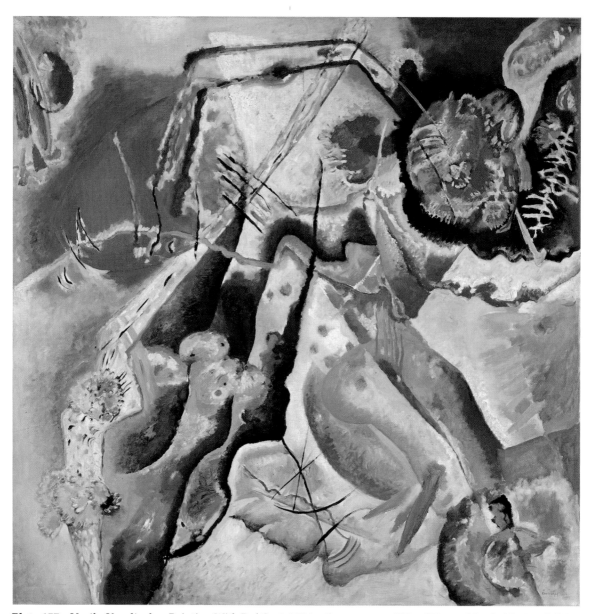

Plate 157 Vasily Kandinsky, *Painting With Red Spot*, 1914, oil on canvas, 130 x 130 cm. Musée National d'Art Moderne, Centre Georges Pompidou, Paris (Nina Kandinsky Donation). © ADAGP, Paris and DACS, London, 1993.

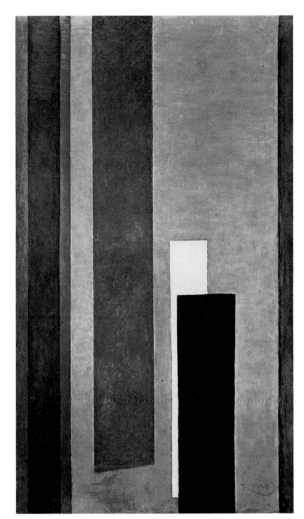

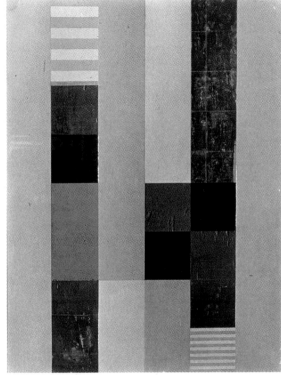

Plate 159 Hans Arp, *Collage*, 1916, collage, 111 x 89 cm. Öffentliche Kunstammlung, Basle. Courtesy Fondation Arp. © DACS, 1993.

Plate 158 František Kupka, *Kolme plochy III* (*Vertical Planes III*), 1912–13, oil on canvas, 200 x 118 cm. National Gallery, Prague. © ADAGP, Paris and DACS, London, 1993.

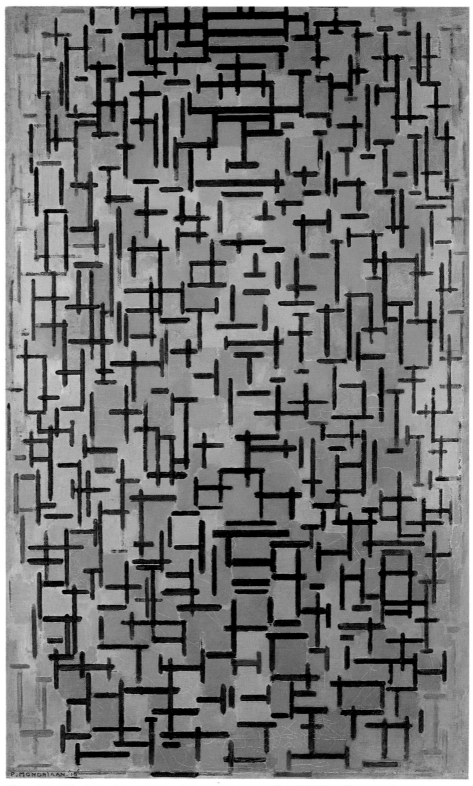

Plate 160 Piet Mondrian, *Composition 1916*, 1916, oil on canvas with wood strip at
bottom edge, 119 x 75 cm. Solomon R. Guggenheim Museum, New York, 49.1229.
Photograph © The Solomon R. Guggenheim Foundation. © DACS, 1993.

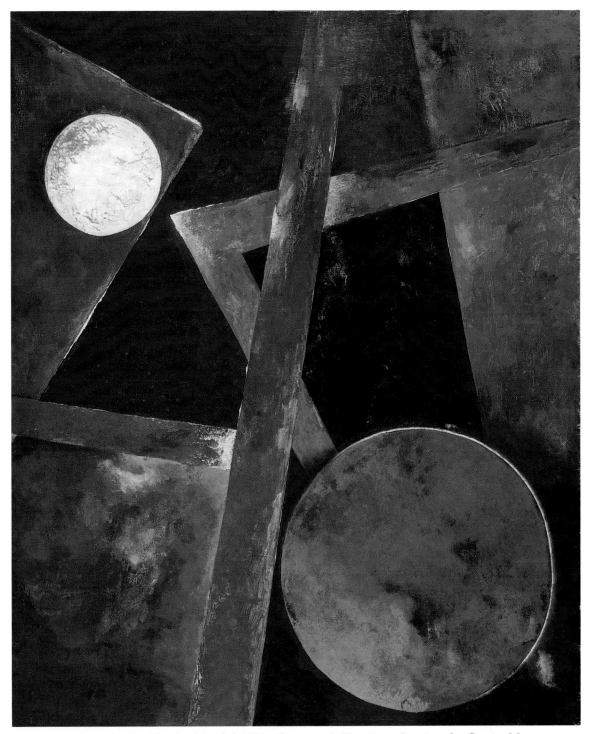

Plate 161 Alexander Rodchenko, *Untitled*, 1920, oil on wood, 85 x 64 cm. Los Angeles County Museum.

Plate 162 Pablo Picasso, *Girl before a Mirror*, March 1932, oil on canvas, 162 x 130 cm. Collection, The Museum of Modern Art, New York, Gift of Mrs Simon Guggenheim. Photo: Saichi Sunami. © DACS, 1993.

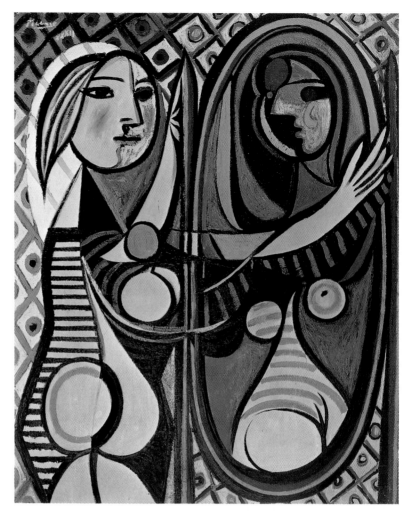

As we shall see, and as Picasso's *Guitarist* helps to show, the weak and strong senses of abstraction are connected both practically and in art-historical terms. While it was a persistent feature of Braque's and Picasso's Cubist work of 1910–12 that its figurative references were often difficult and occasionally impossible to recover, this difficulty was combined with a powerful fascination and a secure avant-garde status. This combination encouraged numerous writers and artists to consider the possibility of a wholly non-figurative or, as Guillaume Apollinaire suggested, a 'pure' painting (Apollinaire, 'On the subject in modern painting'). Though Picasso and Braque turned decisively away from the brink of abstraction, most of the artists associated with the development of abstract art between 1912 and 1920 underwent some form of apprenticeship in Cubist styles and techniques during the preceding two or three years. For example, both Kupka's *Vertical Planes* and Arp's collage of 1916 might be seen as forms of 'post-Cubist' painting (Plates 158 and 159). In a text of 1912, the French painter Robert Delaunay referred to his window pictures of that year as forms of 'pure painting', though they clearly reveal a structure of facetted planes which is thoroughly Cubist in character (Delaunay, 'On the construction of reality in pure painting'; see Plate 164). The awakening of Mondrian's interest in the then recent Cubist paintings of Braque and Picasso – and his working-out over a number of years of what he saw as the implications of those paintings – helps to explain the development towards 'pure' abstraction suggested by the sequence of paintings shown in Plates 165 to 169.

Plate 163 Pablo Picasso, *Le Guitariste* (*Guitarist*), summer 1910, oil on canvas, 100 x 73 cm. Musée National d'Art Moderne, Centre Georges Pompidou, Paris. © DACS, 1993.

Plate 164 Robert Delaunay, *Windows*, 1912, encaustic on canvas, 80 x 70 cm. Collection, The Museum of Modern Art, New York. The Sidney and Harriet Janis Collection. © ADAGP, Paris, and DACS, London, 1993.

Plate 165 Piet Mondrian, *Sea after Sunset*, 1909, oil on board on panel, 63 x 75 cm. Collection Haags Gemeentemuseum, The Hague. © DACS, 1993.

Plate 166 Piet Mondrian, *The Sea*, 1912, oil on canvas, 82 x 92 cm.. Private Collection, Basle. © DACS, 1993.

Plate 167 Piet Mondrian, *Pier and Ocean*, 1914, charcoal and indian ink, 53 x 66 cm. Courtesy Sidney Janis Gallery, New York. © DACS, 1993.

Plate 168 Piet Mondrian, *Compositie No. 10 (Composition No.10 (Pier and Ocean))*, 1915, oil on canvas, 85 x 108 cm. Rijksmuseum Kröller–Müller, Otterlo. Photo: Tom Haartsen. © DACS, 1993.

Plate 169 Piet Mondrian,
Compositie in swart en wit
(*Composition in Line (Black and
White)*), 1916–17, oil on canvas,
100 x 100 cm. Rijksmuseum
Kröller–Müller, Otterlo. Photo:
Tom Haartsen. © DACS, 1993.

On the other hand, it is important to bear in mind that while Cubism emerged from within the context of a Parisian avant-garde, the great majority of the early developments in abstract art took place at some distance from the French capital, in Germany, Austria, Holland and Russia. Abstract art was not simply a form of continuation of that modern tradition which had had Paris as its centre for the previous half century. On the contrary, the idea of a 'pure' or objectless painting tended to cut against the predominant grain of modern French painting, the strength of which had lain in its sophisticated exploration of the problems of realism and self-consciousness in figurative representation. Certainly, that tradition was an indispensable resource for all the artists involved, but it was extended, diversified and changed under the different historical and intellectual conditions of northern and eastern Europe. The working-out of this process, coinciding as it did with the period of the First World War, marked the beginning of the end of French dominance over the visual forms of the modern. Though Paris was to remain a major centre until the beginning of the Second World War, by the early 1920s the idea of the modern in art and design had already come to be associated in the minds of many with the possibility of a universal and therefore international aesthetic, for which forms of abstract painting would provide prototypes and exemplars.

Abstraction and meaning

The process of abstraction typically emphasizes those aspects of painting which we think of as formal. The artist Theo van Doesburg offered a schematic demonstration of the process of abstraction in his book *The Principles of Neo-Plastic Art*. Plate 170 shows him transforming a photographic picture of a cow by stages into a kind of abstract composition – supposedly by paring away its individualizing features and by emphasizing its

Plate 170 Theo van Doesburg, *Asthetische Transfiguration Eines Gegenstandes* (*An Object Aesthetically Transformed*), *c*.1917. From Theo van Doesburg, *Grundbegriffe der Neuen Gestaltenden Kunst* (*Principles of Neoplastic Art*), Bauhausbucher no. 6, 1925, Bauhaus-Archiv, Berlin.

'essential' form. There's something clearly absurd in the contrast between the first and last of Van Doesburg's images. Whether this absurdity was intended or not, the contrast serves to bring home an important point about abstract art in general, and about the possible ways in which it might be interpreted or found meaningful. It is a point to which we shall return continually throughout this chapter. In the encounter with traditional forms of painting, we are accustomed to being able to match certain images against the world, to noticing where they do and do not correspond with appearances (or with our expectations), and to reading kinds of intention into the resulting similarities and differences. Given the sequence of Van Doesburg's illustrations, we can actually engage in a similar form of matching. If we are apprised of the intervening stages, we can easily enough 'read' the abstract painting as referring to the cow. This is to say that we can reconstruct a kind of causal history for the painting, one which commences on the one hand with some actual cow in the world and on the other with some set of intentions on the part of the artist. The process of abstraction is, as it were, the sequence of effects that these intentions have on the 'original' image of the cow, and the final 'abstract' composition is the result. To see the composition as referring to the cow, then, is implicitly to reconstruct a chain of causes, intentions and effects, however odd they may have been.

But what if we were confronted only with the last image in the sequence (Plate 171) – as we might well be in the Museum of Modern Art in New York, where the painting now resides? We might possibly see a cow-like pattern in it, but in the absence of its title I doubt that it would take much to persuade us that our perception was accidental. How else, then, might we find meaning in the painting? The question clearly has relevance to

Plate 171 Theo van Doesburg, *Composition (The Cow)*, *c*.1917, oil on canvas, 38 x 64 cm. Collection, The Museum of Modern Art, New York. Purchase.

the interpretation of abstract art as a whole. In fact, Van Doesburg's sequence presents a case which is deceptively clear-cut. Plates 165 to 169 might be seen as illustrating a similar *process* of abstraction, and guided by Van Doesburg's example, it might therefore seem reasonable to assume that Mondrian's *Composition in Line* of 1916–17 is in some sense a painting of the sea. But to assume this would be to presuppose an unbroken chain connecting it to the earlier paintings. This is not a safe presupposition to make. In the years 1909–14 Mondrian also painted pictures of trees, of windmills and of church towers. A different sequence of illustrations might appear to connect the later painting back to a different naturalistic motif.

 If we have to abandon the information which a sequence of illustrations seems to provide, should we seek some other way to trace an abstract painting back into the world of things, and thus to understand how it has been shaped by the artist's intentions? Or should we rather seek meaning in the internal relations of the painting itself, attending to the differences between shapes and colours as we might listen to the words of an unfamiliar language, not in order to convert them immediately into the terms of our own, but in order to achieve that form of understanding which must accompany any such act of translation, a grasp of the relevant grammar? Rather than seeking to establish the meaning of the painting by locating it within a system of causes and effects, should we consider meaning as integral to that formal system which the painting constitutes?

 That this second method might be an appropriate form of response to art was by no means a new idea in the early twentieth century. As early as 1878 the American painter James McNeil Whistler had defended his practice of titling his paintings 'Nocturnes', 'Harmonies', and so forth, on the grounds that the forms he used were not dictated by the appearance of things in the world, but were simply the forms best suited to the arrangement of his composition (see Plate 172). And as we have seen in the first chapter of this book, the French Symbolists were concerned in the late 1880s and 1890s to assert the

Plate 172 James Abbott McNeil Whistler, *Nocturne in Black and Gold. The Falling Rocket*, 1875, oil on panel, 60 x 47 cm. © The Detroit Institute of Arts. Gift of Dexter M. Ferry Jr.

priority of the 'subjective' and 'ideistic' over the 'objective' and 'realistic'. As G.-Albert Aurier asserted, writing on Paul Gauguin in 1891: 'It is necessary … that we should attain such a position that we cannot doubt that the objects in the painting have no meaning at all as objects, but are only signs, words, having in themselves no other importance whatsoever' (Aurier, 'Symbolism in painting: Paul Gauguin'). Aurier appears to be suggesting that just as words have no intrinsic meaning in themselves, but only by virtue of their possible relations with each other, so the forms in painting should be seen as meaningful not by virtue of their correspondence to certain things in the world, but by virtue of their place and function within the individual composition.

The point then is not that ideas such as these were raised by the advent of abstract art, but rather that the appearance of abstract art made such conclusions inescapable. In fact, there is a stronger point to be made by reversing the terms of the assertion. Had the idea that language is an autonomous system of signs not *already* become inescapable, it would probably not have been possible to conceive of an abstract art that 'meant' anything at all.

Abstract art and language

We need to remember that inquiry into meaning will always at some point reduce to an inquiry into the nature of language itself. But in consideration of early abstract art there is one important reservation to bear in mind. Though analogies between abstract art and language were proposed by some artists and writers early in the twentieth century, par-

ticularly in Russia, these analogies were not pursued out of an interest in the reduction of artistic styles and meanings to specifiable positions and verbal forms, or because any such reduction was in prospect. In fact, as I have suggested, the boot was on the other foot. The analogies were enabled by a new understanding of the formal character of language – that's to say by a conception of language as an autonomous system of signs, which was in that sense consistent with *art* as the Symbolists and subsequently the Russian Formalists conceived it.

It is true of all kinds of human representation that they can be seen as ordered according to some system. Indeed, to call some object of our experience a form of representation is to say that we can perceive in it some intentional form of order; that is, some form of order which is significant *of* human design and significant *in* human terms. 'Human terms' are inescapably the terms of human language. But it does not follow that forms in art are like words, or that they are ordered as words are, or that they are in a one-to-one correspondence with given words. They are not subject to the same kinds of grammatical rules or to the same principles of consistency in usage, and they do not group together to form linguistic statements or propositions.

I will try to clarify my last statement by example. In verbal language, if 'dog' does not always mean a four-footed animal with a tail, such other meanings in English as the word can be given are licensed by metaphorical or other connection to that usage – as in the verb 'to dog', meaning 'to follow'. In fact, we might say that to call 'dog' a word is to acknowledge that its associations cannot be wilfully dissolved or unlearned. It is for this reason that I can be confident of being generally understood when I write such sentences as 'A spaniel is a kind of dog' or 'He dogged her footsteps'. But it was a lesson of modern art as a whole that, while forms in painting may take on the character of tree, house, human figure and so forth, the possibility of meaning is not dependent upon the same form and colour always having the same range of associations. On the contrary. It is a condition of the variety and complexity of meaning in art that a red circle in one painting may be quite free of those associations – say with traffic lights or danger – which are virtually inescapable in another. It doesn't follow that meaning in art is arbitrary, in the sense of being independent of all precedent or reference. Nor does it follow that meaning in art is independent of such frameworks of ideas and concepts as invest our language. All we are saying is that art doesn't 'mean' in quite the same way that meaning is conveyed in written and spoken language.

Essence, expression, spirituality

As Van Doesburg's example suggests, the idea of abstraction as a process tends to involve a kind of essentialism: until at least the mid-point of the twentieth century adherence to the abstract tendency in modern art – in its more clearly geometrical aspects at least – tended to entail the belief that a purer, or higher, or deeper, or more universal form of reality is revealed through the paring away of the incidental and 'inessential' aspects of things. Essentialism of this kind takes its justification from the Platonic idea that there are fundamental entities or universals of which the things we encounter are simply imperfect or impure instances. In the early twentieth century spiritualist forms of Neo-Platonism were briefly fashionable in artistic circles. The pursuit of abstract art was thus associated by many of its early practitioners and advocates with a kind of 'seeing through'; with the idea that the artist is one who penetrates the veil of material existence in order to reveal an essential and underlying spiritual reality.

In the early years of the century, both Kandinsky and Mondrian were drawn to the ideas of the Theosophists, who taught that human beings evolve from physical to spiritual levels of existence, and that certain fundamental laws, hidden from the mass of mankind, are revealed by such initiates as philosophers, founders of religions, and – perhaps – artists. Around 1915 Mondrian was also strongly affected by the Neo-Platonist theories of

the mathematician Dr Schoenmaekers, published in that year. At the same time in Russia Malevich was interested in pseudo-scientific speculations about the fourth dimension.

It's not hard to see how the development of Mondrian's work might appear to an essentialist as a gradual pursuit of that universal reality which is supposedly hidden within the incidental. In a footnote to his first published essay on art, Mondrian himself explicitly characterized the artist as a kind of medium for the expression of the universal.

> In every age the artist perceived what is always *one and the same* in and through all things: *a single beauty* arouses his emotion, although his perception of it changes. This unchanging and *unique beauty is the opposite of what characterizes things as things*: it is the *universal* manifesting itself through them. Consciously or unconsciously the artist endeavours to express plastically the opposite of what he perceives visually – that is why the work of art is so distinctly *other* than nature.
> (Mondrian 'The new plastic in painting', p. 44, emphases in original)

If the artist is accorded a kind of prophetic role in this view, he is also accorded a special responsibility. His practice must be exemplary and it must be tuned to the highest pitch. The circulation of such ideas (crackpot though they may sometimes seem) in the early years of the century may help to explain the powerful sense of mission which is conveyed by the writings of Kandinsky, Mondrian and Malevich. Given the usefulness of the analogy between abstract composition and grammar, and given that to invoke grammar is to invoke a basic condition of rational expression, we need not to forget that each of the principal artists involved in the early development of abstract art was engaged at some formative period with Neo-Platonic and mystical – which is to say *non*-rational – ideas. (We should be warned by van Doesburg's choice of example. Whyever a cow? That a cow plus a set of neo-Platonist delusions should result in an abstract painting is after all not a *rational* idea.)

Style and significance

Of course, not all forms of early abstract art presuppose that a Neo-Platonic or Theosophical point of view is a plausible one. Nor is it the case that to view a work of art as abstract is necessarily to commit oneself to essentialism. It is not to exhaust all further interest in what that work looks like or in how and why it has come to look the way it does, nor is it necessarily to deny that there might be other categories in which certain abstract works could more fruitfully be placed. It will often be more informative to attend to the material differences between works considered as abstract than it is to note that avoidance of figurative reference which they may have in common. If we are to discriminate between those works which come up for the count as abstract, we will need a range of appropriate sub-categories to place them in and we will need labels for those categories. For example, if we were to categorize Kandinsky's *With Red Spot* (Plate 157) as a kind of expressionistic work and Kupka's *Vertical Planes* and Mondrian's *Composition* of 1916 (Plates 158 and 160) as examples of 'post-Cubism', though we might need to go on to test the appropriateness of these designations further, we would nevertheless have suggested grounds for some possibly significant distinctions between the works in question. Similarly, we might contrast the relatively integrated and 'all-over' quality of the Mondrian with the dramatic rhythms and abrupt changes of texture in Rodchenko's untitled painting of 1920 (Plate 161), and in doing so we would effectively be responding to marked differences in the aims and approaches of the two artists. Mondrian was avowedly concerned with 'manifesting the spiritual, therefore the divine, the universal' at a time when Europe was enmeshed in the First World War (Mondrian, letter to A. de Meester-Obreen, February 1915). The Russian Rodchenko, on the other hand, was committed to the direction of 'materialist, constructive work towards communist ends' in

the years immediately following the Russian Revolution ('Programme of the First Working Group of Constructivists', 1922), and thus with determined opposition to the universalist and idealist tendency in modern art.

I do not mean to say that we can immediately 'see' (in the sense of comprehend) the difference in philosophical or political position when we see (in the sense of notice or observe) the stylistic differences between the two works. But we can reliably assume (1) that the differences we observe do have causes, and (2) that among these causes will be differences in aims and beliefs, some of which may well be aims and beliefs regarding the function of art, the development of human society, and so forth. A person who sincerely believes that the organizing principle of human existence is to be discovered in a pattern of cosmic laws and spiritual truths is likely to behave differently under certain circumstances from someone who sincerely believes that the dynamic pattern of human life is determined by the historical struggle between classes, or from another who believes that human existence is defined as the interaction of basic biological needs and drives. All action is affected by belief in some way.

It is also true that a painting composed of ruler-drawn horizontals and verticals is of a different kind from one composed of free-hand lines and patches of colour. Such stylistic differences will be related to differences of belief *in some way*. In talk of meaning, these relations will be of considerable importance. However, it does not follow that we can simply read one form of world view from straight lines and another from wiggly lines, or one from harmonious and another from dynamic compositions. Artistic forms are not simply to be replaced by or translated into the adjectives we use to describe them. The respective meanings of a black painting and a white painting are not necessarily to be translated in the same way that we use 'black' and 'white' to describe contrasting effects.

Representation, figuration and the non-figurative

Paintings like Mondrian's *Composition*, which are abstract in the strong sense of the term and which cannot be directly matched with any identifiable subject, are also sometimes described as 'non-representational' (occasionally 'non-representative') or 'non-figurative'. These are both terms which have been used as alternatives to 'abstract'. I believe that the first is confusing and should be avoided. To think of works of abstract art as things which do not represent is to limit questions about representation to questions about what it is that works of art resemble. While it can be argued that works of art in the Western tradition have mostly tended to represent their subjects by resembling them in some manner, this is by no means the only way in which works of art can represent – as we shall see. Indeed, the claim for meaning in abstract art *requires* that we countenance the possibility of representation in the absence of resemblance; for if there can be no representation without resemblance, then the pictorial order of the abstract painting must be seen as merely accidental, and thus as insignificant – meaningless – in human terms. It was a persistent claim of Symbolist theory in the later nineteenth century that the role of resemblance was overestimated in traditional accounts of meaning in art, and, further, that this overestimation entailed underestimation or even suppression of the emotional functions of art. In the early twentieth century, critics in the Modernist tradition tended to see abstract art as corrective of this tendency. That's to say they saw it as encouraging the appreciation both of the 'purely formal' and 'emotional' tendencies of earlier art, and as demonstrating how much of the meaning and value of art in general is due to factors other than those which serve to secure a sense of likeness to things in the world.

As we saw in the first essay in this book, in the early twentieth century artists, critics and spectators of a Modernist persuasion began to express strong preference for those works they could see as emphasizing formal aspects, and as embodying what they took to be a 'primitive' or 'direct' vision, such as Vincent Van Gogh's *Girl in White* (Plate 173),

Plate 173 Vincent Van Gogh, *Girl in White*, 1890, oil on canvas, 66 x 45 cm. National Gallery of Art, Washington. Chester Dale Collection 1963.10.30 (1694).

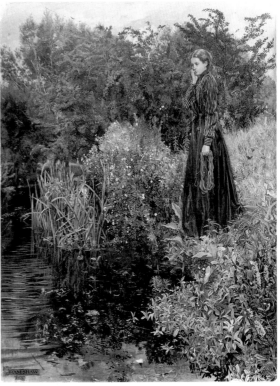

Plate 174 John Byam Shaw, *1900 The Boer War*, 1901, oil on canvas, 102 x 76 cm. Birmingham City Museum and Art Gallery.

over those which exhibited skill and sophistication in the achievement of literal likeness, such as Byam Shaw's *1900 The Boer War* (Plate 174). Generally speaking, preference for works of the first type was justified on the grounds that they were richer in 'feeling' than works of the second. By contrast, skill in the achievement of likeness became associated with lack of emotional content, or with insincerity – which is to say with a form of *mis*representation.

To call a work 'non-figurative' is to use a more specialized form of description. I suggest that figuration is best thought of as designating those types of graphic technique and procedure by means of which the illusion of a solid body – of a 'figure' of some kind, though not necessarily of a human figure – is established in a picture. A non-figurative painting is thus a painting which is made without recourse to those particular types of technique and procedure. It follows that a non-figurative painting is not simply a painting without a figure; it is a painting which offers no space, either technically or conceptually, which a solid body might be imagined as occupying. As Clement Greenberg expressed it,

> It is not in principle that Modernist painting in its latest phase has abandoned the representation of recognizable objects. What it has abandoned in principle is the representation of the kind of space that recognizable, three-dimensional objects can inhabit.
>
> (Greenberg, 'Modernist painting')

Plate 175 Kenneth Noland, *Turnsole*, 1961, synthetic polymer paint on unprimed canvas, 239 x 239 cm. Collection, The Museum of Modern Art, New York. Blanchette Rockefeller Fund. © Kenneth Noland/DACS, London/VAGA, New York, 1993.

That was written in 1961, and the 'latest phase' Greenberg had in mind was one in which the abandonment of illusionist space – or, the 'flattening' of pictorial space – had been carried much further than the artists working half a century earlier could have envisaged. For an example, see the work by Kenneth Noland illustrated above, which is the kind of late-Modernist painting Greenberg had in view at the time when he was writing. Of course in the period 1910–20 contemporary spectators had no means to envisage work such as Noland's, and the paintings of Malevich and Mondrian must indeed have appeared to them as figuratively uninhabitable worlds.

There is a lesson to be learned here. The non-figurativeness of a painting is always *relative*: it is relative, that's to say, both to the expectations aroused by antecedent and

contemporary figurative art and, once a tradition of abstract art has become established, to the extent of *negation* of those expectations which has so far been reached within that tradition. To put it simply, if we compare the Mondrian with a traditional painting such as Byam Shaw's *Boer War* (Plates 160 and 174), the Mondrian will tend to appear flat and empty of all possibility of figuration. But if we look back at the same painting from the vantage-point of the Noland, we are more likely to notice in the Mondrian how different components of the surface tend to separate out into distinct optical planes, all notionally parallel to the picture surface but each occupying a different level of illusionistic depth. Between these different illusionistic levels, some imaginative space still exists for a kind of figuration which the Noland excludes. Even in the Noland, however, the relationship established between the painted rings and the unpainted canvas is one which involves *some* illusion of spatial depth. I am not suggesting that we have an automatic or 'natural' perception of spatial illusion. On the contrary, my point is rather that pictorial space is something we *learn* to read, and that we do so by reference to other forms of pictorial space. The history of painting in Western culture is in large part a history of the relevant forms of learning and of the ways in which that learning has been done. In his essay 'A. and Pangeometry' written in 1925, El Lissitsky asserted that 'New optical experience has taught us that two surfaces of different intensity must be conceived as having a varying distance relationship between them, even though they may lie in the same plane.' (Lissitsky, 'A. and Pangeometry'). The 'new optical experience' he had in mind had been furnished by the work of Malevich and Mondrian.

A further point to note is that the concept of non-figuration as a deliberate mode pre-supposes that the figurative is what is normally expected. The implication is that abstract painting depends for its status as art upon the expectations aroused by paintings which are *pictures*; that is to say, by paintings which, by virtue of their resemblance to other things in the world, can be seen as depictions or illustrations of those things. It follows that the possibility of abstract paintings being seen as *paintings* (that's to say, as potential forms of high art) depends upon our tendency to look at their surfaces as *other* than merely flat – to look at them, in fact, as *potentially* figurative. As Greenberg himself noted, 'The first mark made on a surface destroys its virtual flatness' ('Modernist painting'); the effect of that mark-making is to divide the canvas visually and conceptually into 'figure' and 'ground' and thus, as it were, to create space for some kind of content or meaning (even if, in Greenberg's words again, the illusion is not one 'into which one could imagine oneself walking … [it] is one into which one can only look, can travel through only with the eye'). To put this point another way, it could be said that we do not just 'see' the surface of a painting, we 'see in' that surface the evidence of intentional activity of some kind.

It is its invocation of this expectation of 'seeing-in', I believe, that most tellingly distinguishes abstract painting from ornament. Abstract art presupposes a critical position towards the figurative in art, and towards the very predominance within the European tradition of those describing and narrating functions which the procedures of figuration serve to enable and to advance. But if this critical position is to be established, and if the spectator is to entertain it in actual experience, then the work of abstract art must first evoke and set in play those very functions it aims to disparage. So long as we see the Mondrian as flat, we see it as meaningless (or, it could be said, we see it as 'mere design'). On the other hand, if we see it as resembling some other thing in the world, its identity and its effect as art are compromised. An abstract painting is something standing in place of a picture, which is nevertheless not a picture *of* anything.

Abstraction, design and decoration

We are now in a better position to take up an issue raised in the opening paragraph. Despite the explicit universalizing assumptions of many of the artists themselves, the historically and culturally specific character of abstract art is emphasized when we con-

sider how the two constituent terms – 'abstract' and 'art' – bear upon one another. It may help if we consider some contrary instances. For example, in an Islamic culture in which less priority was placed on the picturing functions of art and more on the significance of pattern and ornament, an 'abstract' art would not of itself have been remarkable. Nor would it have been deserving of any special attention in a culture which had no substantial grounds on which to distinguish paintings and sculptures from other forms of design and decoration. It is pertinent that such pre-Modernist theorists as John Ruskin and William Morris, writing in the mid- and late nineteenth century, idealized the medieval period as one in which art and design were indistinguishable as regards their aesthetic status and interest. To such critics, the realization of an abstract *art* – an 'art' which was categorically distinct from 'design' – could only have appeared as the fulfilment of their worst forecasts. That's to say they would have been likely to view it as an extreme form of that tendency to prise apart the 'aesthetic' and the 'utilitarian' which they saw as a negative consequence of industrialization.

In contrast, Greenberg's Modernist theorization of abstract art presupposes that for better or worse the practices of art and design *are* distinct, if not actually incompatible. A growing tension and difficulty in relations between the concepts of art and design respectively is revealed in the changing critical fortunes of the term 'decoration', as discussed in Chapter 1. In the late 1880s the Symbolists used the concept of decoration to refer to those positive aesthetic values which they saw as independent of the requirements of description and imitation. For Matisse, writing in 1908, the decorative aspect of the painting was coincident with its expressive function, in pursuit of which every single component was critically adjusted ('Notes of a painter'). In 1910, introducing his own translation of Maurice Denis' article on Cézanne, Roger Fry wrote of 'a new courage to attempt in painting that direct expression of imagined states of consciousness which has for long been relegated to music and poetry' (Fry, Introductory note to M. Denis, 'Cézanne'). He saw this tendency as associated with a 'new conception of art, in which the decorative elements preponderate at the expense of the representative'. Clearly the emphasis thus laid on the decorative was a means to assert the relative autonomy of artistic forms as vehicles of expression. With the beginnings of practical interest in the development of abstract art, on the other hand, the achievement of 'mere' decoration became the mark of aesthetic failure – of a failure, that's to say, to establish that promise of intellectual and emotional depth which was associated with painting as a form of art.

The intention to produce abstract art was thus an intention to advance non-figurative works not as forms of 'mere' decoration or ornament but as forms of modern art – that is to say as forms of representation. Reviewing his own development in 1913, Kandinsky wrote of the 'frightening depth of questions, weighted with responsibility' by which he believed himself confronted. 'And the most important: what should replace the missing object? The danger of ornamentation was clear, the dead make-believe existence of stylized forms could only frighten me away' *(Reminiscences*, p.32). As we shall see, the intention to produce abstract art was not one which was formulated suddenly or by any one individual acting alone. It developed, I believe, as a partial consequence of those long-term changes in the relations of 'art' to 'design' and of both to 'figuration' which we can trace through the nineteenth century – changes which are themselves associated, in some theories of Modernism, with the inception of the modern period in art. The emergence of abstract art, that's to say, was specific to a modern European world in which the prevailing tendency of economic and industrial development was to impel distinctions between art and design, and between high and low forms of art, in which meaning in high art was normally associated with figuration; and in which paintings and sculptures were candidates for the status of high art, while examples of design and ornament were not.

I don't mean to say that the artists involved with early forms of abstract art were all intentionally making high art as opposed to design, or even that the distinction was one to which they all assented in principle. On the contrary. The point, as Kandinsky's statement

Plate 176 Giacomo Balla, *Compenetrazione iridescente No. 13* (*Iridescent Interpenetration No 13*), 1914, tempera on card, 72 x 94 cm. Museo Civico di Torino.

Plate 177 Kazimir Malevich, 'First fabric with Suprematist ornament', 1919, canvas/indian ink and gouache, 20 x 10 cm. State Russian Museum, St Petersburg.

quoted above makes clear, was to avoid the reduction of art to *mere* ornament, for example by pursuing stylization too far. What the artists and their supporters hoped was that the development of abstract art would lead to an *aesthetic* renewal of commercial design. The dream of a synthesis of all the arts was one which possessed the artistic avant-gardes in various forms, from the Wagnerian idea of the *Gesamtkunstwerk* ('total artwork') of the 1880s, to that Modern Movement fantasy of the 1930s which saw the well-designed housing estate as a spiritually fulfilling environment. Some, such as the Italian Futurist Giacomo Balla, were encouraged to experiment with abstraction in art as a consequence of work in the fields of design (see Plate 176, which is related to commissioned designs for furnishing materials). Others, such as Malevich, produced designs for textiles, ceramics and so forth which repeated the stylistic characteristics of their abstract paintings (see Plates 177 and 178). I believe, however, that though involvement in decorative schemes provided many avant-garde artists with opportunities to pursue the technical possibilities of an abstract art in the second and third decades of the twentieth century, at a certain point in the careers of each, the divide between the world of art and the world of production became *practically* unbridgeable. The commercial proved more instrumental than the aesthetic. And when this happened the artists tended to feel the need to defend the autonomy of art. For the majority of the artists concerned this was less a matter of prising art and design apart than of asserting the priority of aesthetic dictates over utilitarian considerations whenever the latter functioned to control the practices of design – which, of course, was often.

Plate 178 'Suprematism' cup
decorated by Ilya Chashnik,
1923, porcelain with underglaze
painting, 7 x 13 x 6 cm. State
Russian Museum, St Petersburg.

Such assertions seem generally to have been made in a spirit of resistance to those non-aesthetic forces which the artists concerned identified with an oppressive 'materialism'. However, it needs to be said – and said as forcefully as possible – that neither the 'aesthetic' nor the 'utilitarian' is an immutable or a transcendental category. The value of each changes with historical conditions and priorities, as, of course, do their reciprocal relations. For instance, where materialism was identified with a *progressive* position, as it was by the Russian Constructivists after the Revolution, the priorities tended to be reversed and utilitarian considerations were promoted in opposition to those aesthetic priorities which were associated with a discredited social order. 'Down with art, long live technical science', was one slogan in a 'Productivist Manifesto' written in 1921 by Alexander Rodchenko and Varvara Stepanova. We shall explore these differences further (see pp.226–7 and 241–2). With hindsight, though, we may discover more common ground than there appeared to be at the time between the Constructivists and such apparent idealists as Malevich and Mondrian. Those artists who practised early forms of abstract painting and those who advocated construction both saw their work as pursued in a divided social and cultural world and as a potential means to the healing of those divisions. Mondrian for one appears to have associated the special status accorded to art with 'individuality' (which is to say, in his terms, with a failure to realize the universal). The Dutch De Stijl group, of which both he and van Doesburg were prominent members, was dedicated to synthesis of all the visual arts, including architecture and design. Writing at a moment when Europe was caught up in the First World War, Mondrian looked forward – with a no-doubt unjustified optimism – to a time when all human life would be raised to the same high aesthetic pitch, and when the status of art would be radically altered.

> As long as individuality predominates in the consciousness of an age, art remains *bound to ordinary life* and remains primarily the expression of that life.
>
> However, when the universal dominates, it will permeate life, so that art – so unreal in comparison to that life – will decay, and a new life – which realizes the universal in fact – will replace art.
>
> ('The new plastic in painting', 1917, p. 42)

Intention and quality

In considering early abstract art as art, then, we are necessarily responding to the specific character of the European tradition, to the increasing tendency within that tradition for certain cultural forms to be accorded a special and elevated status, and to the contradiction between that special status on the one hand and the actual social aims of many of the

artists on the other. The special status, I suggest, is associated with the expectation of a certain kind of meaning or content. What distinguishes a 'painting' from a piece of 'mere design' is that the former is supposed to repay attention of a kind and degree not normally accorded to the latter; and this in turn is supposed to be because a painting contains a special kind and quantity of content, or because it conveys a special kind and quantity of significance, or because it embodies a special kind and quantity of meaning. These are all so many ways of trying to say (or to avoid saying) that it has a *value* or *quality* that (mere) design doesn't. At a particular moment in the development of the European tradition we see the emergence of forms of abstract art for which the claim is made by their makers and supporters that they are *at least* as rich in aesthetic quality and in meaning as works of art have traditionally been supposed to be. To note these claims is not, of course, to see them as the only terms in which the distinctness of abstract art might be explained. For example, that modern paintings are also distinguished from other forms of decor in being framed and transportable is not a matter entirely separate from the question of their supposed significance and quality.

As I have already implied, to ascribe meaning to a work of art is to invoke considerations of intention; of what the artist intended to make (did he or she *intend* to make a painting or a piece of decoration?), and of how intention is achieved in the work (is what it looks like how it was *intended* to look?). Considerable controversy nowadays surrounds the relationship between the concepts of content, meaning and significance on the one hand and the concept of intention on the other. For Richard Wollheim, the intention of a work of art simply *is* its meaning; to talk of the one is to be talking of the other (though in Wollheim's understanding of intention, it is quite possible to have an intention which is not conscious) (Wollheim, *Painting as an Art*, pp.17–19 and 37–9). According to this view, what is meant by the meaning of a work of art is what coincides with the intention, conscious or unconscious, of the artist. If the work seems to have a meaning the artist could not have intended, then we should regard it as extraneous or irrelevant to the true identity of the work. For others the meaning of a work is elaborated in interpretation and is a matter quite distinct from what its author may have intended. For still others, meaning is inseparable from social function, and therefore not capable of being limited by the artist's intention. For the moment, I think we can safely say that in order to intend to make a painting it is necessary to have some concept of what a painting is. But what of the intention to make an abstract painting? Could an artist make an abstract painting, and intend it to be abstract, in the absence of any previous example to refer to? To ask this question, I think, is to ask how and when the concept of an abstract painting was formed or acquired.

Plate 179 shows a small watercolour by the Russian artist Vasily Kandinsky, which is conspicuously dated 1910 in the artist's hand. For a long time this was regarded as the 'First Abstract Watercolour', a title which it was given by the artist himself. (It appears as such, for instance, in Methuen's popular *A Dictionary of Modern Painting*, published in 1956, p.2.) Can we take this as secure evidence that abstract art had both a practical and a theoretical existence in 1910? Certainly the *possibility* of an abstract art had been widely canvassed in Munich, where Kandinsky was then living. Before the turn of the century the proliferation of the local variant of Art Nouveau, known as Jugendstil, had led to speculation about the possibility both of non-traditional forms of design and architecture and of an autonomous 'language' of form. The idea of the work of art as something essentially independent of naturalistic appearances was also relatively well rehearsed within the German neo-Romantic tradition. In 1908 the Munich-based art historian Wilhelm Worringer had published a thesis which asserted,

> Our investigations proceed from the presupposition that the work of art, as an autonomous organism, stands before nature on equal terms and, in its deepest and innermost essence, devoid of any connection with it, in so far as by nature is understood the visible surface of things.
>
> (Worringer, *Abstraction and Empathy*)

Plate 179 Vasily Kandinsky, *'First Abstract Watercolour'*, *c*.1912, watercolour, 50 x 65 cm. Musée National d'Art Moderne, Centre Georges Pompidou, Paris. © ADAGP, Paris, and DACS, London, 1993.

Kandinsky was a prominent member of the Blaue Reiter group and was steeped in those Symbolist and Expressionist theories typical of the interests of that group, which assumed that the demand for fidelity to appearances was in conflict with the demand for fidelity to feeling. By 1910 he was working on his own theoretical investigation into the supposedly autonomous expressive aspects of art, which was first published in 1911 as *Concerning the Spiritual in Art*. And yet if Kandinsky did paint the 'First Abstract Watercolour' in 1910, I believe that he was most unlikely to have been able securely to assess just what he had done. It is one thing to be able to conceive of an abstract form. It is another thing, however, to conceive of it *as a form of painting*. And it is still another matter to know how practically to realize such a thing and how to assess success or failure in the outcome. The contemporary Munich artist Hans Schmithals painted his *Composition* in 1902 (Plate 180). It was exhibited with that title at the Tate Gallery in 1980 in the exhibition *Abstraction: Towards a New Art*. At a quick glance, it might perhaps be seen as a very early work of abstract art. And yet its conservative clinging to a world of dramatic effects and modelling techniques renders it critically insignificant to the history of modern art. Its *abstraction* is revealed as nugatory by the thoroughly conventional character of its *figuration*. (To rephrase this in terms of Greenberg's terminology would be to say that though no *immediately* recognizable objects are depicted in the painting, the artist is far from having abandoned the kind of space that recognizable, three-dimensional objects normally inhabit.)

Plate 180 Hans Schmithals, *Polarstern und Sternbild Drache* (*Polar Star and Dragon Constellation; Composition*), 1902, gouache on paper, 48 x 110 cm. Münchner Stadtmuseums.

In fact, to return to Kandinsky, there is nowadays substantial agreement that 1912 is the earliest date at which his watercolour could have been painted, while it may have been very much later that it came to acquire its title. That's to say it may have been with the benefit of hindsight, and only once the idea of an abstract art had attracted some further critical and theoretical elaboration, that the artist came to single out this particular work as marking an important breakthrough. At this point, we might say, he felt able to stand behind what he had made, and to recognize his intentions in what he happened to have done – or to redefine his intentions so as to make the doing an intentional act.

We don't necessarily have to see this as a deliberate act of art-historical falsification on Kandinsky's part. The watercolour may have been associated for him with a moment of genuine transition, and, as I've already suggested, he may not have had the means to describe the significance of that moment until its critical implications had been worked out in his practice, by which time he may well have forgotten exactly when the work was made. It can be said, though, that the retrospective dating of the work does tell us something about the prizes which were at stake once the idea of an abstract art had achieved some art-critical currency. It can also be said that, whatever mistakes they may make about their own past activities, artists very rarely give their works a date *later* than the year they were actually done. In due course we shall be considering a similar circumstance with respect to Kazimir Malevich's *Black Square*.

If we say that the concept of an abstract art had acquired practical form by 1912 at the latest, we are clearly also making an evaluative judgement about those works which constitute the evidence. However compromised the terms may now be supposed to be in the normal practices of art history, questions of quality and originality are unavoidable in the practice of art. The making of an abstract painting would be a literally meaningless matter if no differential standards were to be applied to the result – if any old mess would do, or if work such as Hans Schmidthals' were to be allowed to set the standard. If it was to be a matter of any significance, the relevant intention would have to be formed in relation to some strong measure of aesthetic success or quality. To learn how to paint an abstract painting was thus also to find out what kind of a thing an abstract painting could *and could not* be. My suggestion is that the negatives of achievement were defined by a concept of 'mere ornament' at one extreme and of 'mere imitation' at the other. In his own *Reminiscences* published in 1913, Kandinsky claimed that 'it was only after years of patient struggle ... of constantly evolving ability to experience painterly forms purely and

abstractly' that he arrived at the abstract work for which he was to become known. 'It took a long time', he continued, 'before this question "What should replace the object?" received a proper answer from within me.' What was to replace the object was not something *else* the painting could be said to look like (a flat pattern, for instance). In Kandinsky's terms, it was to be a certain 'spiritual' effect. In fact, Kandinsky comes very close at times to suggesting that some of his works are *pictures* of emotional or spiritual states. In the margins of such works as these there lurks a cranky spiritual*ism* – the absurd belief that emotional states produce auras which are visible to suitably sensitive observers. Nevertheless, the *significant* claim that he made in titling his watercolour was not that it was a picture of the unpicturable, but rather that despite the absence of 'the object', that's to say despite the absence of any significant resemblance to things in the world, it was possessed of meaning and quality to an extent significantly greater than could be expected of 'ornamentation'. His claim was that it was neither a mere design nor a thoughtless doodle, but a deeply felt and significant work of art.

To consider the emergence of abstract art as an historical phenomenon is thus to ask whether works of abstract art are open to being interpreted in ways that works of 'mere design' are not. It is also, unavoidably, to consider the various claims which were made for the autonomy of meaning and value in abstract art. I don't mean by this that we should simply accept these claims at face value and repeat them uncritically. Rather, I suggest that we countenance the possibility that the claims are serious and consider the consequences. One consequence will be to face in imagination the problem with which the artists themselves were grappling: what is it that makes a work of art good or bad, serious or trivial, interesting or uninteresting, meaningful or meaningless, if it is not its success or failure as a *picture* (of something)? To suggest that we try imaginatively to confront the problem of relative quality is *not*, of course, to suggest that the questions here posed are the only terms in which that problem *might* be formulated; nor is it to suggest that *any* way of formulating it would necessarily be immune from objection.

A note on abstract art in its time

As we have already seen, the evidence is that the problem of the value of abstract art was a question of particular pertinence in the European practice of art at the beginning of the twentieth century. Why then? Some clues to an answer can be extracted from the foregoing discussion, that's to say from analysis of the relationship between abstraction and non-figuration. At the end of the nineteenth century the practical critique of figuration – the critique of illusion and of all that illusionistic techniques were used to purvey in the art of the European Salons and Academies – tended often towards abstraction. Emphasis upon the potential 'purity' of form was both a means to challenge the classicizing traditions on their own neo-Platonic ground, and a means to disparage the superficially descriptive, the imitative and the anecdotal. Coincidentally, the *idea* of a universal and underlying reality served the Symbolists as a kind of critical foil to the unwelcome demand for truth to appearances. Meanwhile, the idea of a spiritual truth served some as a light by which they saw revealed what they took to be the generally materialistic values of the contemporary world. Justifications of early abstract art drew not only upon well practised critiques of traditional forms of art but also upon a diverse literature of 'anti-materialist' thought, to which the philosophers Schopenhauer and Nietzsche, the composer Wagner, the poet Mallarmé, the mystics Ouspensky and Madame Blavatsky, and numerous others, had variously though not equally contributed. In the early years of the century this anti-materialism was given a utopian cast. That's to say it was associated with a positive ideal of human potential and human society. During a decade which included a world war, a failed revolution in Germany and a successful one in Russia, the new forms of art were associated with optimistic forms of opposition to the prevailing social and political order, though *not* generally with organized socialism.

Plate 181 George Grosz, *Leichenbegägnis der Dichteus Panizza* (*Funeral Procession, Dedicated to Oscar Panizza*), 1917–18, oil on canvas, 140 x 110 cm. Staatsgalerie Stuttgart. © DACS, 1993.

I do not mean to identify the emergence of abstract art with a vague 'spirit of the age' – though that identification was certainly made by Worringer and Kandinsky among others. Nor do I mean to suggest that abstract paintings were the only modern artistic forms in which such opposition was expressed. In the later part of the same decade the Dadaists in Zurich, Berlin and New York mounted various very different forms of assault upon those notions of order, decorum, composition and taste which were associated with the conventional practice of art (see Plates 181 and 182). What we can say is that the idea of abstract art – the vision of a universal aesthetics and of its potential extension into

Plate 182 Francis Picabia, *La Sainte-Vierge* (*The Holy Virgin*), July 1920. Bibliothèque Littéraire Jacques Doucet. Photo: Lalance. © ADAGP/SPADEM, Paris, and DACS, London, 1993.

'everyday life' – was a part of the conceptual apparatus by means of which certain people individually and in groups attempted at the beginning of the twentieth century to *imagine* their way to a better world. The intention to produce abstract art, that's to say, though it was an *artistic* intention, was an intention formed in and by a world which was not simply a world of art.

On interpretation

One way to test claims for the status of abstract art might be to consider the extent to which it is open to interpretation. Clearly, though, we cannot start where we might start with a conventional figurative painting. That's to say we cannot match the appearance of an abstract painting against our knowledge of the world it depicts, for, as I have suggested, while works of abstract art may represent, it is a feature common to all abstract works that they do not depict. It is an aspect of the intentional character of abstract art that it frustrates the expectations of those seeking naturalistic appearances. In an essay published in January 1916, the Russian artist Kazimir Malevich wrote,

> Only with the disappearance of a habit of mind which sees in pictures little corners of nature, madonnas and shameless *Venuses, shall we witness a work of pure living art* ...

> The artist can be a creator only when the forms of his pictures have nothing in common with nature.

> (*From Cubism and Futurism to Suprematism*, pp.166 and 168; emphasis in the original)

Plate 183 Kazimir Malevich, *Black Square*, 1929, oil on canvas, 80 x 80 cm. Tretyakov Gallery, Moscow.

How then, are we to respond to a work such as Malevich's own *Black Square*, the first version of which was painted shortly before his essay was written (see Plates 156 and 183). (The first of our two reproductions shows the original version, now badly cracked and revealing evidence of an earlier cancelled stage of the composition. The second shows a later version by the artist, retrospectively dated by him to the year 1913, which is probably now closer in texture to the original appearance of the 1914–15 work.) What could this work have meant to a spectator in 1915? How are we now to decide what it represents, or, to put this second question another way, how are we to represent it to ourselves as meaningful? How are we to go about interpreting the work of abstract art? In what follows, we shall consider various ways of responding to this question.

Seeing pictures

In practice the 'habit of mind' Malevich referred to was far from easily abandoned. We can imagine a conversation between two spectators, each of whom clings to the idea that the way to discover meaning in a painting is to discover what it is that it resembles. Each seeks not simply to see Malevich's painting, but to see something *in* it. Person A claims to see a view into a coal cellar full of black cats. Person B claims to see a view out of a prison window on a dark night. Each is attempting to find a figurative pattern to which the painting can be made to correspond. It is a measure of the inappropriateness of this approach that no scrutiny of the painting, however careful, will yield any information more in favour of one viewer than the other. If these conjectural interpretations appear as forms of caricature, they are not really very different in kind from other less obviously absurd attempts to find pictures in abstract paintings. Well before any actual works of abstract art had been produced the very possibility of an abstract painting was satirized in similar terms by an exhibitor in Paris – no doubt in response to the tendency to abstraction

Plate 184 Vasily Kandinsky, *Entwurf zu Komposition VII* (*Study for Composition No.7*), 1913, oil on canvas, 78 x 100 cm. Städtisches Galerie im Lenbachhaus, Munich GMS 63. © ADAGP, Paris, and DACS, London, 1993.

discernible in much late nineteenth-century French painting. In 1883 Alphonse Allais exhibited a sheet of white paper at the Exposition des Arts Incohérents, with the title *First Communion of Anaemic Young Girls in the Snow*. In fact, the possibility of just such 'readings' was raised by one contemporary reviewer of the exhibition in which Malevich's painting was first shown in 1915. The anonymous writer suggested that *Movement of Pictorial Masses in the Fourth Dimension* (one of Malevich's titles) referred to a vision of 'white elephants', the Russian equivalent of pink elephants (quoted in Beringer and Cartier, *Pougny*, p.81).

The problem of the 'habit of mind' is further complicated by the fact that *some* apparently abstract paintings do repay the search for pictorial ingredients or echoes. Kandinsky's *Study for Composition No.7* (Plate 184) may seem at first sight to be as abstract as its title implies. But if we approach it from a position of familiarity with Kandinsky's own previous work – for instance, with *All Saints Day 2* (Plate 185) – we are more likely to read the space of the painting figuratively and to conceive of the coloured lines and patches as abstractions from some world of pictured motifs. The motifs themselves may no longer be identifiable – the horsemen and robed figures and castles on hilltops which populate Kandinsky's works of 1909–11 (Plate 186) – but it may still be appropriate to read the abstract forms as symbolic traces of their existence. To seek an appropriate interpretation

Plate 185 Vasily Kandinsky, *Allerheiligen II* (*All Saints Day* 2), 1911, oil on canvas,
86 x 99 cm. Städtisches Galerie im Lenbachhaus, Munich GMS 62. © ADAGP, Paris, and DACS,
London, 1993.

Plate 186 Vasily Kandinsky,
Improvisation 9, 1910, oil on canvas,
110 x 110 cm. Staatsgalerie
Stuttgart. © ADAGP, Paris, and
DACS, London, 1993.

of a work of abstract art must in some sense be to ask what it is *made of*, both formally and conceptually. Sometimes – as in Kandinsky's *Study for Composition No.7* or Mondrian's *Pier-and-Ocean* painting – it seems that the answer will need to include a description of figurative elements which have featured somehow in the genesis of the picture.

However, such a description will never be adequate to account for all aspects of the abstract painting. As I suggested earlier, the development of abstract art is associated with the intention that *non*-figurative forms of representation should be accorded primary functions in the making of art. We may, for example, uncover the residual presence of a mythological world in Kandinsky's abstract paintings – a presence which is genetic, in the sense that the materials of that world have helped determine the character of the painting without necessarily being identifiable from its appearance. We may also accord that world some controlling function as regards the painting's effect. But we will still also have to acknowledge the effects of the painter's fascination with the *idea* of a 'pure' abstract art. We may otherwise be unable to account for the ways in which his abstract paintings end up so *unlike* the scenes of horsemen, robed figures and castles with which he may at some point have started.

Feeling the spiritual

Sometimes, on the other hand, an abstract painting may be such that we are from the start unable to connect its forms to any apparent world of natural motifs. In such a case it may seem that inquiry into what it is that the painting is made of will have to address itself to the world of ideas. I say ideas, but an influential critical tradition has associated forms of abstract art with the expression of emotions and spiritual states, encouraged no doubt by the long legacy of Symbolism and by the pronouncements of the artists themselves. Malevich wrote of the 'Suprematist' tendency, which he saw as inaugurated by his *Black Square*, in terms of 'the supremacy of pure feeling in creative art' (Malevich, *The Non-Objective World*, p.341). If he has an ideal spectator in view it must be someone who has managed to overcome the naturalistic 'habit of mind' and who is fully responsive to that 'pure feeling' which is identified with the constituents of painting. We can imagine such a spectator, Person C, for whom the meaning of the abstract painting lies in the very avoidance of reference to things in the world. This absence of distractions enables a more intense concentration upon the spiritual content of the painting. For C, the originality of the creative artist is revealed in the extremism of his or her departure from the world of appearances. The painting requires a matching commitment from the spectator.

> Painting, like music, has nothing to do with reproduction of nature, nor interpretation of intellectual meanings. Whoever is able to feel the beauty of colors and forms has understood non-objective painting.
>
> Beauty of appearance takes its way to the heart through the medium of intuitive intelligence called spirit ...
>
> Non-objective art need not be understood or judged. It must be felt and it will influence those who have eyes for the loveliness of forms and colors ...
>
> Non-objective paintings are prophets of spiritual life ...
> (Hilla Rebay, 'The beauty of non-objectivity', pp.145 and 148)

Celebrations of abstract art such as these share the assumption articulated earlier by the English critic and theorist Clive Bell, that 'Art speaks to those who have ears to hear'. The unfortunate corollary is that if the work of art does not 'speak' to you, you cannot learn how to hear. You are not just inexperienced in the appropriate forms of discrimination; you are aesthetically deaf and spiritually dead.

Responding to effects

Given the prevalence of such assumptions among enthusiasts like Hilla Rebay it is not surprising that abstract art should have remained for many other observers a form of practice which appeared arcane and mysterious, or obscurantist and absurd. If our introduction to abstract art comes through writers like Rebay, we are likely to be quite unprepared for the actual appearance of such works as Malevich's, with their somewhat rough-and-ready contours, their resolutely textured surfaces. We need another commentator, a person D, to undermine C's authority and to help us better to understand why these works look as they do. Like Rebay, D is a kind of Modernist, but a Modernist of a more sophisticated cast. For D, to view the surface of a painting as a doorway into a spiritual world is to indulge in a form of wanton superstition. It is to make the painting the arbitrary object of a personal and possibly neurotic search for meaning. Nothing is discovered in the process. D suspects that it is the culturally induced expectation of metaphysical grandeur, and not the painting, that produces C's 'feeling'. For D, interpretation must be constrained by criteria of relevance, and what D means by relevance is relevance to the effects of art. Furthermore, only those effects will count for the purposes of criticism which can be explained as the consequences of technical characteristics – that's to say as the consequences of what can be seen to have been done and made. For D, a well-grounded interpretation will be one which takes adequate account of the formal and technical aspects of the work in question, and which makes no claims for the meaning of that work which cannot be connected to descriptions of those aspects.

In D's view, to talk about technical characteristics is to address painting as a specialized activity. He believes that the modern artist derives his chief inspiration from the medium in which he works and that originality in painting consists of the production of new painterly effects. He sees this newness as relative to the state of development of painting itself, and as involving an attitude which is both self-critical and critical towards received models and exemplars. What is required for the appreciation of this newness, he believes, is acquaintance with painting itself, with its intrinsic concerns, its conventions, its problems and its limitations.

I would call D a sophisticated Modernist and have invented him with an eye to the writings of the American Modernist critic Clement Greenberg. I should make clear, however, that Greenberg has not been associated with the advocacy of Malevich's work. Indeed, his most forthright judgement on Malevich, published in 1942, is that though his work has 'documentary value', it is 'meager in aesthetic results' (Review of four exhibitions of abstract art, p.104). What follows should therefore not be taken as countering the explicit pronouncements of any actual writer, though Person E represents arguments which have been raised in general terms against criticism in the Modernist tradition.

Uncovering meanings

For E, the autonomy which D accords to painting amounts to a powerful closure upon inquiry. In E's eyes, D's emphasis upon formal characteristics and intrinsic concerns serves to distract attention from the social and historical functions of art. The painting appears simply as an illustration of the technical presumptions of D's theory. It is made into a stepping-stone in a highly selective and linear account of the development of painting in general. And as for the matter of relevance to effects, effects are effects upon some person, and that person's subjectivity is not universal and disinterested but contingent and constructed. Criteria of relevance need to take account not only of effects but also of causes – the conditions of production of works of art. In fact, the *Black Square* means nothing unless its production can be represented as an intentional act in the context of some history. To uncover the meaning of the painting we will need to know about the network of practices and discourses within which it was possible to conceive and to make

such a thing. In assessing its critical character, that's to say, we will need to know just how to treat it as a signifying thing, and this will entail far more than being able to relate it to the development of non-figurative forms of pictorial space. Nor will it be enough to consider how the work was proposed and situated in relation to the various alternative forms of practice and of signification obtaining at the moment of its production. We will need to be able to locate it within a context of contemporary debates about the function of art and the role of the avant-garde. And in turn we will need to know to what extent the materials of these debates were furnished and inflected by wider historical events and tendencies.

For example, given the information that the painting was produced in Russia in 1914–15 – that's to say a decade after an abortive revolution and shortly before a successful one – it might be appropriate to interpret it as expressing dissent from the prevailing canons of taste at a time of impending social and political change. In particular, it might be seen on the one hand as critical of that taste for sensuous gratification which was associated with the mimetic imagery of bourgeois culture – the 'little corners of nature, Madonnas and shameless Venuses' – and on the other as affirming the possibility of a radically transformed visual and formal 'language' appropriate to the needs and interests of an envisaged post-revolutionary society. Viewed in the context of Russian history, the painting may be revealed as the vivid repository of historically specific interests and aspirations. Far from the meagreness of its 'aesthetic value' over-riding its 'documentary value', its value as a document is so powerful as to subsume any consideration of the aesthetic.

Playing with texts

E's objections are of a kind often levelled at Modernist criticism and history from the perspective of the Social History of Art. The critique of Modernism was an abiding concern of social historians during the 1970s and '80s. In the supposed world of the Postmodern, however, the conflict between Modernists and social historians itself takes on the aspect of an historical episode. Our last model spectator, Person F, claims a position outside that dialectical world in which Modernists and Social Historians have been wont to argue over the respective priorities of responsive evaluation and historical explanation. From F's point of view, D and E are each in their different ways in the grip of powerful mythologies: that's to say they are each possessed of a misplaced faith in the power of theory to discover truth, whether this is a supposed truth about relative aesthetic merit and effect, or a supposed truth about conditions of production and embedded historical meanings. In F's understanding theories do not discover their objects, rather the objects are constituted by the theories. Whatever the theories make of them is what they are. To claim otherwise would be to assume that works of art have some essential being independent of language, thought or history. In fact, there is no one authentic face of the *Black Square* against which the respective arguments can be tested. There is only ever another interpretation in the endless competition of interpretations. This being the case, F sees no reason not to acknowledge the frankly partial and instrumental nature of our interpretative acts. The *Black Square* F is interested in is the one which serves his or her own imaginative or other ends. To interpret the painting is not to fathom its 'true' meaning and effects, nor to explain its production. It is to set beside it another artifact, another 'text'. And the adequacy of that text will not be measured in terms of its relevance, since in F's view criteria of relevance serve merely as principles of decorum or as restrictions upon thought and invention. For F, the test of critical interpretation is not whether it truthfully recounts the effects of art, but whether it is itself productive of effects and ideas which serve to destabilize an existing critical decorum or orthodoxy.

Lest it should appear that I mean to leave F with the last word, I invite the reader firstly to note potential similarities between F's position and C's and secondly to consider whether F is proposing to do much more than use the *Black Square* as a kind of conversation-piece or rhetorical token. We are entitled, I think, to ask of someone who writes about

a specific work of art why it is that they have chosen that work to write about. And we are likely to be disappointed in an answer which either merely asserts a personal freedom of choice, and which thus leaves us with little ground on which to share a possibility of learning, or which refers us back to the disputed authority of a previous writer and thus simply displaces the question.

We shall return to Malevich and his *Black Square*.

Autonomy

Separate realms, separate rules?

As the foregoing discussion should have made clear, concepts of abstraction are inextricably bound up with concepts of autonomy. In its most straightforward sense the term autonomy refers to the condition of self-government or independence. In the sciences an autonomous process or development is one which can be studied in isolation, on the grounds that it conforms to a set of laws proper to itself. To treat the development of art as an autonomous development – as Modernists are sometimes criticized for doing – is to make the assumption that art develops according to its own laws; or, at least, it is to treat the self-critical character of artistic practice as the most significant factor in determining the development of art. It is to imply that art is in some important sense self-governing. Kandinsky described the moment of his own artistic maturity in these terms:

> Thus did I finally enter the realm of art, which like that of nature, science, political forms etc., is a realm unto itself, is governed by its own laws proper to it alone, and which together with the other realms ultimately forms that great realm which we can only dimly divine.
>
> (Kandinsky, *Reminiscences*, p.38)

The concept of autonomy employed here is roughly consistent with the position which Person D was made to articulate in the previous section: art is seen as a specialized activity with its own intrinsic concerns and problems. On the other hand, Kandinsky imagines an underlying spiritual realm such as Hilla Rebay – quoted as representative of C's position – must have had in mind as the realm to which non-objective paintings promised an entry. In such defences of abstract art it is this 'spiritual realm' itself which is seen as autonomous, and thus, presumably, as indifferent to the changing and conflicting values of history and social life.

As we have seen, such views have been opposed by those for whom art is necessarily implicated in social and political conditions, and who therefore believe that no analysis or explanation of the development of art can be adequate if it does not accord these conditions priority. We need to be careful here. To talk about what should or should not be taken into account in the criticism and history of art is not quite the same as talking about how the practice of art should or should not be conducted. Of course, we would not be surprised to learn that our Person E favours artistic work which reveals evident engagement with social and political themes, any more than we would be surprised to learn that D favours 'pure' forms of abstract art. But though E was made to question the degree of autonomy which D accorded to the development of art, the point the former was making was not so much that art *ought* to be implicated in social processes as that it necessarily *is* and that this should be acknowledged.

Opposition to the autonomy of artistic *practice* has been a more overtly political matter in the history of modern art. As we might expect, the autonomy of the modern artist's position has been most hotly debated when the social and political independence of the artist has been questioned or threatened from some position of effective authority. In 1944

the American Abstract Expressionist Robert Motherwell wrote that 'Modern art is related
to the problems of the modern individual's freedom. For this reason the history of modern
art tends at certain moments to become the history of modern freedom' ('The modern
painter's world'). The point Motherwell was making is that explicit and implicit claims for
the autonomy of art are relative to the wider circumstances of political and social life.
Such claims will tend to express specific perceptions of those circumstances. The meaning
and value we attach to them will in turn be relative to the meaning and value we find in
those circumstances. To the Communist fighting incipient Fascism, the practice of abstract
art may have seemed a form of renunciation. To the artist George Grosz, for example,
writing in Germany in 1925, abstract artists were 'wanderers into the void' who stood
'silent and indifferent, that is, irresponsibly, in relation to social occurrence …' (Grosz and
Herzfelde, 'Art is in danger'; and see Plate 187). To modern liberals who see themselves as
living in a progressive, cooperative and democratic society, the artist next door who
claims complete independence of thought and action may appear an elitist and anti-social
figure. Yet if the same claim were made by an artist living in what was seen as a conser-
vative, bureaucratic and oppressive society, it would be likely to win the unconditional
support of the same liberal constituency (and a Nobel Prize, perhaps). During the 1980s,
the struggles for political independence of the Polish union Solidarity received the appar-
ently heartfelt endorsement of an English prime minister whose own incumbency was
notable for legislation severely limiting the autonomy of British trade unions. The point is
that so far as the practices of both art and politics are concerned, autonomy is a relative
matter.

 I make these points in order to recapitulate and further to develop the conclusion to
the first section. The intention to produce abstract art was formed against a specific his-
torical background, and as that background itself shifted, so did the significance of those
different forms of autonomy-claim by which the production of abstract art was defended.

Three versions of autonomy

Various types of autonomy-thesis have been advanced explicitly or implicitly in the practices of modern art, art criticism and art history. I have grouped these into three broad categories in order to impose some order on our discussion. The three categories of thesis are complementary rather than alternative to each other. They have logical connections one with another, though they have different implications and can usefully be distinguished in their various modes of operation.

The first category of autonomy-thesis concerns the conditions of production of art. According to this thesis, art is subject to its own necessities and tendencies and determinations, which are not significantly affected by such contingent factors as the social status of artists or the level of fees paid for their work. As Clive Bell put it,

> Art and Religion are not professions: they are not occupations for which men can be paid. The artist and the saint do what they have to do, not to make a living, but in obedience to some mysterious necessity. They do not produce to live – they live to produce.
> (Bell, *Art*, p.261)

In a more sophisticated version of this first form of autonomy-thesis, it is argued, for example by Clement Greenberg, that the pursuit of art is the pursuit of a specialized and autonomous discipline. Though that pursuit is not immune to the pressure of economic forces and historical events, the impetus for change is experienced first and foremost in self-critical reference to art itself. It follows that the priorities of the art historian should be determined accordingly. There may be a great deal to be said and written about the social standing of artists, about their changing relations with patrons or dealers and about the political culture within which they do their work, but unless due attention is paid to the problems and possibilities 'intrinsic' to art, work along these lines will certainly be inadequate and may be irrelevant to the task of explaining any artistic development.

Malevich pursued this concept of autonomy at some length in his theoretical work. In his view art was responsive to the world and to history, but it established its all-important aesthetic content – the 'additional element' – in a distinct and parallel world of values. In turn this 'additional element' both influenced the perception of nature and affected the subsequent development of art. In charts produced for a lecture in 1927 he attempted to represent this process schematically (see Plate 188).

The thesis about the autonomy of the production of art has also been given a twist which serves to restore the sense of a critical social purpose. The strongest advocate of this form of the thesis is Theodor Adorno. In his *Aesthetic Theory* he writes,

> Art is social, not merely by virtue of its process of production ... not even only in the social origins of its contents and raw materials. Rather it becomes social by virtue of its oppositional position to society itself, a position it can occupy only by defining itself as autonomous.
> (Adorno, *Aesthetic Theory*, section 335/321)

The second category of autonomy thesis concerns the experience of art. According to this form of the thesis the experience which identifies art as art is aesthetic experience. Aesthetic experience is seen as autonomous, in the sense that it is experience in and for itself and is neither significantly affected by nor admixed with non-aesthetic desire or interest or knowledge. Roger Fry wrote in 1909 of 'that intense disinterested contemplation that belongs to the imaginative life, and which is impossible to the actual life of necessity and action' ('An essay in aesthetics'). In 1967, at a much later stage of the Modernist critical tradition, Clement Greenberg claimed that 'aesthetic judgements are immediate, intuitive, undeliberate, and involuntary' and that therefore 'they leave no room for the conscious application of standards, criteria, rules, or precepts' ('Complaints of an art critic', p.4). This is to accord a form of autonomy to the matter of aesthetic experience and judgement.

DIE MALERISCHE NATURVERÄNDERUNG UNTER DEM EINFLUSSE DES ERGÄNZUNGSELEMENTS.

Plate 188 Kazimir Malevich, *Die Malerische Naturveranderung ...* ('The influence of the additional element on the perception of nature'), *c*.1925, collage, pen and ink, 55 x 79 cm. Collection, The Museum of Modern Art, New York, 822.35.

The third category of autonomy thesis accords autonomy to the forms of art. According to theses of this type, even if some formal element in a painting refers to a feature of the world – a person, a mountain, a jug – in so far as that form functions within a self-contained aesthetic whole, it is not dependent upon that reference for its value. This is to say that a work of art achieves its status as such not as a consequence of its *correspondence* to the appearance of things in the world, but rather through the *coherence* of its own internal organization, the measure of which must be formal. It does not follow from this argument that depiction is inimical to the ends of art, merely that it is inessential and in the last instance irrelevant. For example, Clive Bell's influential concept of 'significant form' proposed that the descriptive or illustrative aspect of art was not so much harmful as irrelevant to the matter of aesthetic quality.

Bell's thesis was propounded in *Art* in 1914 at a time when very little wholly abstract art had actually been produced and when little of that had reached England. His book was largely organized as a justification of the status of Cézanne and of the importance of that shift in the priorities of art and art criticism which he and Fry identified with 'Post-Impressionism' – a shift exemplified in our earlier comparison between Van Gogh and Byam Shaw (Plates 173 and 174). This serves to emphasize a point implied earlier. As we have already seen, claims for the autonomy of artistic form were often made in the later nineteenth century as means to establish a modern position in opposition to 'traditional' forms of culture. In the defence of abstract art a particular stress was given to those distinctions.

In the process the developing modern tradition was itself subject to an increasing polarization as the pursuit of formal autonomy or 'purity' came to seem increasingly incompatible with a commitment to some form of realism. For example, though Cézanne had seen his own practice as inescapably grounded in the study of nature, abstract artists found support in those accounts of Cézanne's work which represented him as committed to the pursuit of 'pure' form. In 1919 Malevich could write of Cézanne, 'With him comes to an end the art that kept our will on the chain of objective, imitative art whilst we dragged ourselves along behind the creative forms of life' ('On new systems in art', p.94). Bell described Cézanne as 'the Christopher Columbus of a new continent of form' (Bell, *Art*).

It is important to bear in mind that though the autonomy claims of Modernist theory have been associated by social historians with the maintenance of a dominant critical regime, during the second decade of the twentieth century claims for the autonomy of art were typically made by artists and writers who believed themselves opposed to the conservative in culture and committed to the vision of a better future. 'In our contemporary life', wrote Malevich, again in 1919, 'there are people who are alive and there are conservatives' ('On the museum', p.71).

The matter of the autonomy of art is an open question. So is the matter of the autonomy of art history. To identify some set of historical processes and practices as a subject of study – as we do when we propose a history of art – is to assume that there are some defensible methodological grounds on which these processes and practices can be distinguished from others. Not all autonomy theses are equally defensible. On the other hand there can be no self-criticism in practice and no inquiry or causal explanation without the operation of some principles of autonomy. As a rule of thumb it might be said that autonomy theses are useful when they serve to stimulate self-criticism, to focus inquiry and to ensure the relevance of explanation, but that they are deleterious when they serve to insulate against criticism, to narrow inquiry or to foreclose the terms of explanation. It will not always be easy to tell, however, just *how* any principle of autonomy is actually being employed. To focus on the formal development of art between 1910 and 1920 is to learn something about the apparent self-critical processes of modern painting. But such a focus would clearly have become too narrow if it imposed ignorance of other historical events and processes of the period.

The idea of a better world

To study history, at least in its human and cultural dimensions, it is not enough simply to consider what happened and to assess people's motives and responses accordingly. We need also imaginatively to entertain those once possible forms of thought and belief which history itself has tended to disqualify or to discredit. With this in mind, I return to the matter of intention. To talk of the intentions of artists and of their ideas is to talk about the ways in which they represent the world and their practices to themselves. But while the reality we encounter is a determinant upon our intentional actions – 'the cause of our expectations being fulfilled or disappointed, of our endeavours succeeding or being frustrated' (Barry Barnes, *Interests and the Growth of Knowledge*, p.26) – our intentions themselves are defined by a knowledge and understanding which is always partial. To assess the outcome of an intentional action (such as a work of art) it will therefore not be enough simply to ask what the artist meant. We will have to give that 'meaning' substance in the light of history – to (re)interpret it in terms of the best knowledge and understanding at our disposal. Through such a process of interpretation we might come to understand an apparently global ambition as an intention formed with regard to a relatively local historical circumstance. Or we might come to understand that what some artist intended as the solution to a relatively small-scale practical problem served in effect to animate a substantial though formerly hidden problem field.

Plate 189, Kazimir Malevich,
Study for a fresco painting:
Prayer(?), 1907, tempera on
cardboard, 70 x 75 cm. State
Russian Museum, St Petersburg.

For instance, in reconstructing the period 1910–14, we are conceiving of a period
when, though war may have been predictable, it was by no means *inevitable*. When we
read Kandinsky writing in 1910–11 of a coming 'epoch of great spirituality' (at the con-
clusion to *Concerning the Spiritual in Art*), it is easy to feel impatience at what appears a
culpable naivety and idealism. Yet even with the benefits of substantial hindsight, Clive
Bell could write of the years around 1910, 'It was a moment at which everyone felt excite-
ment in the air ... certainly there was a stir: in Paris and London at all events there was a
sense of things coming right ... In 1910, only statesmen dreamed of war, and quite a
number of wide-awake people imagined the good times were just around the corner' (Bell,
Old Friends, writing about the circumstances of his first meeting with Fry). For Bell the
'excitement in the air' was very much associated with what he saw as happening in the
realms of art. However absurd the idea may seem to us now, the 'new movement' of
which early abstract art was an important part was seen by Bell and his friends – and by
comparable groups in Paris, in Munich, in St Petersburg, in Moscow and elsewhere – as
signifying a progressive change in human sensibility.

As I have suggested, belief in such a possibility of change was a characteristic of the
teachings of Theosophy, to which Kandinsky, Malevich and Mondrian were all variously
drawn at formative periods of their work. Between the years 1907 and 1911 each painted a
number of pictures in which human figures are represented with symbolic trappings
clearly designed to suggest a 'spiritual' potential (see Plates 189–191). In each case the
spiritual is symbolized through a kind of 'aura', which functions at the same time as an
emphatic decorative element. The legacy of Symbolism is unmistakable in such paintings.
There is no easy way to distinguish cause and effect here. That's to say the artists con-
cerned may well have been attracted to Theosophy in the first place because it appeared to
lend support to ideas about art which were already current. What is clear is that for
Kandinsky, at least, it was the possibility of development in the human capacity for spiri-
tual experience that provided abstract art with its sociological justification:

Plate 190 Piet Mondrian, *Evolution*, 1910–11, oil on canvas, side panels 178 x 85 cm, centre panel 183 x 88 cm. Collection Haags Gemeentemuseum, The Hague. © DACS, 1993.

I believe that the philosophy of the future besides studying the nature of things will also study their spirit with especial attention. Then will the atmosphere be created that will enable men as a whole to feel the spirit of things, to experience this spirit even if unconsciously, just as today the outward form of things is experienced unconsciously by mankind in general, which explains the public's enjoyment of representational [figurative] art. Thus will mankind be enabled to experience first the spiritual in material objects and later the spiritual in abstract forms, and through this new capacity, which will be in the sign of the 'spirit', the enjoyment of abstract = absolute art comes into being.

(Kandinsky, *Reminiscences*, p.42)

Though the explicit influence of Theosophy was largely confined to the pre-war period, the form of idealism to which Kandinsky here gives voice was sustained by many even after the outbreak of the First World War. The abstract artists were generally among those who clung to the hope that this war might prove to be the final and cleansing convulsion of an old and outmoded form of social and moral existence, and that the human potential for a higher plane of existence would be realized in new social forms when it was over. For Mondrian and his fellow contributors to the journal *De Stijl*, writing in 1918 towards the end of the war, the 'new consciousness' was to be a shared vision of international unity, for which the supposedly universal aesthetic quality of abstract art was to serve as a kind of prototype.

1 There is an old and a new consciousness of time.
 The old is connected with the individual.
 The new is connected with the universal.
 The struggle of the individual against the universal is revealing itself in the world war as well as in the art of the present day.

Plate 191 Vasily Kandinsky, *Improvisation 2 (Trauermarsch)* (*Funeral March*), 1909, oil on canvas, 94 x 130 cm. Moderna Museet, Stockholm. © ADAGP, Paris, and DACS, London, 1993.

2 The war is destroying the old world and its contents: individual domination in every state.
3 The new art has brought forward what the new consciousness of time contains:
 a balance between the universal and the individual.
(*Manifesto 1*, pp.278–9)

To sum up this point: if we are adequately to assess artists' intentions and actions in the light of historical conditions, it will be necessary to include among those conditions what it was possible to *imagine*. If we don't do that much we may fall into the error of measuring the realism of artists' practices by the yardstick of our own hindsight on history.

There is a second point to bear in mind, however, when we consider the relationship between abstract art and contemporary historical conditions and events. This concerns the connection between theories of artistic development and theories of historical change as these were understood at the time. For the majority of the intellectuals involved in its preparation and achievement, the Russian Revolution was a Marxist revolution. Among other things this meant firstly that they saw the organized working class as the primary agent of historical change and progress, and secondly that they believed the overthrow of the bourgeois order by the working class was the necessary precondition for any substantial change in culture and in human consciousness. In Marx's words, 'It is not the consciousness of men that determines their existence, but their social existence that determines their consciousness' (Marx, *A Contribution to the Critique of Political Economy*, p. 20). Marx thus inverted the previously predominant view of the relations between history and consciousness, associated with the work of Hegel. For Hegel, human society and culture were the products of the 'general development of the human mind'. For Marx 'social existence' was defined by economic 'relations of production' which are independent of the will of individuals.

In the nineteenth century, socialist cultural theories tended to result in Realist styles. During the 1920s, and increasingly in the 1930s, figurative·forms of realism were pro-

moted as the appropriate artistic forms for a socialist culture. But at the time of the Revolution there were artists, Rodchenko notable among them, who sought to render abstract work consistent with a Marxist and materialist view of history and consciousness. For the Constructivists, 'creativity' had no justifiable meaning outside the actual social contexts of production, hence their concern with 'intellectual production' rather than 'aesthetic activity' and their concern with 'the real participation of intellectual and material production as an equal element in the creation of communist culture' (Rodchenko and Stepanova, 'Programme of the First Working Group of Constructivists', 1922).

It should be clear, however, that those abstract artists whose ideas we have principally been considering were possessed of a Hegelian view of history. That is to say they believed, or acted as if they believed, that significant change could be achieved in thought and by thought. Malevich was a wholehearted supporter of the October Revolution. Yet in 1920 he could write, 'Humanity by its efforts singled out thought from its environment and raises it to the throne of government' ('God is not cast down', published in 1922, p.198). If the abstract artists believed that change in the social organization of society was an inevitable consequence of the desired change in consciousness, there is no real sign of their having envisaged this transformation in class terms. This is to say that if significant connections are there to be made between the development of forms of abstract art and the conditions of war and revolution, it nevertheless does not follow that the meaning or intention of the art can be reduced to a simple equivalence with any political position. Indeed, it was a virtual item of faith among the principal early practitioners and supporters of abstract art that aesthetic meaning is disinterested meaning – and thus not reducible to political meaning.

In fact, despite the apparent idealism of artists such as Kandinsky, Mondrian and Malevich and despite the absence of overt connections linking their work to contemporary events, it may be worth entertaining the apparently improbable idea that the development of abstract art was causally and not just coincidentally connected both with the circumstances of the war and with the subsequent Revolution in Russia. I don't of course mean to suggest that 'revolutions' in art cause social revolutions or provoke wars. I mean that the faith in human capacities which impelled those who entertained the idea of abstract art, though it did not take explicit political form and even though it may now appear absurd, may have been realistic to this extent: firstly that the form of faith involved may have been consistent with the state of mind (the bravery) required to envisage a progressive social and historical change, and secondly that there may have been practical grounds for believing that such a change was worth pursuing. Though the conditions which led certain people to conceive of revolution were not identical to those which led certain other people to conceive of abstract art, the overlaps and coincidences between the two sets of conditions are such that to conceive of the latter in *isolation* from the former may effectively be to misrepresent the historical character of the art.

I also mean to suggest that in so far as one form of this faith was threatening to the established order, so was the other. Its demonstrable idealism notwithstanding, in the early 1920s abstract art was generally equated with Bolshevism in the minds of those Western observers who believed that the Russian Revolution must be contained at all costs. The same equation was subsequently made in the propaganda of the Nazis. As I have suggested, the political connections of abstract art were clearly not so simple, but the responses of those who opposed it do tell us something about its significance.

By the same token it is also worth bearing in mind that for those who lived through the war and its aftermath on the one hand and the Russian Revolution and its betrayal on the other, to continue to uphold the meaning and value of abstract art was to work on under the changed and isolating conditions of a massive historical setback. In the history of modern art few artist have persisted with such apparent consistency and with such an apparently 'pure' and anti-naturalist formal vocabulary as Mondrian. During the 1930s he was living and working in Paris. In 1938 he was persuaded by the artists Ben and Winifred

Nicholson to come to England, where they believed he would be safer if and when a second war broke out. In the event he was in London during the Blitz. He left for America in October 1940, taking with him the manuscript of an essay headed 'Art shows the evil of Nazi and Soviet oppressive tendencies', which he was eventually to call 'Liberation from oppression in art and life'. It is quite clear from the essay that in 1939–40 Mondrian, at least, believed that he still had a specific and important job to do in the light of historical events.

> Human life is oppressed by internal causes – both physical and moral – as well as by external factors. It is necessary to fight against both. All that can help us to understand the evils of oppression is useful to present and future. Therefore it is essential to demonstrate that plastic art can help to clarify this evil …
>
> Art is the aesthetic establishment of complete life – unity and equilibrium – free from all oppression. For this reason it can reveal the evil of oppression and show the way to combat it.
>
> Plastic art establishes the true image of reality, for its primary function is to 'show', not to describe. It is up to us to 'see' what it represents. It cannot reveal more than life teaches, but it can evoke in us the conviction of existent truth. The culture of plastic art can enlighten mankind, for it not only reveals human culture, but being free, advances it.
>
> (Mondrian, 'Liberation from oppression in art and life', pp.322–3)

In the following sections I shall consider further the work of Kazimir Malevich and Piet Mondrian. In both cases I shall be examining some claims made by the artists and others for the meaning and value of their work, but I shall apply a slightly different emphasis in each case. In the section on Malevich I will consider his career in relation to some specific historical events and developments and will look further at the changing context of arguments for the autonomy of the aesthetic. In the section on Mondrian I shall look further into the relationship between problems of explanation and problems of evaluation as these bear upon abstract art.

Kazimir Malevich

The *Black Square* is the most art-historically notorious of all Malevich's works. It was the painting upon which the artist came to base his own professional self-image. It has also been made a virtual icon of radical artistic modernity. In 1916 Malevich described the *Black Square* as 'the first step of pure creation in art. Before it, there were naive deformities and copies of nature'. That quote is taken from the final version of the essay *From Cubism and Futurism to Suprematism* which Malevich first published late in 1915 as a pamphlet with a black square on the jacket cover. In 1933, he used the motif of a miniature black square to sign what appears a relatively conventional and certainly thoroughly figurative self-portrait (Plate 192). On his death two years later a version of the black square was placed at the head of the bed on which his corpse was laid out, another was fixed to the front of the vehicle on which his coffin was carried, while his grave in Nemchinovka was marked with a black square on a white ground (Plates 193–195).

What Malevich meant by 'pure creation' was not a *process* of abstraction. That's to say, the *Black Square* as he represented it was not, like Mondrian's *Pier and Ocean*, the end product of a gradual reduction or formalization of some aspect of the natural world. Albeit the evidence of underpainting now visible suggests that Malevich may have worked *towards* his painting from some less 'absolute' starting point, as he actually presented the work it was supposed to be the elementary component of a new 'purely painterly' order, quite independent of naturalistic appearances. 'Each form is free and individual. Each form is a world' (*From Cubism and Futurism to Suprematism*).

Plate 192 Kazimir Malevich, *Self–portrait*, 1933, oil on canvas, 73 x 66 cm. State Russian Museum, St Petersburg.

Plate 193 (above left) Photograph of Kazimir Malevich lying in state in his apartment, 1935. Archive of State Russian Museum, St Petersburg.

Plate 194 (above) Photograph of the arrival of Kazimir Malevich's funeral procession at Moscow Station, Leningrad. Archive of State Russian Museum, St Petersburg.

Plate 195 (left) Photograph of Kazimir Malevich's grave. Archive of State Russian Museum, St Petersburg.

The *Black Square* was first shown in the exhibition '0.10' ('Zero-Ten') in St Petersburg in December 1915 and was probably painted earlier in that year, though Malevich himself retrospectively dated it 1913. The relationship between the two dates is of some significance for an interpretation of the work, in so far as it tells us something both about Malevich's possible intentions and about the conditions under which those intentions may have been formed.

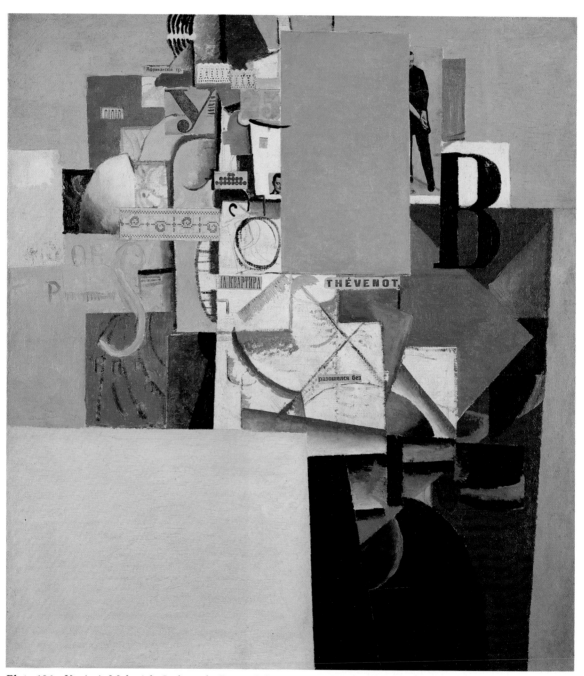

Plate 196 Kazimir Malevich, *Lady at the Poster Column*, 1914, oil and collage on çanvas, 71 x 64 cm. Stedelijk Museum, Amsterdam.

From Cubism and Futurism …

Malevich had shown work in what he himself called a 'Cubo-Futurist' style in the exhibition Tramway V in Petrograd in March 1915 (see for example, Plate 196). Tramway V was subtitled the 'First Futurist Exhibition' and 0.10 the 'Last Futurist Exhibition'. It is of some relevance on the one hand that Futurism was referred to in the titles of both the 1915 exhibitions and on the other that termination of its reign in Russia followed so quickly upon its first announcement.

The original Futurist movement was launched in 1909 with a manifesto published on the front page of *Figaro*, a daily French newspaper of relatively conservative character. The author of the manifesto was the Italian poet and propagandist Filippo Marinetti. The specific and aggressive aim of the Futurist movement was the modernization of Italian culture, but its characteristic rhetoric of modernity for its own sake resonated throughout Europe in the years immediately before the First World War. Two manifestos of Futurist painting appeared early in 1910, the second published in Paris. In 1912 an exhibition of Italian Futurist painting opened in Paris and subsequently travelled to London, Berlin, Brussels, Hamburg, Amsterdam, The Hague, Frankfurt, Breslau, Zürich, Munich and Vienna. The introduction to the catalogue – 'The Exhibitors to the Public' – was published in a Russian journal in the same year. Marinetti himself visited Russia early in 1914. Superficially at least, Futurist painting appeared to transfer the technical concerns of Cubism from the conventional pictorial world of still-lifes, figures and landscapes to a more explicitly modern world of urban uprisings and speeding machines (Plates 197 and 198). The Futurists were much taken with the ideas of the French philosopher Henri Bergson, who wrote of change as the essence of reality and of consciousness as a state of continual flux. He conceived of a kind of life force or vital impulse seeking freedom in face of the resistance of matter. Such ideas were clearly inviting to those, like the Futurists, who were seeking stylistic forms for 'modern' sensations.

Malevich was among those many European artists for whom the transitional self-image of a 'Futurist' was the means to disavow provincialism, to express impatience with the conservative in culture and to assert a commitment to the idea of a modernized world (see Plates 199–201). In Malevich's case the reign of this particular self-image was relatively short-lived. So far as the art of painting was concerned, the Italian Futurists' interpretation of modernity involved concentration upon those forms of imagery and of 'force' which they deemed characteristic of the modern age and of its typical modes of experience. At worst this resulted in forms of journalistic enchantment with speed and machinery – or 'automobilism' as their detractors called it. In 1912–13, Malevich painted pictures with

Plate 197 Luigi Russolo, *The Revolt*, 1911–12, oil on canvas, 150 x 230 cm. Collection Haags Gemeentemuseum, **The Hague.**

Plate 198 Giacomo Balla,
Velocita astratta. L'auto e passata
(*Abstract Speed. The Car Has
Passed*), 1913, oil on canvas, 50 x
66 cm. Tate Gallery, London.

Plate 199 Kazimir
Malevich, *The Woodcutter*,
1912–13, oil on canvas, 94 x
72 cm. Stedelijk Museum,
Amsterdam.

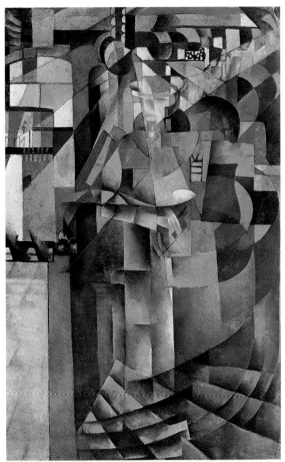

Plate 201 Kazimir Malevich, *Life in the Grand Hotel*, 1913–14, oil on canvas, 108 x 71 cm. Museum of Fine Arts, Kuibyshev.

Plate 200 Kazimir Malevich, *Cubo–Futurism. Dynamic Sensation of a Model*, dated 1911 but probably *c*.1912–13, graphite pencil on cream paper, 62 x 29 cm. Stedelijk Museum, Amsterdam.

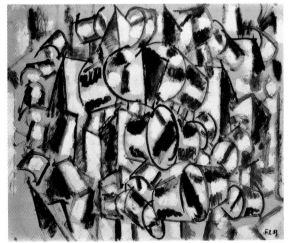

Plate 202 Fernand Léger, *Contrastes de formes* (*Contrasts of Forms*), 1913, gouache on paper, 55 x 46 cm. Rosengart Collection, Lucerne.
© DACS, London, 1993.

simplified forms and metallic effects which evoked the stylistic world of the Futurists and which were comparable to the abstract, mechanized version of Cubism which Fernand Léger established with his *Contrastes de formes* (see Plate 202). But Malevich peopled this formally modernized world with peasants, and he showed them as engaged in the 'timeless' occupations of carrying water, chopping wood, and harvesting crops (see Plate 199). In fact, in combining modern techniques with references to the abiding virtues of the supposedly 'primitive', he proved himself closer than were the Italians to the mainstream of avant-garde art in the early twentieth century.

In the summer of 1913 Malevich attended the self-styled 'First All-Russian Congress of Futurists'. From this small avant-garde gathering held at the dacha of Mikhail Matiushin there emerged a proposal for a 'Futurist' form of theatre. During that same year Malevich collaborated with Matiushin and Kruchenyk on *Victory over the Sun*, an opera for the St Petersburg Union of Youth which was staged at the close of the year. The style of the project was aggressively modern, in the sense of being determinedly anti-naturalistic. In his designs for the sets and costumes Malevich employed a Cubo-Futurist formal vocabulary consistent with the current manner of his paintings (see Plates 203–204). For the backdrop, he adopted the overall format of a box-shaped perspective framing a square aperture or window (see Plate 205). In the sketch for Act 2, Scene 5, the square is bisected diagonally, signifying the encroachment of darkness and the coming victory over the sun – a 'victory' consistent with the anti-rationalist irony of the opera as a whole (see Plate 206). Though no sketch survives for the final backdrop, we can surmise that it might have shown the square aperture entirely dark within its framing perspective.

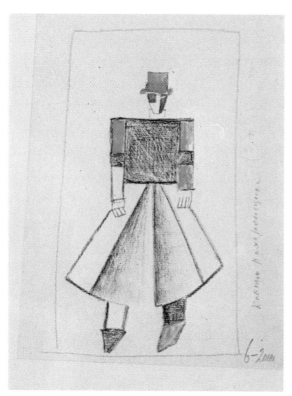

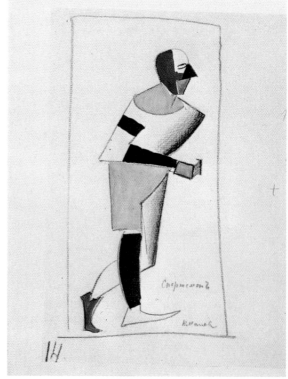

Plate 203 Kazimir Malevich, *Pallbearer*, design for *Victory over the Sun* (libretto by A. Kruchenykh; music by M. Matiushin), 1913, pencil and watercolour on paper, 27 x 21 cm. State Museum of Theatrical and Musical Arts, St Petersburg.

Plate 204 Kazimir Malevich, *Sportsman*, design for *Victory over the Sun*, 1913, watercolour, indian ink and charcoal on paper, 27 x 21 cm. State Russian Museum, St Petersburg.

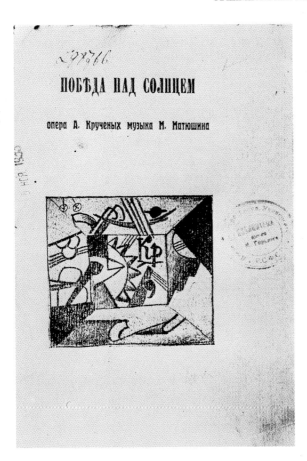

Plate 205 Kazimir Malevich, stage design for Act 1, Scene 4, of *Victory over the Sun*, reproduced on cover of libretto. State Russian Museum, St Petersburg.

Plate 206 Kazimir Malevich, stage design for Act 2, Scene 5, of *Victory over the Sun*, pencil on paper, 21 x 27 cm. State Museum of Theatrical and Musical Arts, St Petersburg.

The nature and significance of this missing last design are confirmed by an inscription written by the artist on the back of one of his later repetitions of the *Black Square*: 'Suprematism 1913 the initial element first manifested itself in Victory over the Sun'. It is further confirmed by a letter which Malevich wrote to Matiushin in 1915, when a second staging of the opera was proposed.

> I'll be very grateful if you yourself would position my curtain design for the act in which the victory is won … This drawing [or design] will have great significance for painting; what had been done unconsciously, is now bearing extraordinary fruit.
> (Letter of 27 May 1915, published 1976, p.156)

The point to emphasize is that in the spring of 1915 Malevich was writing as if he was himself still surprised by the implications of what he had done, as he puts it, 'unconsciously'. It was only two months earlier that he had shown works in his Cubo-Futurist vein in the Tramway V exhibition. It seems unlikely that he would have represented himself in this way in an avant-garde exhibition if he had already produced a body of abstract work about which he felt confident. The evidence therefore suggests either that the 'Suprematist' works exhibited in December 1915 had in fact all been completed since that spring, or alternatively that if the *Black Square* and possibly others had been completed earlier, Malevich himself was not yet sure enough of what he had done to put it forward for exhibition in Tramway V – not yet sure, perhaps, that it was indeed 'painting' or 'art' at all. What is clear, however, is that once he had accepted the implications of the *Black Square* – which may have been taken him a year or more – his view of his practice as an artist was decisively changed. 'I have transformed myself *in the zero of form*', he wrote on a broadsheet distributed at the 0.10 exhibition. The text of the broadsheet was subsequently incorporated as the opening page of Malevich's pamphlet *From Cubism and Futurism to Suprematism*.

A photo of the installation of 0.10 shows the *Black Square* hung across the corner of a room in the position traditionally associated with religious icons in domestic interiors (see Plate 207). The photo suggests that Malevich exhibited more than one black square. Certainly, he painted at least three versions of the composition. One of these can be dated with certainty to the late 1920s, though he seems to have dated all versions to the moment when he believed the idea had first formed.

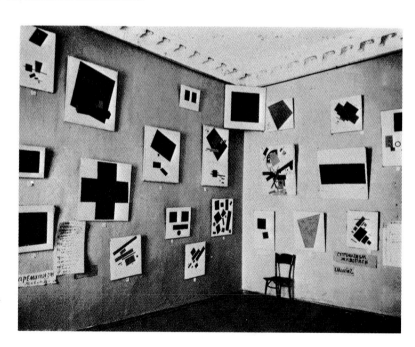

Plate 207 Photo of installation of 0.10 exhibition, St Petersburg, 1915. Archive, State Russian Museum, St Petersburg.

... to Suprematism

To sum up. It seems clear firstly that the idea for the *Black Square* derived at least in substantial part from the stage design of late 1913, with its connotations both of victory and of Futuristic anti-naturalism and anti-rationalism, and secondly that it was not until some time later, probably between the opening of the 'First Futurist exhibition' in March 1915 and the letter of two months later, that what had started as a kind of theatrical conclusion became positively transformed in Malevich's own mind into the initiating work of a would-be global aesthetic to which he was to give the name of Suprematism. Under the circumstances in which he was working at the time – not only the relatively limited circumstances of the Russian avant-garde with its connections out to Paris, to Munich and elsewhere, but also the wider circumstances of impending revolutionary change – the black square must at a certain point have appeared as the potentially powerful symbol both of a cultural *tabula rasa* and of a point of absolute origin from which a new aesthetic culture could be derived. It would not be the first nor the last time in the history of art that what was done 'unconsciously' in response to one set of concerns and problems came to be seen and theorized in relation to a different and much larger problem field.

The first version of *From Cubism and Futurism to Suprematism. The New Realism in Painting*, was complete for the 0.10 exhibition (and was issued under the title *From Cubism to Suprematism*). In his text Malevich represents Suprematism as the latest point of a progressive development commencing with the 'art of the savage'. He had come to believe

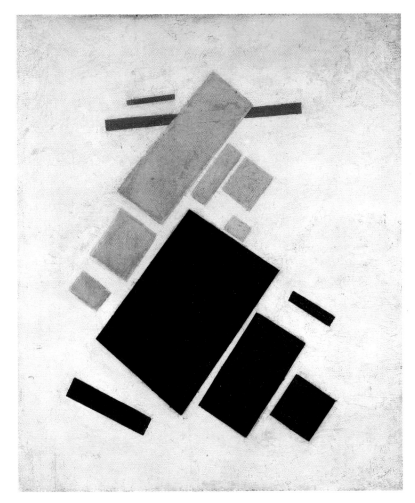

Plate 208 Kazimir Malevich, *Suprematist Composition: Airplane Flying*, 1915 (dated 1914), oil on canvas, 58 x 48 cm. Collection, The Museum of Modern Art, New York. Purchase.

that the savage's attempt to produce a self-image was the birth of the aspiration to naturalism. In some early Suprematist works like *Airplane Flying* of 1915 (Plate 208) he had appeared still to toy with a Futurist iconography. On the way to the Suprematist present, however, Futurism was decisively abandoned on the grounds that 'In pursuing the form of aeroplanes or automobiles, we shall always be anticipating new cast-off forms of technical life', and that 'In pursuing the form of things, we cannot discover painting as an end in itself, the way to direct creation'. Futurism was thus seen to fail on two counts: the nature of its subject-matter ensured that it would date rapidly; and its autonomy as art was compromised by its adherence to forms of illustration. Suprematism was advanced as the positive counter to these negatives.

In a second letter to Matiushin written in May 1915 Malevich mentioned a proposed journal, which connects to the title given the 'Zero-Ten' exhibition of that December: 'In view of the fact that we are preparing to reduce everything to nothing, we have decided to call the journal *Zero*. Later on we too will go beyond zero' (letter of 29 May, p.157). If the *Black Square* was a 'first step', then what would have to follow was not a further reduction in the figurative residues of pictorial form but rather the gradual addition of other non-objective (abstract) elements to constitute an extending series. In ensuing works Malevich proposed further basic elements (see Plate 209). In other paintings datable to the years 1915–16 he combined several different elements into more complex compositions (Plates 210 and 211). Altogether Malevich showed between 38 and 40 abstract works in the 'Zero-Ten' exhibition. It seems likely that these were all produced within a relatively short period in the second half of 1915, together with the long theoretical essay which announced Suprematism as 'The New Realism in Painting'.

Malevich's avant-garde project which had begun in Futurist anti-naturalism and irrationalism was thus continued as an ambitious campaign for the autonomy of artistic creation and of artistic form. In fact he seems to have believed that the potential universality

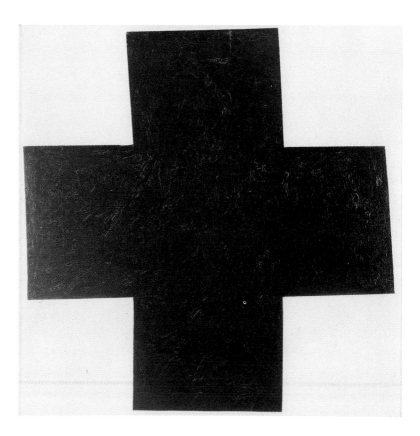

Plate 209 Kazimir Malevich, *Black Cross*, c.1915, oil on canvas, 80 x 80 cm. Musée National d'Art Moderne, Centre Georges Pompidou, Paris. Donation of Scaler Foundation.

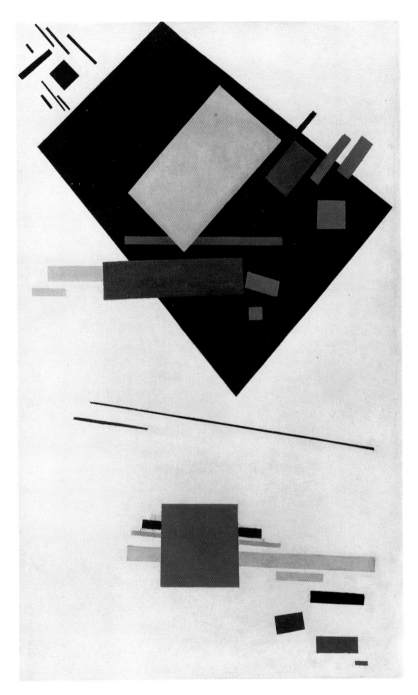

Plate 210 Kazimir Malevich, *Suprematism*, 1915, oil on canvas, 102 x 62 cm. Stedelijk Museum, Amsterdam.

and the absolute formal autonomy of Suprematist art qualified it not simply as the most up-to-date of avant-garde styles, but rather as the potential aesthetic base for an entire new world order. He was thus one of the earliest and most potent generators of that utopian dream which came to possess the wider European Modern Movement of the 1920s: the idea that the intractable problems of modern social existence could be solved if only planning were conducted on an aesthetic basis, with the abstract artist authorized as the ideal planner.

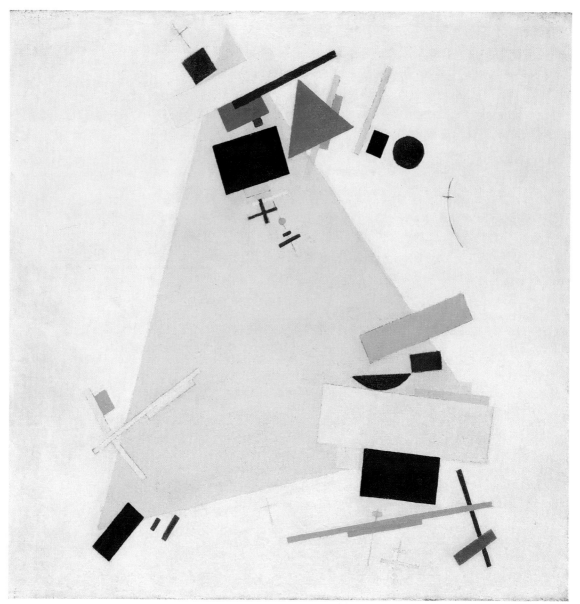

Plate 211 Kazimir Malevich, *Suprematist Composition*, *c.*1916, oil on canvas, 80 x 80 cm.
Tate Gallery, London.

The new realism

Like many of the other members of the artistic avant-garde, when the Revolution came in
1917 Malevich was quick to express an unqualified confidence in the relevance of his own
work. The new forms of art, he assumed, would provide an appropriate basis for the
building of a new culture. How could they not?

> The powerful storm of revolution has born off the garrett, and we, like clouds in the fir-
> mament, have sailed to our freedom. The ensign of anarchy is the ensign of our 'ego', and
> our spirit like a free wind, will make our creative work flutter in the broad spaces of the
> soul.
> (Malevich, 'To the new limit', p.55)

In 1919, in a contribution to a conference on museums, Malevich celebrated the position of the modern Russian artist at the centre of the historical stage.

> The centre of political life has moved to Russia.
> Here has formed the breast against which the entire power of the old-established states smashes itself.
> Hence goes forth and shines in all corners of the earth the new comprehension of the essence of things, and hither to the centre representatives of old culture crawl out of their cracks and come with their worn out old teeth to gnaw themselves a piece from the hem of the new coat.
> A similar centre must be formed for art and creativity.
> Here is the rotating creative axis and race, and it is here that a new contemporary culture must arise, with no room for alms from the old one.
> Hitherto to the new pole of life and excitement all innovators must surely stream in order to take part in creation on a world scale.
> ('On the museum', p.68)

Among the few surviving works datable to this period are a series of 'white on white' paintings, actually composed of cool bluish-white motifs on warm creamy-white grounds, the former tending to blur at the edges and to dissolve into the latter. The effect is to compress the potential figurative space of Malevich's Suprematism into a still narrower range than the works of 1915–16 (see Plate 212).

Works from this series were shown in the Tenth National Exhibition in Moscow in 1919, held under the title 'Non-Objective Creation and Suprematism'. In the same exhibition Alexander Rodchenko exhibited paintings in 'black on black', as forms of materialist riposte to what the Constructivists saw as Malevich's aestheticism and idealism (see Plate 213). As I have already suggested, during the early 1920s there was an increasing tendency for the avant-garde factions in Russia to polarize along the lines of that split between idealists and materialists which was symbolized by this juxtaposition of paintings (Plate 212 and 213). It should be said that to represent the polarization in such terms is to impose the tidy categories of hindsight. At the time, differences between individual positions and commitments emerged largely as barely theorized disagreements over the practical reorganization of educational and curatorial institutions and over the reallocation of their scarce resources in the wake of the Revolution. For the most part the various members of the artistic avant-garde were energetic in their involvement with the task of reorganization, and in the early years of the Revolution their contributions received some overall support and encouragement. The possibility of practical commitment to this task helps to explain both the note of utopian fervour which accompanies much of the artistic theory of the time, and the somewhat *ad hoc* and improvisatory character of much of the artists' actual production.

To say that the disagreements emerged in practical contexts is not, of course, to imply that the issues involved were not theoretically substantial. The apparent coherence of his Suprematism made Malevich both a figurehead and a target in the debates involved. When in 1921 he attempted to establish a foothold in the recently established INKhUK (Institute of Artistic Culture) in Moscow, the attempt failed. Opposition came from the Leftist majority of artists at INKhUK, who had already rejected a programme drawn up by Kandinsky and who were concerned to re-establish the practice of art on the model of technical laboratory work or as a form of utilitarian production. In the rhetoric of the Constructivists, 'art' and 'style' were associated with (bourgeois) 'ideology', and 'constructivism' and 'line' with 'intellectual production' and thus with labour. Notes for a talk to be given at INKhUK in 1921 record Rodchenko's view that 'Line has bid a red farewell to painting'. And it is clear from the same notes that 'painting' means Malevich and the *Black Square*: 'In putting line to the forefront – line as an element by whose exclusive means we can construct and create – we thereby reject all aesthetics of colour, facture and style; because everything that obstructs construction is style (e.g. Malevich's square)'

(*Alexander Rodchenko*, p. 128). In turn, when Malevich's essay 'God is not cast down' was published in 1922 it was taken as a direct attack upon the materialist conception of art – with some justice, considering its elevation of 'thought' to the 'throne of government'.

Plate 212 Kazimir Malevich, *Suprematist Painting (White on White)*, 1917–18, oil on canvas, 97 x 70 cm. Stedelijk Museum, Amsterdam.

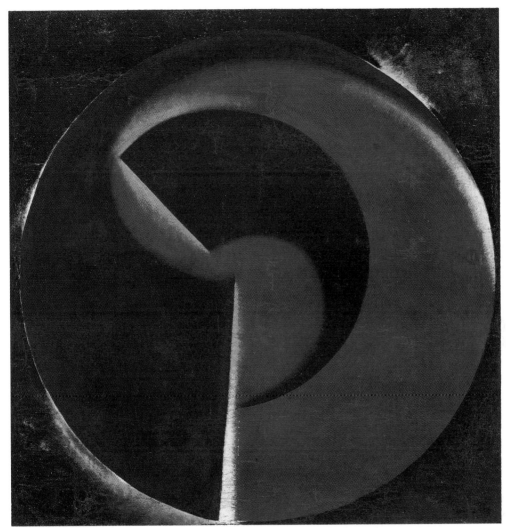

Plate 213 Alexander Rodchenko, *Non-objective Painting: Black on Black*, 1918, oil on canvas, 82 x 79 cm. Collection, The Museum of Modern Art, New York. Gift of the artist, through Jay Leyda.

The limits of autonomy

Between the Revolution and 1926 Malevich occupied a number of important posts in the reorganized art-educational system of the Soviet Union. At the art school of Vitebsk in 1920 he put into practice a teaching regime based on the idea of Suprematism as a complete and universal system, to be realized in collective work. The plan went under the name of UNOVIS (Affirmation of the New Art). Predictably UNOVIS attracted both loyal devotees and determined opposition. Between 1923 and 1926 Malevich was again working in Petrograd, involved in the transformation of the Museum for Artistic Culture into a scholarly institute for research into the culture of modern art. If Suprematism was the practical model of an ideally autonomous painterly culture, then the aim of Malevich's pedagogical work was to establish a complementary critical and art-historical theory. This aim was most clearly formulated in the regime of teaching and research which he was able to implement at GINKhUK in Petrograd between 1924 and 1926. During the period between the Revolution and the mid-twenties he and his followers were also engaged in designs

Plate 214 Kazimir Malevich,
Beta Architekton, 1926, plaster,
27 x 60 x 99 cm. State Russian
Museum, St Petersburg.

for ceramics and textiles (see Plates 177 and 178) and on architectural projects which were
not so much plans for actual buildings or fragments of cities as three-dimensional versions
of complex Suprematist compositions (see Plate 214). These 'architectons' served further
to promote the idea of the artist as the ideal planner of civil life.

In Malevich's own mind the painting of the *Black Square* had both closed an epoch and
initiated a tendency. Working to understand this tendency and to pursue its implications,
he had come to believe that the advanced aesthetic aspect of each epoch – 'the additional
element' – was capable of isolation through painstaking formal analysis. In June 1926 he
completed his 'Introduction to the theory of the "additional element" in painting', so far
the most ambitious exposition of his aesthetic ideas. The 'additional element' he aimed to
identify was nothing less than the aesthetic distillation of the age, for which the artist is
medium in so far as he or she is absorbed in and by an autonomous 'painterly culture',
and thus immune to the distractions of 'extraneous elements' (see Plates 188 and 215).

Publication of the text of Malevich's 'Introduction' proceeded no further than proof
stage, however. Early in 1926 he had been dismissed from his post as director of GINKhUK,
which he had held since the previous year. In June a representative exhibition of work
drew the public criticism that the Institute had been maintained as 'A cloister at the ex-
pense of the state' (review published in *Leningradskaya Pravda*, 10 June 1926; in *Malevich*,
p.82). In December 1926 the Petrograd INKhUK was dismantled by merging its staff and
their departments with the State Institute for the History of Art. Malevich's work proved
incomprehensible to the art historians, who in 1929 finally achieved the expulsion from
the State Institute of the artist and his entire department.

It is clear that Malevich's position on the autonomy of art had come to attract power-
ful opposition by the mid-1920s. It is also clear that the earlier polarization in the world of
modern Russian art had been superseded by another. On the occasion of the 1926 exhibi-
tion the criticism of Malevich's activities came not from the survivors of the Constructivist
avant-garde, but from the direction of the Society of Artists of Revolutionary Russia, the
AKhRR. Founded in 1922, the AKhRR had by the mid-twenties become the most powerful
association of artists in the country, with strong support from the Communist Party. Its
members were committed to the 'truthful' depiction of the ordinary life of the peasantry,
the proletariat and the Red Army and to the rejuvenation of the 'realistic' traditions of the
nineteenth century.

In 1927 Malevich was invited to exhibit a substantial selection of works in Berlin at
the Grosse Berliner Kunstaustellung (Great Berlin Art Exhibition) (see Plate 216). The
extensive campaign of self-representation with which he responded to this invitation
suggests that he intended to secure at least the possibility of a new career for himself in
the West. Though he returned to Russia after a visit to Poland and Germany in the spring

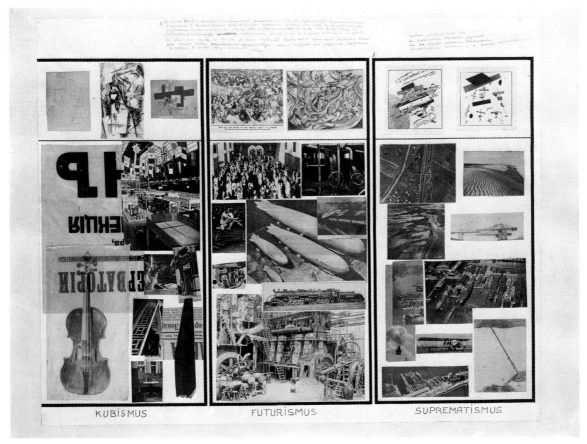

KUBISMUS FUTURISMUS SUPREMATISMUS

Plate 215 Kazimir Malevich, 'The relationship between the painterly perception and the environment of the artist (in Cubism, Futurism and Suprematism)', collage with pencil on transparent paper, pen and ink, 64 x 83 cm. Collection, The Museum of Modern Art, New York.

of 1927, he left explicit instructions that none of the material he had taken to Germany should be returned. Until very recently the Malevich knowable at first hand in the West was largely coincident with the image organized for export by the artist himself in 1927. In forming a retrospective selection of his work up to that date, he offered an account of his career which was negotiable in terms of the established groupings and categories of European avant-gardism: Expressionism/Fauvism, Futurism and Cubism, with Suprematism represented as a distinctive contribution to the wider post-Cubist modern movement. The works through which Malevich constructed his artistic self-image fall into four broad categories: brightly coloured gouaches of 1911–12 which connect to the primitivist-expressionist strain of the Russian and western avant-gardes (Plate 217); paintings and drawings datable to the following year, in which peasant and landscape subjects are rendered with a simplified metallic modelling comparable to Léger's (Plate 199); Cubo-Futurist paintings of 1913–14, which show Malevich as a major figure in the pan-European development of Cubism (Plate 196); and the Suprematist paintings and drawings of 1915–27 by which Malevich is best known and which since 1927 have composed the largest and most immediately coherent group of works in the West (albeit the majority of these were hidden from view until they were traced and acquired by the Stedelijk Museum, Amsterdam, in 1958; the exceptions being a group of paintings and charts selected by Alfred H. Barr Jr. for his exhibition *Cubism and Abstract Art*, held at the Museum of Modern Art, New York, in 1936).

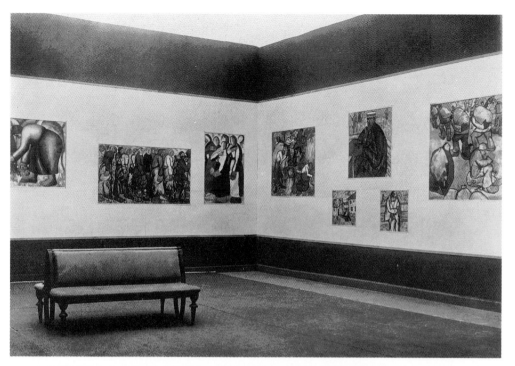

(a)

(b)

Plate 216 (a, b, c and d) Four photographs of the installation of Malevich's work at the *Grosse Berliner Kunstaustellung*, 1927. Original photographs lost, copy photographs courtesy of Stedelijk Museum, Amsterdam.

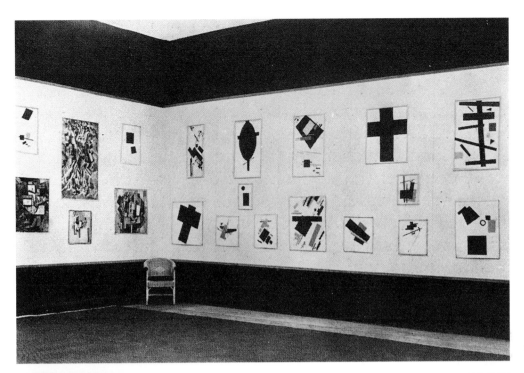

(c)

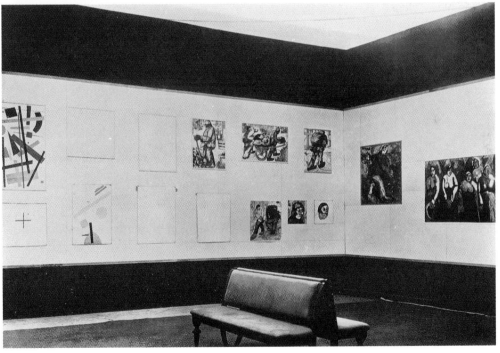

(d)

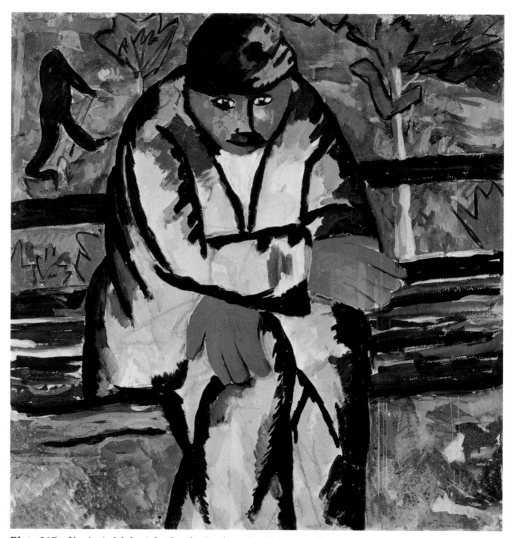

Plate 217 Kazimir Malevich, *On the Boulevard,* 1911, gouache on paper, 72 x 71 cm. Stedelijk Museum, Amsterdam.

When he travelled to Berlin Malevich also took with him a considerable body of theoretical materials, either because he feared – with some reason – that opportunities for publication would increasingly be denied him in Russia, or because he was ambitious to promote his ideas in the West, or for a combination of both reasons. Amongst these materials was the still unpublished 'Introduction to the theory of the "additional element" in painting'. Through the agency of Laszlo Moholy-Nagy, this essay was finally published in German in 1929. It was issued as a Bauhaus book under the title *The Non-Objective World.* Despite the extent and importance of his theoretical work, it was by this text alone that Malevich was to be represented in the West as a theorist of modern art until 1963, when a selection of essays originally published in Russia was issued in Danish. (An English edition based on this selection was published five years later.) With hindsight, the 1927 tour to the West appears as an organized and summative demonstration of Malevich's global form of Modernism, mounted at a moment when practical closures were being applied in Russia and elsewhere to the imaginative possibilities by which that form of Modernism had until then been sustained.

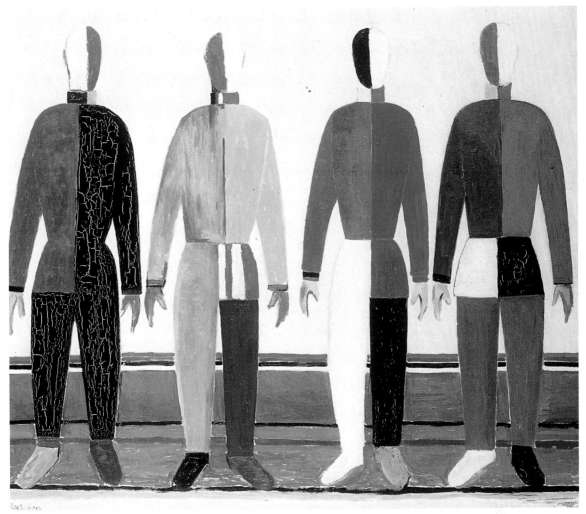

Plate 218 Kazimir Malevich, *Sportsmen*, d. 1912 but probably executed 1928–32, oil on canvas, 142 x 164 cm. State Russian Museum, St Petersburg.

The discussion of Malevich's subsequent work is a separate issue. What can be said here is that it appears as if the utopian aspiration to design the world had been required after 1927 to face the actual awkwardness and absurdity of the people's existence, as that existence was represented in the matching idealizations of Socialist Realism. In the late 1920s and early 1930s we find Malevich combining 'Suprematist' form and colour with stereotypical human figures (Plate 218). If this image of confrontation between Abstraction and Socialist Realism represents some historically actual struggle, it was one in which there could be no victor. At best there was the possibility that the struggle itself could be continued, as it seems to have been, at least intermittently, to the end of Malevich's career as a painter.

Piet Mondrian

A painting called 'Tree'

I would like to begin this discussion of Mondrian's work by looking at a painting from 1913, the *Composition* (*Tree*) now in the Tate Gallery (Plate 219). I wish to consider what it is that the work is *of*, in the sense both of what it depicts and refers to and of what it is made of. We need a way of considering that question which will serve for abstract works and not simply for paintings which are pictures (of something). Firstly, a note of caution about titles, and *a fortiori* about titles of abstract works. In the catalogue to the 0.10 exhibition Malevich wrote:

> In naming several pictures, I do not wish to show that one must look for their form in them, but I want to indicate that real forms were looked upon as heaps of formless pictorial masses from which was created a painted picture which had nothing in common with nature.
>
> (quoted in Berninger and Cartier, *Pougny*, pp.63–4)

In the case of these 'several pictures' we do at least know that such titles as they had were originally given them by the artist. In the earlier Tramway V exhibition, however, five works by Malevich were listed as 'content unknown by author'. It needs to be recognized that the forms of words by which works of art are known and by which they are identified in museums and art galleries are not necessarily reliable guides either to the relevant artists' intentions or even to the actual subjects of the works in question.

As regards the painting by Mondrian, there is a range of possibilities to be borne in mind, amongst which the following are some of the most clear-cut.

1 The artist intended to paint a picture of a tree. He had a tree in front of him as he was working. Some actual tree thus featured in the genesis of the painting and stands as a significant cause of that painting's appearance, whether or not the painting in fact *resembles* a tree. The artist called the painting 'Tree' for that reason.

2 The artist did not intend to paint a picture of a tree. He did not have a tree in front of him as he was working. No tree featured causally in the production of the painting. When the painting was finished, however, it happened to remind the artist of a tree and he called it 'Tree' for that reason.

3 The artist left the picture untitled. When it was first exhibited his dealer labelled and catalogued it as 'Tree', pictures of trees being easier to sell than untitled abstracts. The painting has been known (and seen) as *Tree* since them.

It might seem that this is a somewhat messy situation and that we ought to be able to cut a path through it by asking some such question as whether the painting actually refers to a tree, for example by virtue of its possession of some tree-like property or character. But how are we to decide the matter? On the one hand a picture may happen to look like what it is not actually of. On the other, titles can have a considerable effect on our initial responses, by suggesting what we should see a painting *as* or what we might see *in* it. Once the title has been given, how are we to set it aside in our experience of the painting, and thus in our estimation of what it is that the painting refers to or of what character it expresses? We can broaden this question into a more general inquiry into the ways in which the meanings of paintings are decided by what is said or written about them. To quote Nelson Goodman:

> Pictures are no more immune than the rest of the world to the formative force of language even though they themselves, as symbols, also exert such a force upon the world, including language. Talking does not make the world, or even pictures, but talking and pictures participate in making each other and the world as we know them.
>
> (Goodman, *Languages of Art*)

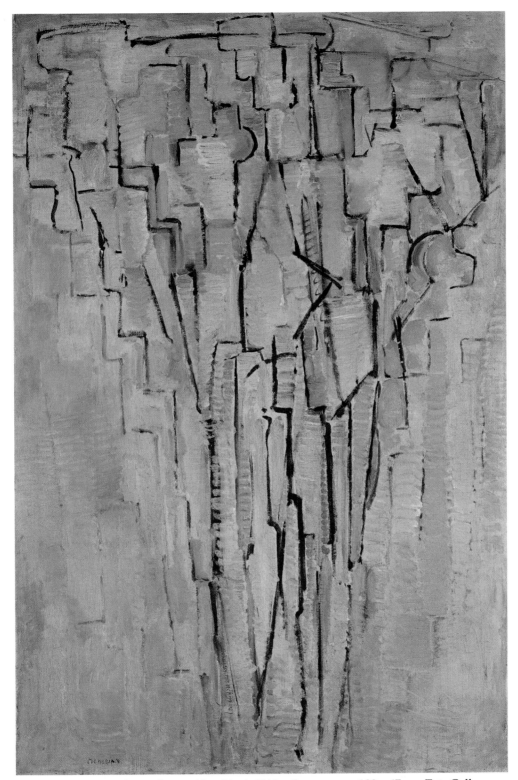

Plate 219 Piet Mondrian, *Composition (Tree)*, 1913, oil on canvas, 100 × 67 cm. Tate Gallery, London. © DACS, 1993.

I raise these matters not to quarrel with the title of this specific painting by Mondrian, but in order to suggest that the painting's connection to some or any tree is a matter which is best not taken for granted. I don't mean to accept that, given the right chain of associations, a relationship can be established between any picture and any other object. I want to know what form of connection the painting has to that which it is *of*. But in order that this issue should not be prejudged, I propose that the question of what the painting actually *is* of should initially be treated as an open one, and this will require that we suspend judgement about the appropriateness of its title.

I now invite readers to scrutinize the reproduction of the painting and to decide for themselves which of the alternatives 1 to 3 above seems most likely to apply. Two points should be made. The first is that preliminary to addressing this question it will be necessary to decide what might count as evidence. The second is that the evidence offered by a reproduction is not necessarily the same as the evidence presented by the actual painting (though we may be able to *deduce* much of the latter from the former). My own conclusion would be that the technical character of the painting – the way in which the image has been formed – suggests an attempt to establish some kind of figure against some kind of ground, suggests also that that figure was intended to read as physically and spatially complex in the way that a tree is complex, and suggests further that the figure has been made to correspond in its formation to *something* which is at least tree-like, which is to say that the figure does not look like a simple invented pattern. I'm not therefore disposed to argue with the labelling of the painting as 'Tree' and would certainly feel no need to consider alternative 3.

However, to take up a point made earlier with respect to Kandinsky's work, to accept the painting as in some sense a picture of a tree is to leave unanswered the question of why it is in so many respects *unlike* one. Or, to put it another way, it is to invite consideration of what *else* the painting is like. After all, unless the difference can be explained away, our sense of the painting's connection to some tree must remain haphazard. In the case of the Mondrian one clear answer is that it is like certain Cubist paintings produced by Braque and Picasso between 1909 and 1911. Mondrian had indeed seen early Cubist works by Braque and Picasso at the Moderne Kunstkring (Modern Art Circle) in Amsterdam late in 1911, and he had moved to Paris soon after. To acknowledge the impact of Cubism on Mondrian's work is in some respect to weaken the role of the tree in determining the appearance of the painting; or at least it is to recognize the presence in his practice of some animating tension between the intention to paint a picture of a tree and the need to engage with what he had taken as the prevailing paradigm of modern painting – that's to say, with Cubism. If the technical character of *Composition (Tree)* suggests that its resemblance to the natural world is better than arbitrary, it is also clear from the same examination of technique that Mondrian was working to produce the kind of complex facetted surface by which analytical Cubist painting was distinguished.

Let us allow that Mondrian had Cubism on his mind when he was painting his picture. If he also had in mind some tree, or even some concept of trees in general, the result can still justifiably be called a painting of a tree. This need not commit us, though, to the view that the artist had a tree in front of him while he worked. Nor are we necessarily saying that the painting's reference to some particular tree or to trees in general is what constitutes the most significant aspect of its content or meaning. It is possible and even likely that what Mondrian was literally referring to as he worked was a previous study such as the painting shown in Plate 220.

To understand just *how* the reference to the tree is complicated is thus firstly to acknowledge the ways in which the appearance of paintings such as this is affected by prevailing *concepts and exemplars* of painting – and by significant changes in those concepts and exemplars. Secondly, it is to see that the position of a work within a technical development or series may be a matter of more moment than the question of what it depicts. To 'see' the tree in the Mondrian painting is by no means to have 'seen' the painting. Rather it

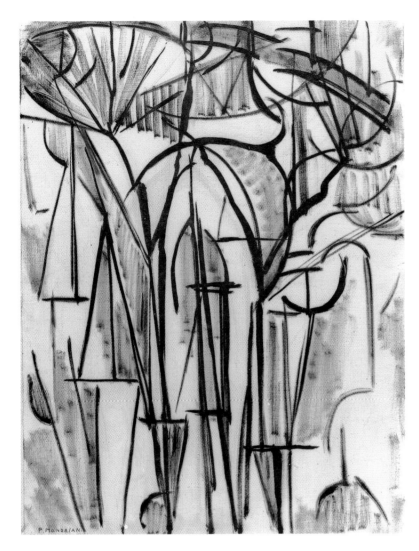

Plate 220 Piet Mondrian, *Composition: Trees I*, 1912, oil on canvas, 81 x 62 cm. Collection Haags Gemeentemuseum, The Hague. © DACS, 1993.

is to have taken the first step in engaging with what it is that the painting itself is engaged in. And to get the measure of this engagement, I believe, we need to sense both the potential attraction of the natural world as a significant cause of the appearance and character of pictures, *and* the power of the idea – clearly felt by all three of the artists we have been principally concerned with – that a painting might be a kind of dynamically constructed world in itself, independent of the appearance of the natural world.

If we look at a sequence of paintings of single trees produced by Mondrian between *c.* 1908 and 1912 (Plates 221–224) what we appear to be watching is the gradual ascendancy of the painting conceived as a self-sufficient world over the painting conceived as a naturalistic picture. We are the more likely to view the sequence in this way if we are familiar with later work to which it appears to be leading, such as *Composition V* of 1913–14 (Plate 225) and *Composition: Checkerboard, Light Colours* of 1919 (Plate 226). This may be misleading however. The *Apple Tree in Blossom* does not really read as a kind of contest between naturalistic appearances and abstract compositional forms, with ultimate victory assured for the latter. To say with hindsight that Mondrian's paintings tend to develop in one direction rather than another is to imply that this is the only way they could have gone and thus to stress the inexorable aspect of the geometry. Whereas, if we

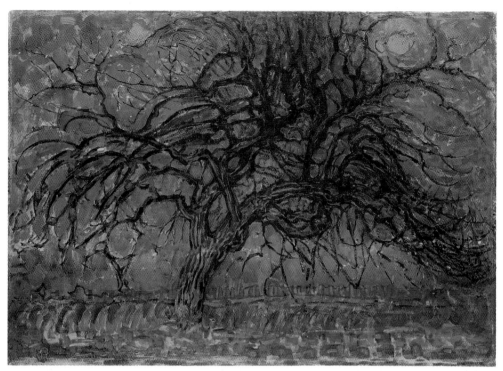

Plate 221 Piet Mondrian, *The Red Tree*, *c*.1908, oil on canvas, 70 x 99 cm. Collection Haags Gemeentemuseum, The Hague. © DACS, 1993.

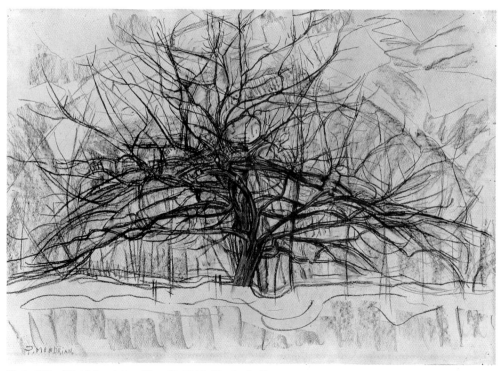

Plate 222 Piet Mondrian, *Tree II*, 1912, black chalk on paper, 57 x 85 cm. Collection Haags Gemeentemuseum, The Hague. © DACS, 1993.

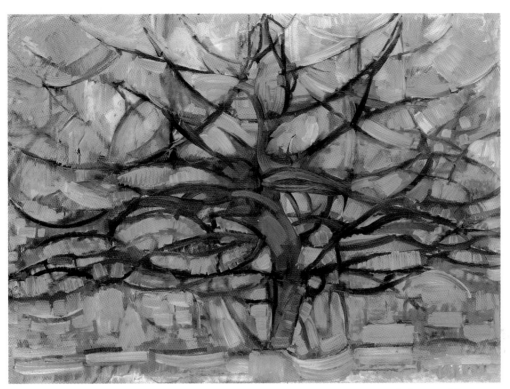

Plate 223 Piet Mondrian, *The Grey Tree*, 1912, oil on canvas, 79 x 108 cm. Collection Haags Gemeentemuseum, The Hague. © DACS, 1993.

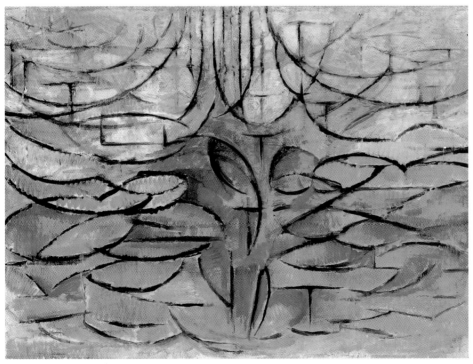

Plate 224 Piet Mondrian, *Bloeiende appelboom* (*Apple Tree in Blossom*), 1912, 78 x 106 cm. Collection Haags Gemeentemuseum, The Hague. © DACS, 1993.

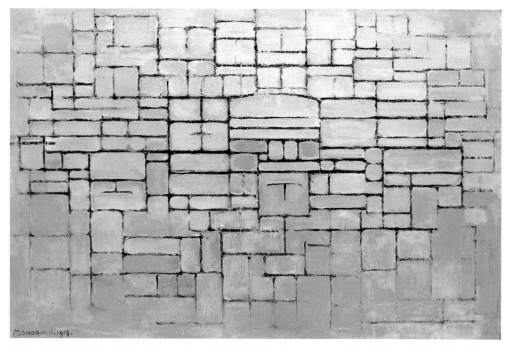

Plate 225 Piet Mondrian, *Composition V*, 1913–14, oil on canvas, 55 x 85 cm. Collection, The Museum of Modern Art, New York. The Sydney and Harriet Janis Collection. © DACS, 1993.

envisage the *Apple Tree in Blossom* as something which was once importantly unpredict-able, it is possible at one and the same moment to see the figure of the tree as merging into the geometric form and to see the geometric form as emerging out of the figure of the tree. This simultaneous experience of possibly contradictory states or meanings – or aporia – may well be true to what it was like to paint such a picture. Our uncertain responses may match some real uncertainty on the part of the artist – an uncertainty perhaps further revealed in the use of titles like 'study' and 'composition'. Beyond a general sense of the physical and conceptual materials to hand, when he commenced making the painting Mondrian may well not have known either how the painting would be achieved or even quite what achieving it would mean. He certainly could not have had in mind – as we can – the paintings he was going to produce in future years. In some important sense he may have been in the process of finding out what painting a 'Mondrian' entailed – experienc-ing a moment of mixed uncertainty and discovery such as both Kandinsky and Malevich seem to have undergone at comparable moments. In each case this may have involved the artist submitting to conditions beyond his will or his ability consciously to formulate, which happened to be conditions of success or failure in modern painting.

Painting as composition

In the case of paintings like the *Composition (Tree)*, it seems we can largely identify the materials worked into a kind of dynamic pictorial balance by Mondrian. We can get some sense both of what these paintings are *of*, and of how other interests affect their connec-tions to what they are of. We can thereby see them as representational – which is to say that we can represent them to ourselves as meaningful. But what of the stylistically 'mature' Mondrian – the kind of painting for which the artist is best known, in which for-mal organization is reduced to patterns of black lines between grey and white, and later simply white, rectangles, and colour at most to the three primaries, red, yellow and blue (see Plates 227 and 228)? How are we to perceive the materials of which these are made and how are we to understand what is at stake?

The first point to be made is that these paintings are very much more complex than they appear to be from standard forms of reproduction. The typical illustration of an abstract painting by Mondrian represents it as if it were a view through a window (see Plate 229). The white areas appear as deep spatial grounds against which the black lines stand out like glazing bars. The sharp edge of the conventional reproduction increases this sense of spatial recession. Yet when Mondrian exhibited his abstract paintings he typically gave them recessed mounts of the kind shown in Plate 228. These served to project the canvas forward into the spectator's actual space and thus explicitly to contradict the reading of the painting as a view into some fictional space. The experience was to be an experience of the actual relations between elements on the actual surface of the painting. It was to be 'purely plastic', and in this sense realistic. That's to say it was to be an experience of those specific lines and colours in those relationships, with whatever illusion of space and depth they happened to establish – whatever sense of plasticity or three-dimensionality. It was not to be a picture of something else.

In face of a typical abstract painting by Mondrian, one is aware of the dense painterly texture of the white areas, which read as distinct and as opaque, and of the enamel-like quality of the black lines, which often show the signs of repeated adjustments to their position and their width. Sometimes the lines and colours are continued past the flat surface of the canvas onto its sides, thus emphasizing the character of the painting as an

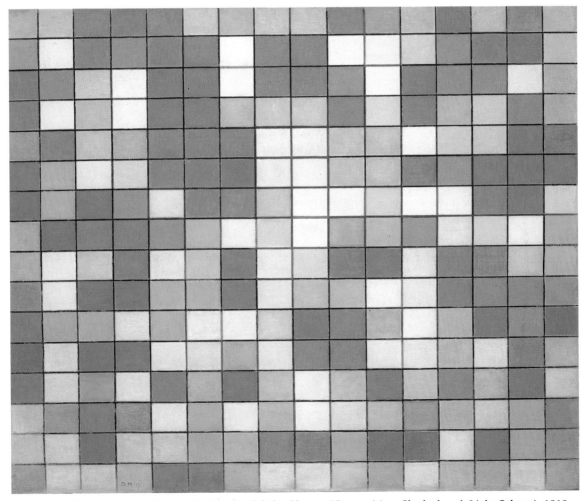

Plate 226 Piet Mondrian, *Compositie: Dambord, lichte kleuren* (*Composition: Checkerboard, Light Colours*), 1919, oil on canvas, 86 x 106 cm. Collection Haags Gemeentemuseum, The Hague. © DACS, 1993.

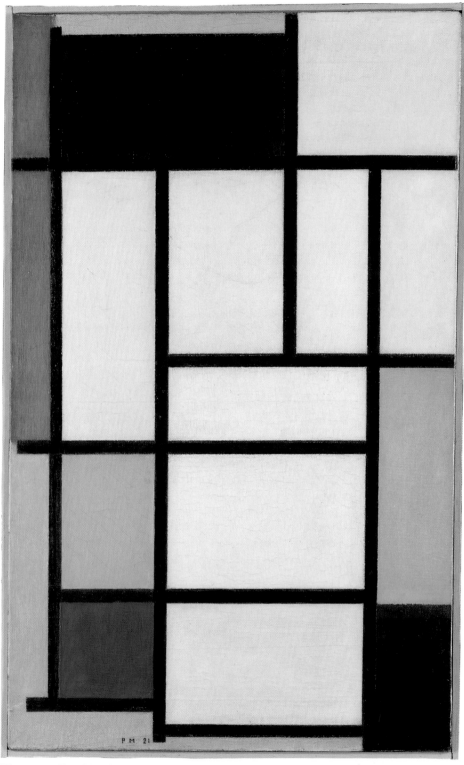

Plate 227 Piet Mondrian, *Compositie met rood, geel en blauw* (*Composition with Red, Yellow and Blue*), 1921, oil on canvas, 40 x 35 cm. Collection Haags Gemeentemuseum, The Hague. © DACS, 1993.

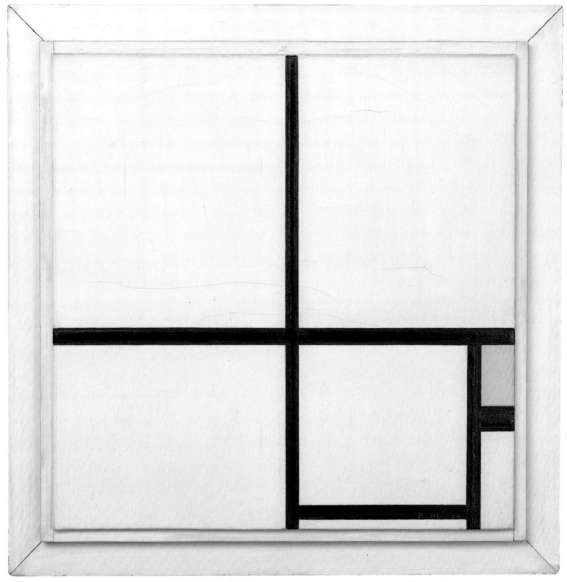

Plate 228 Piet Mondrian, *Composition with Yellow*, 1930, oil on canvas, 46 x 47 cm. Kunstsammlung Nordrhein Westfalen, Dusseldorf. © DACS, 1993.

object sharing the space of the actual world. These various characteristics, rarely discernible in reproduction, serve to convey a powerful sense of the paintings as things which have been *made*. It becomes clear that a crucial balance is maintained between geometrical precision on the one hand and the clear evidence of direct manual touch on the other. While the precision of the technique functions to eliminate the picturesque, it is not carried so far as to impose a sense of the mechanical. It is also evident from the paintings themselves that each is the end product of a process of adjustment or 'tuning' of its various components. To pick up a point made early on, we can say of these paintings that they appear to have been made not, as a pattern might be, automatically, but with the kind of tentative and exploratory procedures normally associated with the pursuit of figuration. The impression is amply confirmed by those canvases which Mondrian left in a preparatory or unfinished condition (for example, see Plate 230). These appear to confirm that his compositions were not so much worked out as worked *towards*.

Plate 229 Piet Mondrian, *Composition with Yellow* (reproduced without frame), 1930, oil on canvas, 46 x 47 cm. Kunstsammlung Nordrhein Westfalen, Dusseldorf. © DACS, 1993.

Plate 230 Piet Mondrian, *Composition* (unfinished), 1938–44, charcoal on canavas, 70 x 73 cm. Sidney Janis Gallery, New York. © DACS, 1993.

I return to the question of what it is that is being thus felt for, if it is not the representation of some figure against a ground; what it is that imposes conditions on Mondrian's activity such that that activity is not merely arbitrary or capricious; or, alternatively, what it is that distinguishes his art from the practice of ('mere') design. In the spirit of our discussion so far there are two ways in which we might address this question. The first is to assume that some figurative content or reference is residually present as a form of genetic trace, even if it is no longer immediately discernible to the spectator: that some requirement of fidelity to a world of waves and dunes and trees persists as it were as a habit in Mondrian's practice; that he is still in some sense seeing his abstract painting as a kind of picture of that world, which has to be made to correspond to some continuing perception or memory; and, perhaps, that we respond to this correspondence at some intuitive level through its effect upon the finished painting. This would be to say that the *Compositions* of 1921 and 1930 are abstract paintings in the weak sense of being 'abstracted from ...'.

The second alternative is to accord autonomy to the aesthetic system according to which Mondrian's paintings are made, and to assume that some 'objective' or rule-like conditions operate within that system in much the same way that grammar may be said to operate within human language – that's to say in response to some basic biological capacities and limits – so that some forms of articulation 'make sense' (or 'look right') while others don't. The evident process of technical adjustment might then be understood as a form of 'tuning' in pursuit of a perfect aesthetic pitch. After all, unless there *is* some relative quality of 'tuning' by means of which Mondrian's paintings can be distinguished from other comparable works – and most appositely from imitations or fakes – what good reason can we have for according those paintings any special significance?

Authenticity and originality

In fact these two forms of response to the initial question need not be seen as mutually exclusive. The case of the hypothetical fake can be used to show how the two senses of abstraction (as process and as state) and the two forms of inquiry (into genetic and aesthetic conditions respectively) might be brought together in face of Mondrian's work. To recapitulate: if we are to accord virtue of some kind to the Mondrian it must be because we see it as in some sense 'achieved'. This can mean that we see it as resolving some disparate set of 'genetic' materials – ideas, exemplars, figurative references and so on – into an attractive or interesting individual configuration. Or it can mean that we see it as having had to conform to some set of language-like conditions (to achieve some quasi-'grammatical' state) in the pursuit of aesthetic quality or 'meaning'. Imagine a painting which appears indistinguishable from *Composition with Yellow 1930* (Plate 228) but which is not by Mondrian and which was painted in order to deceive. The fake is not achieved in either sense. It has not had to be 'abstracted': it stands at the end of a quite different causal chain from that which led to Mondrian's painting – a much shorter one in fact. And far from having had to conform to any language-like conditions in the pursuit of meaning, it has had merely to conform to the appearance of that which was already to hand.

From the point of view of a realistic criticism – one which accords some priority to *how* works of art are connected to the world over *what* they happen to look like – if the genesis of the fake is different, then its meaning and value must be different. It must *be* different. And what do we mean by calling something a fake if we don't mean that its genesis is radically different from that of an 'original', and if we don't mean to accord some *value* to that difference? Paradoxically the more *like* the original the fake is in appearance, the more *unlike* it is in value, since the clearer it becomes that its intentional character was to deceive. (Consider, for instance, the various *ethical* differences between an identical fake, an attempt by another artist to emulate Mondrian's work, and a second version painted by the artist himself.) That we may be unable empirically to perceive the difference between the original and the fake seems to me a less important matter than that they *are* different.

To refer to a work of art as original, then, is to say something not only about its causal character – about the conditions of its production and its relation to those conditions. It is also to say something about its meaning and its ethical quality. To describe Malevich or Mondrian as an artist of originality is to say something not simply about the novelty of their work but also about the meaning and value of that novelty. And this returns us to the problem of the relation of art, conceived as a possibly autonomous activity, to the nature of history. In this case how we approach the problem of those relations is likely to be affected by what we take to be the value of the art in question; that's to say by whether or not we feel that there is some significant quality to be explained.

And what of this 'feeling'? Is the perceiving of quality in art a matter of joining a faith (and of believing in the presence of the quality whether it can be substantiated or not)? Is it rather a matter of learning a set of appropriate competences (and of coming to recognize quality where it is present)? Or does quality 'speak' only to those qualified by some innate sensitivity of disposition (who respond to it intuitively and involuntarily, when it is present)? These various possibilities are perhaps not so easily prised apart in actual experience as they are in theory. But since it has been the aim of this essay to educate, it seems appropriate to take the line that if 'sensitivity' means anything, it refers to some aptitude which is open to being learned and practised. According to this understanding of the term, to become 'sensitive' to abstract art is to be capable of engaging in thought with what it is that the relevant works are made of – capable *in imagination*, that is, of entertaining the possible intentions of the artists concerned, and of achieving some sympathetic understanding of the conditions and concepts under which those intentions may have been formed. The exercise of this imaginative capacity is not, I suggest, the end of the experience of art. It may rather be the beginning of the critical and self-critical process through which the *work* of art actually gets done in our lives – a process which the intentions of artists have in the end no power to prescribe.

References

ADORNO, T., *Aesthetic Theory*, London and Boston, 1984 (published in German in 1970).

ANDERSON, T. (ed.), *Malevich: Essays on Art 1915–1933*, London, Rapp and Whiting, Chester Springs, Dufour Editions, 1969.

APPOLLINAIRE, G., 'On the subject in modern painting', February 1912, edited version in Harrison and Wood (eds.), *Art in Theory*, II.b.3.

AURIER, G.-A., 'Symbolism in painting: Paul Gauguin', *Mercure de Paris*, 11, 1891; printed in H.B. Chipp (ed.), *Theories of Modern Art*, Los Angeles and London, University of California Press, 1968, pp.89–93.

BARNES, B., *Interests and the Growth of Knowledge*, London, Routledge Kegan Paul, 1977.

BELL, C., *Art*, London, Chatto and Windus, 1931 (first published 1914).

BELL, C., *Old Friends: Personal Recollections*, London, Chatto and Windus, 1956.

BERNINGER, H., and CARTIER, J.-A., *Pougny*, Vol.1, *Les Années d'avant-garde, Russie-Berlin, 1910–1923*, Tübingen, Éditions Ernst Wasmuth, 1972.

DELAUNAY, R., 'On the construction of reality in pure painting', 1912, in Harrison and Wood (eds.), *Art in Theory*, II.a.8.

A Dictionary of Modern Painting, Lake, C., and Maillard, R. (eds.), London, Methuen, 1956.

FRY, R., 'An essay in aesthetics', 1909, in Harrison and Wood (eds.), *Art in Theory*, I.b.6.

FRY, R., Introductory note to M. Denis, 'Cézanne', 1910, edited version in Harrison and Wood (eds.), *Art in Theory*, I.a.7.

GOODMAN, N., *Languages of Art*, Oxford, Oxford University Press, 1976.

GREENBERG, C., 'Complaints of an art critic', *Artforum*, October 1967, in C. Harrison and F. Orton, *Modernism, Criticism, Realism*, London and New York, Harper and Row, 1984.

GREENBERG, C., 'Modernist painting', *Art and Literature*, no.4, Spring 1965, pp.193–201, in Harrison and Wood (eds.), *Art in Theory*, section VI.b.4.

GREENBERG, C., Review of four exhibitions of abstract art, *The Nation*, 2 May 1942, in *Clement Greenberg: The Collected Essays and Criticism*, Vol.I *Perceptions and Judgements 1939–1944*, J. O'Brian (ed.), Chicago, Chicago University Press, 1986.

GROSZ, G. and HERZFELDE, W., 'Art is in danger', 1925, edited version in Harrison and Wood (eds.), *Art in Theory*, IV.c.6.

HARRISON, C., and WOOD, P. (eds.), *Art in Theory 1900–1990*, Oxford, Blackwell, 1992.

HOLTZMAN, H., and JAMES, M. (eds.), *The New Art – The New Life: The Collected Writings of Piet Mondrian*, Boston, G.K. Hall, 1986.

KANDINSKY, W., *Concerning the Spiritual in Art*, 1911, edited version in Harrison and Wood (eds.), *Art in Theory*, I.b.7.

KANDINSKY, W., *Reminiscences*, 1913, in R.L. Herbert (ed.), *Modern Artists on Art*, New York, Prentice Hall, 1974.

LISSITSKY, EL, 'A. and Pangeometry', 1925, in Harrison and Wood (eds.), *Art in Theory*, III.c.12.

Malevich 1878–1935, exhibition catalogue, Leningrad, Moscow, Amsterdam, 1988–89.

MALEVICH, K., *From Cubism And Futurism To Suprematism. The New Realism In Painting*, 1916, edited version in Harrison and Wood (eds.), *Art in Theory*, II.a.14.

MALEVICH, K., 'God is not cast down', 1922, in Andersen (ed.), *Malevich*.

MALEVICH, K., letters of 27 and 29 May 1915, in *Malevich 1878–1935*, exhibition catalogue.

MALEVICH, K., *The Non-Objective World*, first published in German in 1927, extracted in H.B. Chipp (ed.), *Theories of Modern Art*, Los Angeles and London, University of California Press, 1968, pp.341–46.

MALEVICH, K., 'On the museum', in Andersen (ed.), *Malevich*.

MALEVICH, K., 'On new systems in art', in Andersen (ed.), *Malevich*.

MALEVICH, K., 'To the new limit', *Anarkhiya* 31, 30 March 1918, in Andersen (ed.), *Malevich*.

MARINETTI, F.T., 'The foundation and manifesto of Futurism', 1909, in Harrison and Wood (eds.), *Art in Theory*, II.a.6.

MARX, K., *A Contribution to the Critique of Political Economy*, M. Dobb (ed.), London, Lawrence and Wishart, 1971 (first published 1859).

MATISSE, H., 'Notes of a painter', 1908, in Harrison and Wood (eds.), *Art in Theory*, I.b.5.

MONDRIAN, P., 'Liberation from oppression in art and life', in Holtzman and James (eds.), *The New Art*, pp.322–25.

MONDRIAN, P., 'The new plastic in painting', *De Stijl*, 1917–18, in Holtzman and James, pp.28–74.

MONDRIAN, P., Letter to A. de Meester-Obreen, in Holtzman and James, pp.15–16.

MONDRIAN, P. and others, *Manifesto 1*, De Stijl, 1918, in Harrison and Wood (eds.), *Art in Theory*, III.c.3.

MOTHERWELL, R., 'The modern painter's world', 1944, in Harrison and Wood (eds.), *Art in Theory*, V.c.4.

NASH, P., 'Abstract art', *The Listener*, 17 August 1932.

REBAY, H., 'The beauty of non-objectivity', 1937, in F. Frascina and C. Harrison (eds.), *Modern Art and Modernism: A Critical Anthology*, London and New York, Harper and Row, 1982, pp.145–48.

Alexander Rodchenko, exhibition catalogue, D. Elliott (ed.), Museum of Modern Art, Oxford, 1979.

RODCHENKO, A. and STEPANOVA, V., 'Programme of the First Working Group of Constructivists', 1922, in Harrison and Wood (eds.), *Art in Theory*, III.d.6.

WOLLHEIM, R., *Painting as an Art*, Princeton and London, Princeton University Press, 1987.

WORRINGER, W., *Abstraction and Empathy*, 1921, edited extract in Harrison and Wood (eds.), *Art in Theory*, I.b.4.

Index

Illustrations are indicated by italicized page numbers.